The Surrealist World
of
Desmond Morris

The Surrealist World
of
Desmond Morris

MICHEL REMY

translated from the French by
Léon Sagaru

JONATHAN CAPE
LONDON

First published 1991
© Interpublications 1991
English translation © Interpublications 1991
Jonathan Cape, 20 Vauxhall Bridge Road, London SW1V 2SA

A CIP catalogue record for this book
is available from the British Library

ISBN 0-224-03131-7

Produced in co-operation with Souffles, Paris
Printed in Italy by Amilcare Pizzi, Milan

CONTENTS

PREFACE

The first time I heard of Desmond Morris's paintings was in Vancouver in the early autumn of 1980. The person who told me about them, my friend the British-born Canadian surrealist painter Ted Kingan, had exhibited with Morris in England in 1948 and well remembered both the man and his painting. But it was not until 1987 when Phaidon published a book on Desmond Morris the painter that I was able to fully appreciate his work. And now the opportunity is mine to say a few introductory words to the present study by Michel Remy, whose authority in matters concerning surrealism in Great Britain is well established.

To begin with, what strikes me is to see that Desmond Morris – a scientist of international renown – considers his painting not as a pastime but as an activity that is just as important to him as his scientific research. This seems marvellous to me because we live encircled by droves of specialists of all kinds, who in the field of real knowledge are as ineffectual as an army of one-eyed soldiers would be from a strategic stand-point. It is also marvellous because it seems obvious to me that the two types of research Desmond Morris undertakes are complementary in the quest to answer the great problems of human and animal behaviour, to which he has dedicated his life.

Thinking matters over, it is not so surprising that the boy who marvelled at what a microscope revealed to him in a drop of water should soon after begin drawing and painting, as if by doing so he sought to associate himself with the genesis of living forms, nor that he should one day cross paths with surrealism . . . Indeed, if in poetry the surrealist movement was concerned with the very conception of language, there where "words make love" before making sense, in the pictorial and sculptural fields it often addressed itself to the birth of forms, including the most elementary and archaic beings. Anglo-Saxon critics, searching for a way to describe these beings coined the adjective "biomorphic", a word which was duly transcribed by a French-speaking critic of limited imagination. I would have preferred "organic", quite simply.

In point of fact, not all surrealist painters emphasized these organic aspects – aspects that enabled the metaphorical evocation of processes such as fertilization, germination, hatching, burgeoning and metamorphosis. These aspects preoccupied only the most dynamic exponents of surrealism, those most orientated towards life and hope. Among them, as we well know, Hans

At the spring of life

by José Pierre

Arp and Yves Tanguy celebrated this universe of births and embryonic forms all through their lives, influencing Max Ernst as much as Salvador Dali, Picasso or Henry Moore, Miro or Arshile Gorky.

There is no doubt that Desmond Morris belongs to this same genre, and it is significant that E.L.T. Mesens chose to show his works alongside those of Joan Miro at the London Gallery in 1950. At the time, from a spiritual point of view, the Desmond Morris of *The Red Dancer*, *The Table* or *Angels at Play* was very close to the Catalan master, as he was to be again a decade later with works like *Egg-head* or *Point of Contact*.

However, it is clear that his affinities with the work of Tanguy, which appeared as early as 1947 in paintings like *Entry to a Landscape* or *Master of the Situation*, were bound to return triumphantly, and this came about during 1969 in *The Teacher's Doubt*, *The Explorer has Arrived*, and *The Ritual*. We might even say that Desmond Morris retraces the same itinerary that Yves Tanguy followed from 1926 up to his death in 1955. But like Picasso or Henry Moore, who in taking inspiration from Arp and Tanguy did not paint Arps or Tanguys but Picassos or Henry Moores, Desmond Morris has always painted Desmond Morrises.

Perhaps even more than Hans Arp, of all the surrealist painters Yves Tanguy made the most prolific use of the technique of "automatism". Taking inspiration from Tanguy's example thus meant entering into the mainstream of automatic creation, of real surrealist creation, which establishes communication between the interior world of the artist and the exterior world, the microcosm and the macrocosm.

The four young painters who instinctively chose Tanguy as their master on the eve of the Second World War knew what they were doing, even at a time when the painter could sell nothing at all and was in total eclipse behind the more showy renown of Salvador Dali. Because between 1937 and 1940, these four artists – the Austrian Wolfgang Paalen, the Chilean Matta, the Englishman Gordon Onslow-Ford and the Catalan Esteban Francès – had each discovered the secret of surrealist automatism, in other words the means of access to the "kingdom of the Mothers" which Goethe speaks of in the *Second Faust*.

In turn, Desmond Morris discovered in Tanguy's work the secret that gave him access to those deep interiors where this perfectly material

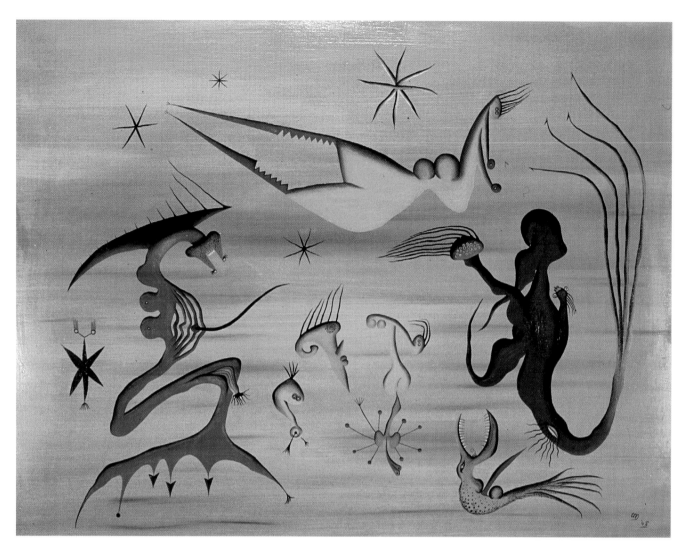

Celebration
1948
Oil on board
28 × 37 in.
Eric Franck Gallery,
Geneva

and materialist miracle repeats itself: the moment when from the inorganic we move to the organic, when from nothing or next to nothing is born something that palpitates in the full sense of the word; the moment when life surges into the world and begins to fill forms, to organize itself, and soon after to proliferate.

Because it is to just such a fabulous spectacle that Desmond Morris invites us. Fabulous and funny. Which is not the case with Tanguy who plunges us into the immense melancholy of origins. In some respects then, Morris is a sort of cheerful Yves Tanguy, just as Tanguy might be described as a sad Desmond Morris. There is such a love of life in the painter of *For Insiders Only* (1973) that even when he evokes dramatic situations (*The Kill*, 1973) or a dream atmosphere (*The Sleepwalker*, 1976), the forces of darkness never threaten to triumph over the forces of life.

I find it stimulating that in the world of today such an eminent zoologist should show so much optimism in favour of life at every level, from the infinitely small creature wriggling under the lens of a microscope to the supposedly superior animals that we boast of being. Yes, it is good for painting that thanks to Desmond Morris we have before our eyes works that we can praise without reserve, just as they exalt us without reserve – a rare thing indeed and good for the inhabitants of this old Earth both great and small. For in his colourful messages Desmond Morris assures us that our planet will go on turning round the Sun, and that Life will go on taking all sorts of risks on its surface.

Biarritz,
31 October 1990

INTERVIEW WITH DESMOND MORRIS

M.R. Do you believe in Darwinism, and if so how does it relate to your painting?

D.M. Yes, I am a Darwinist. I believe in the concept of evolution, which is fundamental to my way of thinking. As a scientist, Darwin has been the most important figure in my life. All my research on animal behaviour is founded on the concept of evolution. And it is the same with my painting. What happens in my pictures is a sort of 'subjective evolution', an evolution that goes on inside my mind. My paintings evolve from canvas to canvas, and the organisms that appear there – the biomorphs – change from one work to the next as if there is some sort of evolutionary principle in operation. But the fact that there is a biological process underlying the development of my paintings does not mean that I am a scientific illustrator. Far from it, because the evolutionary principles involved are operating in my unconscious mind. There is nothing deliberate or planned about them; what happens is purely intuitive. I never sit down to think out how the painting is going to develop. When I paint there is a good deal of automatism, as is the case with most surrealist painting. The fact that I happen to be a biologist as well as a painter means that I have a deeper understanding of the evolutionary process and it is this process that influences my work, but not directly or specifically, rather in an unconscious, generalized way.

M.R. In your family background, what might explain your interest for biology as much as for painting?

D.M. Well, as for biology, my great-grandfather, William Morris, was amongst other things a Victorian naturalist and it was his splendid brass microscope in a trunk in the attic that enabled me to start exploring a totally new world. In my childhood I was always surrounded by animals and it was only natural that biological forms, colours and animal patterns should become part of my thought processes, and that I should become interested in animal behaviour. That is where the colours, shapes and symbolic actions and interactions, that are the very substance of my paintings, come from. My interest in painting stems from the fact that I was a very secretive child, extremely shy, and liked to be on my own a great deal. I learned to become an observer at an early age. I don't have an ear for music, and although I enjoy it I haven't the slightest talent in that direction. On the other hand, my eye

The one and the other

developed a singular capacity to respond to visual stimuli, to grasp the slightest differences between one red spot and another, in nature, or between the shape of one leaf and that of another, and these very subtle distinctions are at the heart of the exploration in each of my paintings, not as illustrations, I repeat, but rather at an underlying, intuitive level.

M.R. How did your first contact with real painting come about?

D.M. When I was at school in England around the age of fourteen or fifteen, I discovered from art books in the school library that it was permissible to allow one's imagination to control the visual images. When I was younger I had always been told that if you painted a flower it had to look exactly like a flower, a house like a house, and I had no other idea of art other than the representational approach. That did not interest me at all and I had always ignored painting because it seemed to me to be simply boring decoration and illustration. I saw no need to paint a bird when the real bird was far more intricate and beautiful than its reproduction in a painting. The subtlety and complexity of a feather, I knew, could never be recreated in a painting. But in the art books I found in the school library, amongst which was *The Painter's Object* by Myfanwy Evans, the wife of John Piper, and the small Penguin collection on contemporary painters like Paul Nash, Graham Sutherland, Edward Burra and Henry Moore, I discovered that you could paint without being a slave to the external world. Instead of copying it you could distil it. This was a revelation for me. Not long after, I began going to exhibitions quite regularly, where I confirmed this possibility of letting the imagination work on its own.

M.R. How do you place yourself in surrealism, and what do you consider to be the relationship between surrealism and politics?

D.M. I feel an affinity with the surrealist movement because it defends the liberty of the artist. It encourages a personal subjective rebellion against the traditional attitudes of the establishment. For this reason I find it astonishing that certain surrealists have declared their support of this or that political party. No politician wants people to be free, no matter what they may say in their vacuous speech-making. The Left wants to direct them in one way, the Right in another.

Whatever political party is running the country, it wants the country to go *its* way. Real liberty for the artist means refusing to be enlisted or used by any party. You only have to look at what happened to art in Soviet Russia in recent years to see what a mistake it was for certain surrealists to join the Communist Party. I am totally non-political and I agree with Breton's declaration according to which an artist should never be engaged in the service of an idea once that idea threatens to take away his or her independence. The individual artist today must be free to explore his or her personal and subjective vision of the world. It is that freedom that has made for the extreme diversity of surrealist works. To my mind, any attempt to impose a political programme on this freedom is a form of tyranny and a big mistake.

M.R. Do you think that a declaration of principles of a political order should be made in certain circumstances? For example, if a number of surrealists decided tomorrow to sign and publish a declaration in favour of artists threatened in their life or liberty, would you be willing to add your name to theirs in spite of your distaste for politics?

D.M. I would make a personal declaration but I would not sign a group declaration. Some years ago when I began to become well known for my books I swore that I would never sit on any sort of committee or join any sort of group, no matter what the reason. The group as such does not interest me. Even if I was in agreement with the terms of a particular manifesto in defence of another artist, I would not sign it. I would write my own document. For example, I was asked to sign a declaration against certain cruel treatments inflicted on animals; I was thoroughly in agreement with it, but I wouldn't sign it. Instead, what I did do was to make a whole television series on the subject, based on my own personal script. It has already been shown in nineteen countries and the script has been published as a book. For me that is much more satisfying than putting my signature to a document composed by some committee. I simply don't like groups – it's something going back to my childhood. I want to remain outside of them. When you belong to a group that is commercial or political in nature, there comes a time when you are bound to compromise yourself, because it is impossible for all the ideas of the group to be simultaneously your own. In art today this is particularly relevant

because now, in the late-twentieth century, all the great aesthetic battles against academicism have been won and art groups have become less and less useful. All the most exciting artists today are highly individualistic with intensely personal visions. The 'schools of art' are almost a thing of the past. The 'isms' are far less important than they used to be. But it must be said that in the past, when the war against the art establishment was still being waged, group activities were important. There was safety in numbers then and the groups gave their members added strength. This was particularly true of the surrealists, whose concerted actions were highly significant in bringing about the present-day conditions of freedom. It is only now, because of their earlier efforts, that artists can be faithful to their 'personal images' and remain so.

M.R. In 1958, you organized an exhibition entitled "The Lost Image". What did you mean by that expression?

D.M. With the development of photography in the nineteenth century it became possible to capture and reproduce reality, and, because of this, photography inherited the duty of representing accurately the external world. This set painters free to explore new visual ideas and enabled them to liberate their imaginations. From that time onwards different art movements, one after the other, did away with traditional styles, gradually breaking all the chains that had tied the earlier artists down to the task of reproducing the external world. Impressionism, fauvism, cubism, futurism, abstractionism, dadaism, surrealism – all the 'isms' – tore away, bit by bit, the old restrictions. Finally with tachisme and minimalism, all the old images were lost. Completely blank canvases were exhibited. The shock was complete and in the blinding light of a pure white painting the artist was at last free. But freedom is like a desert – you can go in any direction but there are no signposts. The old traditional image had been lost, but without any new image to replace it there was soon sterility. Now only those individuals with a powerful, personal vision could succeed after such a total rejection of the traditional form of representationalism. This can create huge problems for artists who lack a strongly idiosyncratic, individualistic imagery, but for others it has meant the possibility of unfettered exploration. We sometimes forget how recent this is. I have seen it all happen in my

own lifetime. When I exhibited my paintings in the 1940s I was actually called a madman. I was vilified because I rebelled against the traditional art that still dominated much of the art world at that time – despite the revolutions that had already taken place in the previous decades. It has taken a long time for the message to be accepted by society in general.

M.R. Some people see direct influences from Miro or Tanguy in your works. What do you think of that?

D.M. There is no denying that I am close to Tanguy insofar as he also elaborated a very personal world, but the difference is that my background was that of a zoologist while his was that of a merchant seaman. He seems to have been greatly influenced by the image of small objects scattered on the beach and, in my opinion, the weakness of some of his very last paintings stems from the fact that the magic is killed by the too great resemblance between his invented objects and ordinary pebbles. The world he depicts is a static world, usually sad and silent; mine is full of sexuality, violence and biological activity. But don't misunderstand me – I am a great admirer of his. He is one of the greatest surrealists – perhaps the most purely surrealist of them all.

M.R. And Miro?

D.M. I share Miro's passionate love of lively forms. His paintings overflow with sexuality, humour, joy and violence. In this sense I am near to him, but technically, I am quite different. If I am close to Tanguy and Miro it is because we are all three fascinated by biomorphic forms – perhaps I should say natural forms because of the strong mineral element in Tanguy's land-scapes. For myself, the botanical and zoological world supplies me with biological concepts and natural processes with which neither Tanguy nor Miro could have been closely familiar. There is little or nothing in my paintings that can be indentified as belonging to a particular species in the external world, but the underlying principles active in natural forms are all there. Cephalization, for example, which is the process by which the extremity of an organism becomes differentiated into a head; or segmentation, by which a body becomes subdivided into repeated units; or allometric growth, or cell division, or bifurcation, or polymorphism. I am aware of all

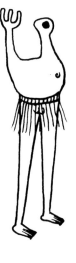

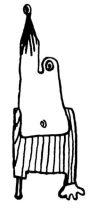

these biological processes, but in my paintings I do not apply them scientifically or analytically. I apply them unconsciously and intuitively. What I mean is that, if you have an inner knowledge of such developments as segmentation, differentia-tion, articulation and the growth patterns of lobes, spicules, fins and spines – and you happen also to be a painter – then automatically these biological phenomena are going to work through you and into the pictures without any conscious intervention.

M.R. Would that be a likely junction point between your two activities?

D.M. Yes. When I see a red spot on a bird's beak I know that it is an important visual sign. As a scientist I learn about its potency as a sign stimulus. I study it and I analyse its function. While this is happening, I am also developing a subjective feeling for the dramatic qualities of 'redness' and 'spottedness'. Unconscious am-biguities set in – red, fire, danger, blood, dramatic, fixating, conspicuous, attention spot, eye, sun, hole, orifice, point, full stop. Visual echoes, sym-bolic equivalents, substitutions all start to come into operation, but I am never conscious of what has been happening until after I have completed the painting. I paint as if I am in a dream, as if I am hallucinating. The actual moment of creation is like watching a dream unfold.

M.R. Does the imagery evolve as the painting is elaborated?

D.M. Yes, I have this fantasy that some pictures go on painting themselves after I have gone to bed . . . like flowers unfolding paradoxically in the night. Each picture grows organically and, when I move from one painting to the next, a new scene develops, as though I have opened another window onto my endless private landscape.

M.R. Do you do preparatory drawings?

D.M. No, hardly ever. Of the eight hundred paintings I have done, there are only three that have been preceded by preparatory drawings. There are no preparatory titles either. Usually I give a picture its title shortly after completing it, just a label – any title that springs to mind by a process of free association. One exception was a picture called *The Blind Watchmaker*, which was based on the title of a book a friend of mine had just written. He used it for his dust-jacket. I did

a drawing for it too. I had a prior idea. It was an exception.

M.R. What exactly does your pictorial technique consist of? To what extent does your conscious mind intervene, and at what moment?

D.M. In answering I particularly have in mind a painting called *The Attentive Friend*, but what I say holds for most of my work from the Seventies. The painting began with a small shape, high up in the centre of the canvas. This was joined by several other small companion-shapes. Suddenly I felt that what I had were not individual organisms but details of a much larger being that had somehow developed from beneath these first forms. This major form then insisted on growing a long, rather delicate, stinging tip. On the right of the canvas a friend arrived and became over-attentive, almost touching the stinging tip. Then I felt that this close relationship had a witness. This explains the rather bland, inoffensive figure on the left, quietly watching the interaction. These small, quiet, 'watcher' figures often appear in my paintings and I sometimes think that they must be me, watching the story unfold in my personal world.

When I am in front of a painting it is as if I am in front of a microscope on whose slide I have placed a drop of water from the pond in my garden – which is still something I like doing when I have a spare moment, though I rarely do have any these days, unfortunately. What you see in that drop of water are incredible dramas – your field of vision is filled with changing, developing forms. I often sit an hour or so in front of the blank canvas until – suddenly – something enters my field of vision, to float and drift about in my imagination. I have to work fast then. In the beginning I paint quickly, not bothering about details. Then I spend the next three or four hours carefully transforming what I have painted. During this stage, I switch on the radio – I need to stop inventing. I have to consolidate. But at the moment when the forms first come to me, I work in complete silence. Once they have been trapped I can then start working with fine brushes to add the details, transforming them into the completed biomorphs. At this later stage I have to reduce the inventive-ness – the intervention of my imagination – otherwise the paintings become overloaded. By the way, there are two or three paintings I've done which I think are too full, where you can't really distinguish the forms from each other.

That is one of my weak points – a *horror vacui* – which is common among self-taught artists. Looking back, I prefer the paintings where there is more breathing space. An amusing point is that when I was encouraging chimpanzees to paint – as one of my scientific investigations – they always knew where and when to stop. In this sense they were more advanced than me!

M.R. Do you share – even in a paradoxical sense – a certain mistrust of science, such as the French surrealists showed in the Fifties? And what do you think of science's intrinsic impulse to theorize?

D.M. As you know, we belong to a high-risk species. Our humanity is defined by the risks it takes. You can't be inventive without taking risks and making mistakes. Of course, you can behave like the tortoise, which is ten times older than mankind and certainly lives much longer, but that lifestyle is not for me. I think that the curiosity and inventiveness of the scientist and the artist are one and the same, but of course they use different methods. The scientist uses a method of experimentation, the artist one of discovery. Picasso said: "I do not seek, I find." Well, the artist finds and the scientist seeks. All the same, there are close similarities when it comes to important moments. It is surprising how many vital steps have been taken in science, not by sysytematic investigation and probing, but the *eureka* moments of pure chance. Like great artists, the best scientists manage to keep a childlike curiosity throughout their lives. For official reasons, many scientists publicly link their research to economic, cultural or techno-logical developments, but in reality the primary reason for undertaking the research is a powerful urge to satisfy their acute sense of curiosity. So at a basic level, perhaps artists and scientists are not so different after all.

The fact that certain scientific discoveries can create enormous problems must be put down to human nature. Every advance we make can be either used or abused. If it is abused that is not the fault of science itself, but of the way society exploits it. In any case, the alternative to scientific research is the blind rigidity of faith and religion.

M.R. What do you think then of the losses of control that science is responsible for?

D.M. It is true that a lot of discoveries are taken over by politicians, racketeers, arms-dealers and

warmongers. But if we want to avoid the risk of all that, we will have to return to the primeval forest. There will always be a risk . . . for me, the most important pleasure in the life of a human being is that of having the vision of a childlike adult, or an adult-child, of retaining the inquisitiveness and inventiveness of the child. The scientist should never stop looking for the exception to the laws already in place. The generalizations of today should become the exceptions of tomorrow. The real scientist is a rebel because he or she does not accept the world as it exists. If the rules he or she uncovers become rigid, it is the fault of society, not science. For instance, in physics one of the problems that seems to me to be fundamental right now is how to invent an 'anti-gravitational machine'. As soon as it becomes possible to oppose gravity, the whole world will be transformed. We shall no longer be imprisoned by the earth's surface – we will be able to float and travel with ease through the air – rather like one of my early biomorphs. Although this discovery will immediately revolutionize all kinds of transportation, and make a jet plane look as clumsy as a stagecoach, and will give us all kinds of exciting possibilities for worldwide travel, it will probably be used to serve the ends of warfare or big business, but what can you expect? All knives can either kill or cut bread, but you can't make the knife responsible for the act, far less the person who made it. And you can't stop manufacturing knives because of this risk. If we follow that line, we become like tortoises stuck in their shells.

M.R. How do you link up your interest in ancient art with your own painting?

D.M. What fascinates me in ancient art and in tribal art too is that it reminds us that ninety per cent of all human artistic activity has not been aimed at the accurate representation of the external world. The European mode of thinking, from Classical Greece to Victorian times, has been dominated by the idea that the artist is someone who serves society by precisely recording external reality. And this explains why the work of the early surrealists was viewed as something extraordinary and bizarre. In fact, what is strange and unusual – in global terms – is to want to represent the external world with precision. That is what is atypical, because if you look at ancient or tribal art, you won't find that. Prehistoric art stands out by its magical distilling

Confrontation
1948
Oil on canvas
18 × 12 in.
Eric Franck Gallery,
Geneva

of the world. Look at the human figures in my book on *The Art of Ancient Cyprus* – they have two heads, three necks, no arms, eyes made of a circle of little dots – all kinds of variations. This playfulness is part of the ancient artist's inventiveness, of the pure joy of creation. Human and animal figures may be the basis of these works of art, but the shapes are constantly changed and manipulated . . . and it is this *distillation* of externals that is important.

M.R. How do you reconcile your activity as a painter with your activity as a well-known writer?

D.M. Well, in fact there are two Desmond Morrises, and they are quite different people. I can easily pass from one to the other, but I cannot be both at the same time. When I'm Desmond Morris the painter, I am quite different. The private, secret part of my brain starts working and for me that is the most important and serious thing in my whole life – much more so than the rest. The other side, the public Desmond Morris, also has a major role in my life, of course, but strangely I find that less challenging. There is rarely any clash between the two aspects. The one helps the other. I obey the two sides of my brain alternately.

M.R. Haven't there been some moments of tension, when making a choice?

D.M. Very rarely. The only examples come from my public life. Something happens there and the 'other Morris', the surrealist, subjective Morris, will not accept it. Then I sometimes do things which other people think odd. On occasion I have simply upped and left without warning because I couldn't make certain compromises. Several times I have just said "I won't go on with this. Goodbye," and I have left a job or resigned a position. The individualist inside me rebels, and I leave even if I have no idea of what I will do next. But more often what happens is that my painting helps me with my other work. Because it gives full rein to my subjective nature and my fantasies, it satisfies that part of my brain and enables me to be more intensely objective when I am the scientific Morris. And it also works vice versa. By satisfying the objective side of my nature as a scientist, I can be more intensely subjective when I am painting. Each side releases the other. I have my studio and my library: they are my two domains.

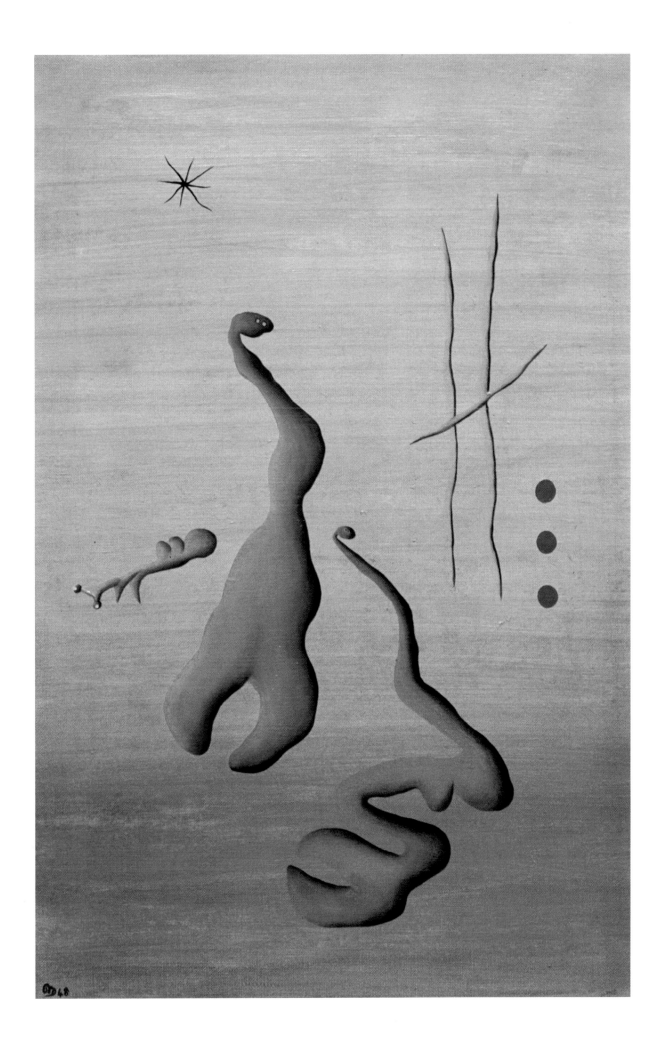

INTRODUCTION

In the beginning: surrealism

Will Desmond Morris's naked apes ever enter – one black-lit day – the circle of Great Transparents André Breton caught sight of off the coasts of Gaspesia?

Saying whether a painter or poet belongs to the surrealist movement or not is a risky affair, especially if the artist in question prefers to pursue the "vertiginous descent into the hidden places" of the subconscious in the solitude of the studio, without feeling the need to constantly refer to what was no doubt the most radical aesthetic and intellectual movement of the twentieth century. Even more difficult is the task of evaluating the faithfulness to the fundamentals of surrealism of a painter or poet who, because of his youth, joined the ranks of the group when it was living out its last hours as a constituted entity. And it is an almost impossible task when this painter or poet – while asserting his solidarity with the surrealist adventure – turns out to be an author of international bestsellers, whose success is mainly due to the mass diffusion of scientific research, where the role of the imagination would seem to be singularly reduced.

And yet the name of Desmond Morris cannot be separated from the history of surrealism in England, from its hesitations and promises, much less from an international movement whose chief concern is to avoid the adoption of models and clichés, and tirelessly tune in to the most discordant voices. The problem at hand then is not to award an honorary title to Desmond Morris by affiliating him by hook or by crook to surrealism, but rather to gauge the extent to which he inscribes his pictorial research in the permanence of the surrealist spirit.

We are bound to admit that in spite of the twenty or so collective exhibitions organized by the surrealist group between 1936 and 1950, and the simultaneous publication of several manifestos, declarations, leaflets and reviews, not to mention the twenty numbers of the group's magazine in London, the *London Bulletin*, surrealist activity in England remained little known. This was due largely to the gigantic shadow cast by French surrealism and the personalities of its 'actors', and also to the English group's apparent lack of organization and co-ordination in its initiatives, as well as definitive theoretical standpoints – this at a time when everywhere else the group and group activity were playing a vital role.

This unwritten history so full of aspirations, conflicts and disappointments, and in which Desmond Morris figures as of the post-war years, is inseparably linked from start to finish to the colourful and spirited personality of E.L.T. Mesens, who with Magritte and Nougé had launched the Belgian surrealist group in the Twenties. Edouard Mesens had managed several galleries, organized a good many exhibitions, and published several reviews and group works, but more importantly he had acted as a sort of 'ferryman' by contributing to the forming and strengthening of ties between the Brussels group and French surrealists. In late 1937 Mesens left his native Brussels to take up residence in the British capital, where he assumed management of the London Gallery. This establishment – formerly pleasantly daring in spirit – was to become the headquarters of, and rallying point for, surrealist activities in England, which had been launched in June 1936 during the International Surrealist Exhibition at the Burlington Galleries. In April 1938, Mesens's publishing – with the help of Roland Penrose – of the first issue of the *London Bulletin*, inaugurated two years of intense activity. In the course of this period, thanks to the collaboration of the Mayor Gallery and the Guggenheim Jeune, he managed to implement an exhibitions policy to which he remained faithful. This consisted of sharing the hanging space between surrealist painters from the Continent – most of whom were little known in England – and English surrealists, who, since 1936, had been trying to give body and coherence to their work. Thanks to this recentring of activities, Magritte, Delvaux, Man Ray, Yves Tanguy and Wolfgang Paalen were shown for the first time in London, while the English painters Humphrey Jennings and Roland Penrose, and the sculptor F.E. McWilliam, among others, had their first one-man exhibitions there.

Mesens's courage, spirit of initiative, and deep conviction were to dominate the war years. Between 1940 and 1945, surrealist activity in England continued, and was marked by group exhibitions, publications and even internal debates of an ideological nature whose aim was to safeguard the 'purity' of surrealist protestation and ensure that painters and poets should not bring 'dishonour' on themselves. This remarkable spirit of resistance and constancy in English surrealism enabled the London Gallery to reopen once the war was over, and it was thus that Mesens was able to *reorient* surrealist activity.

New premises for the London Gallery were found at 23 Brook Street to replace those at 28 Cork Street badly damaged by bombing, but

what with delays in the reconstruction programme caused by administrative red tape, the new gallery was not to open before 5 November 1946, with a one-man show dedicated to Wilfredo Lam, unknown in England at the time. A few months later, in March 1947, Mesens was able to organize an exhibition of exceptional scope entitled "The Cubist Spirit in its Time", with no less than fifty-seven works by artists such as Léger, Braque, Duchamp, Picasso, Picabia and Man Ray. Then, using the four rooms spread over two floors of his bookshop-gallery to their full advantage, he began holding exhibitions at a steady pace, showing two or three artists at the same time – an arrangement that enabled him to use the fame of one or another of these painters to introduce the works of a lesser-known painter to the public. This abundant activity in presenting new works was to be all the more important given the fact that the surrealist group hardly ever met as a constituted body any longer. Its last concerted intervention had been the signing and publication of a solemn declaration during the International Surrealist Exhibition of 1947, but most of the fourteen signatures had been forwarded by mail and not affixed in person during a general meeting. We are thus justified in thinking that behind Mesens's systematic *signalling* of surrealism and his exploring of its immediate environs lay a secret hope – albeit one devoid of illusions – of seeing group activity start up again and be redynamized. It is in this overall perspective that Desmond Morris's arrival should be placed.

On 2 February 1950, following a year marked by exhibitions of the works of de Chirico, André Masson, Picasso, John Craxton, Esteban Francès, John Banting, Roland Penrose and Stephen Gilbert, a three-man show opened with the works of Joan Miro, Cyril Hamersma (who was to disappear soon after) and Desmond Morris. Each artist was represented by roughly the same number of works and Desmond Morris's seventeen titles were preceded in the catalogue by a few lines written by Mesens:

"Has painted for several years. Released not long ago from the army. Studies at Birmingham University. His recent works show a steady affirmation of personality."

The young man of 22 years that was Desmond Morris at the time thus stepped right into the middle of the history of English surrealism, travelling a king's highway in a joint exhibition with Miro, and chosen by Mesens. It is indeed a

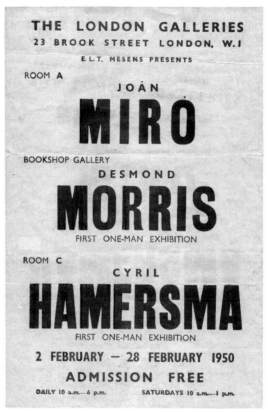

Poster for the first London exhibition of Desmond Morris paintings in February 1950, when he was still a student at Birmingham University

pity to think that the dispersion of the group's members and the absence of group activity, which resulted a few months later in the definitive closing of the London Gallery, left Desmond Morris on a threshold that he had doubtless crossed but from which he would henceforth have to launch out on his explorations alone. It is to his own tenacity and conviction – as secret and solitary as they were deeply rooted – that we owe the existence today of an impressive pictorial production, varied yet faithful to itself. As we shall have the opportunity of seeing, this *oeuvre* is nothing more than the indissociable reverse side – the palimpsest we might say – of another activity of exploration: biological and zoological research, in which Desmond Morris has become one of the best-known figures throughout the world in the last two decades. This double face, or double-sidedness, has left quite a few critics puzzled and doubtful; yet it is nothing more than a clear example of the non-contradiction, or the cross-fertilization between what only appear to be two antagonistic activities and ways of thinking: art and science, the aesthetic and the scientific, the imaginary and the analytical.

In 1974, in an interview published in the

Oxford magazine *Lycidas*, Desmond Morris emphasized the sort of pleasure that we feel in not attempting to oppress or suppress one or the other of these activities, of letting them *speak for themselves*:

It is true that my paintings are very biomorphic, very preoccupied with biological shapes, and that my biological writings are largely concerned with visual patterns of behaviour. I have never resisted that kind of leakage. (. . .)
Recently, neurophysiologists have begun to pay more attention to this problem and it now seems likely that this division that I am postulating into two types of mental process actually has some structural basis in the brain. If this research makes further advances, and confirms that the two kinds of activity are mutually beneficial, perhaps the time will come when we will give up the folly of separating sub-adults into the imaginative and the analytical – artists and scientists – and encourage them to be both at once.

As we well know, this attack on dualism has been one of the corner-stones of the surrealist stance. In the eyes of the surrealists – for whom the dialectic process was supposed to guide all human thought, on condition that the term of the process be indefinitely deferred – giving in to a dualism of whatever nature amounts to cutting one's self off from *comprehension*, in the etymological sense of the word, and from reality, and prohibiting one's self access to the totality of human experience. We should bear in mind the "point of the spirit" put forward by André Breton as being the point where "the communicable and the incommunicable" cease to be "seen in contradictory fashion", the ultimately inaccessible place towards which we tend constantly; and we should also bear in mind the "short circuits" that Breton, in the same *Second*

Manifesto asked his friends to multiply in the domain of thought and at the same time in the physical world. But beyond this attack, it is clear, as is indicated by the hope expressed at the end of his declaration, that Desmond Morris basically refuses to accept that thought should have a single origin, thus questioning the idea of origin itself. It is this refusal that underlies the surrealist conception of beauty, the desire to favour the interactions and convulsions of the subjective and the objective, and it is this refusal that Desmond Morris's painting protests. With all the vividness of their colours and the surprises of their forms, the pictorial spaces that are ceaselessly opening in his paintings and drawings, the shapes that constantly abandon them in order to better inhabit them, proclaim this impossible origin to be fixed, between the biological and the psychic, this vacuum paradoxically but inevitably original, there where man, if he is to find himself again, can only see and live sideways:

The orange flowers of the sideways men
swing from the fifty debts of the ancient
 bottles
that belonged to the dejected clearing
beyond the folding hills over the fence across
 the crimson field
where in our youth we stripped the moon.
The legs and toes of unlisted lives wave to the
 winged plants of some other minute.
Below the spines of glass stems the furcoats
 are unlocked.
Around the sun and moon a sphere engraves
 its name.
The daughters of the outside are coming in
on toads-wing feathers.
Aabbcc and the rain is dead.
Welcome to your two spheres at once.

Between reality and its images. . . .

DAILY 10–6

SATURDAYS 10–1

CATALOGUE INSIDE

2nd

FROM THURSDAY TO TUESDAY 28th FEBRUARY 1950

23 BROOK STREET W.1

THE LONDON GALLERY LTD.

ROOM A

Joan MIRÓ

C.L.L. Means presents

AND

CYRIL

HAMERSMA

first one-man exhibition

ROOM C

N GALLERY LTD.

. W.I

AND

DESMOND

MORRIS

first one-man exhibition

BOOKSHOP GALLERY

THE LONDON GALLERY LTD.

23 BROOK STREET W.I

Catalogue of the first
London exhibition of
Desmond Morris
paintings

CATALOGUE

JOAN MIRÓ **ROOM A**

Catalan painter of world-wide reputation. Born Montroig, near Barcelona, 1893. Studied Ecole des Beaux-Arts, Barcelona, 1907; Gali Academy, Barcelona, 1915. First exhibition, Barcelona, 1918. Paris, 1919. Closely allied with Surrealists. Designs for ballet "Jeux d'Enfants," 1932. Has work in permanent collection of Museum of Modern Art (New York) and in the most important collections in Europe and the U.S.A.

1. DANSEUSE NEGRE (1921).
2. TETE DE PAYSAN CATALAN (1925).
3. LA MAIN BLANCHE (1925).
4. LE CRI (1925).
5. LE COIT (1925).
6. LEDA (1926).
7. LES AMOUREUX (1926).
8. MUSIQUE (1927).
9. L'ADULTERE (1928).
10. ETCHING (1933) limited 100 proofs.
11. TWO WOMEN (1925).
12. DRAWING (1937).
13. ETCHING (1947) limited 70 proofs.
14. PORTRAIT OF J.M., engraved by LOUIS MARCOUSSIS and decorated by the model (1938), Artist's proof.

DESMOND MORRIS **BOOKSHOP GALLERY**

Has painted for several years. Released not long ago from army. Studies at Birmingham University. His recent works show a steady affirmation of personality.

1. THE NEST (November 1947).
2. THE SHOOLMASTER (December 1947).
3. WOMEN CONFRONTED (January 1948).
4. THE ENCOUNTER (February 1948).
5. THE GREEN SPRITE (February 1948).
6. THE DOVE (April 1948).
7. THE HUNTER (May 1948).
8. THE CITY (May-June 1948).
9. THE COURTSHIP (July 1948).
10. THE TABLE (September 1948).
11. THE JUMPING THREE (March 1949).
12. THE OBSERVER (April 1949).
13. THE INHABITANTS (April 1949).
14. THE VISITOR (June 1949).
15. THE FAMILY (July 1949).
16. THE WITNESS (September 1949).
17. THE RITUAL (December 1949).

CYRIL HAMERSMA **ROOM C**

Born Hammersmith 1919, of Dutch origin. Called up 1939. Exhibited at Oxford 1940. Encouraged by Albert Rutherston and the late Randolph Schwabe. Captured in Greece 1941. Painted assiduously as a P.O.W. in Germany, where he discovered his present style.

1. THE SCREW.
2. THE FAG-END.
3. THE SHOES.
4. THE MATCHBOX.
5. THE CAKE.
6. THE TEAPOT.
7. THE COFFEE POT.
8. THE BRASS VASE.
9. THE OIL STOVE.
10. THE ALARM CLOCK.
11. THE TOMATO.
12. THE VILLAGE.
13. THE POOL.
14. THE TREE.
15. THE COPSE.
16. THE TELEPHONE.

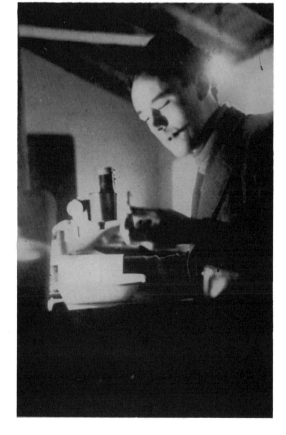

Desmond Morris
studying marine
organisms under the
microscope at a
Biological Research
Station in the Isle of
Man, 1950

In the water mirror 1944–1950

When the exhibition at the London Gallery opened in February 1950, Desmond Morris was living at Swindon in Wiltshire, while continuing his studies in zoology at the University of Birmingham. His early interest in the study of animals was matched from 1944 onwards by a passion for drawing, which was encouraged the following year – as he himself is fond of reminding people – by the reactions of disapproval against his first creations. He began using oils, without any technical advice whatsoever, converting his parents' greenhouse into a painter's studio where he completed a hundred and fifty pictures in three years, a quarter of which he was to destroy during the same period. In 1948, some eighty-nine paintings were produced, but – mindful of representing the signals of his subconscious in the most intense fashion – he kept only thirty-six of them. This is why what we can still see of this period carries the sifted seeds of what was to become Morris's pictorial space.

The exhibition of 1950 was not Morris's first. In January 1948, after a full year spent painting – under the influence of James Bomford, a local patron and modern art collector, he had given up his studies for a time – he showed his works at the Swindon Arts Centre. The only positive comments came from Mervyn Levy, the British art critic, who had been in charge of the art department at the Chiseldon Army College, where Morris himself had taught Fine Art under his direction. In his report on the exhibition broadcast by the BBC, Levy spoke of the "visionary power" underlying Desmond Morris's attempt to "express the intangible core which is at the heart of all physically existing forms". Most of the local reactions, however, were violently unfavourable, and letters to the editor of the local newspaper denounced "nightmares attempting to pass themselves off as art", the "atrocities" or "fanatical monstrosities" that had been framed in order to masquerade as art. In spite of this immediate hostility, the local authorities allowed him to organize a second exhibition in August along with other young artists who had followed courses at the Chiseldon school. Among these was Ted Kingan, who later became one of the most interesting painters of the surrealist group in Vancouver in Canada. Reactions were even more hostile and one of the readers of the local paper went so far as to demand that the paintings be "burnt in a furnace". Needless to say, not one painting was sold.

By then it was becoming quite clear that it would be impossible to earn a living by painting alone, so after he was demobilized from the army Desmond Morris made the decision to study zoology at the University of Birmingham. By a lucky chance, since the middle of the Thirties, there had been an informal group of surrealist artists in Birmingham, meeting from time to time in the home of one of their number, Conroy Maddox, whose influence and role are preponderant in the history of surrealism in England. It was only natural then that Morris should join them and exhibit with them in February 1949, under the aegis of the Birmingham Artists' Committee. Among the other participants were Emmy Bridgwater, John Melville, Oscar Mellor and William Gear. Relations between Conroy Maddox and E.L.T. Mesens had been solid and close since Maddox first joined the British surrealist group in 1938, and it was through him that Morris, a regular visitor to the London Gallery, was to meet Mesens and suggest an exhibition. Impressed by the three hundred or so paintings Morris had already turned out, Mesens accepted, but because of the gallery's financial difficulties demanded that the artist assume the expenses. Thanks to the generosity of a friend, Tony Hubbard, whose acquaintance he had made in the army, the exhibition went on, and in this way Desmond Morris was able to meet the London surrealists, amongst whom were John Banting, Roland Penrose, Lee Miller and George Melly. The evening of the opening, Desmond Morris was dressed in corduroy from head to foot, with a shirt and tie made from the same material.

Only a few paintings among the seventeen on show were sold, but Mesens's recognition of Morris's work and his decision to exhibit him at the same time as Miro (the painter Morris most admired) were a great encouragement. While he was unable to attend the group's rare meetings at Penrose's home or at the Barcelona Restaurant because of the distance that separated him from London and his lack of funds, he nevertheless exhibited his works in Bristol in 1951 as part of the Festival of Britain, and in the same year at the Belgian Summer Festival in Knokke-le-Zoute, organized by Mesens. Under the title "Les Tendances d'Avant-Garde dans la Peinture Britannique Actuelle", Mesens had selected fifty works "by painters who for the most part do not take part in propaganda events", as the preface of the catalogue states. Along with Desmond Morris (who exhibited a work from

1948 entitled *The Dove*) were the names of John Banting, William Gear, Stephen Gilbert, Humphrey Jennings, Gordon Onslow-Ford, Roland Penrose, Edith Rimmington and "Scottie" Wilson, another painter whom Mesens had 'discovered' in 1945. At the end of the year he took part in a new event organized by the Birmingham Artists' Committee and transferred his studio from Swindon to Oxford. In May and June of 1952 he was again alongside "Scottie" Wilson in an exhibition at the Ashmolean Museum in Oxford, whose curator was in the habit of setting aside a room for exhibitions of contemporary art. Morris's film *Time Flower* was also shown on this occasion.

While it is obvious that Desmond Morris's painting during his first few years of activity points to a definite iconoclastic strain, and that forms of biological origin already begin to haunt his pictures, the remarkable feature is the juvenile but dedicated energy made over to the destructuring of human or animal figures, in reaction against academicism and 'decoration'. A comparison of four drawings done at the time suffices to show how concerned Morris was with *placing* his stroke, as we speak of "placing a voice", and of defining his angle of attack. The first drawing dates from 1948 and is reminiscent of Picasso by the elementary nature and hyper-

trophy of the forms chosen in the body; the three others, which date from '47 & '49, illustrate three differing directions in the more or less automatic exploitation of the stroke. Between the geometric automatism of the line (drawings II and III) and the dreamlike automatism in *locating* forms (drawing IV), the artist attempts to lay out paths in a spirit of complete freedom. At any rate, the first painted works declare open warfare not so much against a type of art as against a comfortable traditional vision. The external world is definitely still the departure point (this was to change from 1947), but deformation and the accentuation of details backed up by the shock of colours constitute the first vital steps in the disruption of visual habits. We shall take just one

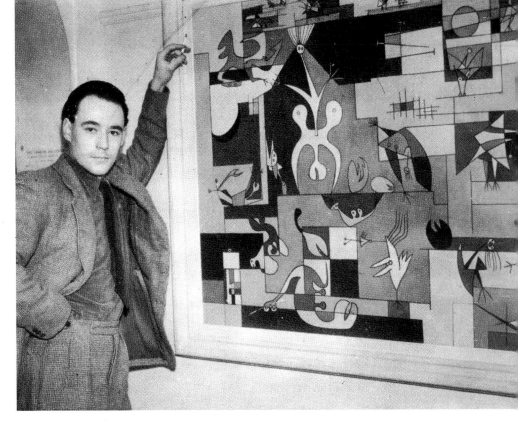

Desmond Morris at the opening of his first London exhibition in 1950. The large painting entitled *The City* (1948) has since been destroyed by the artist

The catalogue of an exhibition in Belgium in 1951 at which Desmond Morris showed his work abroad for the first time

example of this temptation to pass through the looking-glass: *Seated Woman* (1946), which by its play of broken lines and parallels disperses the body; what represents the hair, represents the eyelashes elsewhere, and the same thick black strokes striate other surfaces, as if they liberated other images inside the image to which the title refers. The body is thus reduced to masses of colour that – in a manner contrary to its own unity – give rhythm to the picture. The perfect

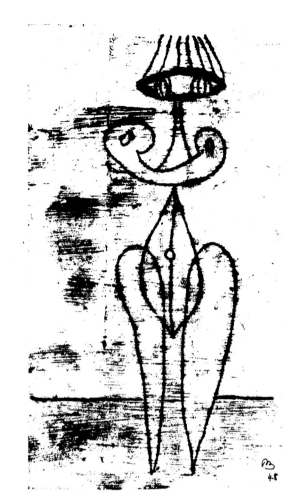

The Bride
1948
Monotype: oil on paper
7 × 4 in.

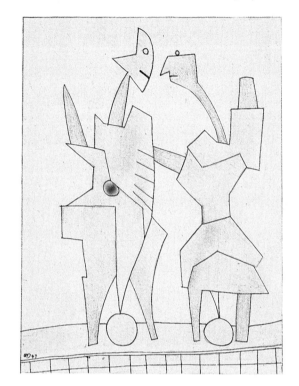

*Ambivalent
Encounter*
1947
Ink and pencil
9 × 7 in.

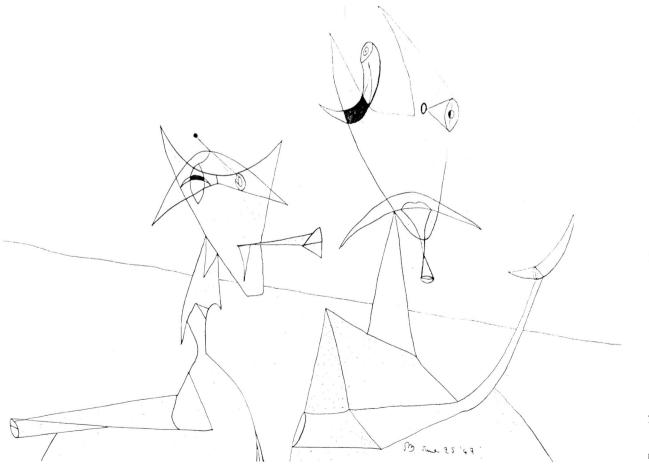

Two Figures
1949
Ink
10 × 14 in.

Two Drinks
1949
Ink
10 × 10 in.

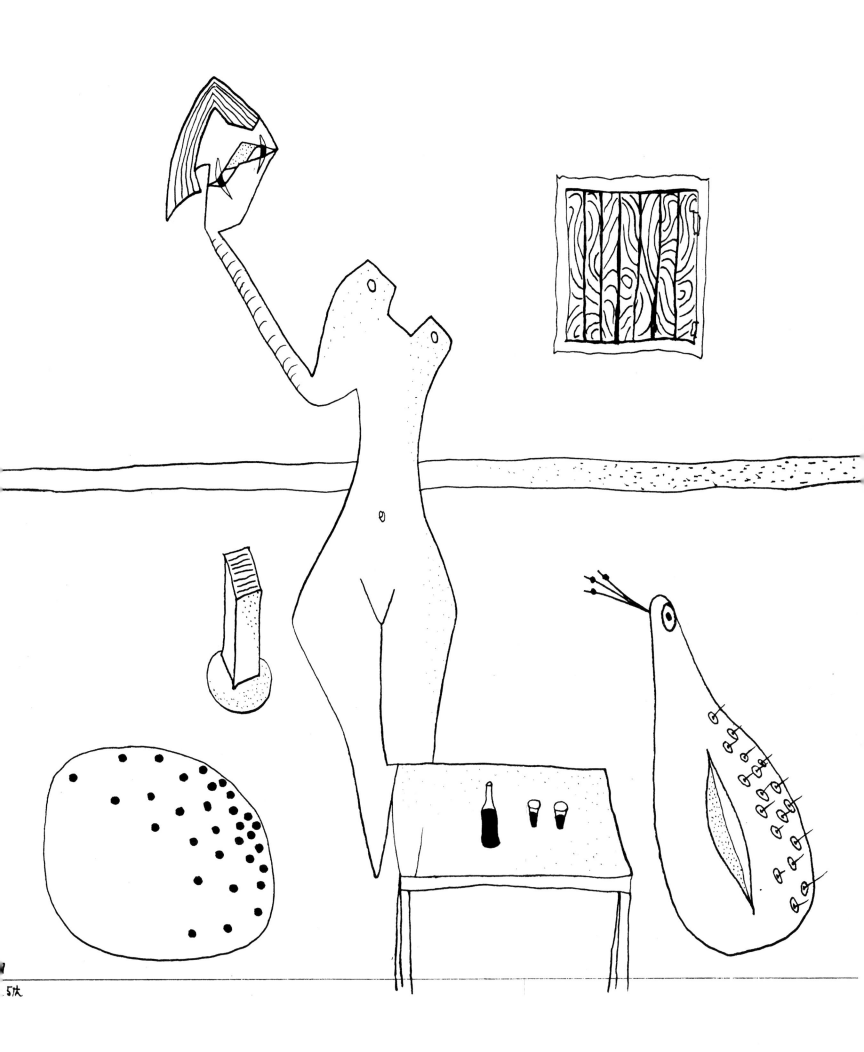

5化

balance of the whole, underscored by the armrests of the armchair, a metonymic vestige, bears witness to the position of the painter, at the utmost extreme of dislocation. It is almost as if we are hearing the words he wrote at the time, which point to a certain pose:

. . . but if I am to escape from reality on the raft of my imagination, what constitutes the planks and rope that go to build the raft? They come from your world and I must have them before I can escape to mine. For mine is an existence within an existence, a personal place where I would go and shut myself up. Sometimes I feel the whole affair hopeless and I gaze through a clouded veil . . . I am like a fly in a web, a kitten in a knotted sack. A short struggle, a glimpse of freedom and the veil is back.

It is interesting to note that the titles of the paintings done from 1945 to 1946, at least those that can be traced, evoke the favourite subjects of traditional painting; they are 'portraits', 'landscapes', 'genre scenes'. There are a few

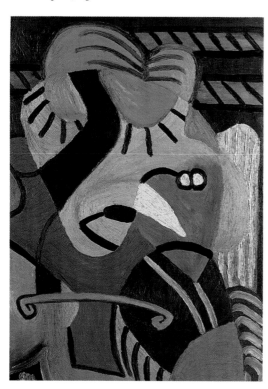

that promise strangeness, such as *The Entry of a Siren, The Philosopher's Abyss, Two Fish in Heaven, Landscape without a Memory*, but they are outnumbered by far by *The Kiss, Night Comes, Girl Selling Flowers, Portrait of a Lady, Mother and Child, The Family, Christmas Painting* or *Woman in an Armchair*. Needless to say, the pictorial

Seated Woman
1946
Oil on card
19 × 14 in.

treatment these titles receive tears them away from tradition. They are totally ironic.

In 1947, Desmond Morris's continuing dissatisfaction with the *effectiveness* of images, that the artist must feel for himself regardless of any pre-existing law, was suddenly resolved. This came about on his completing the painting entitled *Entry to a Landscape* in which a slimy and tentacular shape finds itself derisively attached to a dark stone-like wall by two very flimsy-looking nails; to this shape is affixed in turn, just as derisively, a red thread, the vestige of an attachment that is now broken. By means of a long vulva-like interstice that crosses and opens the picture vertically, this visceral shape appears to be intent on moving into the open space, that is virtually empty, with neither horizon nor relief. Only a few months later this opening was to turn from the vertical to the horizontal, and thus liberated and enlarged, made up the wide empty space of the paintings of the future, as if a censuring lock had sprung free under the pressure of repressed feelings and it was at last possible to admit to being the witness of such primitive scenes. In point of fact, the paintings that follow do depict the famous biomorphic forms in a very elementary and frontal manner, as if they had been come upon at the very instant of the birth of a ritual or the beginning of movement; in *The Red Dancer, The Courtship I, The Lovers* and *Celebration*, forms are given a minimal function: that of their movement itself. Others seem to have the sole function of butting in; it is thus in *Master of the Situation*, where a sort of commentary on the painting itself creates a situation by strewing airy space and not the earth with the remains of foetus-birds, so complete is the absence of distinction between horizontal and vertical.

In *The Apple-pickers*, the fruit float up into the 'sky' much to the despair of the outstretched and impotent arms; by forcing the pickers to jump up, the apples are responsible for the creation of space which in return affects the body in its contours and solidity. In this sense the painting entitled *The Green Sprite* sums up, by its overall dislocation, a painting like *Man Jumping* where the limbs are literally separated from a body which to all intents and purposes has disappeared in its fall, or a neighbouring painting entitled *The Jumping Three*, a large format where it appears that all the obstacles, symbolized by the posts set aside to the left, have been hurdled for the sheer pleasure of it. In short, movement creates space and the paintings

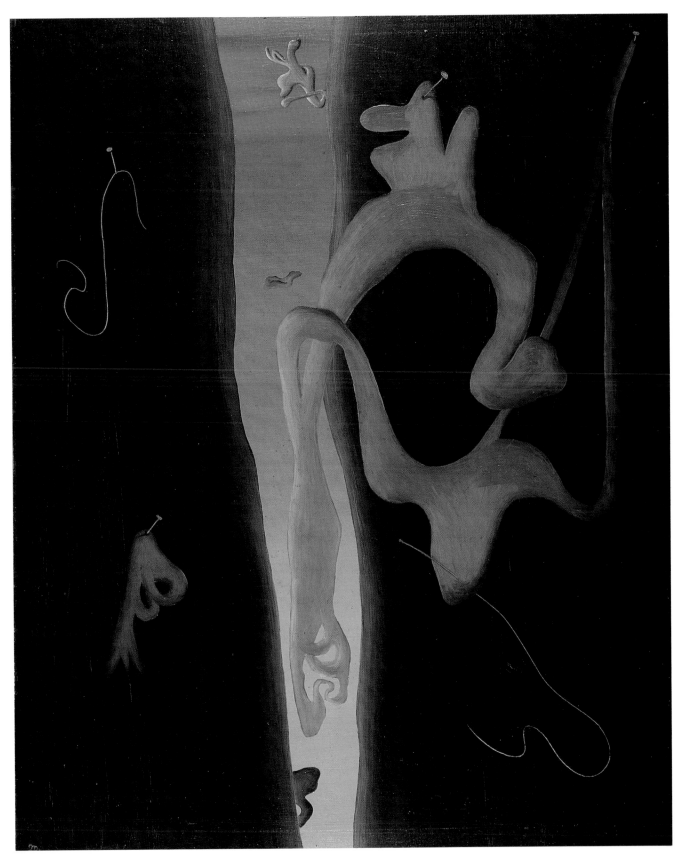

Entry to a Landscape
1947
Oil on board
20 × 16 in.
Peter Nahum Gallery,
London

The Red Dancer
1948
Oil and pastel on card
18 × 13 in.

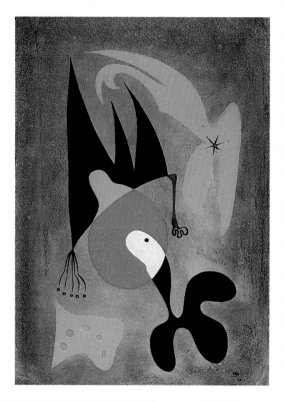

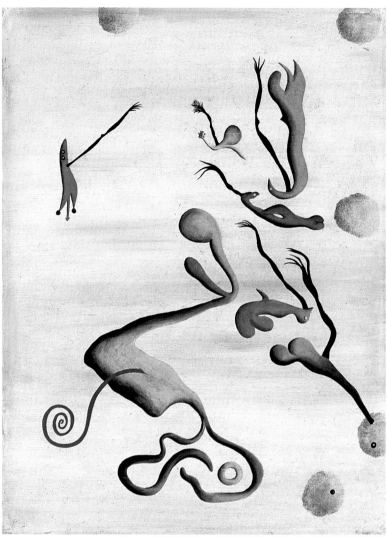

Master of the Situation
1947
Oil on canvas
16 × 12 in.
Collection Mr Alasdair
Fraser, London

The Green Sprite
1948
Oil on canvas
8 × 6 in.

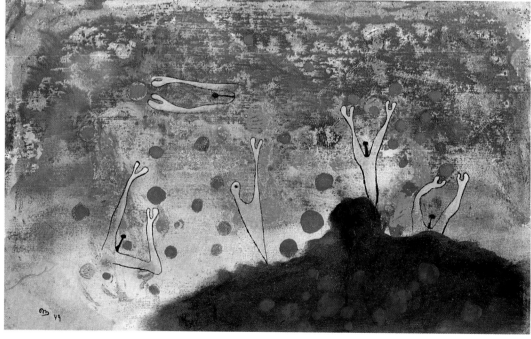

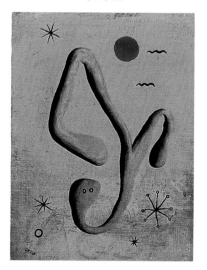

The Apple-pickers
1949
Oil and indian ink on paper
8 × 13 in.
Collection Mr Philip
Oakes, London

The Jumping Three
1949
Oil on canvas
30 × 50 in.

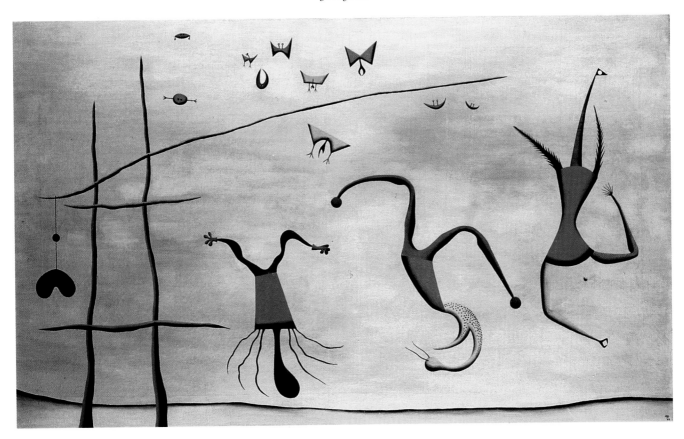

Man Jumping
1948
Oil on canvas
21 × 16 in.
Collection Mr Gordon
Harris, London

ironically–titled painting *Only the Guest is at Ease* illustrates: whether one is going or coming, the person who is not yet there or who is no longer there is the only one to really witness the scene of fragmentation that is played out. The marine transparency of the wash parallels the transparency of vision. More ironic still perhaps is the painting entitled *Red and Orange Situation* which says what cannot be said by abstaining in its title from anything other than a purely objective statement; and yet a scene of love and aggression seems to be being played out there . . .

In all these paintings, the line is predominant, and the floating corpuscles are nothing more than lines in expansion or bodies in the process of being reduced to lines, they are signs waiting to be grouped or resolved, as in *The Love Letter* or *The Serious Game* where the geometric minimalism and mute balance (the red of the

are so many places of pure encounter where forms can be nothing but organically pure, that is to say stripped of any functions they may once have had. This is also the case in *The Encounter* or in *Confrontation*, painted around the same time, and in *The Witness*, where sight and its object only exist in relation to one another, in reciprocal justification, as is emphasized by the black and blue parallel, or again in *The Proposal*, where the *raison d'être* of the two shapes, one clearly masculine, the other feminine, is the presentation in outstretched hands of an oblong-shaped, blood red object. Could Eros be proposing to Logos?

In *The Intruder*, where flat colours underscore the frontal impression, and in *The Inhabitants* where on the contrary, the depth of the decal creates a subterranean or sea-plant place, forms equipped with eyelashes and dendrite growths are quite clearly in only temporary occupation. This same motif was to be considerably developed and deepened twenty years later. An impressive work from 1947, *Giant Instrument for the Construction of Synthetic Women*, sums up this primordial intensity of vision in the way it creates space. The painting shows in humorous fashion – a little in the manner of a Picabia enthusiastic about soft shapes – the composition of a woman's body. The seams and stitches, the stretched threads, the parts linked in defiance of gravity clearly show that we are in a rarefied place where nothing exists other than in the assembly of tentatively floating forms. This calls to mind the striking painting entitled *Lost Bird of Youth*, where a skeleton form evocative of *The Progenitor* of the following year, devoid of *substance*, sets free a bird whose flight will no doubt uncoil the spiral hanging to the right.

In fact, the painting is nothing more than a point of departure or arrival, an inchoate place. The two paintings that correspond to these two movements are clear: either the forms separate and disintegrate (*The Departure*), or they surge forward monstrously (*The Important Arrival*); in any event, they amount to the same thing, as the

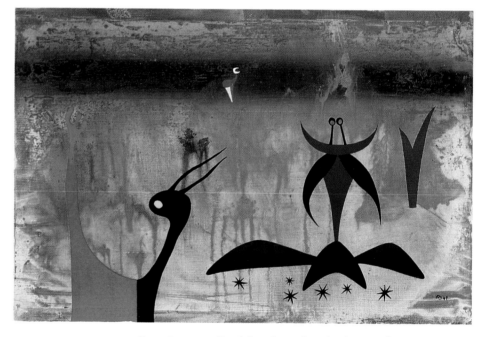

lines is neutralized by the ochre background) create a sort of hermetic austerity as in some of Miro's paintings. This use of the line is of course reminiscent of the prehistoric wall paintings, an imitation of which Morris playfully reinscribed in *The Hunter*, but it is also a conscious attempt to purify and extend the means of presenting biomorphs, while locating them in a time outside history. This reaches a sort of plenitude with the use of plaster in the same painting, but also in *The Close Friend*, and with a greater measure of success in *The Dove*. The line traced in plaster intensifies the

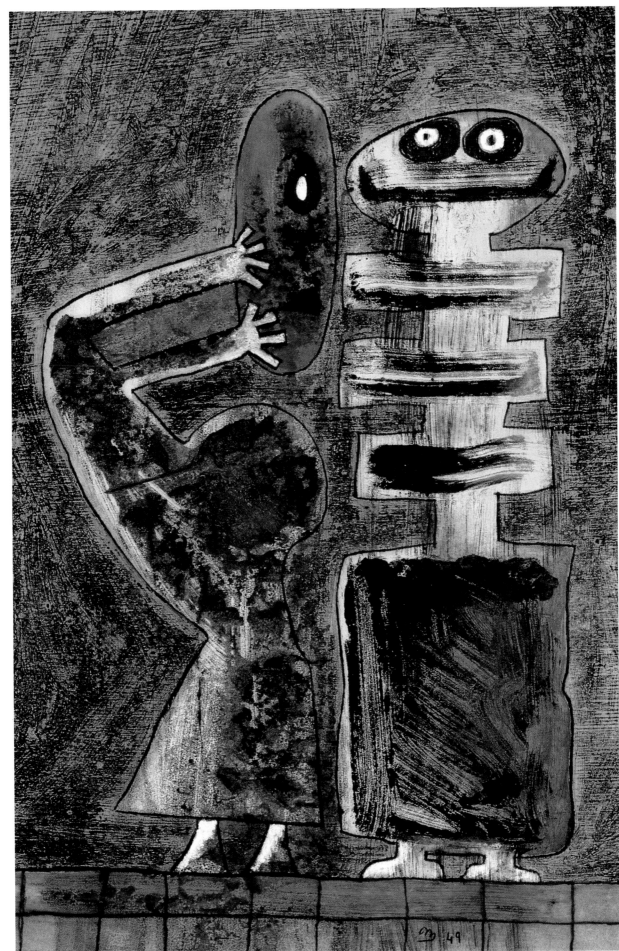

The Proposal
1949
Oil on paper
14 × 9 in.
British Museum,
London

Tribal Conceits
1949
Oil and crayon on paper
20 × 12 in.
Collection Mr Joris de
Schepper, London

*The Trappings of
Privacy*
1949
Oil on paper
20 × 12 in.
British Museum,
London

*Giant Instrument for
the Production of Synthetic
Women*
1947
Oil on canvas
10 × 8 in.
Collection Mr Francis
Wykeham-Martin,
Gloucestershire

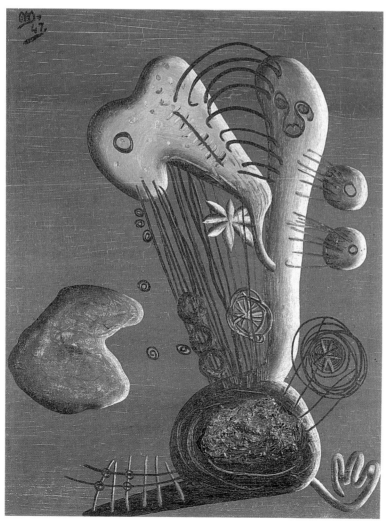

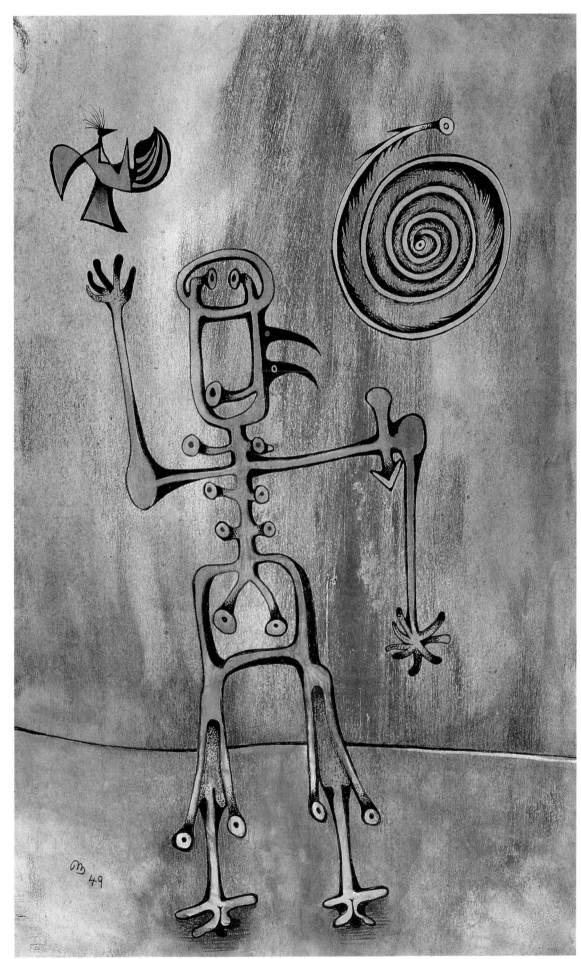

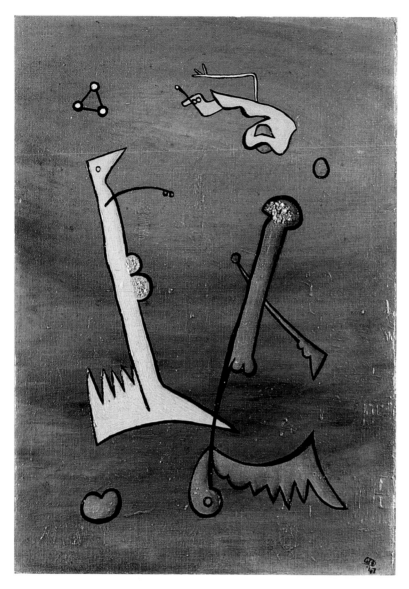

The Important Arrival
1949
Oil on paper
8 × 13 in.

The Departure
1947
Oil on board
14 × 10 in.

*Red and Orange
Situation*
1948
Oil on card
16 × 12 in.

Student
1951
Ink
10 × 8 in.

Only the Guest is at
Ease
1949
Oil on Paper
10 × 15 in.
Collection Mrs Celia Philo,
London

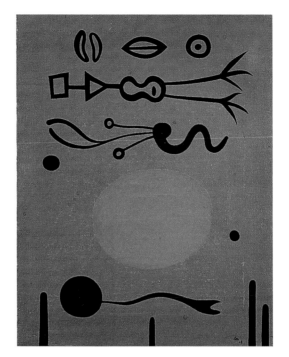

The Love Letter
1948
Oil on canvas
20 × 16 in.

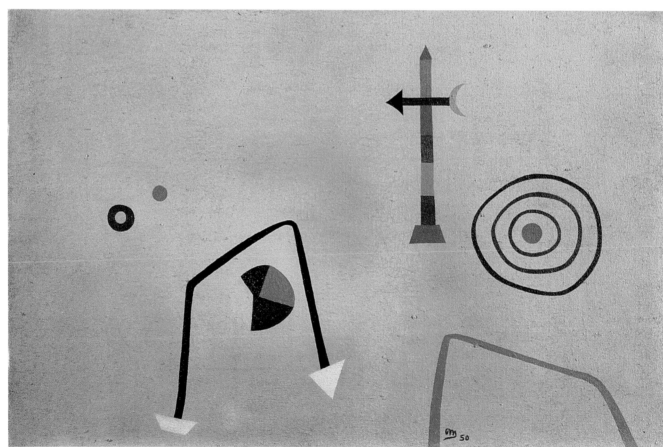

The Serious Game
1950
Oil on canvas
10 × 16 in.

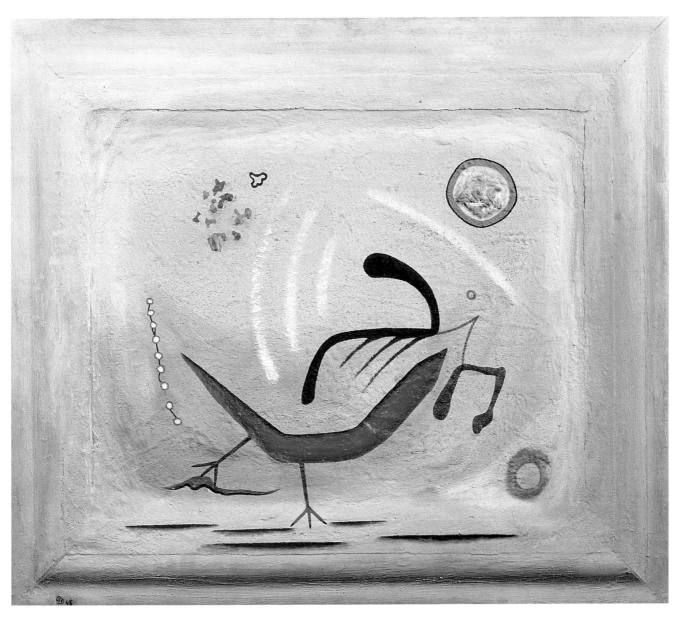

The Dove
1948
Oil and plaster on canvas
23 × 26 in.

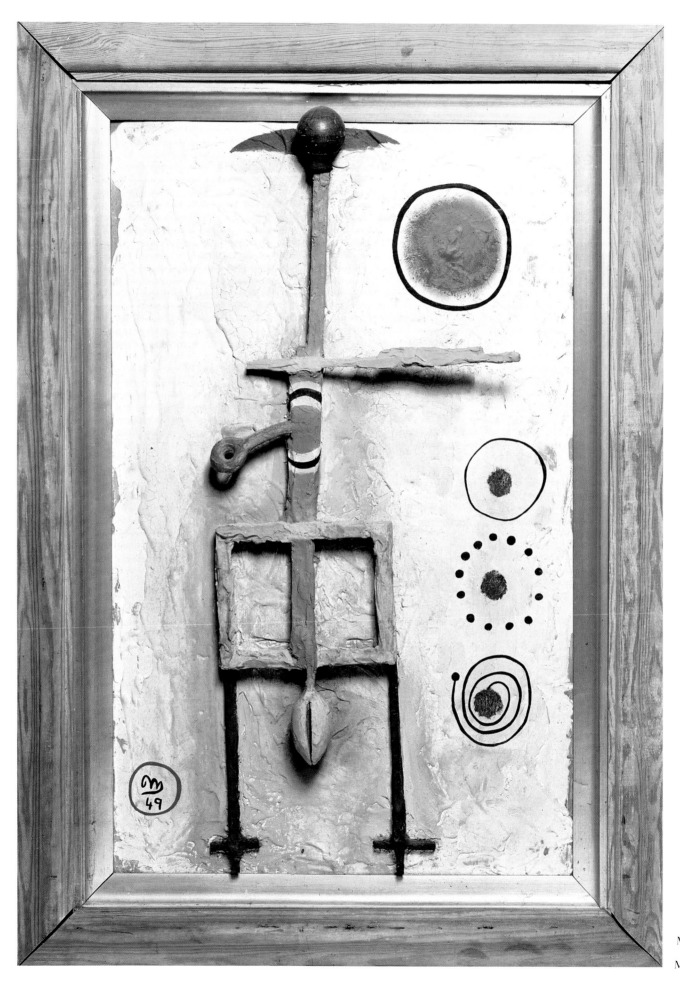

War-woman
1949
Mixed media on
28 × 17 in.
Mayor Gallery, L

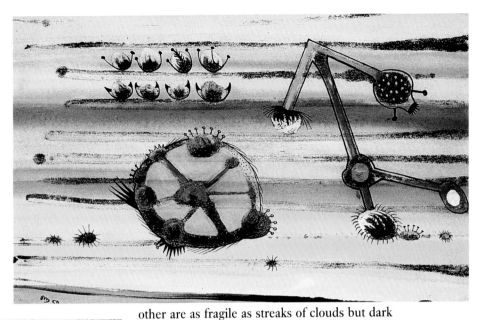

First Glimpse of Treasure
1950
Oil, ink and watercolour
on paper
8 × 13 in.

elementary nature of the drawing, conferring a new and more vital dynamism on the bird or the figure, accentuated by the colour range; in *The Dove*, the intense red and yellow *act* on the pale blue field. These techniques show their full potential in *War-woman* where the use of brightly painted wood, cork and rubber creates a totem-like object whose aggressiveness is born of the acute and right angles that constitute it, with all the more force since the figure seen is to surge out from the plaster surface where

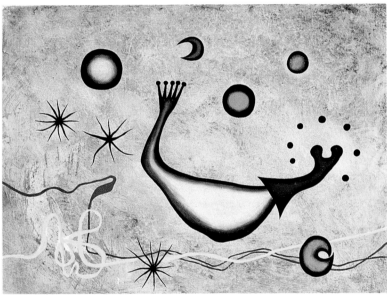

mysterious circular symbols recall lost woman-hood.

In the following year, 1950, Desmond Morris's technique changed, and a process whereby the relationship between space and the biomorphs was to be modified appeared. Even if in certain paintings forms still cross space in flight apparently doomed not to last, we notice the introduction of lines that, though they are not horizons, are like sketches of planes, and provide bases to the paintings. In *The Gloved Face* the three threads that tangle at the bottom seem to be on the point of 'receiving', as we say in gymnastics (a metaphor Morris would relish), the face we guess is behind the glove, an imprisoned face, lost for not being able to see anything or be seen; the eye of the spectator itself is solicited to circularize its vision through small circles that make up a large circle, as if to prevent the viewer's eye from escaping. This is even more striking in *First Glimpse of Treasure* where horizontal planes that follow one on the

The Gloved Face
1950
Oil on board
9 × 12 in.

other are as fragile as streaks of clouds but dark enough in colour to supply an undeniable base for the round and angular forms that float there, so much so that the object which appears on the right can only be a sea-anchor on the point of hooking on to the glimpsed treasure. The structural base of the painting is sufficiently strong to ensure that the relation to be established is less ephemeral, and that our vision should 'freeze on the image'. This is confirmed in *The Survivors* where the background is constituted by short, dipping, red and ochre lines, in which are stuck three lanky shapes, as if in cement. And the same process is continued with *The Progenitor* where the sovereign, mammary-ridden figure in the foreground constitutes in itself a sufficiently strong structuring point to make the forms that appear in front of it seem to dance above the ground; a feeling that is emphasized by the alignment of the four vertical 'watching' forms to the right, which reflect the image of the central figure's power. Similarly, in *The Trap*, the grass in the foreground and the fence in the background define a flat field expressly for the purpose of seeing a story unfold; as is the case in *Endogenous Activities* or *Blue Landscape*, where the landscape asserts itself in its material expanse by the solid implantation of even its most rudimentary elements, underscored by the thick black line-bodies and the imprisonment of the colours. What is more, the title of the former work (*Endogenous Activities*) is self-explanatory: the picture establishes its basis in itself. Everywhere in these new paintings, the static state and the nonchalance of movement refer to secret and faraway histories which we are given the task to piece together on our own. Not only do the forms inhabit these places, they have been there for a very long time. This temporal dimension, this stability, indicates a new direction in inspiration and bathes the paintings in a great calm which is obviously due to the painter's conviction of having reached a stage in the plastic mastery

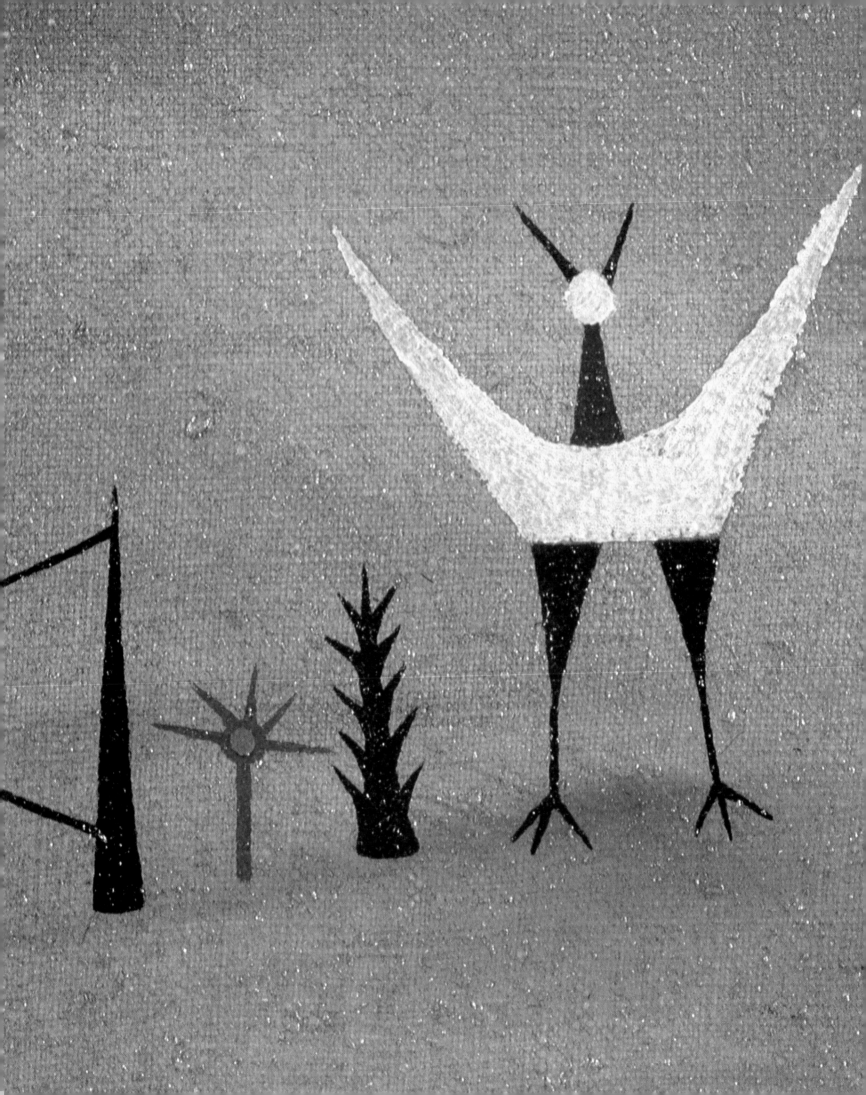

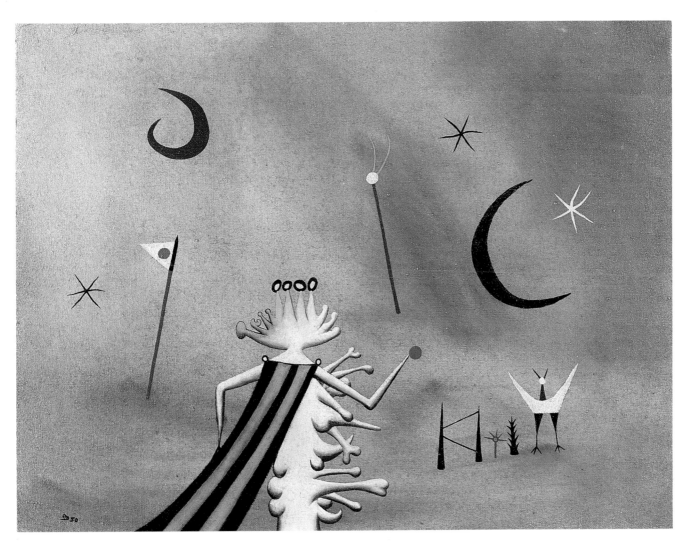

The Progenitor
1950
Oil on canvas
12 × 16 in.
Collection Mr Mark
Seidenfeld, New York

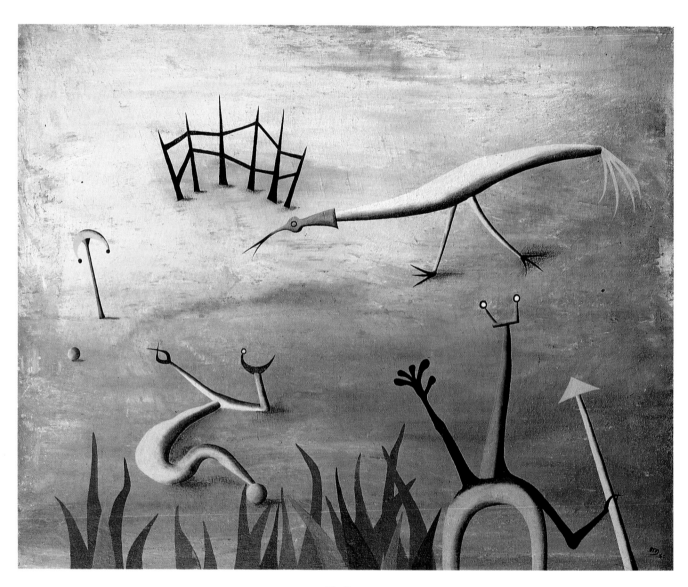

The Trap
1950
Oil on canvas
16 × 20 in.
Collection Mr Tom
Maschler, London

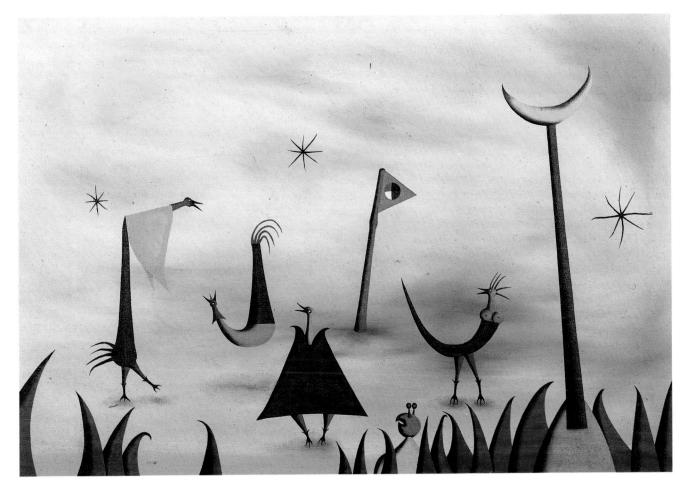

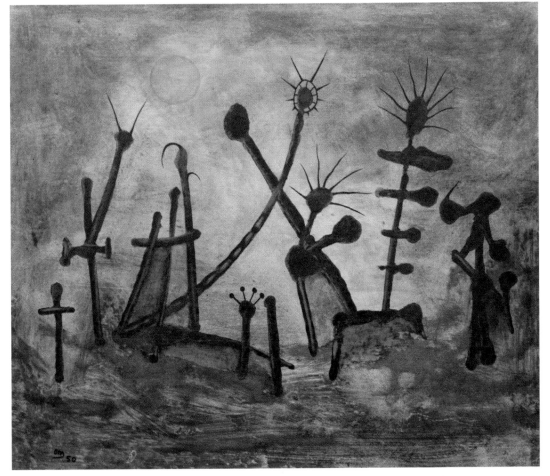

Endogenous Activities
1950
Oil on canvas
21 × 31 in.
Collection Mrs Mary
Horswell, Hampshire

Blue Landscape
1950
Oil on board
12 × 14 in.
Collection Professor
Aubrey Manning,
Edinburgh

Cat VIII (Cat and Moon)
1949
Mixed media
13 × 8 in.
Collection Mr Joris de
Schepper, London

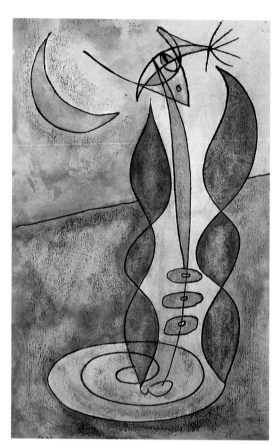

of interior images. Another experiment, lighter and yet interesting as such, dates back to 1949: the cat series, where a few twisted lines suffice to settle the outline of the body, rounded out by fur or not, and a spiral stands for the tail. The omnipresence of the moon recalls the close symbolic relationship, and this creates play on meaning beyond the forms themselves. All the more so since the line captures perfectly – from next to nothing – the various expressions that can be discerned on the faces, and suffices in itself 'to tell a story'. It is almost as if these cats

Cat VI (Two Cats)
1949
Mixed media
13 × 8 in.
Peter Nahum Gallery,
London

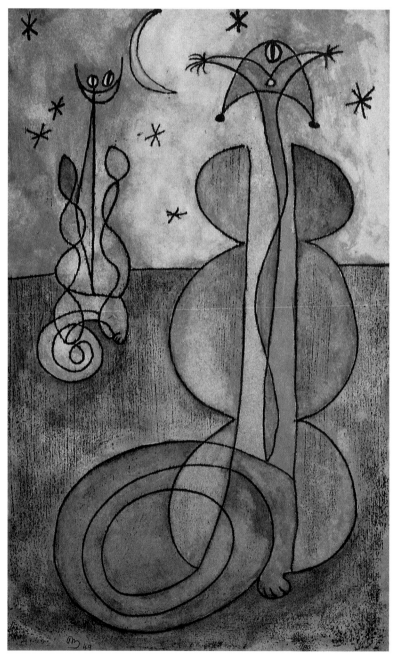

are an intermediary stage, on their way towards the biomorphs of the Seventies, the interlacing of forms heralding the organic overlays and the transparency of the bodies.

When Desmond Morris abandoned his Swindon studio for Oxford in 1951, it was clear that he had succeeded in opening a pictorial space akin to the space of automatism, that is to say to spontaneous graphics whose links with objective reality were becoming more and more tenuous. Indeed, this automatism still tolerates the evocation of parts of the body, which are at the basis of Morris's eroticism: eyes, breasts, mouths, as well as certain simple geometrical shapes. Nonetheless, Morris gives himself over totally to the pure dynamism of lines that can thicken more or less to become veritable prehensile tentacles. By that time, then, he has developed a vocabulary of coloured forms all inevitably subject to pure movement and opened the space of what could be termed a *suspended game*. In direct relation to this, the aerial lightness of the first paintings is gradually perturbed by the appearance of a ground line. Thus, by 1950, the biomorphs seem to have emerged from a vacuum to assert themselves, for their own sake, before finding a place to live. Titles evolve, too, from anonymous abstractions, such as *Confrontation* or *The Jumping Three* to more descriptive nouns which pretend to identify what we see (*The Progenitor, The Hunter, The Trap* . . .). This ambivalence of the concrete and the abstract, the physical and the mental, will recur throughout this study.

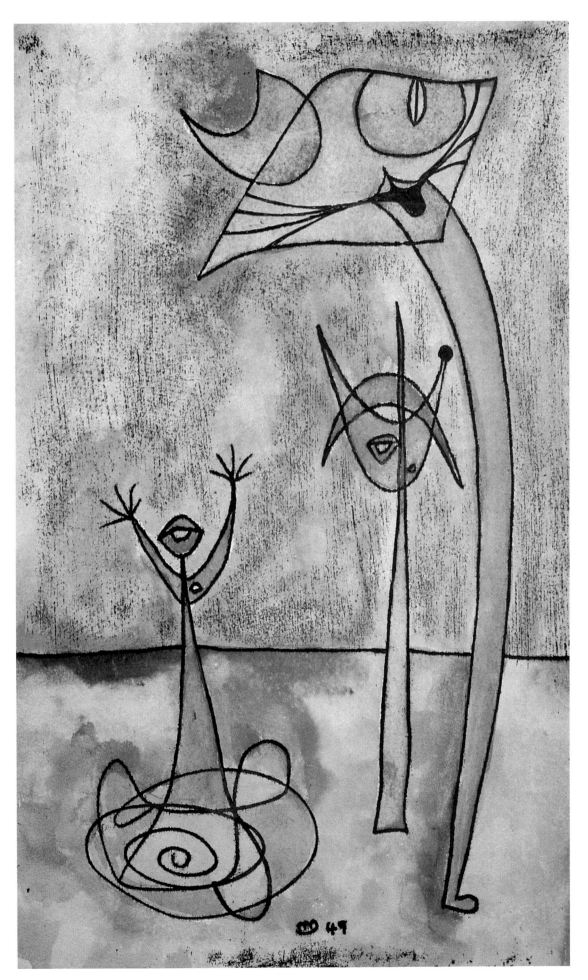

Cat IX (Three Cats)
1949
Mixed media
13 × 8 in.
Collection Mr Joris de
Schepper, London

At the same time, and illustrating once again in the history of surrealism both the principle of non-contradiction and the necessary interaction of artistic practices whose separation is perpetuated by traditional thinking, Desmond Morris wrote texts which deserve to figure in any anthology of surrealist poetry that pretends to be exhaustive. Several of the visions that explode in these texts remind one of the best of the *cadavres exquis*, those which on every reading, in the narrow framework of a phrase or a stanza, continually disrupt the relationships between objects:

> Exotic heads and unhappy unicorns
> trample the antlers of the polar saucers
> in the husband's library.
> The fiddle on the floor is sitting
> in front of the fire
> without noticing the flowers
> in the chimney
> and outside the air is crowded with boulders.
> Squares of hairs are singing
> in parallel
> with no particular aim in view
> and the suicides
> on the edge of the interminable armchairs
> are feeling bored.

In this poem, which dates from 1948, the leitmotif of vision, or rather of its questioning, clearly points to the need to suspend visual codes, as is asserted in Morris's paintings. The same leitmotif is the leading thread of several texts, one of which is the long dreamlike "The Woman in the Moon" where "*the face of the woman in the moon is watching a young girl reading the directions on a sealed box*". Through this provocation of the traditional dualism which separates the object that is seen from the subject that sees it, Desmond Morris asks us to be sufficiently visionary to accept that:

> The petals are falling from the Freudian flower
> as the precarious parrot
> calls to its ancestors
> to launch the lifeboat
> that the one-eyed needle god
> dubs wicked.

This "botany lesson", as the title informs us, is a lesson of life and death, and the call to the ancestors – the ascent through the *flowers* of the unconscious – corresponds to a call for life.

Desmond Morris in the The Black Dreamroom, Swindon, 1949. The entire room, including the walls, ceiling and woodwork, was painted black and then decorated with brightly coloured images

What better commentary could we hope for on the paintings that we have just been considering? Indeed, Desmond Morris's poetry (a few surviving examples of which appear in the Appendix), bears witness to an ear tuned into the calls of the interior, questioning the morbid stability of external 'reality' with each word. In this new 'order' of things, one should be able to affirm that "sickness of the legs can be cured by a wonderfully reflecting transparent rope", and the insistence, which underlies the poem *The Scented Line*, on the reciprocal relations between things and on their capacity to return into themselves, is surely no contradiction of such a proposition:

> Beyond the scented line
> the corrosion of my seeing limbs
> grows soft with unbelievable spray
> which staggers from the foliage
> at your leaning feet.
> The lips of my heart grow weak
> at the threshold of your great vision
> and my hunting bones subside,
> attendant on the flight
> of the white arrow's swarm.

It is in this search for all possible points of *disanchoring* that we should situate the 'decorated poems' Morris wrote for his friends (which explains why so few survive). The example reproduced below reveals a singular complexity of construction that blends geometric and organic forms, hard and angular lines and automatic

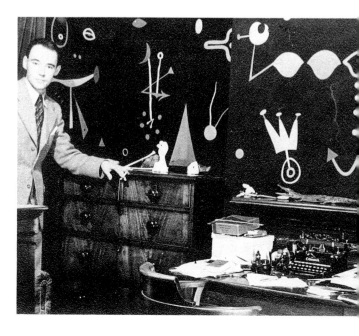

strokes in aerial surgings where the former rise up over the latter as if they were attempting to draw them up in the same ascending movement. The most apparent counterpoint appears with the text tracing a contrary movement, reading from top left down to bottom right. But there is more than this: the movement of normal, 'descending' reading is contradicted by the ascensional explosion of the meaning; indeed, the poem ends, right at the bottom, with the sun, whose zenithal position in the sky, which in the

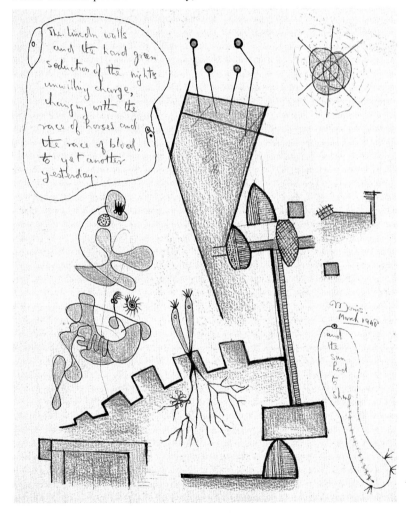

drawing is evoked by the nebulous form to the top right, upends once more the entire poem and turns the reading of text and image into a never-ending game:

> The Lincoln walls
> and the hard green
> seduction of the night's
> unwilling charge,
> changing with the
> race of horses and

the race of blood,
to yet another
yesterday.

And the sun had to shine.

Could it be that this is the same sun that shines in the centre of the tablecloth embroidered by his wife Ramona in 1950, and taken from a drawing done the year before? A tablecloth that spreads in spangled fashion symbols of the creation of mankind and the world: crescent moon, wheel, vulva, starry corpuscles, lips, male organ – arranged around a double figure, man and woman, whose genital organs are also breasts.

Just as we cannot – in the framework of this study – develop an analysis of Desmond Morris's texts other than to underline the surrealist poet's impatience to multiply experience, we can only give a very brief analysis of the two surrealist films he made in 1950. One of them – *The Butterfly and the Pin* – has left no trace, neither scenario nor copy. The other – *Time Flower* – was edited in August and September 1950 after shooting in Swindon, Wanborough, Avebury (with its famed alignments of stones) and in the hills around Marlborough. The reader will find the script at the end of this work and a cursory glance at it will reveal that before anything else the film rests on spatial and temporal dislocation, on the systematic rupture of the chain of meaning and the merging of objects into each other: an eye appears in a mouth; a clock (whose dial is covered with letters instead of figures) bleeds when a dart sticks into it; a rotting glove holds a clock's pendulum, eggs become eyes and a hedgehog turns into a bullock's skull; fingers nervously thrumming on a tabletop are transformed into running legs; a ravine becomes the brick paving of a courtyard; a strange doctor, run through by a sword, continues painting at an easel; a hammock – hanging by a table where a young runaway girl is seated – is occupied by a baby alligator; shut eyes turn into joined hands; a bird perches on a violin that explodes – such are the images of one of the films, based on a young woman being chased by a man through forests and ravines, and along the edges of bottomless abysses. Paternal figures and phallic symbols abound in this Freudian fantasy of deflowering by time, whose initial situation ("a young girl lying face downwards in the grass, grasping at tufts of grass") is not unlike a more hysterical rendition of little Alice's predicament before she

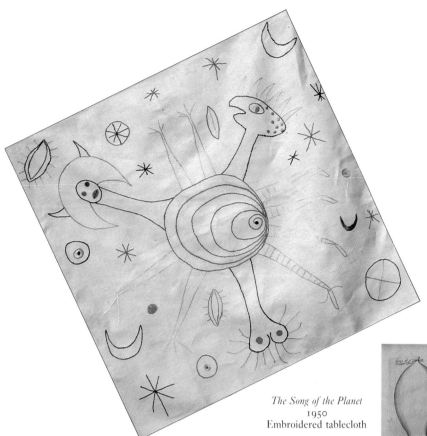

The Song of the Planet
1950
Embroidered tablecloth

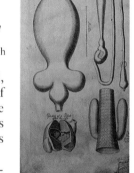

Illustration from *The Comparative Anatomy of Stomach and Guts Begun*, 1681, by Nehemiah Grew, a book discovered in the family attic by Desmond Morris when he was a child

stepped through the looking-glass. Indeed, much use is made of the mirror in all sorts of situations – the doubling and disquieting image of the self – so much so that it becomes obvious that here it is the looking-glass that passes through Alice.

No doubt all the resources of editing, cross-fading and overlaying were used to telescope the memory of the unconscious and the chronological time of dream events, and to underscore the omnipotence of chance in the unfolding of the film's chase, in the syncopated passage from one space to another. To be sure, in this film one of Desmond Morris's vital preoccupations – perceptible in his paintings – becomes clear: that of time. Time can only be organic and soft, if we may say so, in referring to Salvador Dali's painting *The Persistence of Memory*, to which Morris's works show some affinity. The present is liquidated in favour of a temporality born of the concrete images surging up from the hidden places in the mind.

To quote Breton, Desmond Morris's eye is an eye that is "resolutely wild". This adjective takes on its full creative force when we consider the few experiences that contributed to forming the visual powers of the young adolescent, and which also explain his enthusiasm for biology and zoology. In the first place, we should note the total absence of an artistic tradition in the family. His father was a writer, his grandfather the editor of a newspaper founded by his great-grandfather, whose father had been a bookseller; a culture of reading and writing which was bound to develop the powers of imagination. In the second place, we should remember that at a

very early age he was surrounded at home by a great many animals, and that with the aid of an acute sensitivity, was able to keep in mind several key events of childhood that were to nourish the "visual education" that was lacking in his family environment. It was the lake, owned by his family, where he loved to spend his leisure hours floating on a small raft he had built, that gave him his first aesthetic shock:

One afternoon, nosing through the rushes at one side of the lake, I glimpsed a rounded white and yellow shape floating just below the surface of the water. I prodded it with the blade of my paddle and immediately it disintegrated, swirling out among the weeds like thick cream dropped into coffee. It was probably only the carcass of a dead water-fowl, but it seemed to have no feathers and in my imagination it became a dead baby cast in the water by a forlorn young mother. The sinister image invaded my memory and locked itself there.

The solitary and sensitive only child that Desmond Morris then was thus developed a certain liking for the bizarre and the macabre. As he is fond of recalling, to get his own back for not being able to go and see the horror films showing at the local cinema because of his age, he persuaded a school friend whose father was an undertaker to help him get into the mortuary at night. This was during the war years and the staff was greatly overworked, which meant that surveillance at night was fairly nominal. The bodies of soldiers brought home from the front were laid out on the slabs waiting to be embalmed, and this is the scene which Desmond Morris recalls with surprising clarity:

Every slab was occupied. Some of the bodies were so badly damaged that they had to be embalmed one half at a time. In one case the blood on only the left side of the body had been replaced by formalin, and the corpse had a marvellous two-tone face, divided by a sharp line right down the middle of the nose, pale blue on the left, grey-pink on the right. Before I left I made a surprising discovery: with all the blood washed away, the shiny organs inside the human body had a strange, voluptuous beauty of their own. I would remember them . . .

His impatience to become more absorbed in the forms, colours and movements of the lake's insects and fish led him to discover in another treasure trove of the unconscious – the family

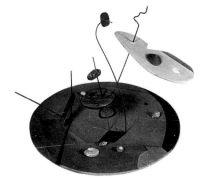

attic – the microscope that had belonged to his great-grandfather William Morris, who was something of a Victorian naturalist. Subsequently he spent many long hours exploring the secret life of animal reality. *If I am watching a lizard, I become a lizard. Gazing down through the water at a pike, I become a pike. No danger for me of anthropomorphizing. Just the opposite.* It is this power of occultation of the self – so reminiscent of the Keatsian romantic stance – that we should bear in mind when considering Morris's pictorial work. The forms that we see there are the inexhaustible images that surge up from the amniotic fluids of the unconscious mind, a realm Desmond Morris decided to delve into one day in his sixteenth year. Indeed, it was at this moment that another decisive discovery took place, one which linked in the adolescent's unconscious mind the most blatant reality and its aesthetic realization, and which was later to reappear in scenes depicting the organic liberation of forms. In the family attic once again he came upon a book of anatomical plates that had once belonged to his great-grandfather, *The Comparative Anatomy of Stomach and Guts Begun.* The 30 × 18 cm. etchings showed with the almost excessive realism of the engraver's art details of stomach pouches, intestinal pipes, gizzards, bladders, appendices and diverse sphincters taken from different animal species. The examples that we show here point up the scientific preoccupation with detail, so hypertrophied that one begins to doubt the limits between the real and the imaginary, a process we soon find in Desmond Morris's paintings.

At Dauntsey School, where he was enrolled as a boarder at the age of thirteen, he also came upon a few rare books on modern art in which he learnt that it was possible, once one had the means in hand, to master the image not by the canons of representation and the imitation of reality, but by the imagination. These preliminary intuitions received powerful confirmation in his many visits to the home of a family friend, James Bomford, a major collector of contemporary paintings, who sometimes even lent works to young Desmond to allow him to study them at leisure in his own home. Not only Renoir and Soutine, but also Paul Klee, Picasso and Masson passed through his hands in this way. Bomford often invited painters and poets to evenings at his home, and it is there that Desmond Morris met Dylan Thomas and Tambimuttu, the editor of *Poetry London*, along with a great many painters who, though they were little known,

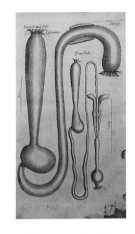

Illustrations from *The Comparative Anatomy of Stomach and Guts Begun*, 1681, by Nehemiah Grew

encouraged him to realize his wish of creating images that should answer to nothing but themselves. His first literary contact with a vision that approached the surrealist vision came in a book written by Myfanwy Evans, the wife of John Piper, entitled *The Painter's Object*, which reproduced the works of six avant-garde representatives of contemporary art, from constructivism to surrealism, among whom were Paul Nash, Henry Moore and Julian Trevelyan, all members of the pre-war English surrealist group.

The detonating event, however, was Morris's discovery, in 1944, of Goya's famous series of etchings *The Disasters of War*, a discovery or rather a confirmation, initially of a moral order, of mankind's intrinsic cruelty, which the deafening clamour of the Second World War could only amplify. Since the age of twelve or thirteen he had developed a deep repugnance for *humanity*: the drawn-out death agony of his father resulting from experiences in the trenches of the First World War, his hatred of the complacent politicians who had sent his father so young into combat, his repressed anger at the hypocrisy and cowardice of a Church which, in any case, excused these horrors by exchanging them for promises of eternal life – all these feelings bolstered Desmond Morris in his will to explore the world that he felt existed, in which the individual merges into the collective.

The discovery of Goya's etchings was also important from an aesthetic point of view. The power of the image and the energy unleashed by the graphics made one thing abundantly clear: the mere surface of the white page or the untouched canvas held all the potential that traditional art so scandalously watered down in its fear of radical truth, in other words, of the calling into question of the self. Morris was to see this 'truth' at long last in the great exhibition dedicated to Picasso which was held at the Victoria and Albert Museum in London, and its effects are easily read in his paintings from 1946, and even more so in those of 1947. Not long after this he was to discover English surrealist painting, of which he had already caught a glimpse in books. This discovery was a singular paradox though, because it came by the intermediary of works by Paul Nash and John Tunnard. The first-named painter definitely perturbs natural reality, though very cautiously opening the way to odd encounters rather than creating; in the latter's works, perspectives and fractured planes telescope with barely identifiable fragments of objects in a dreamlike, but very

'clean' and only slightly 'wild' space. At the outset the two artists struck Morris as being too polite and orderly, too easy to accept and – unconsciously moved by the surrealist's refusal of compromise – he became urgently intent on pushing even further forward in the questioning of reality, and to paint – as he declared metaphorically – not pets but wild animals.

On 3 September 1949 he went to Paris with a painter friend Oscar Mellor. There he met the sculptor Prinner and Frédéric Delenglade, who had illustrated an edition of *Alice in Wonderland*, and visited the Matta exhibition at the Galerie Drouin.

We know what happened afterwards, with the first public manifestations of this desire to fully record – an impossible, infinite task – the primordial images and the forms born of the constant movement between the internal and external worlds, in the hope of discovering another *substance* over there, and then return towards one's self, towards Being, here and now.

Space in Desmond Morris's paintings is an interior space reflecting *that which, though non-existent, is just as intense as that which exists,* so obvious is it that a drama is being played out in them between the world and the mind. It is an interior space, or rather a space that *interiorizes at the moment of their perception* the concrete or objective images seen on the surface of water or earth. In this Desmond Morris links up with one of the fundamentals of surrealism as expounded by André Breton in the inaugural speech he made at the International Surrealist Exhibition in London in June 1936: all limits and distinctions between perception and representation are to be abolished since they are nothing more than obstacles to the complete expression of the individual:

What is important is that mental representation (in the object's physical absence) provides, as Freud has said, 'sensations related to processes taking place on different levels of the mental personality, even the most profound.' The necessarily more and more systematic exploration of these sensations in art is working towards the abolition of the ego in the id, and is thereupon forced to make the pleasure principle predominate over the reality principle. It tends to give even greater freedom to instinctive impulses, and to break down the barrier raised before civilised man, a barrier which the primitive and the child ignore.

Although Morris, at the age of twenty-two, had not read this text, it is no less true that his approach unconsciously follows all of its terms. The last sentence in particular was to be a leitmotif in his work and foreshadows in spectacular fashion the irruption of the new images of the Fifties. At the time, Morris's profound conviction as to the aesthetic, biological and philosophical importance of such an attitude towards the representation of exclusively and purely interior models explains his engagement in a tireless pictorial activity that, up to the present day, has ceaselessly questioned the tenets of aesthetics, biology and philosophy as artificially separated activities of the mind. It is in this sense that what Breton goes on to say contains, here again, an objective anticipation of Desmond Morris's choices:

Is that to say that the reality of the exterior world has become subject to caution for the artist constrained to draw the elements of his work from internal perception? To maintain that this was so would be to witness either a great poverty of thought or extremely bad faith. In the mental domain just as in the physical domain, it is quite clear that there could be no question of "spontaneous generation". Surrealist painters could not bring even the most apparently free of their creations to light were it not for the "visual remains" of external perception. It is only by regrouping these disorganized elements that they are able to reclaim both their individual and their collective rights at once.

From this point it should be understood that the development of Desmond Morris's painting entails the development of a space, or rather of spaces, where the problematic reconciliation of contraries is played out and repeated in diverse forms. The reconciliation of the real and the imaginary, of the seen and the visible, of the already there and the to come. Morris's space is a space where images and mirages (the difference becomes tenuous) rise up and are called forth *before all thought,* a space that creates its own thought – or, one might say, its own *thinking.* We shall have the opportunity to come back to this later. It suffices for the time being to say that this space refuses all submission to sense, if only because the images that rise up there declare themselves to be ephemeral, and yet, because of their fleeting nature, unavoidable. Indeed, if these images aspired to lastingness, if they belonged to a constituted discourse and supported

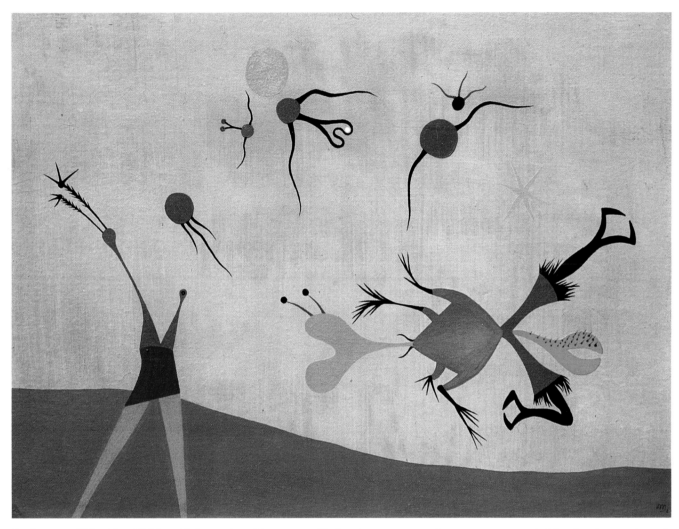

it, they would be identifiable and thus rejectable and easy to avoid. In other words, their sudden presence, because it is sudden, provokes a return to a more and more original process; but in vain, for in this invitation to a world elsewhere that extends beyond the image, presence itself falls apart and disappears.

It is interesting to note that the different stages of development in Desmond Morris's painting correspond to his changing residence. In the twenty years between 1952 and 1973, he changed studios at least six times, almost as if he wanted to confirm and reinforce in a new exterior space the evolution of his interior spaces. Often his moving from one place to

The Intruder
1949
Oil on card
12 × 16 in.
Collection Mr Paul Weir
Wroughton, Wiltshire

another was accompanied by the destruction of entire series of paintings, an experience whose cleansing effect he insists on even today. A new vigour in the inspiration and plastic treatment of the image appears with redoubled impatience since what is at stake is the exploration of new visions and the effacing of older ones, now static and void. Such is the rhythm that reorientates his art along the same thread every eight or ten years in the course of his ephemeral stays in different places. His painting constantly betrays a movement of uprising, but also of effacement, as if the biomorphs could only proclaim their presence in the silence of an absence that is perhaps their own eventual absence.

The lost image 1951–1960

From 1951 to 1956 Desmond Morris went on working at Oxford where his research in biology and zoology meant that he painted a good deal less. The few drawings that he did were more often than not destined to illustrate articles concerning animal behaviour. Only a dozen works survive from the year 1952, half of them on paper; there is no work recorded for 1953; and only one for 1954 and 1955. In 1954, after having studied with the ethologist and Nobel Prize winner Niko Tinbergen, he received a doctor's degree for his research into the reproductive behaviour of animals, and this led to post-doctoral research that was to take him even further away from picture-making.

The few works done during this five-year period point nonetheless to constant exploration and the development of the studies undertaken in the late Forties. A base line had appeared in the paintings at that time, which served as a reference, an earth line, as we have called it elsewhere. This line conferred on the forms that

danced on its surface or over it more substance, more gravity so to speak, by which we might say that the link with reality was trying to assert itself. Far be it from us to suppose that Morris was *de-poeticizing* his former approach in favour of a certain 'realism'; on the contrary, that would signify that his painting was beginning to find its place in that inexhaustibly problematic zone which is the border, the outer limit of *reality*, at the point where the image surges up, between the object that is no more and the object that is not yet. Henceforth, Morris's forms seem intent on being not just poetic and lyric, but also problematical.

Oddly enough, for two reasons, the problem arose as early as 1950 in the painting entitled *The Springing Season*, one of the last Morris did that year. In the first place, the animal shapes suggested there are in themselves composite and fragmented in their unity. Up until then they had found their origin and end in themselves, drawing their existence from their own contours

The Springing Season
1950
Oil on card
14 × 24 in.

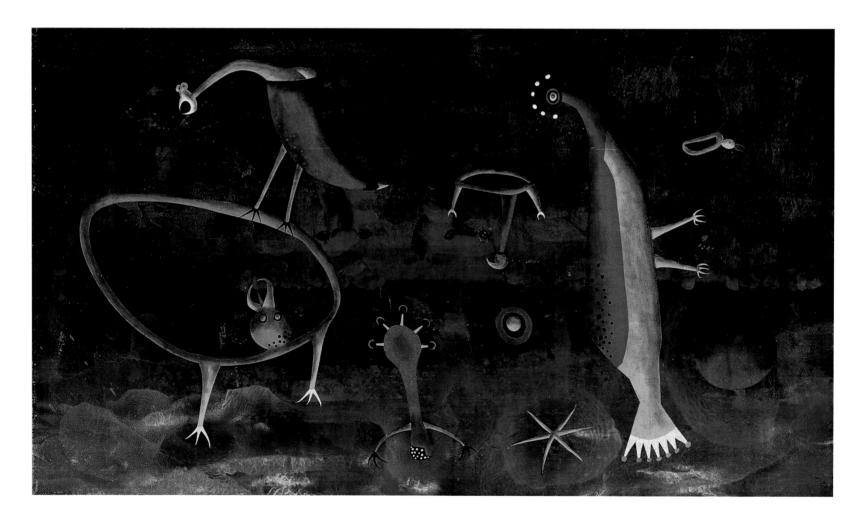

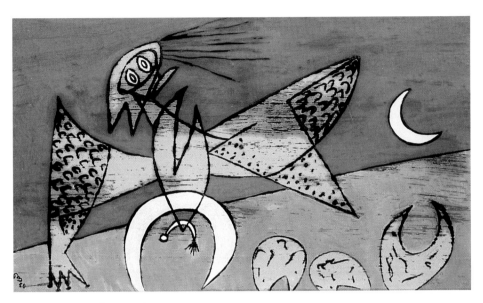

Father at the Nest
1950
Oil on paper
8 × 13 in.
Collection Mr Joris de
Schepper, London

and colours. Here, for the most part they refer to perfectly identifiable parts of animals: feet, tails, beaks, eyes – even if these parts are grafted on to imaginary bodies, full or empty, which recall the beings of the preceding paintings. In the second place, these miscellaneous *characters* occupy impossible positions, forming a circle in the field of the painting (underlined in almost tautological fashion by the circle traced in the centre of the ring of animals) in defiance of even the most minimal semblance of plausibility. These dislocated positions, in a state of near weightlessness, are reminiscent of paintings like *Celebration* or *The Red Dancer*, where the dislocation effect is brought about by the absence of an earth line, an absence reinforced by the twilight (or pre-dawn) darkness of the background. In plain words, the ethereal and almost unreal purity of the joyous circle is brought back to the clayey, ochre-red glebe by the direct evocation of recognizable animal forms. All the circles, half-circles and arcs that give the painting the spring-like lightness of life-sources or amorous leaps – all that the title evokes – convey nonetheless an irreducible zoological reality. We find the same effect in *Father at the Nest* done the same year, where the simplifying of the shapes of heads and the strong repeated presence of the crescent moon shape, a mythical and magical allusion to fecundity, are powerless to counterbalance the painting's downward movement, an effect of

gravity to which the diagonal line and the overturned crescent greatly contribute. In *Angels at Play* and *Greeting Ceremony*, the same play on forms is evident: the ethereal is brought down to earth in the first-named painting, and in the second, caricature-like hypertrophy gives the bodies a *social* heaviness in which we may discern harbinger signs of the interest Desmond Morris was later to show for the public behaviour of human beings.

Furthermore, it was in 1951 that he followed up for a short period the experiments which he had begun in 1949 with his paintings of cats, and had continued in 1950 in the portrait entitled *The Bride*. Here, as with the cats, Desmond Morris is concerned with evoking a figure using the least possible lines, lines that double back and cross over; the angular bodies made up of primary forms look as if they were inspired by

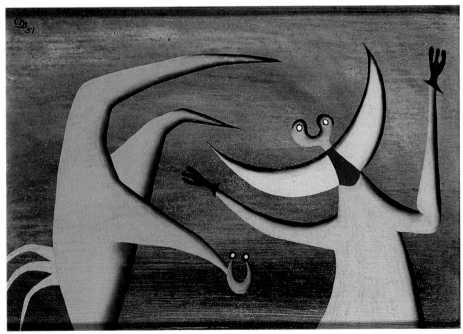

The Greeting Ceremony
1951
Oil on board
7 × 10 in.

the buffoons and harlequins of the Commedia dell'Arte. *Head of a Young Girl I & II* are examples of this; they are studies where Desmond Morris attempts to exercise the line within constraints of resemblance. *The Jester*, from 1951, represents an advanced state of this same experimentation, if only in the perfect harmony of forms and colours. The frontality of the figure, that would be almost Brauner-like if the magic element were present, its balance marked by the symmetry of small pink circles and black and white triangles, and its geometric angularity, are all indicative of mechanics that are those of the clown behind the impassive face.

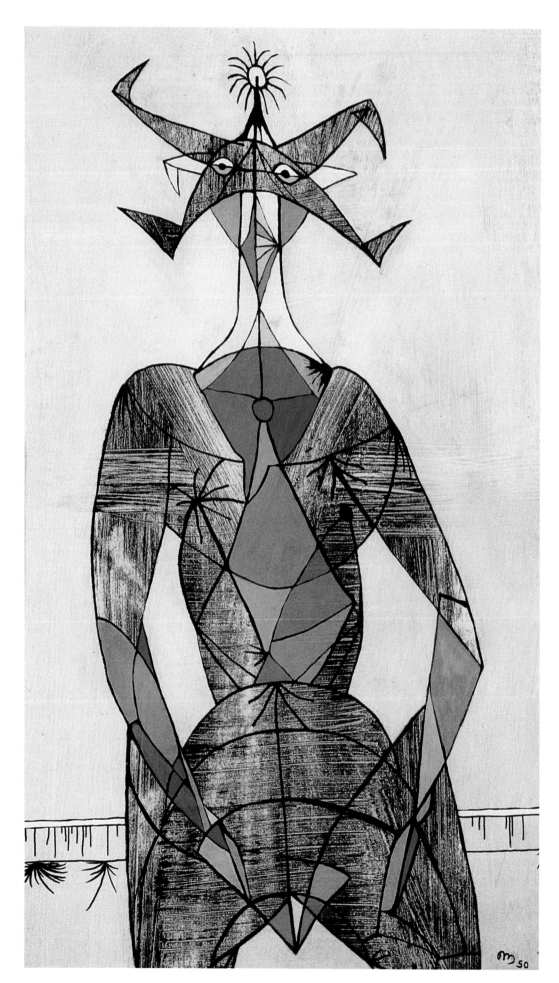

The Bride
1950
Oil and ink on paper
13 × 8 in.

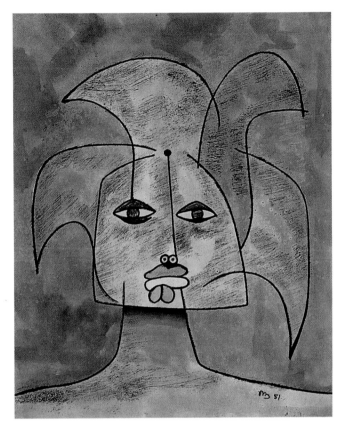

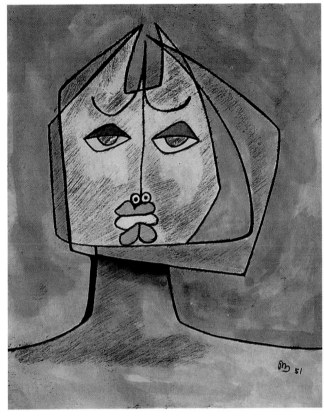

Head of Girl I
1951
Mixed media
10 × 8 in.

Head of Girl II
1951
Mixed media
10 × 8 in.

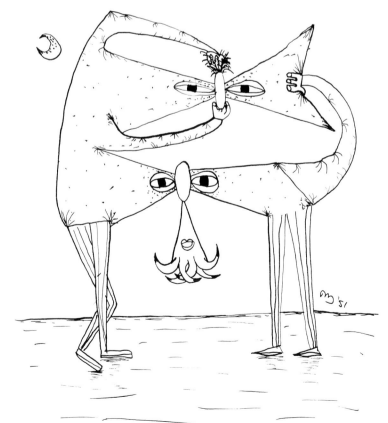

Partners
1951
Ink
10 × 8 in.

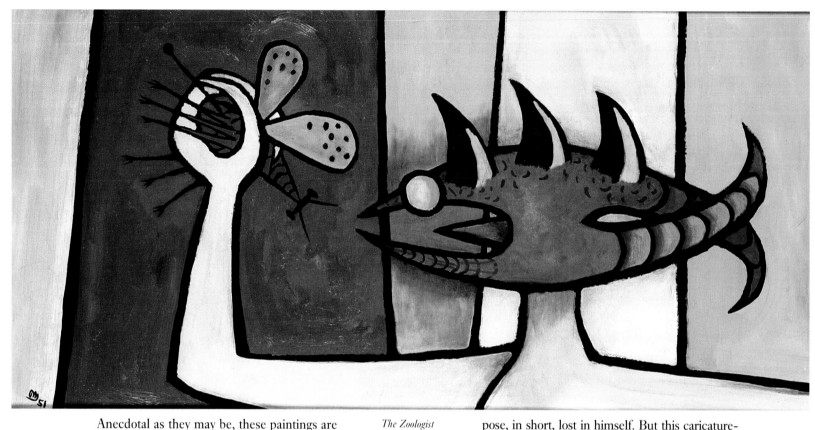

The Zoologist
1951
Oil on board
12 × 24 in.
Collection Dr John
Godfrey, London

Anecdotal as they may be, these paintings are nonetheless a necessary passage towards another series of 'portraits' painted in 1951 and 1952, where the line, or rather the heavily scored stroke takes on an aggressiveness and violence that are rare for Morris. These portraits, amongst which are *The Zoologist, The Entomologist, The Scientist, The Comforter* and *The Orator's Daughter* all refer to precise social functions and depict monstrous transformations of the bodies in relation to them. In *The Entomologist* and *The Comforter* the bodies are hypertrophied and the faces seem to suffer from a sort of elephantiasis; while in *The Orator's Daughter* the limbs and the face are fleshless and angular, evocative of a predatory and voracious nature. What we have here are metamorphoses in the true Kafka spirit, in particular in *The Entomologist* where the character holds an enormous beetle in his hands while his face seems to have sprouted a proboscis, his hair is woven into wasps' bodies and his eyes wave at the ends of peduncles. *The Scientist* is without doubt far more whimsical, a ballerina-like figure, whose body is made up of two bean-shapes and a sort of retort whose stem replaces neck and head, is standing on top of a pile of machine-like elements and gazing through a telescope, oblivious of his appearance and comic pose, in short, lost in himself. But this caricature-like interlude should not divert our attention from the teratological tendencies of the other paintings. A painting similar in manner was done in 1958, *Bird Warning*, where a low-angle shot shows a bird apparently about to jump up or fly away; the drawing is geometrical, the outlines heavily scored in and seen in transparency, all of which confers on the bird a surprising and even monstrous aggressiveness.

The two portraits of women, *Woman Thinking to Herself* and *Woman with Birds* develop the same bold strokes while applying them, as it were, to portraits similar to those done in 1950 and 1951. But here, lines and shapes serve a poeticization of the face and are somewhat akin to those of Picasso in paintings he did in the early Thirties and at the end of the Second World War, in particular during his stay at Antibes. Forms are elementary but nonetheless double: here an eye becomes a fish by the simple fluttering of the eyelashes, but remains an eye despite this (*Woman with Birds*), there an oscillating thought-wave shapes the face to its rhythm. In either case the face is deformed and elongated because it is modelled by the object it is looking at. In these first works of the Fifties, Desmond Morris seems intent on getting inside

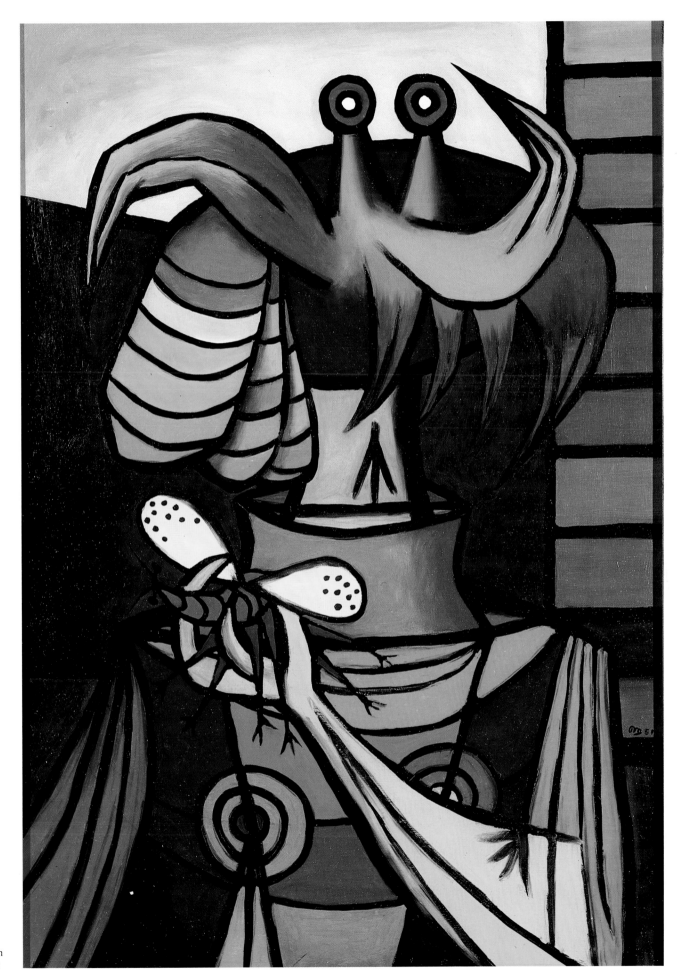

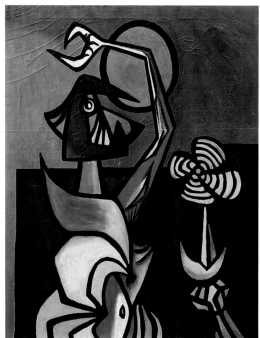

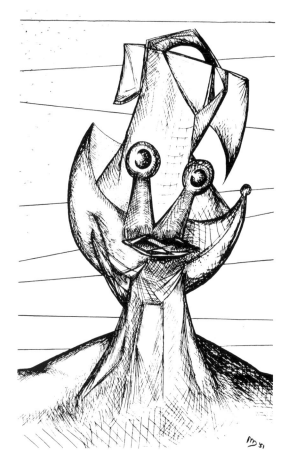

The Orator's Daughter
1951
Oil on canvas
27 × 21 in.
Collection Dr John
Godfrey, London

Philosopher's Head
1951
Ink
10 × 8 in.

the human; *The Entomologist, The Orator's Daughter* and *The Zoologist* are all veritable autopsies revealing organs in transformation towards bright and clear-cut colours, so strong is the life that inhabits them: getting inside the human not to analyse but to detach himself from it and point out its fundamental animality. Which explains the emphasis on the chaos of forms, the ironic pointing out of the profound barbary that makes up the individual, glimpsed thus in the wink of an eye. In this, we see how the initial experimenting with forms, after moving through faces, spreads to bodies and their identity. Morris's iconoclastic fascination with the portrait seems to indicate that he is trying to settle up old accounts with the image of man, and to *go beyond* the human.

This is what the dislocated and sombre images of a text dating from 1950 had already attempted to do. In "A Small Desperation", human, moral and social values are cried down and the overall paralysis of the imagination indicted. The following extract ends the text:

Sickness of the legs can be cured
by a wonderfully reflecting transparent rope,
but the cords hanging from the trees
are never clean enough to swing from
by one's hips.
Blood running to the head can be diverted
into graduated bottles
and the humidity may be calculated
to reveal the hideous beauty of the drop of
sweat
that is about to appear.

In 1956 Desmond Morris was appointed head of the Granada film and television unit at the Zoological Society of London, whose aim

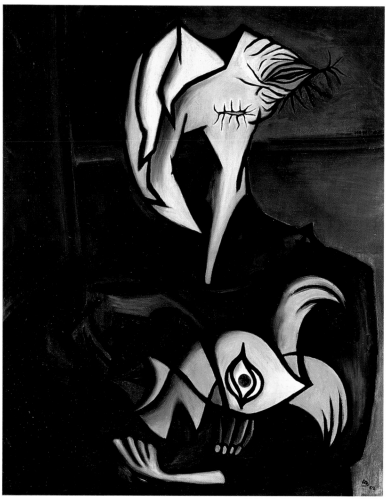

The Comforter
1952
Oil on board
32 × 26 in.
Private collection
Devon

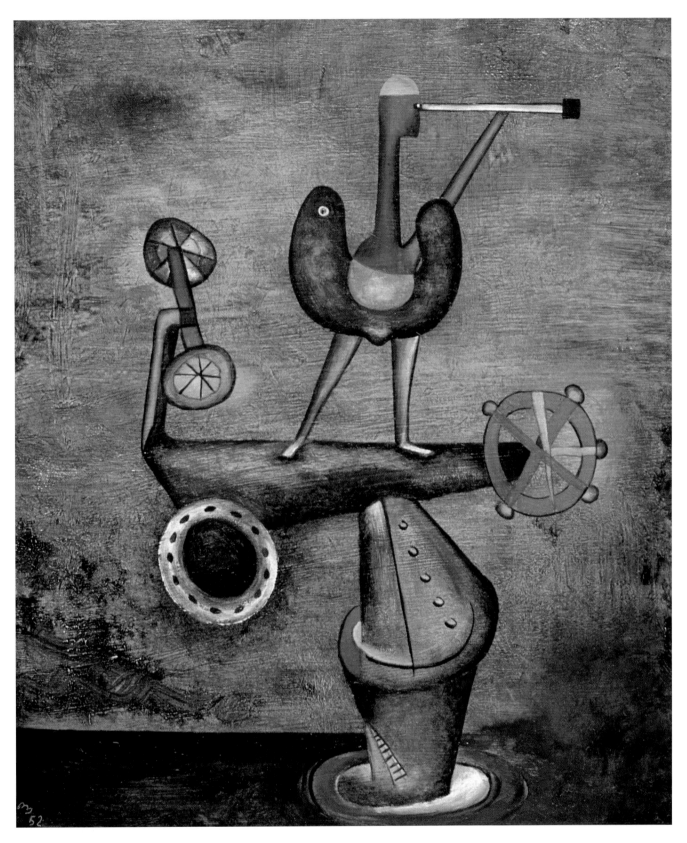

The Scientist
1952
Oil on board
13 × 10 in.
Collection Mr Norman
Goldstein, Canada

Forgotten Landscape
1954
Ink
10 × 8 in.

Woman with Birds
1956
Oil on canvas
9 × 12 in.
Collection Mrs Ramona
Morris, Oxford

Bird Warning
1958
Oil on board
9 × 10 in.

The Taste of Tomorrow
1953
Ink
10 × 8 in.

was the study of animals and their behaviour and the visual recording of scientifically interesting cases. Consequently, he took up residence in a small flat in Regent's Park, and with no studio to work in was obliged to confine himself to small formats. After laying in a supply of thirty-six 7 × 14 in. canvases he set to painting them, producing between 1956 and 1958 a series of scenes alternately depicting human beings and animals. Subjects are invariably seen in identical or parallel situations, as if they were tending to become interchangeable, in keeping with the elementary simplicity and stereotyped nature of situations. Most of these paintings present groupings of a social or symbolic nature that create a fundamental relationship between man and animal. In *The Birdcatcher* and *The Serpent's Choice* we have scenes of animal conflict or predatory situations of surprise attack. In the latter painting, the small defenceless group of little animals – eyes wide with fright and

the joyous and earthy coupling of the solar circle and the lunar crescent. And social situations too, as in *Interrupted Game* where the solar disc illuminates the half-circle of those at play, broken by the aggressiveness of six spears stuck into the ground, the central figure being cast in the role of arbitrator. Or *The Orator's Moment* where the white figure perched on the fragile bars is about to address eight black waders, an hierarchical situation whose mockery is plain in the meagre sexual attributes of the so-called head, and in his red, horn-like plume which confers on the painting the genuine dynamism echoed in the title: indeed, the chief's authority is at stake in this harangue . . . There are also parent or family situations as in *The Colony* where the contrary directions of the birds' beaks indicate perplexity in face of their new territory, a perplexity that is all too human! Noteworthy here is the care taken in the composition: the circularity of the sun echoed in the half-circle of

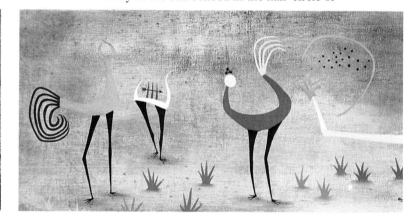

fascination – seems to be wondering which of its number is to be the victim. In the former, we wonder whether the hand which appears to be enticing with seed, or, in the centre, holding a camouflaged lure-whistle will manage to seize its prey. *The Hunt* raises an extremely banal scene to the level of a ritual, with a magic circle forming not just around the victim but with it. The similarity in shape between the white animals and the prey, and the colour echo between the prey and the limbs of the hunter, suggest the ritual *miming* by which the gestures of the hunt are shared. More 'classical', *The Killing Game* transforms the victim into a blood-red ghost, hands spread in totem fashion, while hunters with oversized sex organs or loincloths shoot their arrows.

There are also courtship rituals, as in *Spinster in Spring* where the spinster averts her eyes from

The Serpent's Choice
1958
Oil on canvas
7 × 14 in.

The Birdcatcher
1958
Oil on canvas
7 × 14 in.

the barrier draws the eye to the middle of the painting, to the line of vision that strives to be horizontal but is continually broken. In *Family Relations* protective maternity attempts to be playful, juggling with the differences or correspondences that are established around her, as is emphasized by the contrast between the two similar creatures on the left and their counterparts on the right. Lastly there are symbolic situations, as in *The White Horse* where the magical and 'impossible' apparition in the moonlight reduces the biped spectators to identical grey and anonymous forms, devoid of all means of comprehension, defence or attack; or in *Exodus Blues* where burnt-black forms cross the desert and literally disintegrate; or again in *Rites of Winter* where the characters gain in substance as they rehearse propitiatory poses. Similarly, *There's No Time Like the Future* and *Premonition*

The Hunt
1957
Oil on canvas
7 × 14 in.
Collection Dr John
Godfrey, London

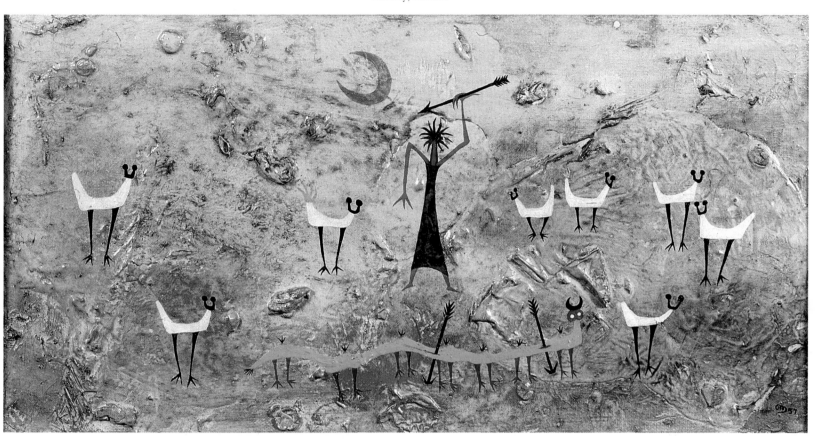

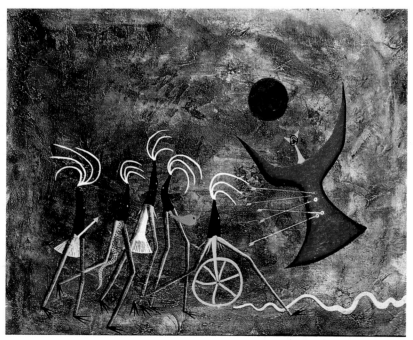

The Killing Game
1960
Oil and plaster on canvas
16 × 20 in.

Spinster in the Spring
1958
Oil on canvas
7 × 14 in.

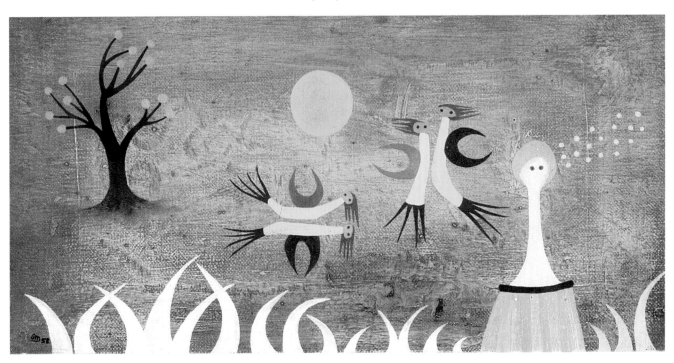

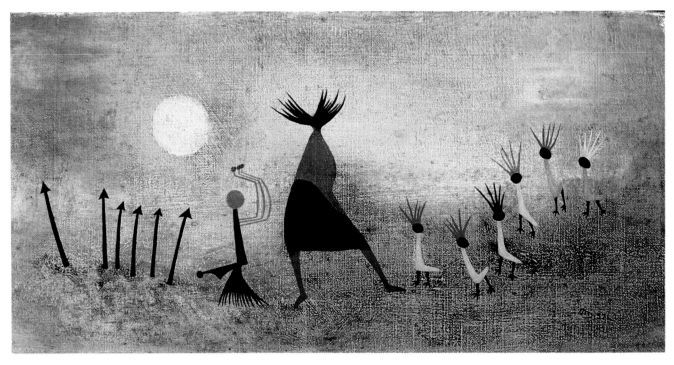

Interrupted Game 1957
Oil on canvas
7 × 14 in.
Private collection, London

The Orator's Moment
1958
Oil on canvas
7 × 14 in.
Collection Mr James
Mayor, London

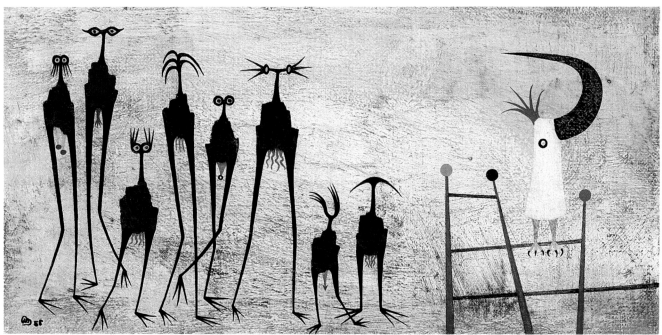

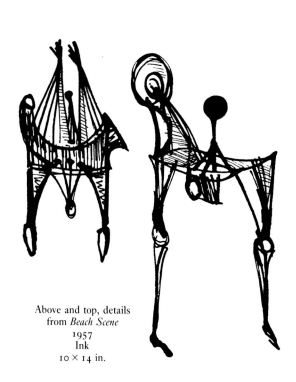

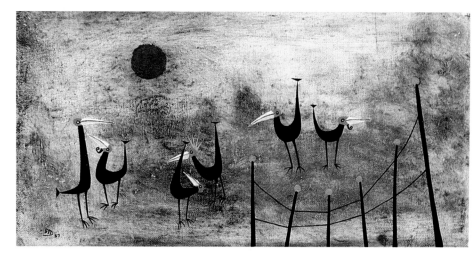

The Colony
1957
Oil on canvas
7 × 14 in.

Above and top, details
from *Beach Scene*
1957
Ink
10 × 14 in.

Family Relations
1958
Oil on canvas
13 × 36 in.

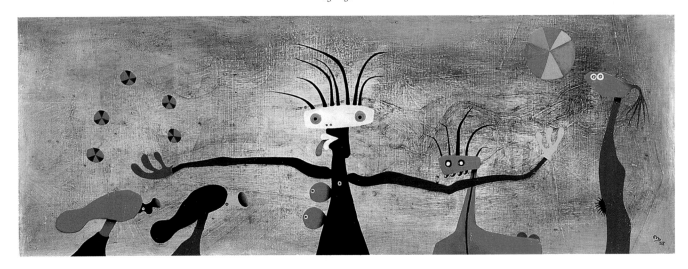

Drawings on this
page: details from
Political Scene,
1954
Ink
8 × 8 in.

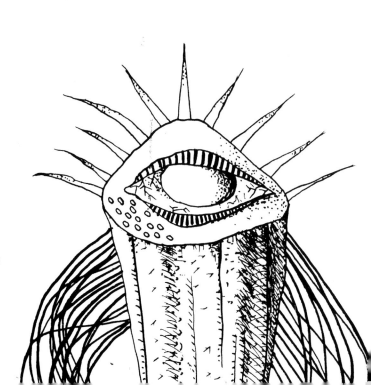

The White Horse
1958
Oil on canvas
7 × 14 in.

Rites of Winter
1960
Coloured inks on paper
10 × 14 in.

Exodus Blues
1960
Coloured inks on paper
8 × 11 in.
Eric Franck Gallery,
Geneva

of Life present dreamlike scenes under the moonlight; the first-named painting harks back to folktales which tell of the fabulous animal that can be ridden by an entire family, and the latter, apparently, refers to the dawn of creation where winged creatures watch the passage of smaller and newer creatures in front of the crumbling remains of a barrier, which no longer defines any limit. The same dilemma is to be witnessed in *The Fear of the Past* where what passes plunges the spectators into their own *primariness*.

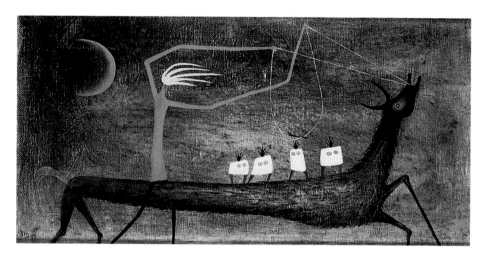

This set of themes dealing with the foreign and with the *difference* it introduces was already visible – in a more obvious and stronger fashion – in *The Horizontal One* painted in 1954. Here too the body lying on the ground is equipped with a great many legs while the slender and dismayed bipeds surrounding it have bird-like legs and no upper limbs. What is patent in these paintings is that the vertical bodies composed of long legs and an enormous head (or of a trunk carried by spindly legs), and the horizontal bodies, elongated, with many legs and often several humps, are all reductions and exaggerations that are characteristic of children's drawings. In this way, each *character* represents a stage so imaginary as to be real in the evolution of picture-making, a stage in the process of the child's elaboration of the human or animal likeness. Indeed, a study of drawings done by children of different ages reveals that bodies are often part and parcel of the head, and that legs dangle from a head to form a cephalopod, this before the child introduces a trunk joined to the head, before he or she separates the one from the other . . . all stages which Morris seems to allude to in his creatures. Moreover, the painting *The Victor* not only juxtaposes certain examples

There's No Time Like the Future
1957
Oil on canvas
7 × 14 in.
Collection Mrs Marjorie Morris, Oxford

of child discovery, but also – if the title has any significance – emphasizes the feeling of superiority and enthusiasm that this discovery brings. In this we sense Morris's obsession with Darwin's theory of evolution; indeed, the omni-presence of the moon helps set the scene for us in a twilight (or is it pre-dawn?) phase of humanity, torn away from maternal chaos.

A canvas dating from the last years of the Fifties, *The Revolt of the Pets*, indicates change in metaphoric manner. Here the fence appears (symbolically at least) to confine supposedly-domestic animals that are quite obviously in a state of rebellion. Like their monstrous keeper, these animals correspond to no known species; they are chimera-like composites of fish, cattle, birds and diverse objects. The painting points to a certain acceleration of Morris's inspiration, perhaps subsequent to his having realized that he had reached a certain stage and would have to choose a direction. Oddly enough, one of the last canvases dating from this period is entitled *The Egg-thieves*. Here, four wiry forms somewhat akin to praying mantises have – by moonlight once again – driven a bird from its nest to thieve its eggs. The source of creation itself is rifled since to steal an egg amounts to stealing the animal about to hatch from it. Surprisingly, the Sixties were to be marked by a veritable obsession with cell shapes, eggs and other primary forms associated, at least in a preliminary phase, with an almost hermetically closed space. In this way, it is clear that something is being stolen so that something else can be set free. We shall say more on this point later.

All through these eight or nine years the tendency that was to mark Morris's painting was becoming increasingly clear. In his avowed primitivist desire, the painter was intent on rediscovering the fundamental signs of the group's sociality, those of man as a social animal. The images he gives us are residual, and yet intrinsically whimsical; they are pictures from our collective past; primordial pictures, images without image, mirages rising amidst the separation from chaos. They are situated so clearly and so frontally at the origin of the most elementary social gestures that the surprise to be read in the attitudes of the creatures, in their bulging eyes, often reduced to marble-shapes at the end of peduncles, reminds of what must have been the amazement of the first person to have discovered laughter. This naive humour, literally inno-cent, is ever present with Morris, in particular when, during the Seventies, he redeveloped the

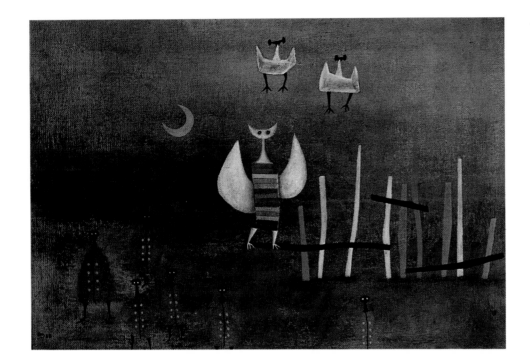

Premonition of Life
1958
Oil on canvas
11 × 16 in.

Fear of the Past
1957
Oil on canvas
7 × 14 in.

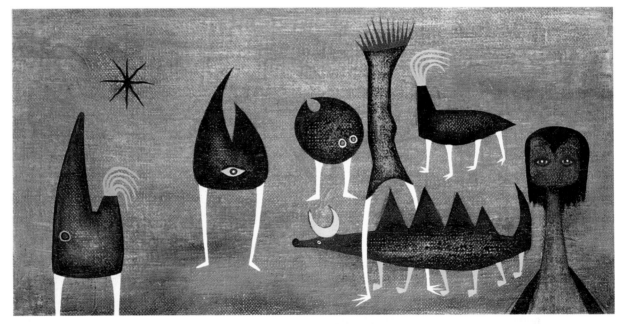

The Horizontal One
1954
Oil on panel
10 × 15 in.
Collection Dr John
Godfrey, London

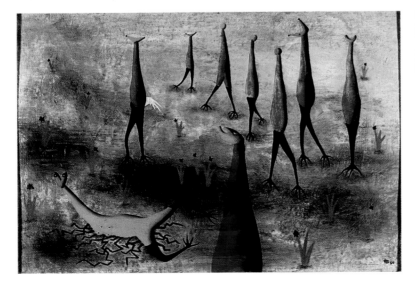

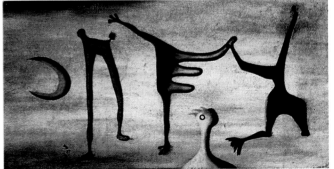

The Victor
1957
Oil on canvas
7 × 14 in.
Private collection,
London

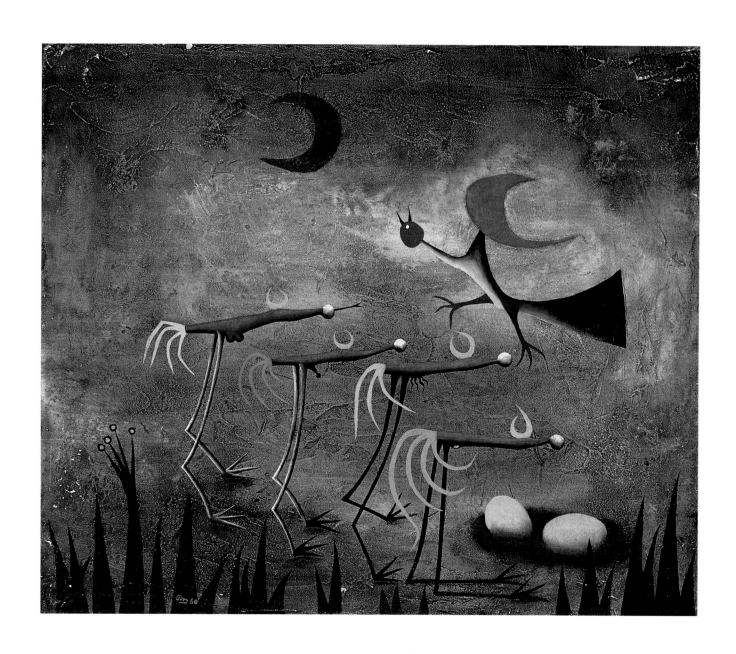

The Egg-thieves
1960
Oil and plaster on canvas
14 × 17 in.
Collection Mr Tom
Maschler, London

situations depicted in the paintings we have just considered. Quite obviously, it is also the naive and innocent laughter of the scientist faced with the discovery he has just made, and which is already beyond him.

This concern with the primordial, which on the aesthetic level brings the technique of these paintings close to certain prehistoric cave drawings (another key interest in Morris's life during this period) can be traced to the experiments he was then carrying out in the fields of biology and zoology. Indeed, we must remember that while he continued painting, Morris also began to analyse the capacity of chimpanzees to paint. A year after beginning his research into the origin of the aesthetic gesture – and here again we find the obsession with origins – he organized an exhibition of paintings and drawings done by chimpanzees at the London Institute of Contemporary Arts, and the following year (1958) collaborated with Mervyn Levy in organizing a perhaps even more provocative show entitled "The Lost Image" at the Royal Festival Hall, London, where works by primates, very young children, and adults were shown side by side.

These exhibitions raised a storm of protest in England and abroad, and were widely berated by people already incensed by pop art and lyrical abstraction. What is the world coming to? What about the sacrosanct artistic values? What is becoming of beauty? Of art? One is tempted to answer as the Dadaists did thirty-six years before that time: nothing, nothing, nothing. Because Morris was not intent on attacking art (that was already being done for him) but on seeking out the first image-making gesture, or perhaps we should say, in strict respect of the root of the word, the first *imagining* gesture, the gesture which precedes the image.

Thus it was that the first exhibition in the world of drawings by chimpanzees opened on 17 September 1957, by Congo of London Zoo and Betsy of Baltimore Zoo. As Desmond Morris was to declare some time later in a very serious article published by the review *Natural History*, the object of this show was to throw light on the origins of aesthetic activity by going beyond prehistoric drawings, which he clearly said *had proven to be an artistic form much too advanced to tell us how it all began.* The same was true of so-called primitive arts whose stage of evolution as represented in the present day is in all points comparable to that of Western art. As for children's art, which seems to hold something of the secret of the artistic gesture, it is too early

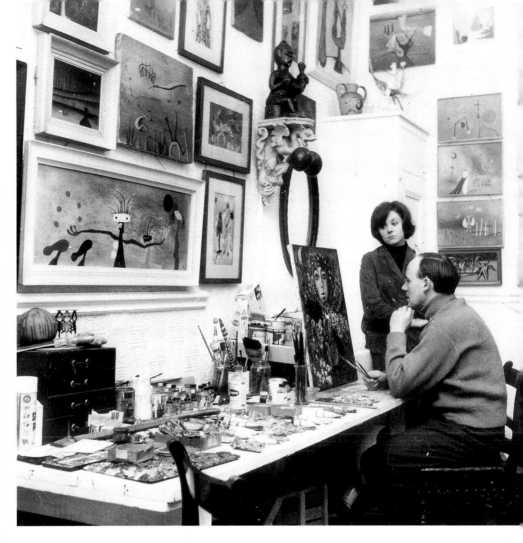

Ramona and Desmond Morris in the London studio in 1960

overshadowed by the influence of parents and schooling. Thus Morris set about directing the execution of *infra-human* works (the adjective is his own), *where elements of visual composition are so simple that they can be the object of analyses that are impossible to do on the more complex and charged images of man.*

Between 1956 and 1961, Desmond Morris collected pictures done in Germany, Russia, Holland, Switzerland and the United States by thirty-two monkeys, gorillas, orang-utangs and chimpanzees. The most interesting of these were by the chimpanzees, and in particular by Congo of the London Zoo, with whom Morris carried out experiments over three years. Without going into the details of these works, we might do well to point out two clear stages; first, the drawings where Congo's pencil reveals not only an acute sense of limits – whether they be those of the sheet of paper or of a rectangle of varying dimensions drawn on it – but also a rudimentary sense of balance. Second, the paintings where a recurring structure was easily discernible: that of a fan-shape, the formal mastery of which had become increasingly clear. Similarly, in other experiments with pencil drawings, it became apparent that the animal reacted to the presence of geometrical figures already on the sheet of paper it was given, establishing a relationship of balance between them and the lines it drew. In the course of these

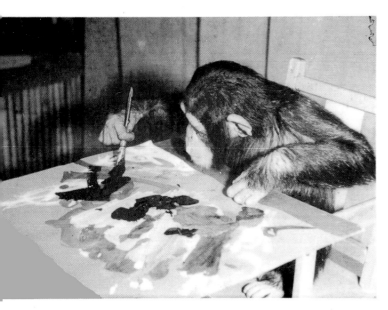

few years, Morris noted a sort of evolution in his subjects: strokes became longer and snaked about more, circles and spirals and even quite complex horizontals appeared; in short there was a sense of *placing* and *linking* at work.

On 15 September of the following year (1958), the exhibition entitled "The Lost Image" resumed these experiments and broadened their scope by allowing the viewer to compare pictures done by Congo with those of very young children and "tachiste" automatic drawings done by art students: forty-five works in all divided into three sections. In the catalogue, Mervyn Levy stressed the similarity between drawings by the chimpanzee and the child, the progression from disconnected lines to continuous patterns which in the chimpanzee showed "the development of integrating images", thus of "intelligence", and in the child "the emergence of the symbolic image". In opposition to this, Levy went on to say that the "tachiste" drawings of the students from the Ipswich Art School corresponded to a "death wish", a "desire to neutralize creative intelligence" and "to abolish the personality", in short, to "a regression more primitive even than the scribblings of an ape". In the second of the catalogue's texts, Desmond Morris describes once more the process by which Congo achieved a basic pattern, based, as with children, on simple lines; children, however, quickly move forward to the stage of producing "diagrammatic patterns such as circles, squares, triangles and crosses", indicating that the child is "starting down the long road of visual differentiation". This combining of forms to create pictorial images was absent from Congo's work, despite the tendency to order and balance that was undeniably there. Colin Moss, who reported the conditions under which the Ipswich students worked, emphasized the boredom which descended on all of the students excepting one during the experiment of automatism to which they submitted.

Barring one or two doubtful hypotheses (the boredom of the students being a sign of the death wish inherent in tachisme . . .) the main conclusion of these experiments seems to be the idea that differentiation as a process originates the aesthetic gesture, and it is this which underlies all of Desmond Morris's picture-making. Indeed this concept questions the idea of origin; it can only be postulated before the process of differentiation actually takes place, before a difference. That is, we must literally read it between the lines drawn by apes and children, in the repeated interruptions of their tracings. Desmond Morris seems to be attempting to launch out on a meta-historic reconstitution of evolution, between yesterday, the day before yesterday and today, a reconstitution whose *principle* is unexpectedly given to us by two poems from the beginning of the Fifties, "Lees Cottage" and "The Evening's Horses".

What these two texts celebrate is the renewed desire to be set free from the insistence of the present, heavy with its chronological rigidity, and to plunge into the time of the ever-present, which, since it is inseparable from the repetition of rituals, escapes from history. Morris's time is, if not the time of memories, that of the fluctuations of remembering.

This is the time of the caged grasses,
the hour of abstract ritual,
or the infinite fluttering that circles
the dimly-lit cavities of the mind.

With a slower pace
the solemn peace of tidal memory
finds itself alone, surrounded
by stupid, cursing waves.

Between being shut in and being set free, between the closure and opening, birth and death, the identity of things is in question because it is only in this intermediary space that we can hope to move back through the mainstream currents of memory, to make time stutter and relive the primordial scenes. The horses of evening, instigators and provokers of the imagination, come galloping up to project us into a time essentially composed of echoes:

The evening's horses run their race
towards the simple shapes
of shadowed yesterday.

The nightwind's plumage feels
its flutter ending in the target's rim,
and then my echoes are mingled

with the salt of a stone's shallow tears
calling softly to my mate
to unfold the story of her white seduction.

These echoes are snap-shots of our history, but independent of its unfolding, which seems to be reduced to a call, an idle wish since that which is to be said has all the candour of seduction – is it the primordial temptation? – that is to say of the timelessness of appearances and their pure play, beyond all truth. This text is the encounter outside of time of the myth of Orpheus with that of Lot's wife, both figures who are punished for their having wanted to possess the object of seduction in a single glance. A glance that was one too many since what it sought to apprehend was the certainty of presence, indeed illusory, thus refusing the floating fecundity of absence. All of this can be perfectly applied to the paintings we have seen, which are so many Orpheus-like temptations to *gaze* on the origin, so many impatient desires to give one's self up to the absence of chronological time which we know are in vain. But at the same time, as Maurice Blanchot points out, this impatience is the sign of inspiration, of the movement that continually carries the artist nearer to the inaccessible origin.

As in "Alligators' Toes", a dream Desmond Morris had one night in 1955, it is clear that monsters haunt the waters of dream and pursue the dreamer relentlessly, like his double, to pipe

Poster for the exhibition of paintings by chimpanzees organized by Desmond Morris at the Institute of Contemporary Arts in London in 1957

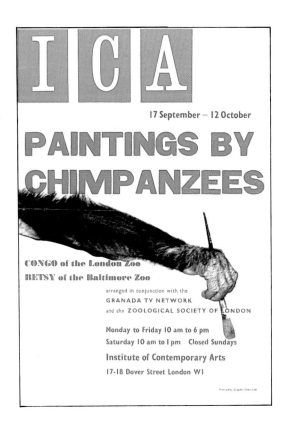

into his ears a music made up of the clamours of war, flood and apocalypse, and plunge him into the night of time – probably that of Congo. If we are to travel through this immemorial night, we must strip ourselves bare of the images that weigh us down, and through the lost image and its absence, perhaps we shall come again into the presence of our creative origin.

Three examples of paintings by the chimpanzee Congo made during a series of experiments by Desmond Morris to investigate the origins of aesthetics

75

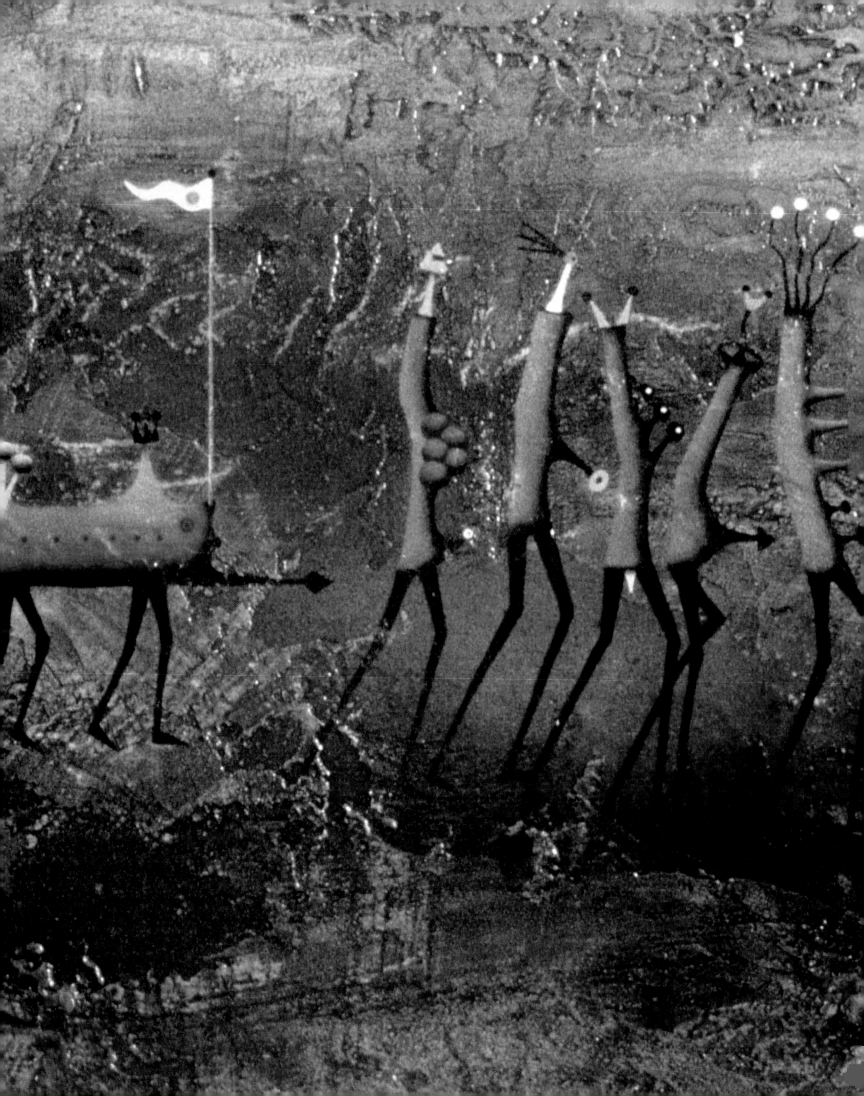

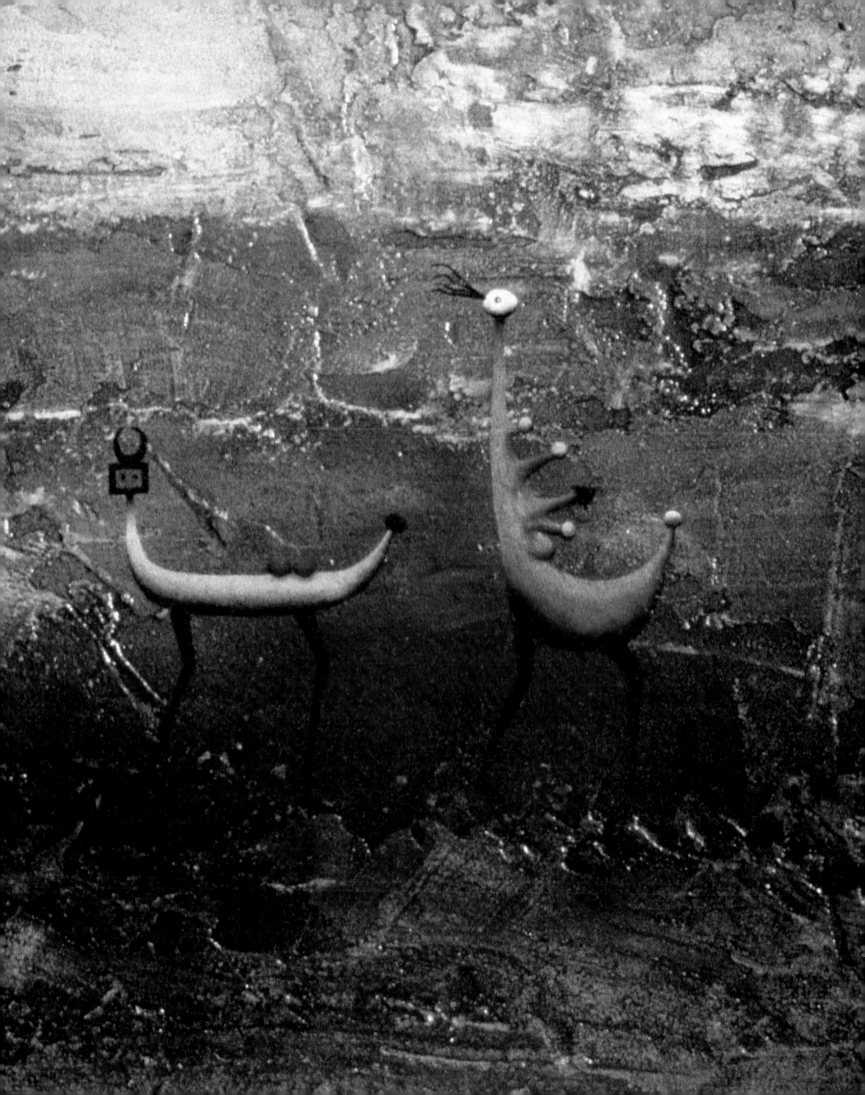

THREE

The two exhibitions of 1957 and 1958 and the research that led up to them were capped in 1962 by the publishing of *The Biology of Art*, a fundamental work in understanding Desmond Morris. The book gives a clear and precise synthesis built up from the accounts of various experiments carried out with chimpanzees in Europe and the United States. As we have already seen, the major discovery concerned the elaboration of compositions as drawings followed one after the other; and it was also shown that these drawings were better composed and structured than those made by young human beings. According to Morris, this is due to the "other problems of calligraphic organization" that preoccupy the child's mind as it draws, and distract its attention from the basics of composition. An attempt to verify these hypotheses by a systematic parallel study of children's drawings with those of Congo revealed, on one hand, the importance of the link between *the rhythmic repetition of rewarding activities* and *the rhythmic organization of space*, and on the other, the existence of an aesthetic source common to both man and animal, evidenced by the recurrence of certain motifs. The muscular development of the chimpanzee, which is more precocious than that of the child, explains the earlier appearance of curved lines in its drawings; for other reasons of conceptual origin, the broken line or the zigzag, and even more so, the spiral, are more difficult to attain in both cases. Even so, at the stage where lines begin to cross, the ape is satisfied with drawing a loop while the child does not stop until it has scored in a whirlwind of lines. If there is a similarity between the animal and man – of which Morris is convinced – it ceases at this stage, around the age of three.

On the basis of these results, Desmond Morris concludes by proposing six principles of pictorial composition that apply – he says – just as much to Leonardo as to Congo, and give the keys to understanding the nature of artistic creation. These keys are certainly not definitive, but they are operational. First, the aesthetic value of a work depends on its being a self-rewarding process. Morris quotes the case of a chimpanzee that received a food reward after each drawing; it was not long before the animal began doing no more than scribble a few lines before stretching out its paw to receive its reward; all the attention formerly given to rhythm, balance, tracing and composition had disappeared.

The oviparous image 1961–1968

Detail from *Four Biomorphs*
1960
Ink
8 × 10 in.

Second, the mastery of composition is inseparable from a partiality for balance, regularity and symmetry. Third, for both the child and the chimpanzee, the notion of differentiation is central in the development of lines into distinct forms, and this is directly linked to the fourth principle which is that of thematic variation. In the beginning, the exploration of lines is confused and chaotic, but a motif soon emerges that both chimpanzee and child preserve and repeat with variations. This is a major element and it is clear that the evaluation of a work is not done with regard to a given originating point, but rather to a process of gradual modification, not according to the leap it seems to have made compared to the preceding work – a pure illusion – but according to an imperceptible movement of shifting, setting aside or curving vis-à-vis its reference as we may suppose it to be. Similarly, in painting, what Morris is intent on finding are the moments when, through such and such a scene or shape, we rediscover the traces of our own history, by delayed action so to speak.

The fifth principle is that of optimum heterogeneity, which coincides with the moment the work is considered to be finished. Quite plainly, Congo had a very precise idea of when each of his drawings was finished, and it was impossible to make him go on with them after this point. If forced to do so he would score lines across the drawing. The same conviction of having attained the 'goal' is noticeable in the child. Last but not least, these five principles are capped by a sixth: that of a system of images of universal value, visible in the chimpanzee's partiality for certain compositions. This is especially obvious with children, whose drawings of trees, houses and animals are surprisingly uniform in structure from one country or continent to another.

It was important to summarize this book, now long out of print, which ends with the hope that an Institute for the Study of the Biology of Art be founded, whereby such fragmentary experiments would be pursued. This did not come about, but it is undeniable that the experiments *seeped through* a good deal in the paintings of Desmond Morris. For in abandoning his almost animistic magic and ritual scenes – the manifestations of original gregariousness – and moving on to radically different paintings where enormous cells and other egg-shaped forms occupy almost the entire surface of the painting, Morris moves back not only towards the origin of the human being, but also in the history of biology itself. There is no end to verifying this osmosis

between his aesthetic and scientific preoccupations. For Morris, the act of painting literally moves back into consciousness towards the prelanguage state. In a statement printed in the art magazine *The Studio*, in 1962, he summed up as follows his intermediary position between two activities which are in fact two attitudes towards life:

> To this day, painting has remained for me an act of rebellion, a private pursuit which I indulge in despite the fact that there are many good reasons why I should not do so.
> The simple, direct creative act of painting a picture is a childlike ritual of exploration . . . It can act, for an adult, as a gesture of defiance against the increasing intrusion into everyday life of good, sound, common sense . . .
> My paintings, on the other hand, gave me the chance to use my knowledge of animal processes and biological principles in a different way. In my biological work I was a slave to the actual – I had to find out how things have evolved and why they are the way they are. But, in my pictures, if I wanted a creature of any particular shape or size or colour, I could make it so. As a release from the intensive slavery to fact, I could indulge in fancy and create a fauna of my own, obeying visual laws imposed, not by nature, but my own imagination.

This liberation represents not a contrary activity but one that is parallel, as if it revealed the impossible potential of a scientific system. In fact, it confers on such a system a reverse side, its double, which, like a river passing under a mass of unpassable rock, rushes from one block to another and winds around those that resist, eroding them with inflexible determination. This image sums up Desmond Morris's approach, and throws light on the detours his imagination can take. He goes on to say:

> . . . but, to be honest, the whole process of how my paintings come into being is still a mystery to me. When I leave for my studio, my mind becomes a blank and, after hours of painting, a picture has grown out of nothing and stares at me. I stare back at it, cautiously surprised and puzzled to know where it has sprung from.
> The process of painting itself is an almost unconscious act and is certainly free of any verbalization . . . The act of painting is automatic, compulsive, an extension of one's visual worries and desires.

As we can see, mankind loses itself in its origins. And all through the Sixties, in between the facts, in between the data gleaned by scientific observation and the impulses of the imagination – between the slipping of the former and the mastery of the latter – Morris's questioning continues in a *systematic* drift. So much so that even the events of his life obey this dialectic oscillation between zoo and studio.

In 1959, he was appointed Curator of Mammals at the London Zoological Society; in 1962, he published *The Biology of Art*; in 1964 he received a visit from Joan Miro who was intent on acquiring a drawing by Congo. On this occasion, recalling that one of Miro's very first drawings depicted an enormous snake, Desmond Morris settled the coils of a giant python from the London Zoo around the painter. The photograph that was taken of this event by Lee Miller became famous, and, in the immediate relationship it established with a living image of

Joan Miro visiting Desmond Morris in London in 1964, where the Spanish master enjoyed the experience of being wrapped in the coils of a giant python

the origin, it symbolized the reciprocal inter-penetration of the scientific and the aesthetic, of the biological and the artistic. For what animal is more *original* than the serpent?

In 1965 Morris left the studio at Primrose Hill, which he shared with the writer Philip Oakes, and moved to a house in the Barnet area of north London. Here he set up a new studio, and this move was to exert an influence on the development of his painting. Two years later, in 1967, he suddenly decided to resign his zoologist's post and take up the management of the Institute of Contemporary Arts, founded in 1947 by Roland Penrose, an early exponent of English surrealism and member of the group. At the time, Penrose was general secretary of this organization, and Herbert Read its president. Desmond Morris was immediately put in charge of setting up new premises in The Mall, since the Dover Street premises were now far too small. This new, official and energy-consuming

The seven years we are concerned with at present (1961–68) are marked by an obsession with the organic and the genetic. The period began by an overall ousting of the proto-human and biomorphic creatures that had peopled his small format paintings. *The Egg-thieves* has already been mentioned, but the two most striking paintings from this period, if only for their large size, are *The Assembly* and *Processional*, the first painted in 1960, the second in 1961. Both works plainly depict predators and prey, victors and victims, headless bipeds and quad-rupeds with enormous bodies, red and yellow comma-shaped bodies on cave wall-like back-grounds, hunting scenes and joyous frolics, parades where the small beings of the Fifties reappear, as if the painter were taking leave of them in a last round of inspection; indeed, the two works are remarkable for their condensation. The *coup de grâce*, however, was to be finally dealt to the biomorphs in 1961 with *Moon-dance*;

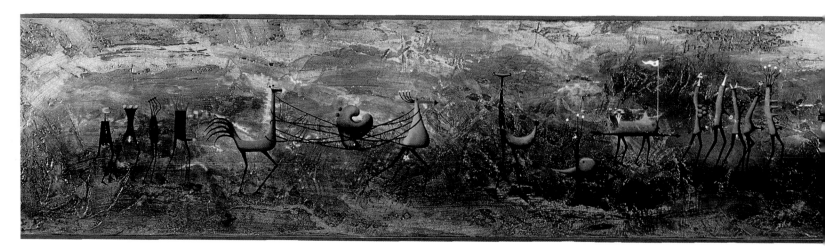

activity put a complete block on his personal painting, and not one picture is recorded for 1967. At the end of that year a considerable and indeed unexpected event came about in Morris's life: *The Naked Ape* was published, and in just a few days achieved worldwide acclaim. For the first time in his life he became financially independent, and consequently resigned his director's post at the ICA, where, in any event, administrative and personal problems were beginning to arise. In 1968 he and his wife left England to set up home in a large villa on Malta, where their son was born later in the same year. Morris was to remain there for five years, until 1973, painting most of the time and taking a break now and again to write a book.

they are still recognizable by their eyelashes and antennae, but have become black corpuscles with burnt appendices, forms which herald in the components of certain cells in paintings from the same year.

Simultaneously, in portrait scenes of groups captured in medium close-range shots (to use a term from film-making), certain characters appear whose main interest resides in the new facial model they present. In 1960, *Family Portrait*, *Expectant Figures* and *Family Group* reduce faces to enormous growing tubercles. Shapes have no regularity though they remain vaguely evocative of the circle, the oval or the ellipse; and even more arresting is the fact that on their surfaces an intense distribution of

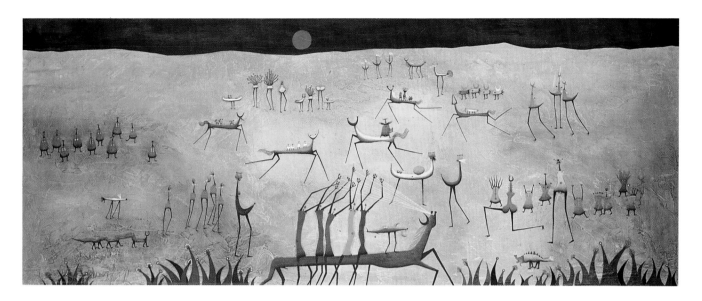

The Assembly
1960
Oil and plaster on board
34 × 84 in.

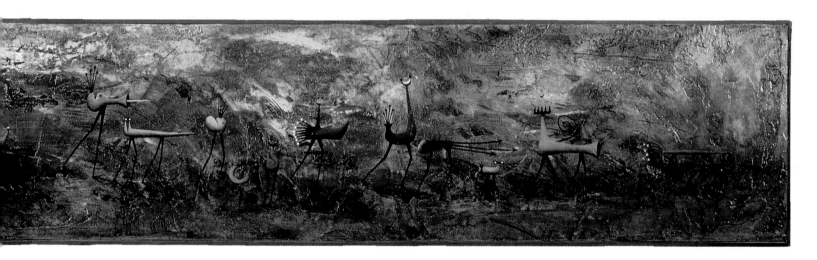

Processional
1961
Oil and plaster on board
12 × 96 in.

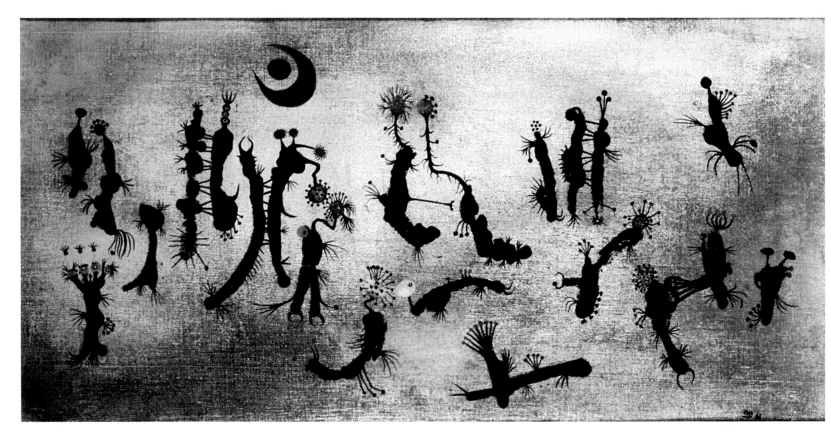

mouths, noses, lips, eyes, ears, nostrils and chins is going on . . . What we are witnessing is a veritable mutation of matter: these faces are in a way enormous foetuses whose identification process the painter has attempted to caricature or symbolize. This is clearer still in two paintings from 1961 that explore this organic constitution, the significantly-titled *First Love*, and *Three Rivals*. In the former work, the face of the child sucking at one of its mother's five breasts, in its deformity and schematic tracing, refers to the face of the mother. This is indeed a formation-deformation where what appears first are the lips. The whole of the mother's head is shaped like an enormous mouth. As for the three rivals, their heads are bean shapes seen in full mitosis under the influence and the protection – as in the other four paintings – of the moon, the maternal growth principle. It is in the course of this shift towards the moment when bodies are formed that the leitmotifs of subsequent paintings appear: mouths made of beans with their backs stuck together, breasts formed of pure circles, the echoes of circular eyes, bean-cells, spindly organs, bone shapes, tibias, femurs, ribs, whose hardening is not yet complete.

This stage – obviously transitory – was immediately followed by a sort of formal purging that gave us the strange *White Landscape* series of which there were originally thirteen paintings, though only eight now survive. The one reproduced here is particularly noteworthy, the whiteness of the landscape being validated only by what bursts forth there: three strict columns from which hang three visceral forms, traces of growth that stand for nothing but themselves (as is shown by the straight line that crosses the space), whose filaments, hairs and lashes are signs of prehensile development to come. This search for minimal forms is pursued in an exploration of strict geometric forms that would be abstract if not for the presence of the small circles – eyes and/or breasts – and the larger circles – the moon or the sun. Whatever the viewer chooses to see in them, it would seem that *Moment of Judgement, The New Challenge* and *The Ruling Power* blend masculine and feminine attributes that tend towards one another or are quite simply juxtaposed and waiting. A remarkable example of this – one extremely successful in its balance of tensions – is to be seen in the painting entitled *Lovejoy and Killjoy*. Two standing characters, the one geometric, the other 'non-formal', their sexual organs in erection,

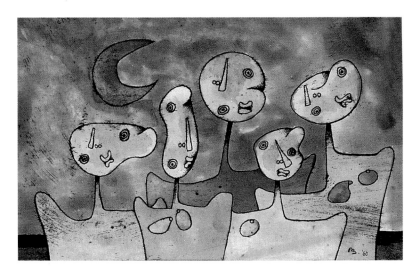

Family Portrait
1960
Mixed media
8 × 13 in.

Expectant Figures
1960
Mixed media
12 × 16 in.
Collection Mr Robert Page,
London

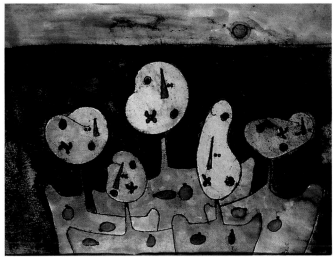

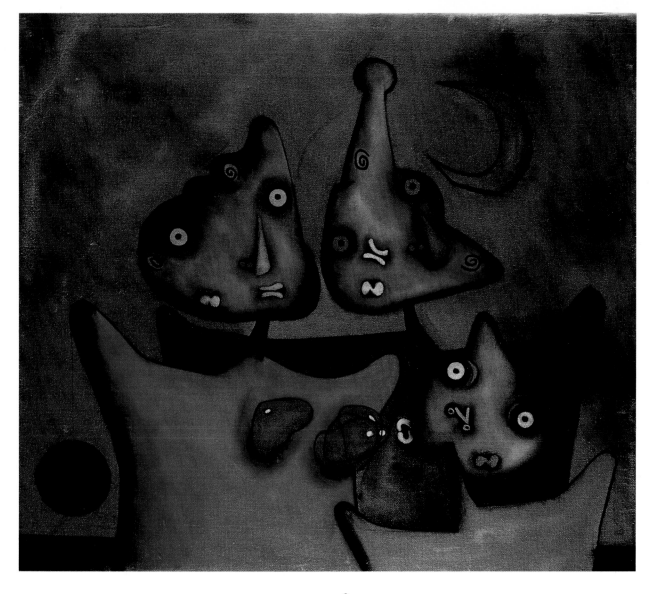

Family Group
1960
Oil on canvas
22 × 25 in.

First Love
1961
Oil on canvas
13 × 27 in.

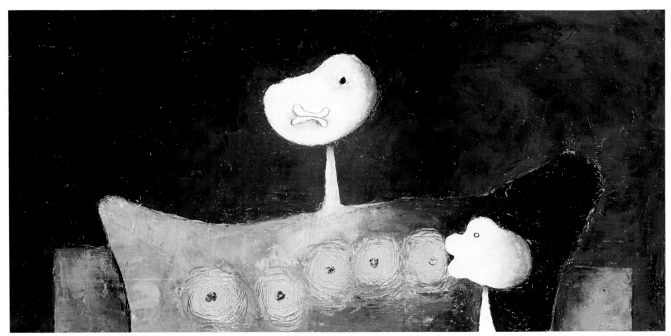

Family Group
1960
Ink
20 × 14 in.

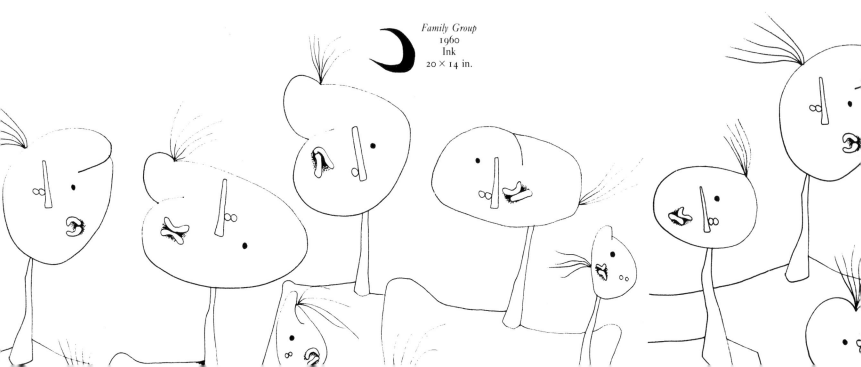

Three Rivals
1961
Oil on canvas
19 × 23 in.

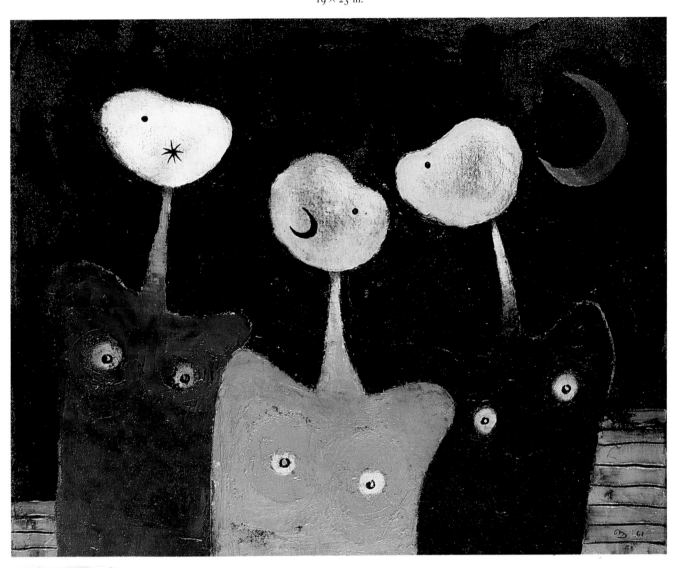

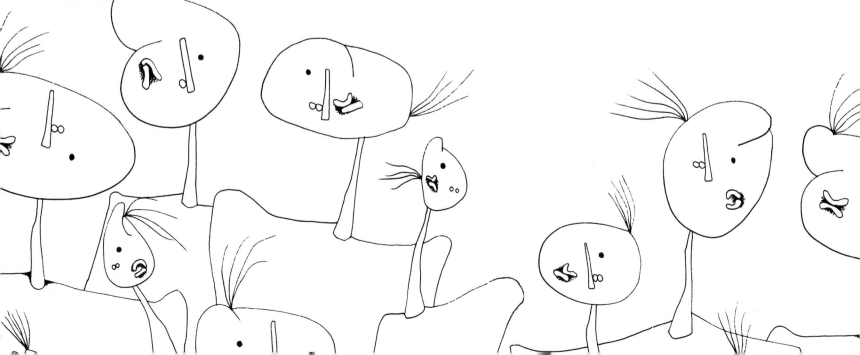

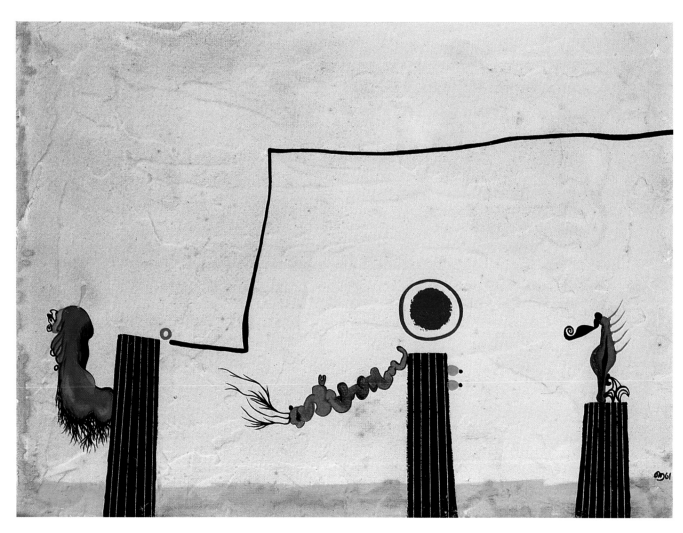

White Landscape
1961
Oil and plaster on board
13 × 14 in.

Moment of Judgment
1961
Oil and plaster on board
24 × 12 in.

The New Challenge
1961
Oil and plaster on board
24 × 15 in.

The Ruling Power
1961
Oil and plaster on board
24 × 12 in.

87

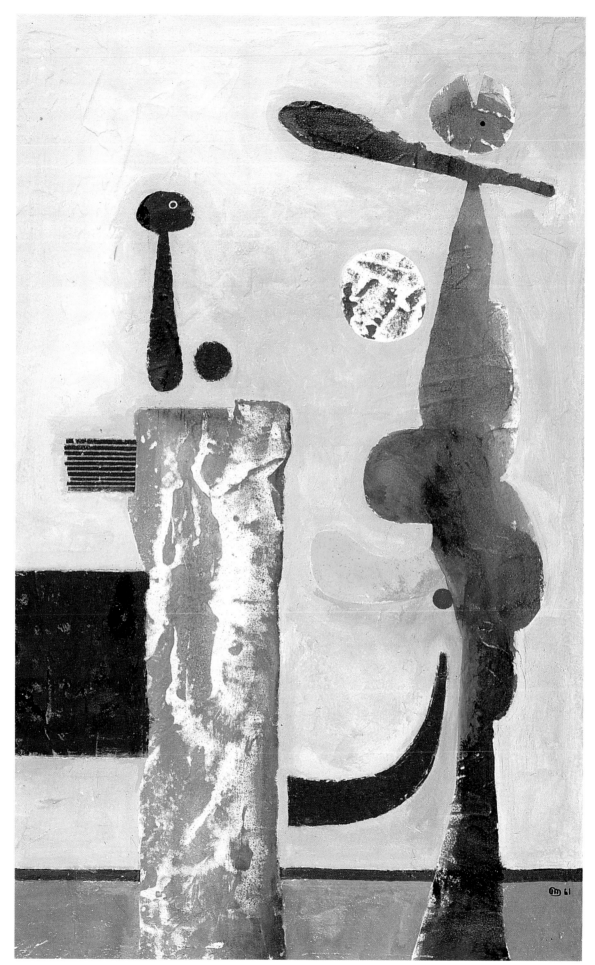

Lovejoy and Killjoy
1961
Oil and plaster on board
24 × 15 in.

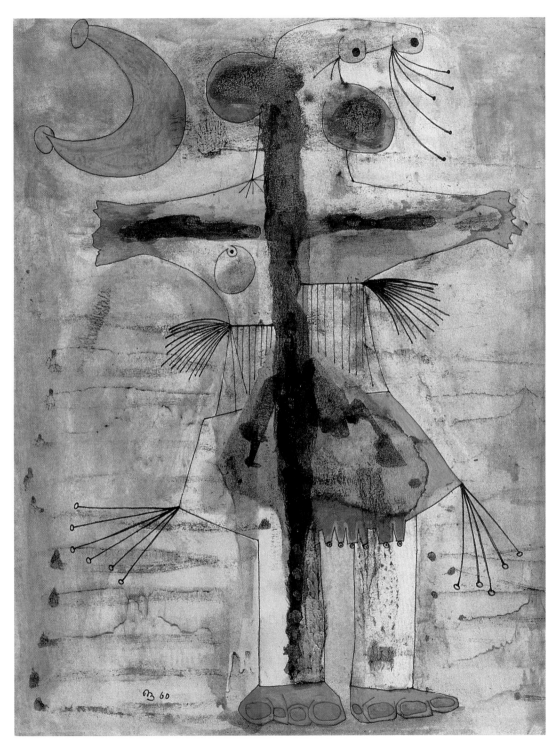

The Expansive
Invitation
1960
Coloured inks on paper
11 × 8 in.
The Currier Museum,
Manchester,
New Hampshire, U.S.A.

tiny ovules, symbolizes the gathering of gametes before fertilization. Similarly, *Cell-head V and VII* depict the chain of primary elements, the basic shapes of our vision of the world; the circles, triangles, rectangles, groups of parallel lines, crescents and right angles from which emerge more elaborate image forms. By the combination of pigment and oil, the background these primary signs stand out against is evocative of a wall surface, plastery and irregular, over-grown with lichen, a surface of cooled magma where the traces of an order to come are to

seem to strangely affirm their difference; and yet complementarity between them is achieved by the ball-shape, which is as round as a head, a breast, a testicle or a moon, unless it be a sun . . .

Since drawings often best reveal the new directions taken by an artist, we would do well to note here *The Expansive Invitation*, made in 1960, where the non-coincidence between colours and outlines suggests the general detachment of elementary forms and their displacement beyond the place assigned to them by the morphology of bodies: in short, a dislocation and flattening out that are invitations to see beyond the edges.

The asceticism of the early Sixties reaches its culmination in the series of twenty-eight *Cell-heads* and four *Egg Heads* painted compulsively over a two-year period. *It was as if I had changed the lens of my microscope*, says Desmond Morris, *and was concentrating on the heads of my biomorphs to the exclusion of everything else.* We would like to comment that, rather than a microscope, the instrument in question would seem to be a telescope, since in these paintings the infinitely small becomes infinitely large and the space between the cells and egg heads becomes outer space. Naturally, each of these paintings calls for a specific commentary, but suffice to say here that, on the whole we are made aware of an internal tension, which is equivalent to the stasis that precedes the moment of meiotic reduction. The first painting of this series, with its long phallic rectangle whose base is surrounded by

Detail from *Figures in Water*
1960
Ink
10 × 14 in.

appear. In the following *Cell-head* paintings (*XVII* to *XXVIII*) geometrical forms give place to tangles of confused lines in some ways reminiscent of those drawn by Congo or by two-year-old children. But here the lines are more like nervures and veins that attempt to disseminate the too strict guidelines of the earlier paintings in this series. Tension spreads throughout the cell and announces the ebullition of its elements, as in *Cell-head XVII, XXIV, XXV or XXVIII*. In *XXV* the cell is even attacked from

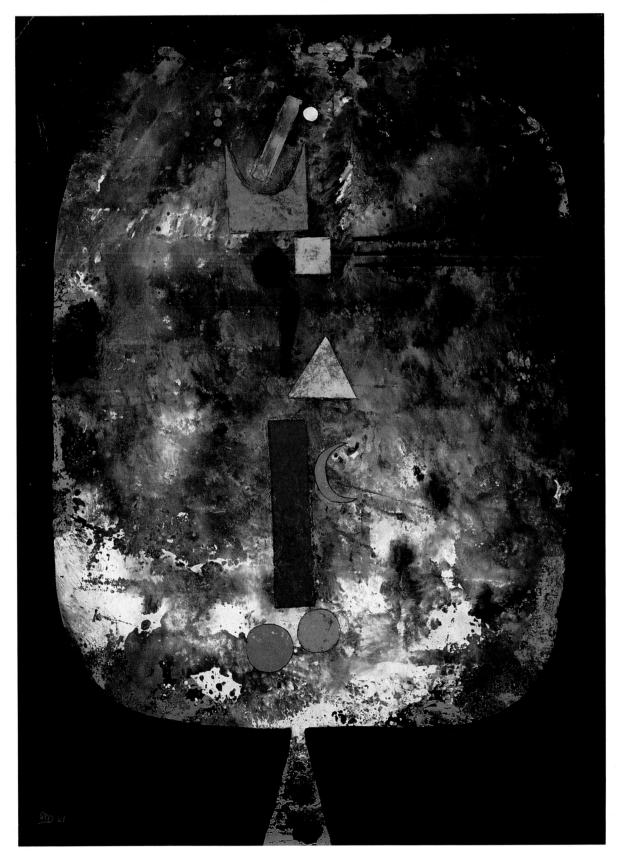

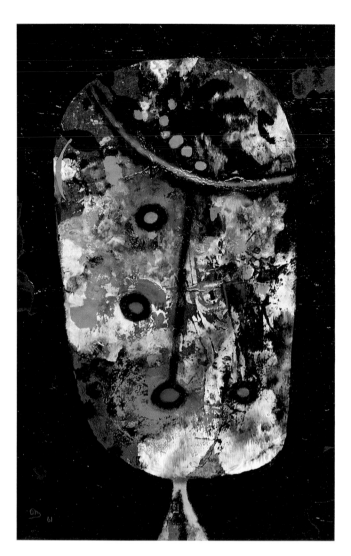

Cell-head XVII
1961
Oil on paper
16 × 10 in.

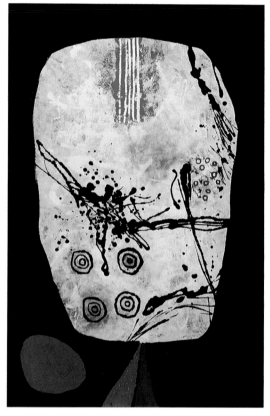

Cell-head XIX
1961
Oil on board
36 × 24 in.

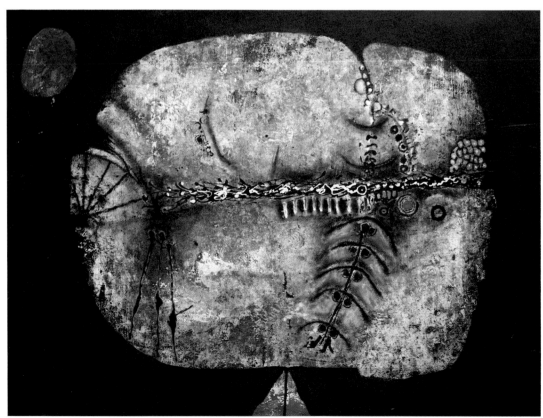

Cell-head XXIV
1961
Oil on board
28 × 38 in.

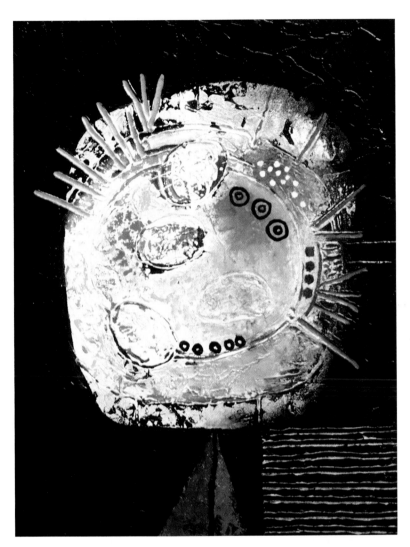

Cell-head XXV
1962
Oil on canvas
26 × 20 in.

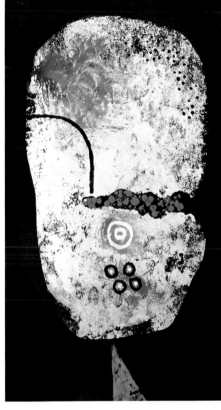

Cell-head XXVI
1962
Oil on board
27 × 15 in.

Cell-head XXVIII
1962
Oil on canvas
22 × 29 in.

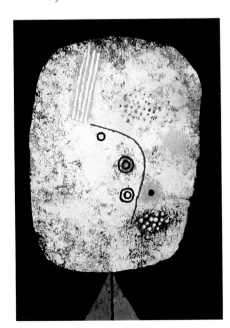

Cell-head XXVII
1962
Oil on card
28 × 20 in.

Hardhead
1962
Oil on board
36 × 24 in.

Parasite in the House
1965
Oil on board
36 × 24 in.

Egghead I
1961
Oil and plaster on board
18 × 24 in.
Eric Franck Gallery,
Geneva

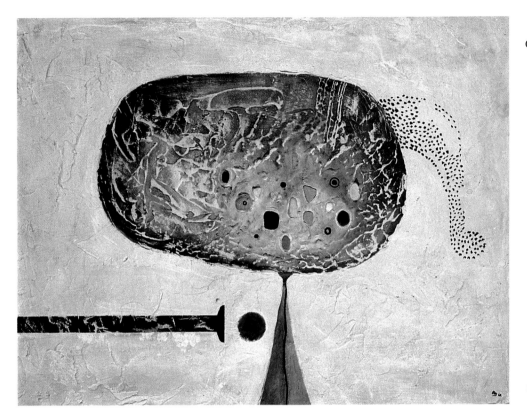

Egghead II
1962
Oil and plaster on board
20 × 25 in.

Egghead IV
1962
Oil and plaster on board
18 × 24 in.

Egghead III
1962
Oil and plaster on board
18 × 24 in.

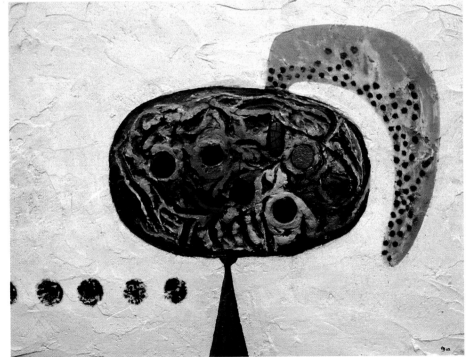

the outside. This aggressiveness is avowed in *Hard Head* where one of the edges of the cell is gouged in four places, and becomes even clearer still in a later painting which brings a retrospective explanation of the series. The painting in question is *Parasite in the House* where two "cell heads" are stuck together in a monstrous intercourse. The striations and circles have become recognizable facial features.

With the "egg-head" series, the follow-on stage comes about by the simple, organic logic of evolution. The black background of the "cell-heads" – the barely disturbed opaque night of the amniotic fluids – turns to a white field against which stands out an ovoid shape, the basis of constituted cells. The movement, emphasized in heads III and IV by signs which are exterior to them but identical to those they

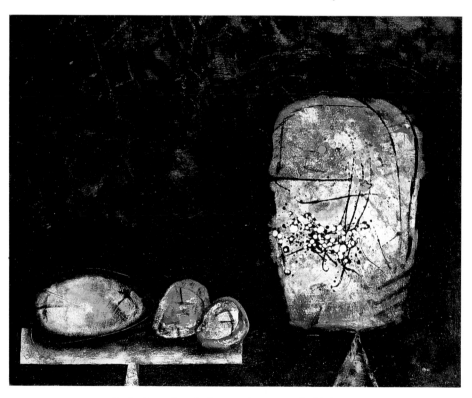

The Offering
1962
Oil on card
26 × 32 in.

contain, is that of ovulation, at the term of which the excluded female gametes will continue to circulate before disappearing. While the "cell-heads" present themselves as being massive, set astride a coloured triangle and occupying the entire canvas, the "egg-heads" appear to be more fragile as they sit on the tip of a black peduncle, as if they were about to break off and float away into the whiteness that surrounds them, to liberate their cells, as the heads in paintings II and IV seem to be on the verge of

doing. A premonition of this evolution from one type of head to another can be read in *Splitting Head*, which is a good example of pictorial mitosis, and in *The Offering* where mitosis is seen from the sacrificial angle, with the victims of ovulation lying on the table. In both cases vision is duplicated, attracted by what is still happening *in* the cells and by what can go on *between* them.

Indeed, what is it that underlies this exploration of the real world of imaginary cells if not an obsession with their origin? This explains why a series of paintings was done in parallel to them, in which the painter attempted *to express* – in the strict etymological sense of the word – all their reproductive energy. Ovulation is indeed the reverse side, or at least the possible explanation of all these heads, cells or eggs. The titles of most of the works done between 1961 and 1966 are clear enough: *Force of Fusion, Fertilization (I, II & III), Growing Point, Ovulation, Point of Contact, Genius Embryo*, as are others that we shall also be looking at. In the first four paintings, in the constant presence of a black sun, a ball surrounded by a halo of nuclear light, what we are witnessing is an ejaculatory explosion amidst expectant cells (this is represented in a more 'abstract' manner by a painting like *Bold Moment* where the tension towards fusion is even stronger). *Ovulation* represents the following stage, in which two black bars cross to indicate the end of the operation. If we superimpose this painting over *The Addiction of Privacy* we find that the same tracing is used again metaphorically, conferring on the process of ovulation an homuncular *figure* where the cell is a head, the two eggs breasts or testicles, and the ejaculatory spurt the long neck. *The Day of the Zygote* is the final result; it retains the nuclear bomb halo but already there are long peduncles equipped with round "heads", on one side of which appear prehensile lashes.

This was foreshadowed in an important painting done in 1962, *Children of Fortune*, that differs from other works from the same year, in which shapes in play at different levels evoke not only child-like representations of animals or human figures, but also the images of fusion, ovulation and mitosis of other paintings. The same holds true, in a calmer mode, for *Simple Pleasures*, where the most elementary strokes, circles and cellular forms in suspension in the painting herald the encounter between the feminine and masculine principles. Regarding this, it is interesting to compare the painting in question with *The Morphology of Envy* where

Splitting Head
1962
Oil on canvas
19 × 14 in.

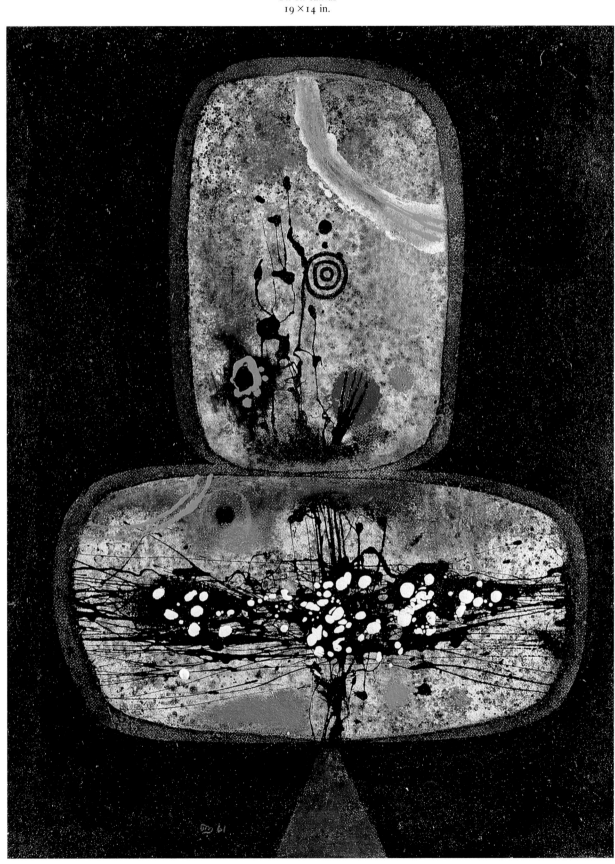

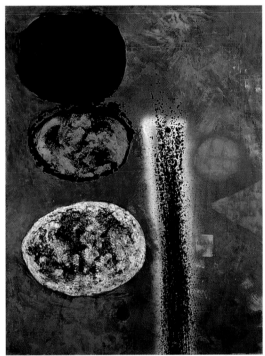

Fertilization I
1961
Oil on board
41 × 35 in.

Force of Fusion
1961
Oil on canvas
16 × 12 in.

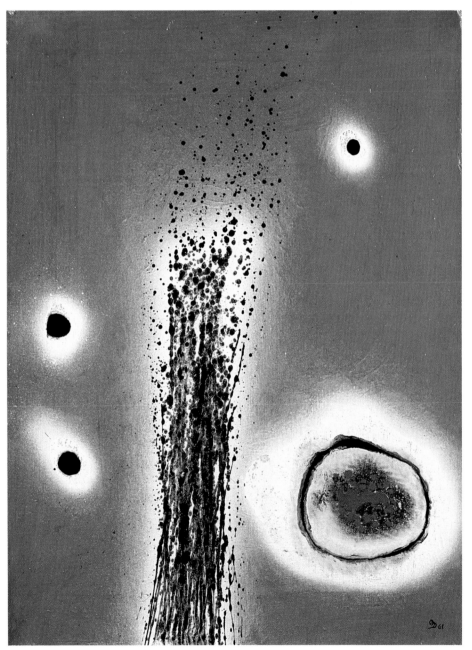

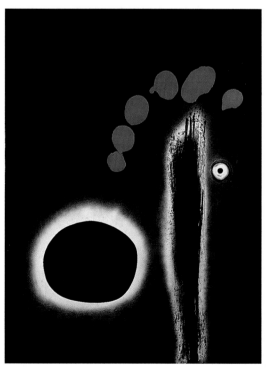

Fertilization II
1961
Oil on board
39 × 30 in.

Fertilization III
1962
Oil on canvas
16 × 12 in.

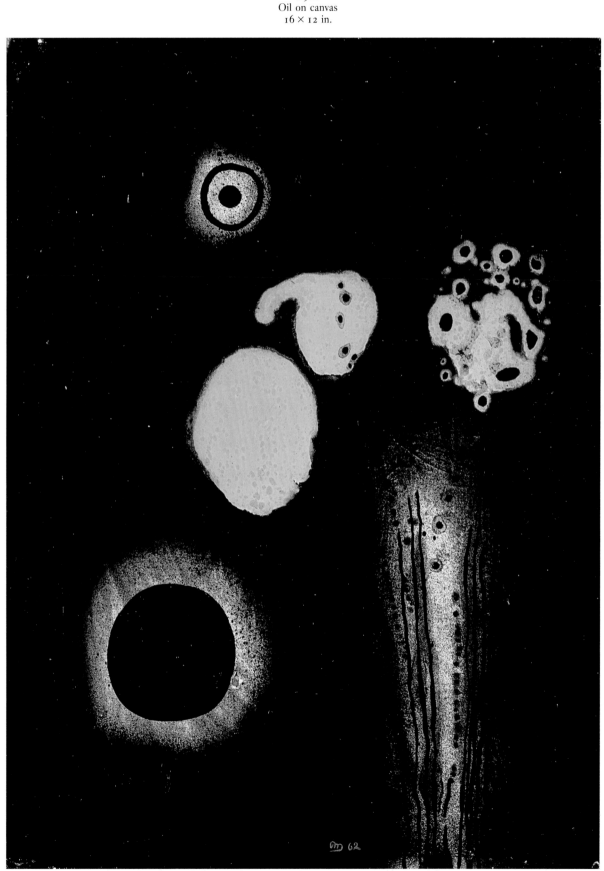

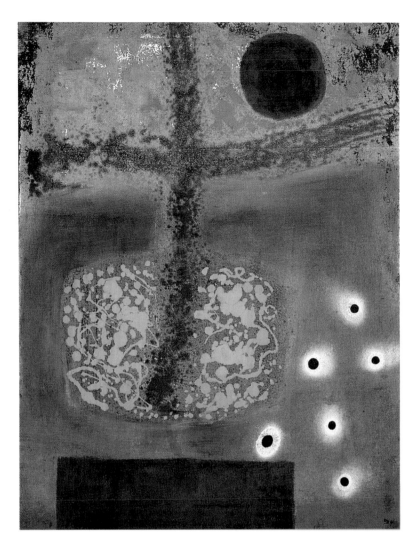

Ovulation
1961
Oil on canvas
29 × 22 in.

Bold Moment
1964
Oil on board
25 × 23 in.

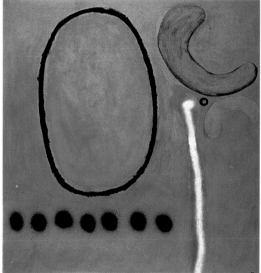

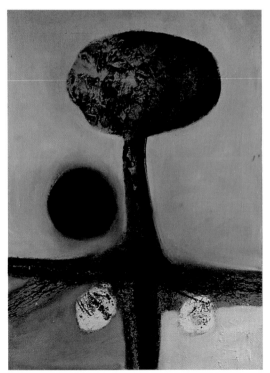

*The Addiction of
Privacy*
1961
Oil on canvas
30 × 20 in.

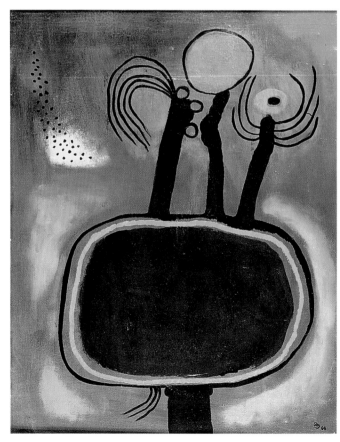

The Day of the Zygote
1966
Oil on board
20 × 16 in.

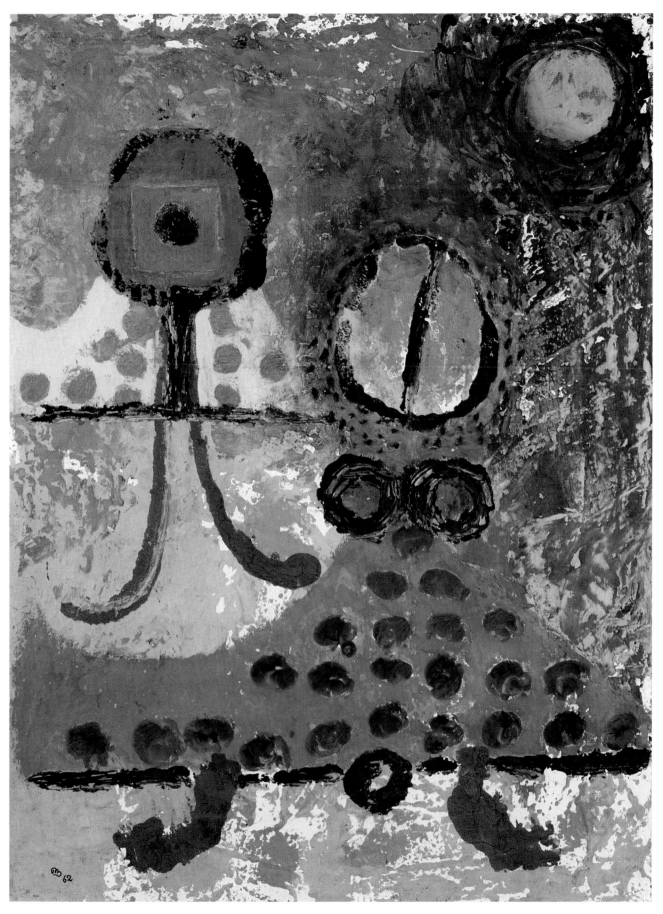

Children of Fortune
1962
Oil on canvas
15 × 11 in.

Simple Pleasures
1962
Oil on board
32 × 43 in.

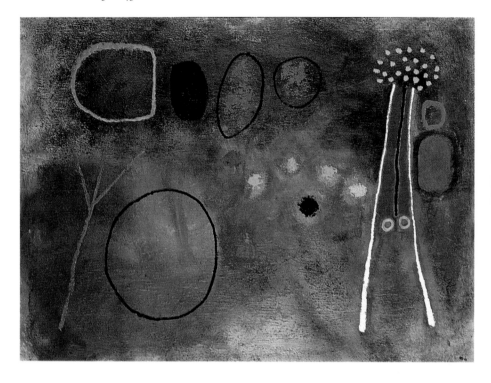

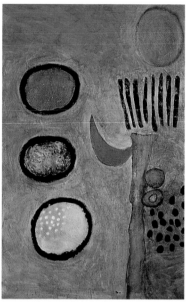

The Morphology of
Envy
1965
Oil on board
36 × 24 in.

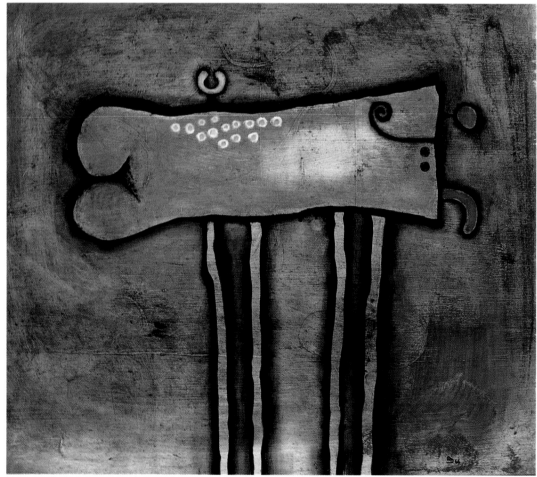

Lonely Quadruped
1966
Oil on board
17 × 20 in.

the bold outlines give the encounter a more aggressive aspect, while the suspension of the reproductive act creates heightened tension.

All of these paintings form a series which is concerned with the desire to procreate, to open the body, to lay bare the organs and recombine them in order to proclaim their participation in the act of creation. As if it were not enough to have described creation by trying to ally it as closely as possible with gametes, eggs and zygotes, but that it were now necessary to interpret its role, as we say in the theatre, and reinscribe it amidst this tumult. This is what the following paintings set out to do, dividing themselves into 'scenes' and 'portraits' which all depict meetings and fusions of organs.

Lonely Quadruped, painted in 1966, gives us a first key in the unravelling of this process, a little in the manner of a totem figure. Just as it is held that the giraffe has a long neck because of the circumstances of its natural environment, the quadruped in question has seen its legs grow longer and its body stretch into a sort of feminine trunk recumbent on one side. The animal is caught at a given stage of its evolution, the prominent appurtenances being the traces of past or future organs. The literal statement of the title forces us to consider as being a likeness what is in fact like nothing on earth: isn't this the sole representative of a species? The principle underlying this approach is even more plainly stated in *Days of Quantity* where the shapes hanging like bats turn out to be animal appendices, trunks, teats or testicles, as if the artist were inviting us to witness the generation of the generating organs themselves.

As we can see, from 1965 or 1966 onwards, Desmond Morris's painting is that of a Darwinism applied inside the body, a Darwinism turned inside out. This is especially plain in the paintings of "signals", an emblematic illustration of which is *Growing Signals*. Here we have the hermaphroditic vision of uterine organs laid bare and supported by two enormous testicles, between which a blood red area is speckled with black cells, either ovules or spermatozoids. The word *growing* in the title directly refers to the process at work in these forms. And it is this same process that a series of large formats done between 1966 and 1969 attempts to represent. The first is *Coupling Strategies* (1966) which is structured in dualities of forms and colours. The latter establish a close relationship with the burnt sienna of the earth background; certain white shapes stand out radically against it, while others – in brown or ochre tones – seem to drift

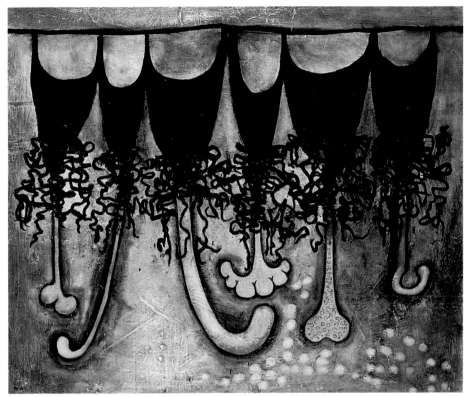

Days of Quantity
1966
Oil on board
25 × 30 in.

away from it. The painting is thus articulated around a process of differentiation, an idea reinforced by the division of the surface into two parts, and further accentuated by the vertical planes placed on a prop: the echoing white shapes, the open uterine cavities, and the contacts and rubbing together of soft organic elements. It is a summary-painting in which Morris is concerned with exploring the infinite possibilities of combining traces. *A Lapse of Heart* (1968) takes up again the same structure in almost mimetic fashion, but renders it more complex. Firstly, the dark tones are neutralized as if the space here were more interior, twilit or rather suffused with pre-dawn light, and this renders the movements between the diverse elements more subtle and the balance more 'tense'. Fertilization is figured by the pouring of small seeds into one of the uterine receptacles, which is joined to a sort of organic mechanism presented on either side of the exchange point in differing but complementary forms. This erotic arrangement is at the origin of the 'lapse of heart', the setting into movement of the genetic machinery having demanded too much energy. Painted the same year, *Nuptial Display* deals with precisely the same relationship between man and woman, with unmasked humour and all the appropriate ostentation. The evocation of the sexual organs is schematic, they are hypertrophied but only to better emphasize the origin of the life-giving forces of generation, which is also figured

103

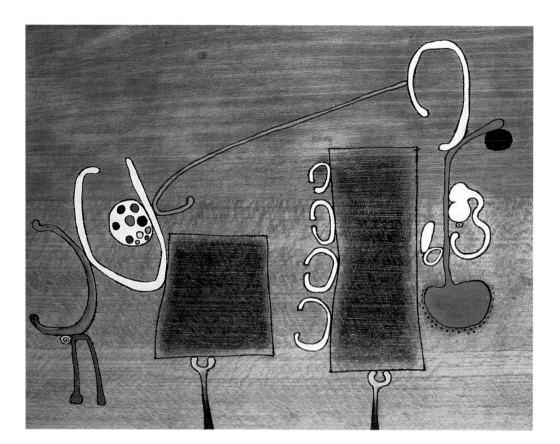

Coupling Strategies
1966
Oil on panel
10 × 14 in.

A Lapse of Heart
1968
Oil on board
45 × 60 in.

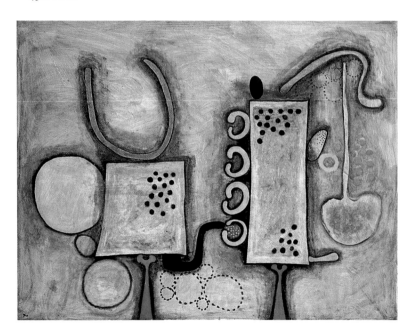

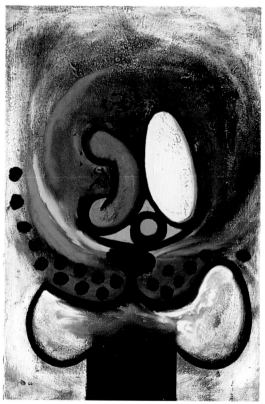

Growing Signals
1966
Oil on canvas
21 × 14 in.

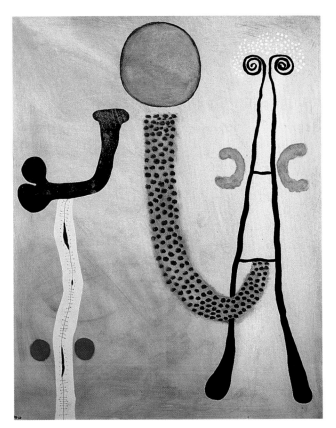

Nuptial Display
1968
Oil on board
29 × 23 in.

Festival
1969
Oil on board
45 × 60 in.

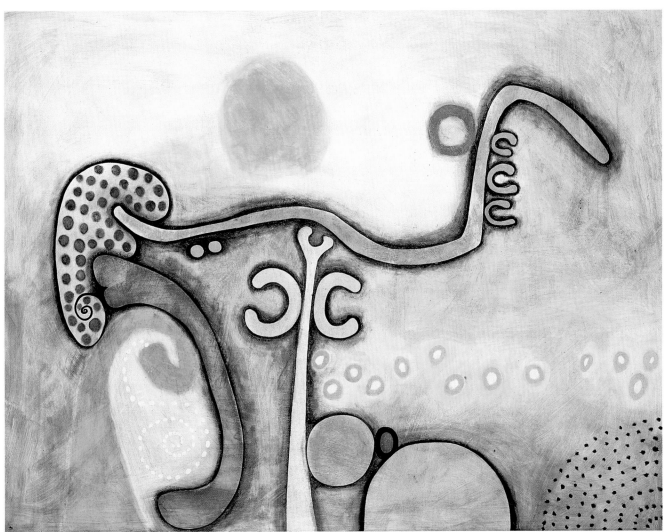

by the halo of light around the woman, who is the source of the ovule borne up by the unbroken flow of black gametes. The halo, the uterine crescents and the spermatozoid shapes are also apparent in *Festival* (1969) which sums up in its enthusiastic confusion the movement in Desmond Morris's organic world at that time. The general tonality is bright: egg-yolk yellow and blood red dominate and the organs stand side by side as if in a grouping of energies. From the circle of black dots at the bottom right to the scintillating gametes and the 'sun' which dominates the whole composition, all the forms are drawn by their colours into a sensual celebration. Morris is taking us into those visceral depths where *it all happens*.

Desmond Morris's metaphorical approach is patent. In all these paintings, the organs and

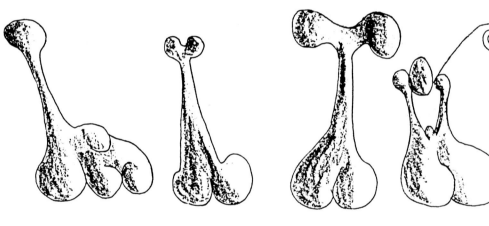

Detail from *Ten Biomorphs* 1966 Ink and pencil 8 × 13 in.

their functions are evoked in an absolute purity and simplicity. They are icon-like signs, the pure signs of organs, not their image in the representational sense of the word but their infra-image, the image-principle beyond which the organs cannot be further reduced. The effect of this reduction is not 'to water them down' or simplify them, but to point up their essential vitality and intensity. This is why the forms of these infra-images are depicted in the vital forms of other organs; in effect, it is no longer a matter of repeating given forms in a sort of reality, but to reinscribe them in whatever they have of the primordial. What then is the little crescent that repeatedly sticks itself on here and there? A shrivelled spermatozoid, a kidney capsule, a detached trunk, a uterine cavity? None of these things and all of them at the same time. And elsewhere something else again, because what is revealed in this figure is the *dual* and the tension it contains. In these two horns stretching towards one another to join the past –

the nostalgic image of unity but also its future, hoped-for image – we find the primordial symbol of generation around which, if we look carefully, the movement of organs is centred. Further proof of this movement is to be found in *Nuptial Display* where it is striking to remark how the two red crescents attract the two small red balls; they might easily curl up and settle themselves there, so that the original unity will be restored in this libidinal leap for a time. We even come almost within sight of this mythical and mythopoetical unity in *Intimate Decision* where the interweaving and overlapping of forms that clearly evoke sex organs, buttocks and breasts are crossed over, dominated and intimately tied together by the bright red crescent-filament, a thread of blood which joins together the two partners, one of whom is supported by a pedestal stool, the other by what looks like an iron bedpost. A moment of intensity where the flesh is turned inside out, exposing the organs in fusion.

This search for the primitive unified figure, which haunts the collective unconscious of genetics, reveals itself in all its multiplicity in the 'portraits' done between 1966 and 1969. *Organic Statue* erects a lunar shape atop a mass of interwoven organs amongst which we 'recognize' the female body lying on one side first seen in *Lonely Quadruped*, a male organ and testicles, an egg and bony shapes. The entire composition suggests a celebration of sorts, a monument of organs detached from their functions, hence the static nature of the scene which contrasts with the others we have seen. Quite the contrary is *Guard Figure* which takes up in humorous fashion the theme of the ovule spurt in two ways: in the image of the members rising up as if to brandish weapons, and in that of the luminous hair, both of which are perfect examples of a reinscription whose playfulness is in phase with libidinal intensity. This is in part emphasized by the two halves of the body, represented as strict likenesses: the eyes and, to the right, along the body-line, a pair of round forms: breasts, buttocks or testicles. Whatever the case may be, for the traditional mind they are favoured erotic zones – hence the irony of the title. More 'sublimated' we might say, *Daydream Zone* shows the same receptacle-forms in full light; opening to the right, under the impulsion of a push from behind, they liberate the different-sized cells they are filled with. We are in an intermediary zone between fantasy and reality, between the *slipped* image of the organs and their real form;

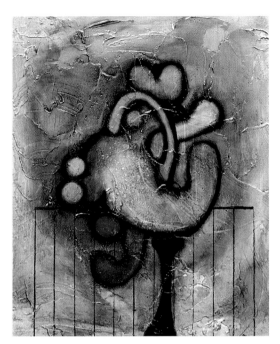

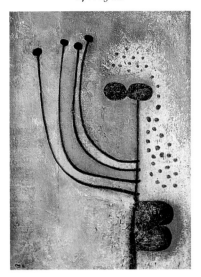

Intimate Decision
1966
Oil and plaster on canvas
18 × 15 in.
Private Collection,
Belgium

Guard Figure
1966
Oil on wood
17 × 13 in.

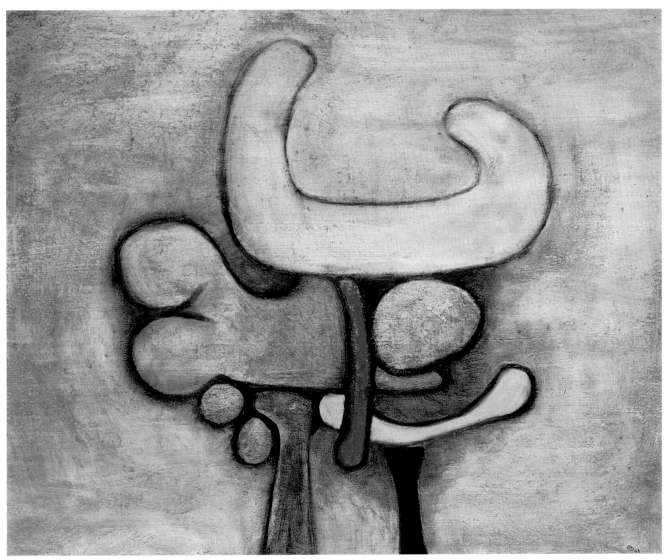

Organic Statue
1966
Oil on card
17 × 21 in.

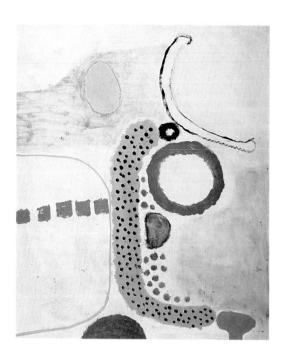

Daydream Zone
1969
Oil on board
33 × 27 in.

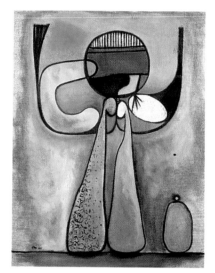

*Figure of Some
Importance*
1966
Oil on canvas
32 × 25 in.

Extrovert
1966
Oil on canvas
36 × 48 in.

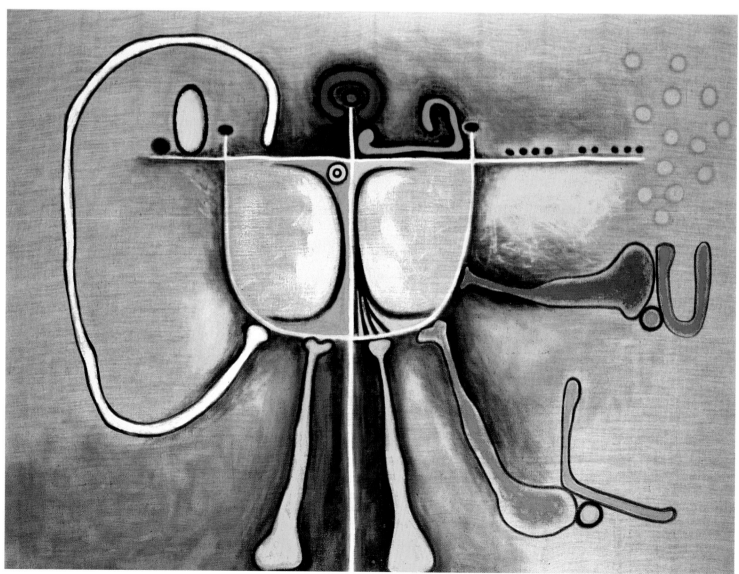

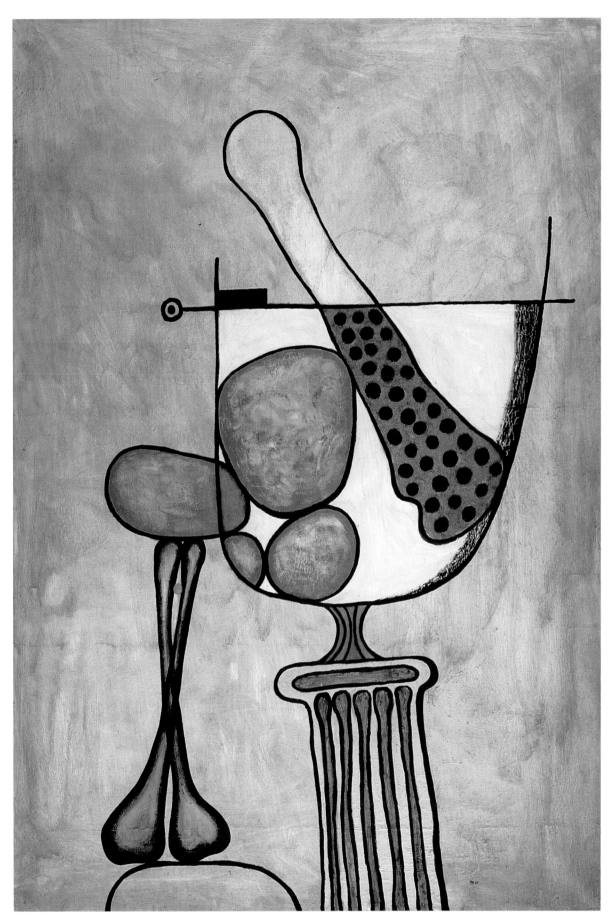

Ambiguous Offering
1965
Oil on canvas
54 × 37 in.

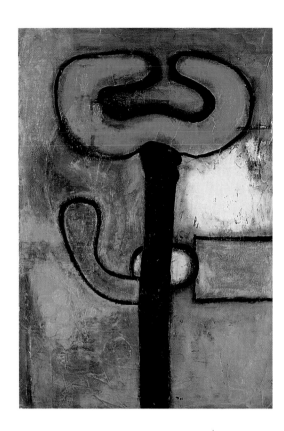

Proud Figure
1966
Oil on canvas
24 × 17 in.

indeed the painting's title sums up the space-time dimension of virtually all the works from this period. Between the image and the mirage . . .

Two paintings from 1966, *Figure of Some Importance* and *Extrovert*, show ovoid shapes contained in glass-shaped receptacles whose base, in the first-named work, looks like a monstrously-stretched scrotum, and in the second, like a peduncle. The forms in *Extrovert* present themselves in centrifugal fashion, star-spangled around the central uterine receptacle, and among them we find spurts of ovules, luminous balls and crescents that are over-sized, spindly or compact. The same statement is presented, although more dryly, in two works from the preceding year, 1965, *Ambiguous Offering* and *The Mysterious Gift*, in which the exchange between interior and exterior is conveyed by ovoid shapes and images of bones, and the more specific distribution of colour. In all four works the vase shape plays an almost alchemical role as the crucible of procreation.

The universal, symbolic value of recurring forms is expressed again in *Proud Figure* and *Strong Figure* (1966) where it is the head which is now represented as a blue crescent. In the first-named painting, the figure is placed atop a black column amidst which appears a mauve half-crescent, an erect and proud sex organ, meta-phorically inseparable from a yellow egg nudged by a red rectangle. The background is luminous, as in the second-named painting where the crescent is turned upside down, its two tips pointing downwards like a mouth stretched towards the erect sex organ or like shoulders

protecting the two breasts (which correspond to the two eyes placed on the crescent, the shapes being interchangeable). In these two parallel works, Morris clearly experiments with colours and their signalling value – pale pink breasts, egg-yolk yellow – in correspondences of forms around the crescent which we expect will sooner or later absorb them. Something similar to an ingestion of this sort is visible in *The Adviser* (1968) which (masculine or feminine?) is the veritable guardian figure of this period. At the top of a black triangular body and two small red breasts explodes the marbled whiteness (thick paint is applied on this area alone) of the crescent-mouth-face-uterus covered by another more diaphanous pale green crescent from which droop two soft forms – elongated testicles in some ways reminiscent of those in *Figure of Some Importance* – which liberate luminous ovules. Above right, the same recurrent sun, but, more conspicuous, the outrageously thick-lipped mouth that contains four small variegated balls, seem to originate a circular movement of rejection and resumption, excretion and ingestion snaking up from the bottom right to the top left to 'fall' into the gaping uterine cavity and begin again. The whole is in perfect balance and crystallizes in the same space genetic and erotic operations which are not concomitant but are nonetheless *primary*, hermaphroditic, a-temporal and a-chronological, this hieratic, ovule-juggling figure does well to dispense advice since it *originates* creation. Furthermore, the tips of the mouth-horns, if we consider this as being a face, represent eyes that

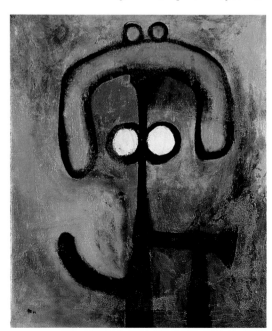

Strong Figure
1966
Oil on canvas
25 × 21 in.

The Adviser
1968
Oil on board
32 × 27 in.
Collection Dr and Mrs
Michel Remy,
Nice

The Antagonist
1968
Oil on board
32 × 27 in.

Breeding Figure
1966
Ink
10 × 14 in.

structurally refer to the two red breasts, and these in turn refer to the ovules, thus creating another movement, through space and time, which surges up from the black volcano, the alchemists' *terra nigra*, the original and erupting mother earth.

This extremely complex painting (in keeping with the four or five different types of paint that Morris used on it, something unique in his production) should be considered alongside the picture entitled *The Antagonist*. The creature in question is a mass that is both gastropod and cephalopod, to which the black hatchings give a relief. The mass bristles with horns and long soft shapes and stands on two tibia between which droops the mockery of a sex organ; it seems to be fighting against itself in a never-ending and contradictory gestation. One might almost take this to be a painting by Archimboldo, though one where none of the composites can be identified.

Identify indeed! Nothing in these paintings can be surely and definitely identified. Careful inspection reveals that we are close to scientifically identifiable organs, but not quite close enough: these organs are systematically refused even an identity. They can only be postulated under the discursive insistence of our desire to explain logically as of the fragmentary forms or deformed reminiscences that we see. That is to say we are forced back from a process of differentiation towards known organs, in the hope that our deductions will hold up, which is the exact contrary of Morris's process of differentiation whereby he attempts to move back towards the primordial unknown. The different ovules, eggs and ovoids in all these works symbolize this double process of creation, the one tending towards an end, in the viewer's mind, the other towards a beginning, in Morris's own canvas, or rather before it is actually completed. We are constantly set before a gaping hole, dumb-struck and hesitating between memory and hope, at the centre of a green orbit just as in the following text which Morris wrote in the Sixties, an orbit lacking an eye to see:

The socket of green
close by the crowded limb,
calls to our moist palms
and dares our knotted tongue
to recall the day the clock stopped
with deep regrets that all our pains
are folded down
and stuck fast to the memory

of neglected eggs,
lying snug in the nest
of our longing.

At this stage in our analysis, a poetic text such as this appears to be a parallel commentary on many of the paintings we have seen; the text's itinerary is in fact perfectly summed up in two drawings, one from 1960, the other from 1966, juxtaposed here to show that Morris's writing is indeed submerged in the timelessness of desire, between the past and the future, nostalgia and expectancy. The text tends towards a vision that would unleash language and give the power of grasping back to hands, towards a birth that would take us out of our comfort. Ultimately, it is the all-seeing eye of the cells, the gametes, the little circles, the figures of breasts or testicles, the horned tips of the crescents, or the sun figures that hold this power to hatch "neglected eggs" and allow the origin to be born. Like the image that haunts the paintings of the Sixties, our eye has no alternative but to be oviparous.

By the end of the Sixties it was plain that the concept of differentiation – applied to cell evolution and the relationships between organs – was dominant. Desmond Morris had attempted to track it down and come to grips with it by modifying the shapes of the reproductive organs, and in this very changing he had come upon similar forms, equivalent in the system of functional signalization they evoked. The formats of his paintings had grown considerably, averaging 32×24 in. with some as big as 45×60 in., almost as if the desire to approach these smallest and most intimate organs called for an enlargement of the microscope's lens. Here again is the paradox of the abyss and its temptation: the irrepressible urge to plunge into the depths of the organic and seize the active principle. The larger the paintings, the more the attempt seems doomed to failure, with the origin ever remaining out of reach. The egg always arrives *afterwards*, too late.

A decorated poem from 1970 multiplies these points of origin by overlaying them with a dislocation of meaning. The space of the work is shared between a text whose meaning delves into the animal, vegetable and mineral realms, and a drawing which unfolds like a serpent looking for its eggs. The theme is extremely 'human':

> Love is a lizard
> handy with a fly,
> hot on a flat stomach stone,
> quick of glance
> and slow in winter,
> skin bright, feather-tongued,
> clinging like lichen,
> vanishing
> like
> a
> mirrored
> smile . . .

Indeed, everything seems to tend towards an ultimate mirror, even if it is a distorting mirror, as all mirrors are. Perhaps the egg of origin lies then between image and mirage . . .

Needless to say, the great change brought about in Desmond Morris's life by the publishing of *The Naked Ape* had a considerable effect on his way of painting and on its motifs. During the five or six years of his stay on Malta – apart from his writing works to follow on from *The Naked Ape* – the rhythm of his creation was in no way disrupted by social or professional engagements.

Meta-morphic rituals 1969–1980

The Mediterranean sun, the peaceful life in harmony with natural rather than man-made rhythms, the calm that comes with voluntary exile, everything that gives added intensity to the white light of the exterior and the black light of the interior, encouraged the painter to penetrate into new and obscure realms. It was almost as if he was engaged in regulating and reorienting the lights of his mind. External tranquillity enabled Morris to return into himself, to quieten the internal tumult of the immediately preceding years; affording a moment of introspection that must have considerably increased his desire to explore the spaces of origin. Doubtless it was by pure coincidence and objective chance then that one day, in 1969, he came upon a painting entitled *The Mistress*, that he had done in 1947 during his first "biomorphic phase", which he decided to repaint. The result was the enchanting *The Teacher's Doubt*. This return to grass roots was doubly the beginning of a new creative phase, an offset repetition, a repetition of the provocation of origins launched during the preceding years but elsewhere. This is how he relates this "meeting up again" whose 'spirit' seems significant here in understanding the guidelines of his paintings during the Seventies, if we are to avoid any hasty judgement as to the apparent identity of these paintings.

I carefully re-worked the early scene. It was as if, after many experiments and excursions, I wished now to return to my first love – to my simply presented biomorphs in their smoothly featureless dream-world. And return I did, from that day to this. There were still a few injections of the large-scale, loosely painted lyrical works inspired by the sweet life of the Mediterranean and its seductive light, but gradually the original, meticulous, biomorphic style reasserted itself until, by 1972, it had regained total domination. From that date until 1986 there has been no further experiment in styles, merely a progressive unfolding of scene after scene of the personal world into which I plunged myself with Entry to a Landscape *at the beginning of 1947. Despite the idyllic conditions on Malta and the hot sun beating down outside, it was this introspective world that now obsessed me once more in my studio.*

Destroying the work from 1947, repainting it, and in doing so opening it to new spaces, indicates perfectly the movements of drift and differentiation at work in Desmond Morris. What returns is not the same, but the same

Desmond Morris
watching his pet deer (see
opposite page) in his
London garden, 1967

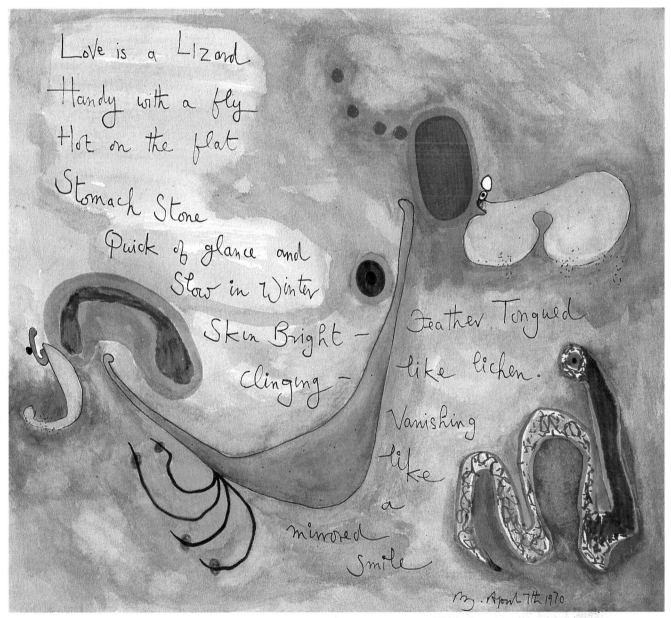

Love is a Lizard
Decorated poem, 1970

which has become another, if we may express the dialectic in these terms. In fact, the new images are requisite: they are determined by the older ones in which they existed either fully or partially. The one speaks with the other, poses questions and gives answers because they are part of the same drift; new images are implied by older ones, just as in turn they imply the older ones, and this perpetual return can only function in a differential movement tending towards a point that remains inaccessible. From here on there are no radical changes in Morris's work, only an acceleration – facilitated by material circumstances – of his search for *identity*.

Three paintings from 1969 *The Teacher's Doubt, The Ritual* and *The Explorer has Arrived*, all present a similar structure, one which Morris

interrogation is turned against the person who should know, but who in fact doubts and will never know: the teacher, who has become an organic inkwell stuck on a pedestal, and before whom flits gaily a small round spermatozoid shape . . . The same interrogation is carried over to the "natives" when the explorer of the third painting arrives; their amazement mirrors the bewilderment of the explorer, who, like the teacher, stands back from what he or she does not understand. All angles and hollows, this explorer has burst into a fluid and full world of kangaroos and dinosaurs undergoing deformation. The magic circle of *The Ritual* seems, however, to present a different situation altogether: one where there is a willingness to integrate masculine and feminine sex organs, kidney, appendix

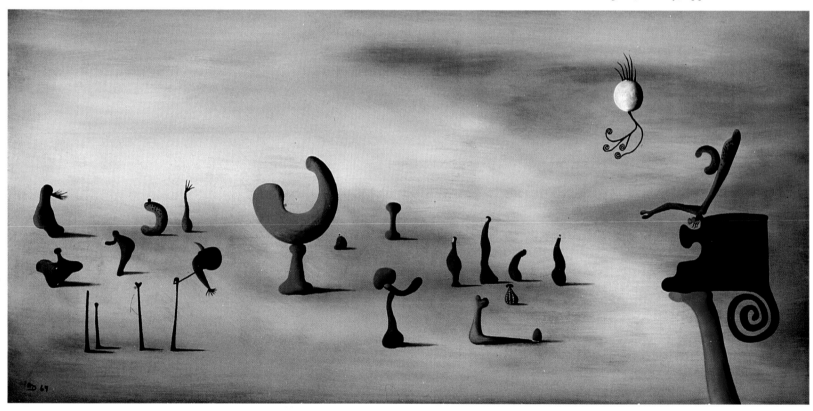

The Teacher's Doubt
1969
Oil on canvas
12 × 26 in.

often makes use of: a gathering in a loose circle of miscellaneous forms participating more or less in the same event. In the first of these works, a circle of "pupils" surrounds a globe so misshapen that it has become one of those uterine crescents that so often haunt Morris's works from the Sixties. As the central object and focal point for the spectators, this feminine horn – the earth become a matrix, the earth-mother reduced to the extreme of its function – has apparently inspired the 'doubt' of the title. The

and uterine shapes in a celebration of organic proliferation beyond the walls of the body, an idea echoed in the symbolism of the 'fortified city' standing away to the right.

These three paintings set the key for the Seventies, but we should remember that Morris also painted *Birthday Emotions, Daydream Zone* and *Festival* which we have seen elsewhere, during the same period, and that the following year, 1970, he produced works like *Greenery Pastimes* and *The Entertainer*, in which reappear

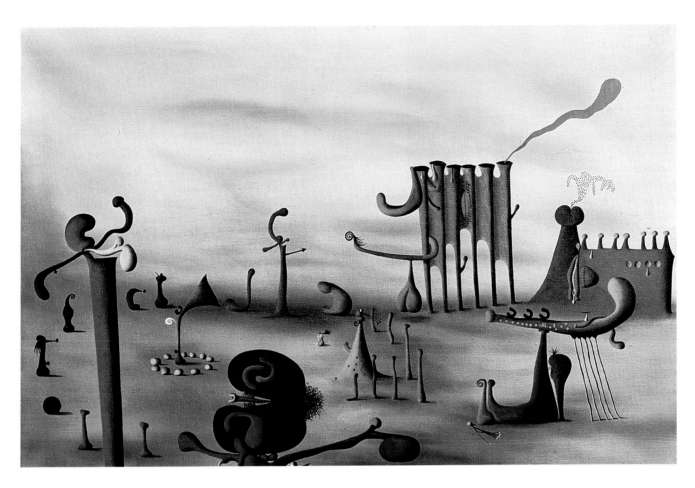

The Ritual
1969
Oil on canvas
24 × 36 in.
Private collection,
London

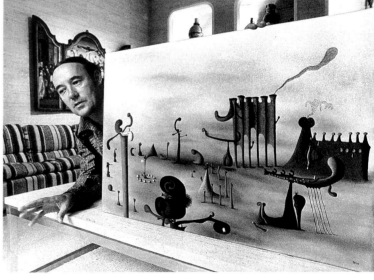

Desmond Morris
with *The Ritual* in the
drawing-room of his
Oxford house in the early
1970s

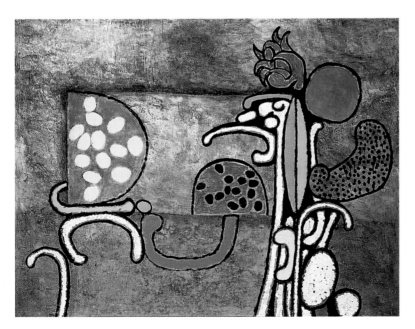

Greenery Pastimes
1970
Oil on board
45 × 59 in.

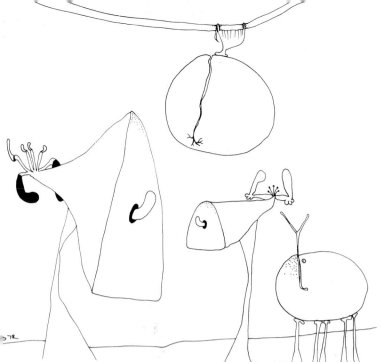

diversely-oriented uterine horns, sexual organs, eggs, beans and small cells, whose difference in shape or size creates a movement of visual unfolding. In the two last-named works free forms are arranged around a central rectangle, as if in mockery of a unified and strict body. The humour and playfulness of both paintings are also present in biomorphic works that are contemporary or come after.

From 1972 onwards these two tendencies – the biomorphic and the infra-organic – come together in a dialectic whose synthesis it would be vain to look for, since the interpretation of the two sources (or reservoirs?) of inspiration is continually in play and questioning itself. Indeed, the plastic experiments of that year are carried out along two parallel lines, according to two opposite movements, the one by extension and expansion, the other by withdrawal and concentration. This can be seen clearly in a drawing done in 1972 where "animal" forms, which are henceforth to proliferate as biomorphs, are represented in the process of detaching themselves to live their own lives. A round shape hanging over them seems to be cracking, like an egg hatching or a cell dividing . . . Structurally, these movements correspond either to open space paintings, to group scenes, or to 'characters' or 'portraits'. This is what is summed up in two paintings done the same year *The Parade of Memories* and *The Protégé*. In the former of these works, we see elongated forms – legs, sexual organs, ears – towering over the static presence of a series of creatures standing in a row as if on parade, as the title indicates, and soft white forms surging up from a vulva-like hole in the ground. Small eggs with black appendices (a representation of fertilization?) are spread over the ground. There is an almost clumsy saturation of the canvas (something we often encounter during this period) and it is clear that we have left behind both the minimal forms and arche-typal scenes of the Fifties, and the tense balance

of the Sixties. Perhaps we might read into this profusion an avowal of the refusal of mastery, which is that of the explorer (or scientist) in the course of his exploration.

On the other hand, the circular structure of *The Protégé* begins a contrary movement. The "head" to which the well-known crescent shapes give a contour by joining end to end contains several other primordial forms that we have already seen elsewhere. The idea of protection introduced by the title refers apparently to a primitive regression, which we shall speak of later, and is emphasized by the interiorization of forms present 'on the outside' in other paintings of the same period. It is also quite conceivable that both these movements should link up in the interior of the same painting, as is the case in *The Moment of Partial Truth* where four forms which are the result of diverse accretions and growths (one still seems to be undergoing vivisection, unless it is drawing the bleeding form beside it to itself) seem intent on passing on the truth of their monstrous formation, while around them 'sit' other simpler, vassal forms, their witnesses. The emblematic element of the painting is of course the parturition-like process in the centre.

The fact that rites and ceremonies are the favoured subjects of this period can be explained quite simply: what is in question here is the resurrection and conjuring up of originating signs. *The Ceremony of the Hole* is interesting in this respect; a large figure made up of a tangle of sexual organs, seated on five forms which look as much like the stumps of legs as penises, seems to be watching a hole around which sit a dozen small creatures, all of them reminiscent of one or another of the large figure's organs. A sacrificial victim suspended over the hole is also part of this ceremony in propitiation to the earth's creative energy. A similar ritual centrality marks *The Guardian of the Cycle*, a complex title particularly when we remark that the central tree is hermaphroditic and that the cycle might be that of time, of woman, of the birth of the small white forms around the trunk, or of the moon present at the end of a branch. A companion painting *The Guardian of the Trap* depicts forms – especially male sexual organs – caught in a spider-web trap, and indeed these same forms seem to be lacking among the foreground figures. *The Kill* and *The Audience Discovers it is the Performance* share the same irony, an irony that all of these visceral forms – with their power of setting a distance between themselves, beyond

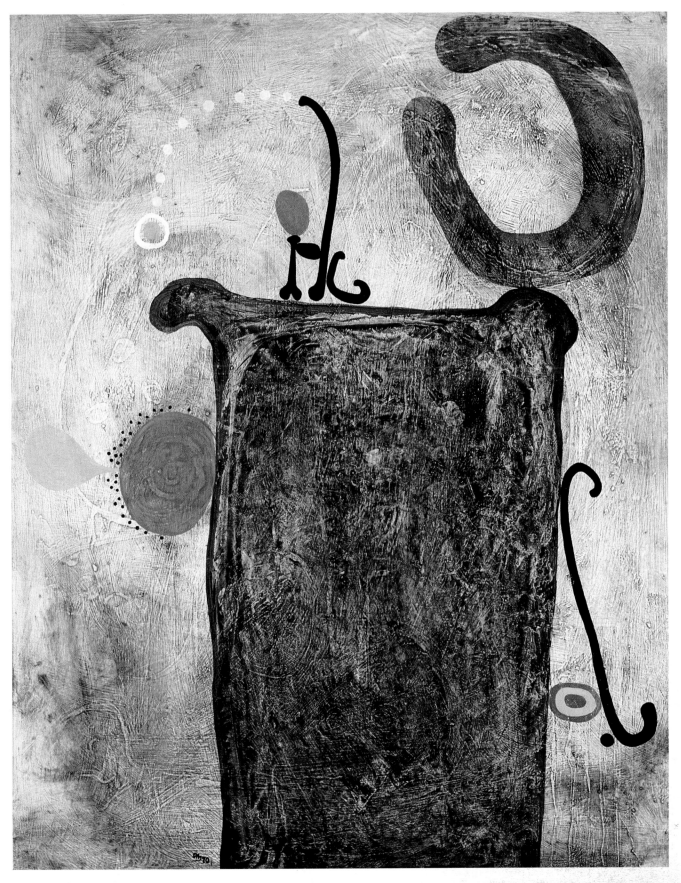

The Entertainer
1970
Oil on board
29 × 23 in.

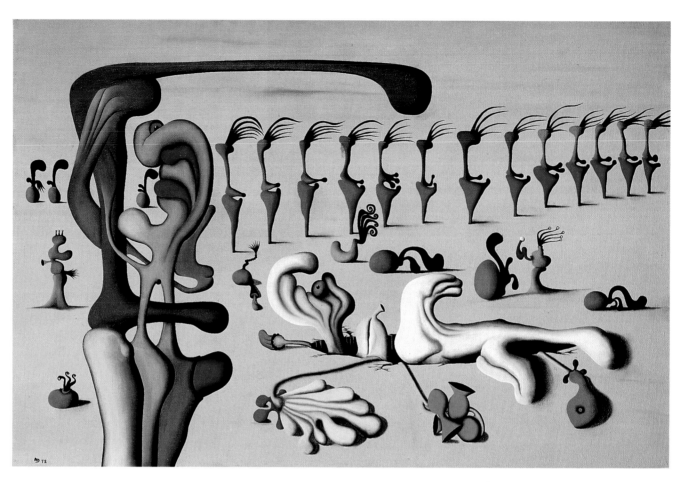

The Parade of
Memories
1972
Oil on canvas
20 × 30 in.

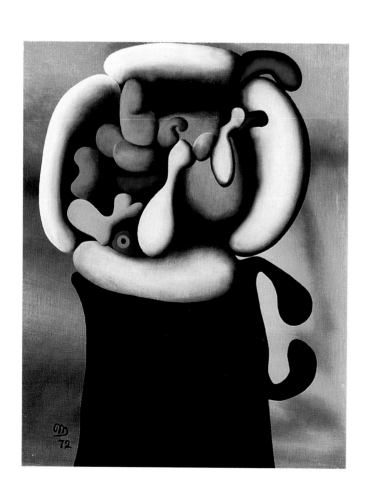

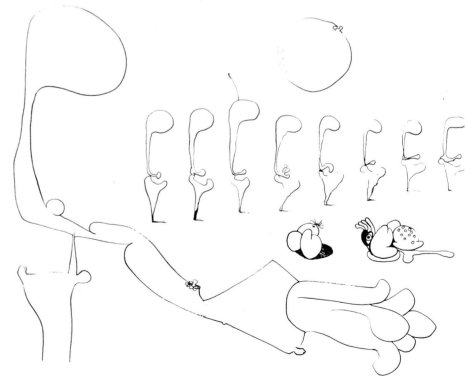

The Protégé
1972
Oil on board
10 × 8 in.

Parade
1972
Ink
9 × 10 in.

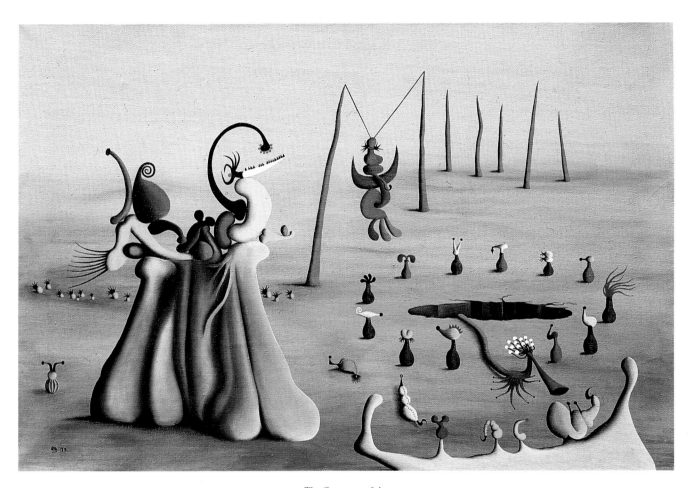

The Ceremony of the
Hole
1972
Oil on canvas
20 × 30 in.

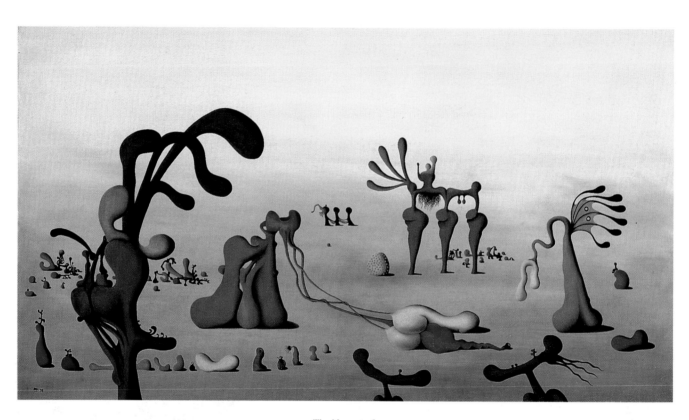

The Moment of
Partial
Truth
1973
Oil on canvas
20 × 36 in.

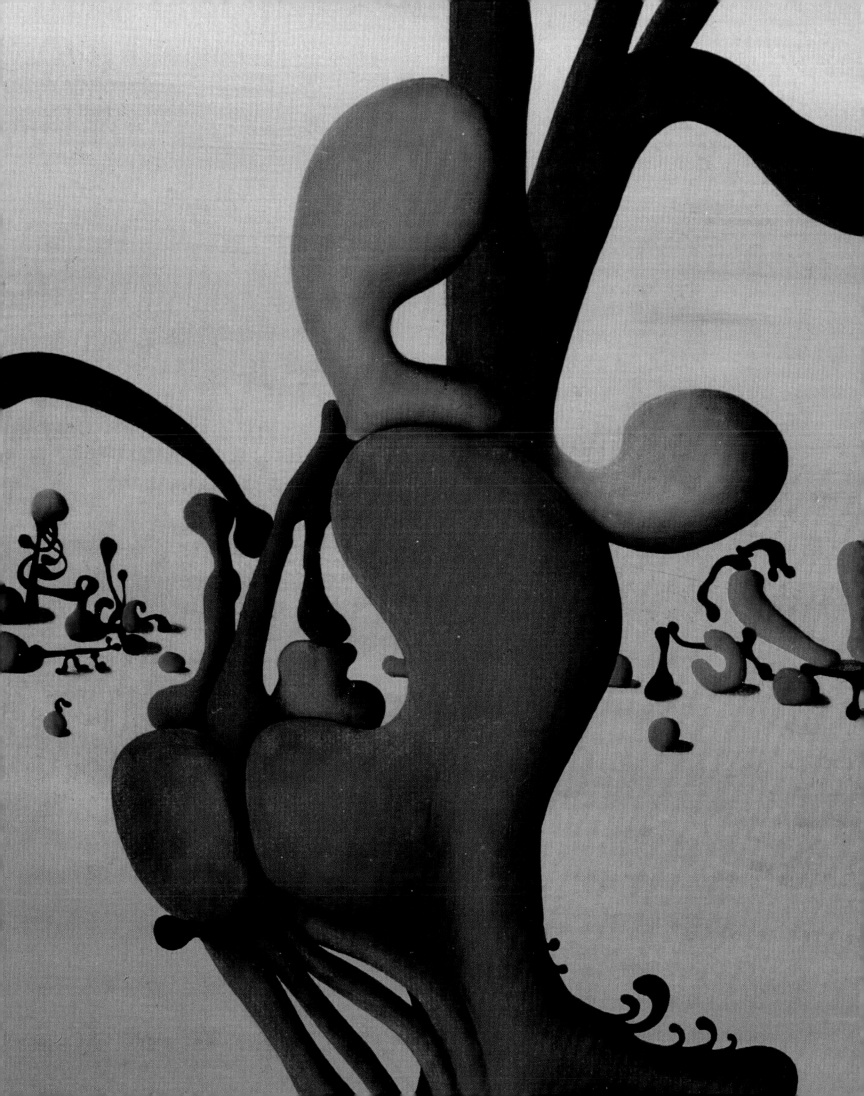

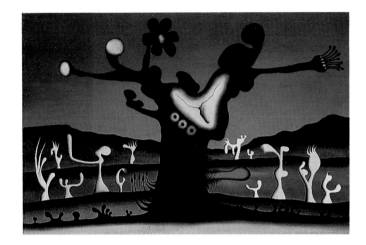

The Guardian of the Cycle
1972
Oil on canvas
12 × 18 in.

The Guardian of the Trap
1973
Oil on canvas
20 × 36 in.

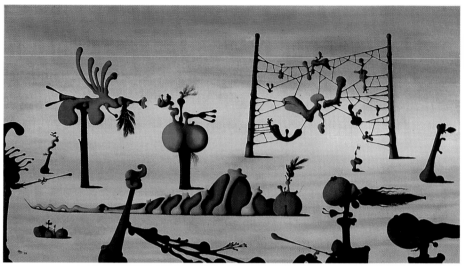

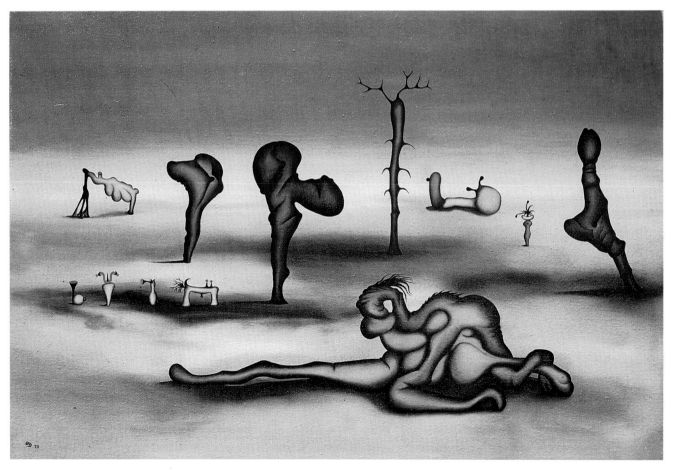

The Kil
1973
Oil on can
20 × 30 i
Collection Chr
Moran and C
London

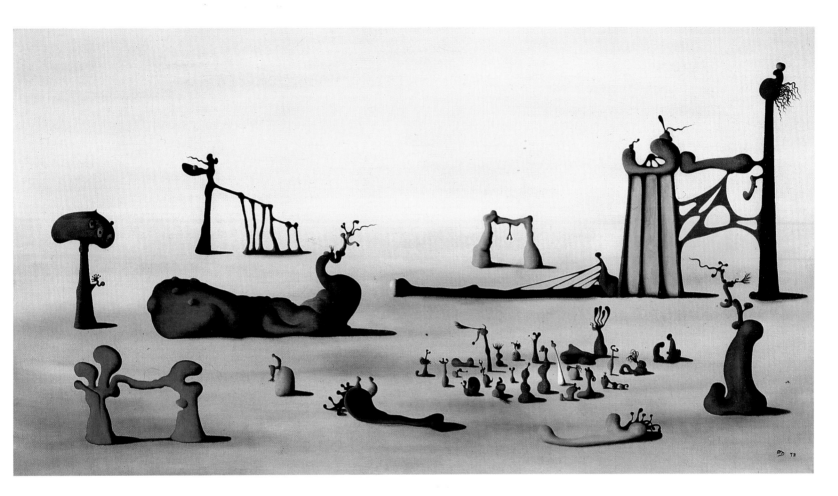

The Audience Discovers it is
the Performance
1973
Oil on canvas
20 × 36 in.
Private collection,
Oxfordshire

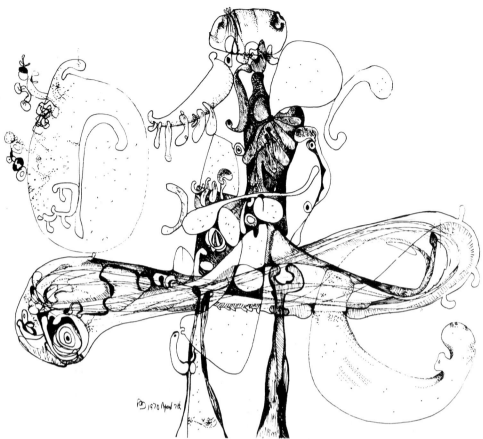

all identity or identification – seem to partake of. In the first-named painting, the forms laid out on the ground and apparently engaged in the action 'contain' in their contours those forms still standing around the phallic "chief"; in the second, an insoluble and infinite exchange is going on between the circle of small cells in the centre and the circle of larger forms surrounding it, suggesting that the viewers have become the viewed. This very process might well be that of all the paintings, where forms refer to each other, so pregnant are they with the impulse that created them.

All the works from the Seventies and some done later depict places where the forces of metaphorical device are at work. The drawing reproduced here gives a remarkable summary of them. The ellipse-like movement seems to translate a sort of calm panic that has taken hold of these organs gone mad, redistributed in a body that is now transparent and the scene of new festivities. This seems to amount to saying that what is important is not so much what might unify – as the explanatory discourse we are engaged in might seem to indicate – but what sets apart. Proof of this lies perhaps in the very fact that our explanations themselves never arrive at a stable and definitive meaning. The figures which follow one on another only seem to be repetitive because they do not form into a system – one that would satisfy the rational mind intent on grasping a totality. On the contrary, they differ incessantly, repeating the loss of

Figure in Conflict
1970
Ink
9 × 10 in.

meaning. These figures which surge up and avoid all representation are defigured figures. It is not their presentation that is important (deleting the prefix re-) but their pure, simple and immediate production.

These arrangements are all the more surprising in that they are founded on pre-existing structures – structures fixed in set arrangements – only the better to go beyond them. We have already spoken of paintings dealing with ceremonies and rites; we might add to these the panic that spreads among the extremely long and erect phallic forms in *Disturbance in the Colony* (1973) on the appearance of a white reptile form quite distinct from them; or *Stop Them If You Can!* (1973) where some foul play has obviously taken place this side of the diagonal which divides the painting from bottom right to top left, and beyond which the culprits are making good their escape. More static scenes such as *Totemic Decline* (1978), *The Neglected Rival* (1973), *The Arena* or even *Ancestors* (1976), where figures are arranged in a circle, depict an enclosure, a *palum*, a place of safekeeping closed in on itself (*Totemic Decline, Ancestors*), or a place where an attempt at mastéry is made *(The Arena)*. And yet to no avail. In effect, this traditional and mythical arrangement is short-circuited by forms that cannot be mastered: the 'characters' that compose the arrangement are in constant meta-morphosis, and in this sense are similar to the characters external to it. The result of this duplication of the arrangement is that the "outsider" which is in fact latent in each of the forms detaches the ritual from itself; the ritual is no longer a ritual of conservation, but of transformation. Hence the eruptive and dual character, in *The Arena*, of the red crescent, a feminine shape that terminates in a foreskin; hence the renunciation of the "rival", dark, aged and dessicated, in face of the clear and triumphal grey penis-bodies in the background; hence the attack undertaken by the "new forms" – all of them different – against the green creatures – all identical – gathered around the totem; hence, too, the open rivalry of *Contestants*, symbolic of the movement of replacement that runs through these scenes.

Thus we find ourselves facing a major problem: where is this generalized metamorphism of forms and structures leading? What is the meaning of this evolution that is more Darwinist than Darwin's theory itself? What the temporality and what the vehicle? With Darwin, evolution is considered in the chronological sense alone:

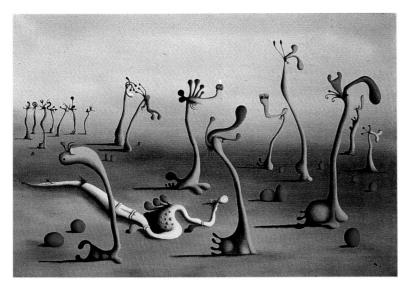

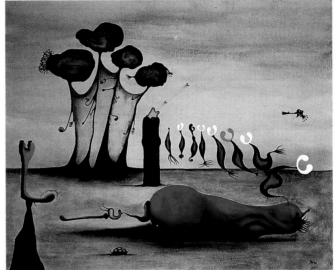

Disturbance in the Colony
1973
Oil on canvas
20 × 30 in.
Collection Mr Edward
Anixter, Chicago

Stop Them If You Can!
1973
Oil on canvas
24 × 30 in.

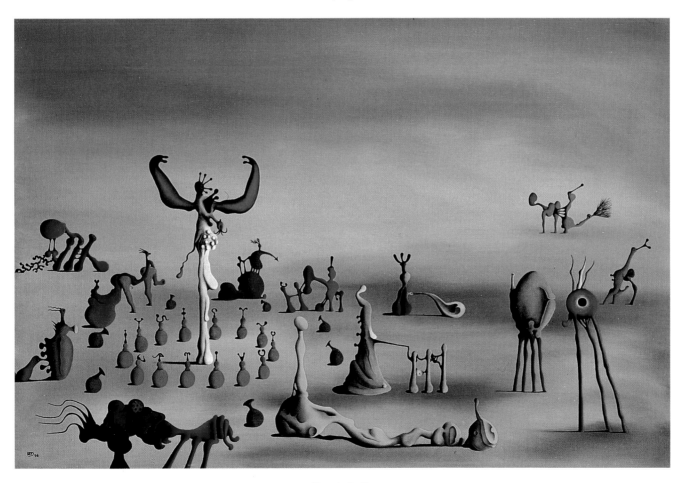

Totemic Decline
1976
Oil on canvas
24 × 36 in.

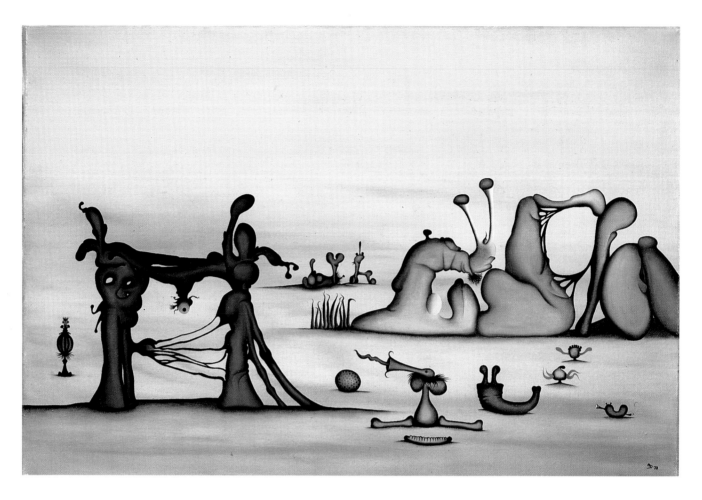

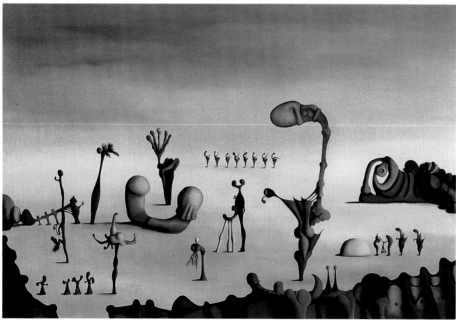

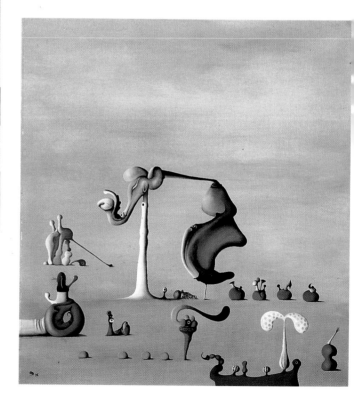

The Neglected Rival
1973
Oil on canvas
20 × 30 in.
Collection Equinox Ltd,
Oxford

The Arena
1976
Oil on canvas
24 × 36 in.

Ancestors
1976
Oil on panel
20 × 22 in.
Private Collection
London

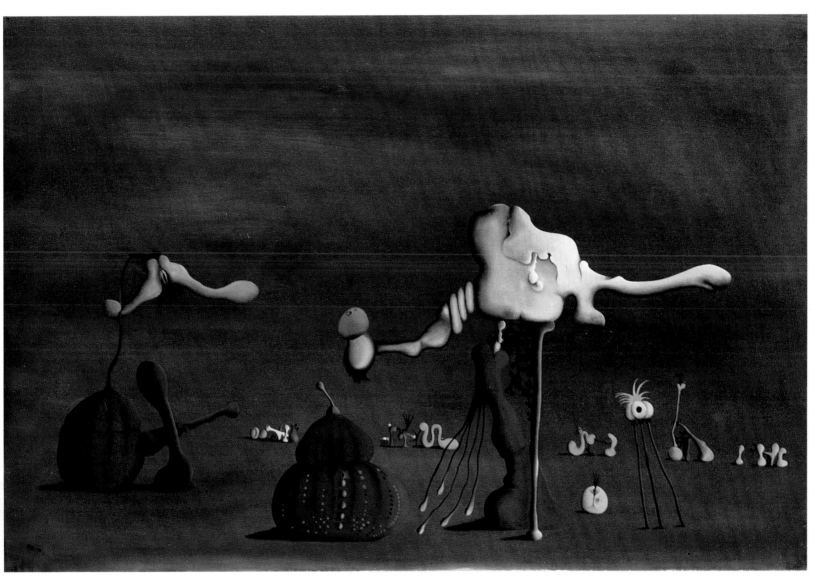

Contestants
1976
Oil on canvas
24 × 36 in.

Darwin moves along the time scale *towards us*. It would seem that things are less clear with Desmond Morris, where we cannot be sure we are moving up the time scale towards our age. The poem that bears the title of a painting we have just considered – *Stop Them If You Can!* – enables us to raise this question:

The end
stands at the corner of the field.
There is a follower whose rose's cobwebs
drip and spray the pollen of his tears,
until the undulating furrow
flows with arrows.
A flight of shafts moves
towards the orchard wall
and to the prone beginning.

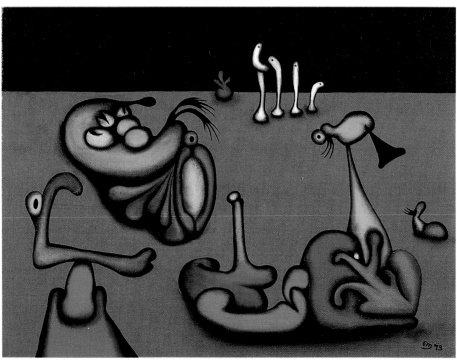

Whatever the re-reading of the painting this text invites us to engage in, the important thing is its upending of the acting and temporal sequences. The time of these paintings matches their space, it is blank.

Two paintings done a year apart are particularly interesting in this respect. In *The Unimportance of Yesterday*, where the floating archetypal forms, presented frontally in a row, are dealt a dis-respectful kick by a leg capped by a funnel, the time of the title seems to have been challenged – a time in which the forms are supposed to be inscribed. In like fashion, *The Day After Yesterday* refers us back to *our* present, in which the forms,

The Perennial Discovery
1973
Oil on canvas
12 × 16 in.

with their swollen buttocks and sexual organs, cannot be comprehended, reiterating thus the mocking and devious nature of the title. *The Perennial Discovery* is perhaps more precise, grouping as it does a mass of masculine "signals" and body-less organs – vulva, uterus, perineum – that float before the amazed eye; the original confrontation is retracted from time. This process is also that of *The Erosion of Longing* – or rather it preceded this scene in which the beings are transmuted into statues: pure, inorganic signs like those with which Klee peopled his paintings. There is a twilight void in this picture, an absence of life which, by contrast, enhances the dynamism at work in the other paintings. At any rate, here too, time is frozen in a timeless state.

And yet "the flight of shafts moves" – like Zeno of Elea's arrow – towards its target, and the titles of the following three paintings attest this inexhaustible movement by recalling it to our minds. Whether it be in the proliferation of tongues and tentacles that tear the surface and the rocks of the landscape in *The Fertility of Pain*, or in the series of blood-red tubes from which ventral, nasal and sexual forms emerge in *Polymorphic Growth*, or in the accumulation of interpenetrating uterine and visceral forms in *The Gravity of Power*, it is clear that Morris's pictures escape from any external determinism and – as is clearly implied in the titles – draw this faculty of metamorphosis from themselves. Nomads inside themselves, the "characters" – like space and temporality – retreat from any objective truth and are nothing more than *intensities* that we would like to see form into an evolutionary chain, logical and Darwinian. But in vain.

This intensity, this metamorphic impulse – which the bright and biting colours the painter uses play up so clearly – is condensed in two remarkable paintings. In *Sting Appeal*, Morris evokes a banal zoological situation which he turns inside out, emptying it of its logic and of its likely meaning to surrender it to pure intensity of a libidinal order. The wasp's sting shaft, with its appended testicles, is pointed towards a spermatozoid shape behind which a series of eruptions and explosions of small white needles, tongues, and ovoid and testicle shapes, is taking place. This painting condenses all the others by its explicitness, and the stage-setting of such a feverish conduction. *The Budding Force* is perhaps even more intense. Indeed, subsequent to a process of condensation, the feminine sex organ seen from the outside and the internal feminine

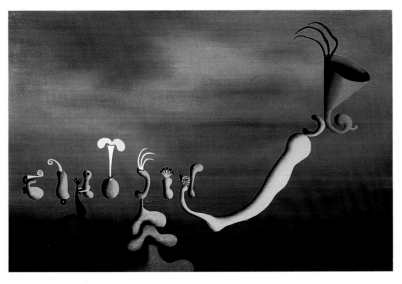

The Unimportance of
Yesterday
1972
Oil on canvas
12 × 18 in.

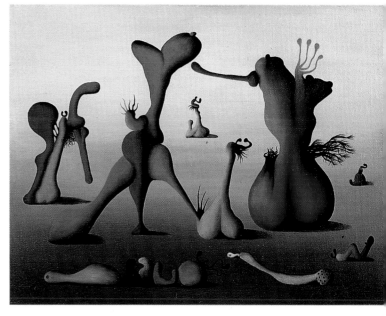

The Day After
Yesterday
1973
Oil on canvas
12 × 16 in.

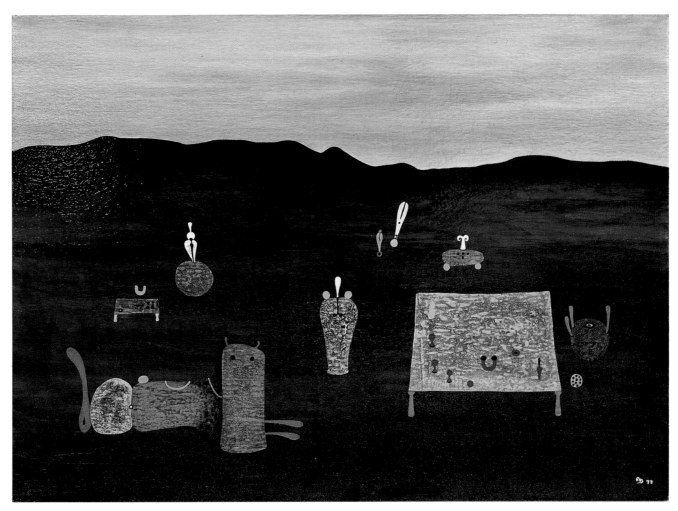

The Erosion of
Longing
1973
Oil on canvas
16 × 22 in.
Collection Mr Hans
Redmann, Berlin

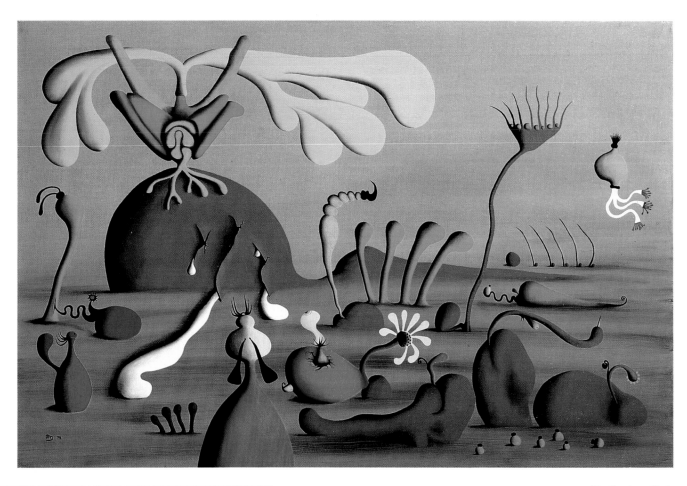

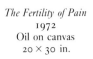

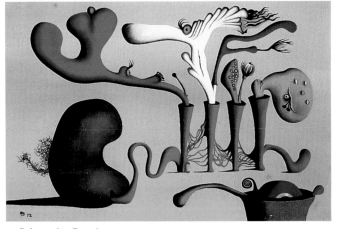

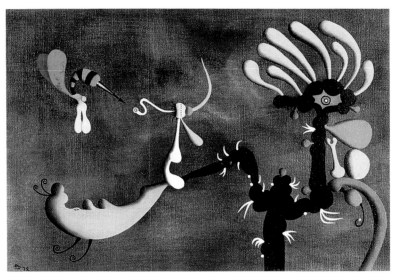

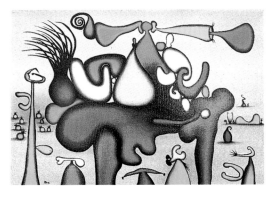

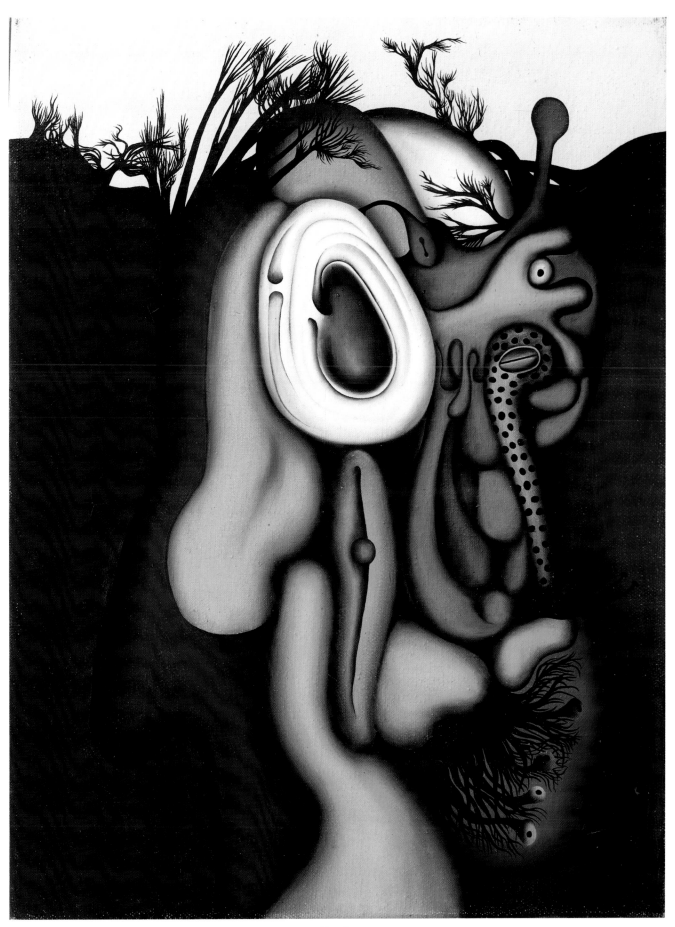

The Budding Force 1973
Oil on canvas
16 × 12 in.
Private Collection, Oxfordshire

organs seen in cutaway – the inside of themselves – are represented as subterranean geological forces. Like a lava flow they exert an immense pressure upwards, in an effort to irrupt – or erupt – on the surface of the earth, where vegetable life turns out to be fragments of hair growth. So much so that this buried body is in fact a body within a body, and that the strain of disembodiment at work is that of birth, and more precisely of the birth of the place of birth itself, duplicated here inside and outside. What the picture emphasizes then is the postponement *ad infinitum* of that which is born, since its place of origin – already dual in being both feminine and telluric – is itself duplicated. As we have already pointed out, there is no origin other than that which is reconstituted *a posteriori*, through its traces and forces.

This set of problems concerning transformation and differentiation is singularly concentrated in the "portraits", unique figures which Morris painted at the same time as the other works. The mating that takes place in *The Observers* under the mocking eye of the (original) serpent enables the bodies to slide out of themselves and facilitates the loss of organs, which dangle at the end of filaments. In fact, "they" observe nothing and it is we who are the voyeurs. Something similar takes place in *The Onlookers* where the simple constructions of red cells and black filaments set on statue bases are more looked at than looking. The same questioning appears again in another form in *The Three Members* which, of course, lack an entire body. While they are identical in their upper parts, the sexual

organs differ in their figuration and can only assert themselves in a *display* of their lack and surfeit, enhanced by the three gametes falling from the sky. Two paintings from 1972, which represent the ritual convocation of primordial forms, invite us to participate more fully in this game of identification. *The attentive Friend* mingles animal, insect and human elements; a penis terminates in a scorpion's tail, another in an arrow that has certain feminine characteristics, eggs and small spermatozoids, and any number of testicles below its open horn, stretched out like an arm. Similarly *The Visitor*, plunges us into perplexity: which one is the visitor around this table that is rising into the air? All the characters are possible visitors, and possible hosts too. This interchangeability of functions is a recurring trait in Morris's painting: it leads ultimately to the pure and simple eradication of function.

Yet, the "figure" designated in the title *Ascending Figure* exists by its function alone, one which is validated by the two spectators in the foreground. A comparison of the two parallel paintings from 1976 *Private Figure* and *Public Figure* will show that, apart from an undeniable closure of forms in the former work, and an opening in the latter (emphasized by the closure of the bust), both open inside themselves by the play of friction and the inter-relating (that they oblige us to engage in) between the traces of organs that make them up. This is a remarkable example of equivalence in and by difference. A remarkable example of irony, too, since the titles lead us to believe – and this is true of all of Morris's paintings – that the "figures" or scenes refer to the titles. Whereas Desmond Morris's painting proclaims the bankruptcy of everything that refers to a discourse or a system.

Thus organs are liberated from bodies and become body-less bodies, wandering in search of limbs and parts that might give them back their status as wholes. This is a strange reversal of the myth of Isis and Osiris, in which Osiris's sexual organ – which Isis lacks in order to reconstitute her brother's body in its entirety – sets out alone in search of the body to which it belongs . . . While these forms lose their solidity of attachment, they gain in fluidity. And it is not the least of the merits of Morris's work that it plunges us with each painting of this period into a libidinal stream where every organ is equivalent to another, a stream which crosses spaces that are innocently neutral, spaces of asepsis, to use Breton's image, conducive to exchanges, slidings, confusions and transfusions.

Ascending Figure
1976
Oil on canvas
24 × 36 in.

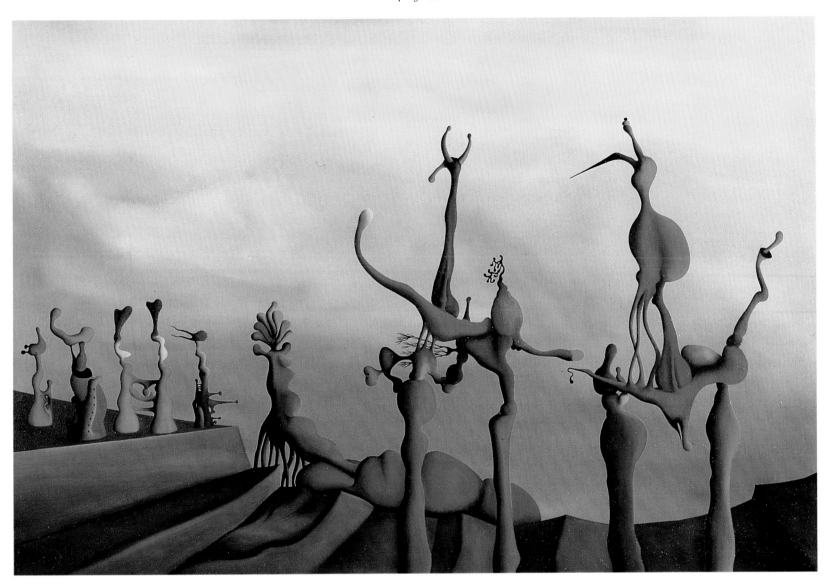

Sage
1975
Ink
8 × 8 in.

Closed Head
1977
Ink
4 × 3 in.

Quiet Figure
1977
Ink
6 × 4 in.

Troubled Landscape
1979
Ink
8 × 8 in.

There is something Dali-like in this obsession with the soft, or the swollen (which is virtually the same thing); and in the use of luminous colours that contrast with the night of time and the spaces where the diverse scenes of the paintings are played out. The preference for bright, smooth tonalities and primary tones has the effect of making these forms independent, much as in naive art where colours form a system which answers to their author alone, and certainly not to any external reality. Morris's colours are signs of intensity, signs of difference.

But there is more. These colours and this absence of rough texture remind us that we are still beneath the surface of the skin; so what is in question is not to attain to the depth of origin, since that is in vain, but to solicit the origin, to provoke it and make it rise up as it were, by making as many organs out of one skin. We follow it, we slide along the surface, we rub up against it in the secret hope that this hymen-skin will swell up and tear apart in a forbidden revelation of the secret. It is this same hope that is to be read in the passages repeated in one form or another, to the extent that the transformation becomes the primordial and obsessional subject of these paintings. This can be further verified in the drawings of this period which are in no way preparatory sketches for paintings but rather moments of freer exploration, more detached from the *work* that is to be done. The four drawings presented here, chosen over a

The Observers
1973
Oil on canvas
20 × 30 in.

period of three years, indicate in their simplest and most complex readings that what is at work is a cutting up of the body in order to liberate its evolutive power, autonomous and re-creative, from the interior, or perhaps we should say from the *intestine*. A drawing done in 1979, that we have added to the others, depicts this obstinate

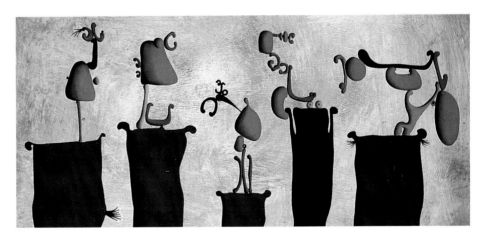

The Onlookers
1972
Oil on board
11 × 21 in.
Private Collection,
London

attempt to penetrate under the skin in the dot technique used to trace the internal organs, which evokes them while suggesting their hidden character. Morris does not paint a "scene" or a "portrait": his titles are appended after the painting is completed; instead he coils up *inside them* in an attempt to approach the secret of the transformation that takes place there. This is why these forms are all evocative of such and

The Three Members
1972
Oil on canvas
12 × 18 in.

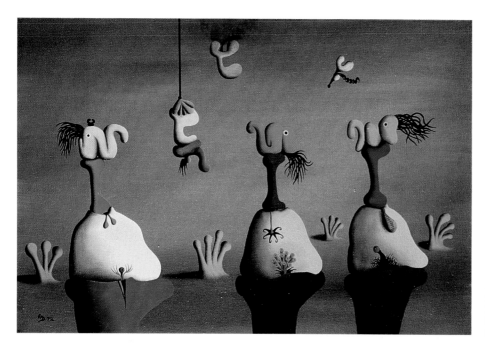

The attentive Friend
1972
Oil on canvas
12 × 18 in.
Collection Mrs Marjorie
Morris, Oxford

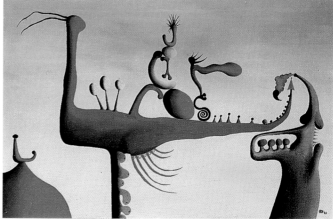

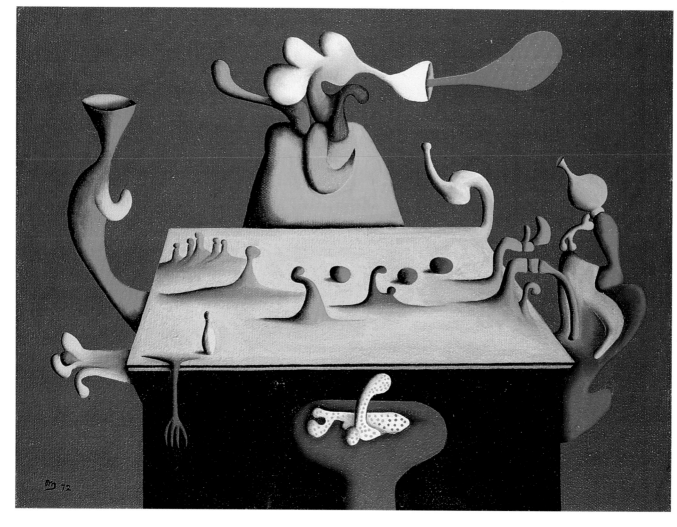

The Visitor
1972
Oil on canvas
12 × 16 in.

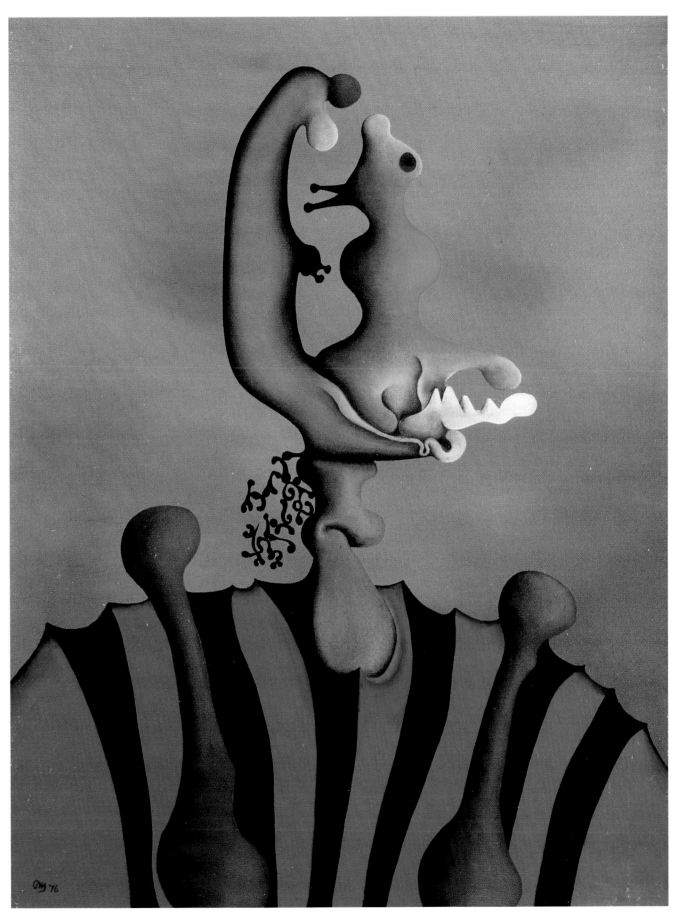

Public Figure
1976
Oil on board
16 × 12 in.

such an organ, more or less simplified, symbolic or archetypal. Circles, crescents, protuberances, tapering forms, erectile organs and prehensile eyelashes all suggest a mythopoetic organic depth, but by the difference that separates them from real organs, they prevent us from definitively attaching this depth to a logical, rational surface. It is in this suggestivity, in this irreducible separation between the seen and the visible, that Desmond Morris's metamorphic transformation has its being, ritualized not just in such and such a ceremonial scene, but also in its effectuation, in its circulation from one painting to another, and even in the few rare objects of pottery and sculpture that he produced at the beginning of this period.

In the final analysis, what Desmond Morris paints is the soft, the prehensile, the swollen, the smooth, the distended, the erectile – the list is

Fertility Figure
1973
Plaster
Ht: 3 in.

by no means complete – in the process of constitution: essences that are becoming substances. To a certain extent, he has perhaps been painting the same picture over and over again. And what is extraordinary is that by force of repetition of these forms in constant variation – and thus ephemeral – and these absolutely unidentifiable organs, by force of rituals of transformation, Desmond Morris challenges this ephemerality and confers a "reality" on these forms. By this gift he attempts to fill the gaping abyss he has opened up simultaneously between the conscious and the subconscious. The paradox is that it is the obstinate repetition of this gesture of compensation – endless because it is realized with the aid of ephemeral forms – the repetition of the "ceremony of the hole", which, perhaps, reveals the unspeakable secret.

On his return from Malta in 1973, Morris was

Stone Head
1970
Limestone
Ht: 16 in.

given a research post at Wolfson College in Oxford, where he joined the University's zoology department. He was fortunate enough to find an old Victorian coach-house right by the house into which he moved with his family, and it was there – after a period of settling in prolonged by his difficulty in regaining interest in animal behaviour – that he began to paint again.

This renewal of activity also found expression in his organizing, for the first time in twenty-two years, several exhibitions; the first, at the Stooshnoff Fine Art Gallery in London in spring 1974, was reserved for his most recent biomorphs. Two years later, four more exhibitions were held: at Wolfson College in Oxford (paintings from the Fifties and Sixties); at the Quadrangle Gallery, also in Oxford, at the Lasson Gallery in London in October, and a retrospective of sixty paintings at the Public Art Gallery of Swindon, where twenty-eight years before the local paper had so decried his work. At the beginning of 1978 he took part in the "Surrealism Unlimited" exhibition organized by Conroy Maddox at the Camden Arts Centre in London in order to testify to the continuing vigour of surrealism, and in response to the big historical and 'sedate' retrospective at the Hayward Gallery, which opened at the same time. In

October of the same year, the Gallery D'Eendt in Amsterdam – specializing in magico-fantastic and magico-realist art – invited him to show his recent works there.

In 1978 and 1979 he travelled round the world twice, 'location hunting' as it were, for geographical and topographical impressions. During these trips he discovered many places to which he would return later with more precise scientific projects that would enable him to catalogue the most striking particularities of the marine and terrestrial fauna of certain countries.

While the period from 1970 to 1976 saw a number of very productive years (notably 1972, 1973 and 1976), the years 1977 to 1984 produced relatively few works and only one painting *Aggro*, of which we shall say more later. But during this same period, the other half of Desmond Morris produced no less than eight books amongst which were titles as famous as *Manwatching* (1977), *Gestures* (1979), the first volume of his autobiography entitled *Animal Days* (1979), *The Soccer Tribe* (1981), which confirmed him as an authority on football behaviour, and *The Book of Ages* (1983), which delved into the process of aging. In these books, which all demanded long and patient research in the field (*Gestures* was written in collaboration with three colleagues and called for trips to twenty-eight countries), Desmond Morris sets out tirelessly again and again in search of origins, working through rituals. In all the analyses and statistics he places himself in a border-zone between the plain facts – superficial and so obvious as to have become almost unnoticeable – and the mythical substrata, irrational and poetic. He lays bare a life which lies under the mask of the skin and social conventions, the unconscious of behaviour, the original reason for gestures. In these books Morris's space is an everyday space: that of language and the social body, and he is concerned with what lies between appearances and their organic and psychic origin, between the *here* and the *elsewhere*. As in his paintings, he confronts us with a multitude of possibilities of origination presented in an encyclopaedic cataloguing of territorial, protective, aggressive, obscene, sexually-related, dress, parental, infantile, and sporting signals . . . An anthology of impalpable forms haunted by his consuming desire to reach imaginary shores and touch their outlines. It is thus obvious that – in spite of the tendency to univocity and exhaustive explanation – the separation between the public and private, scientific and mythical, sociological and pictorial domains – in short, between the two hemispheres of Desmond Morris's mind, is not as clear as it seems to be. Everywhere, neurones and their dendrites stretch their prehensile antennae to blaze new trails through the forest of signs.

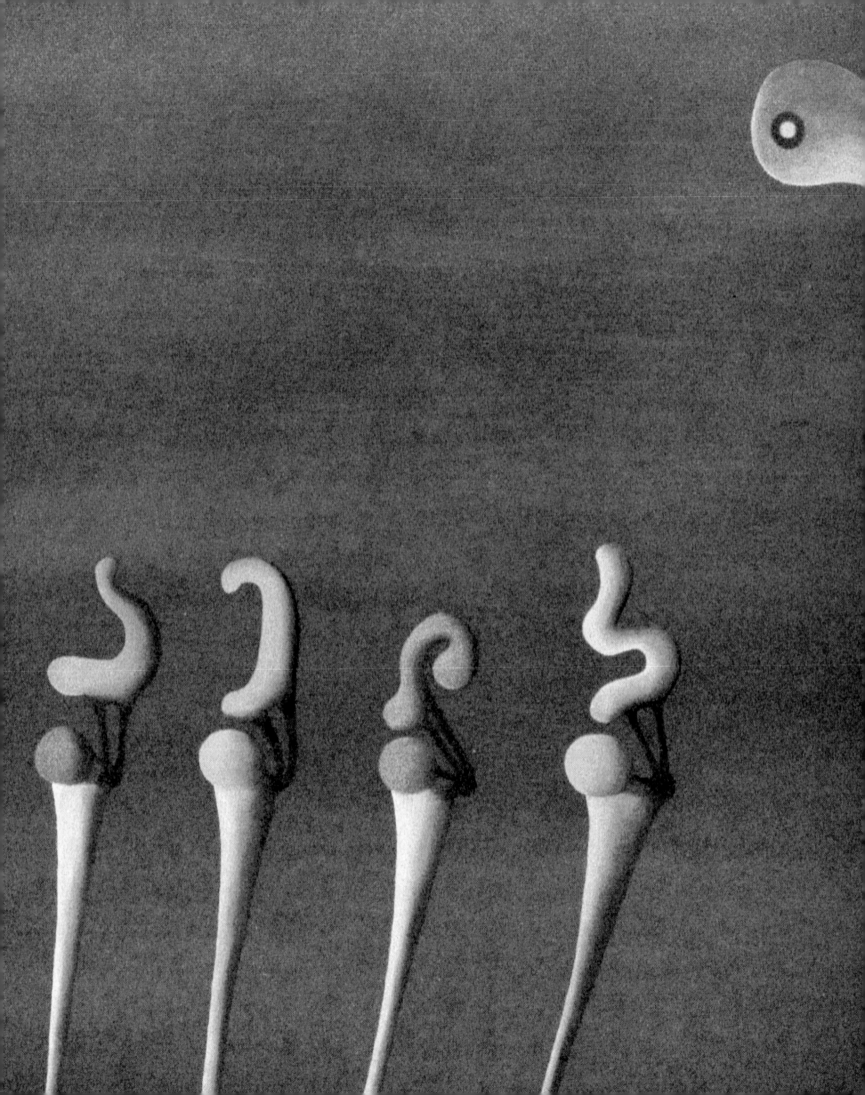

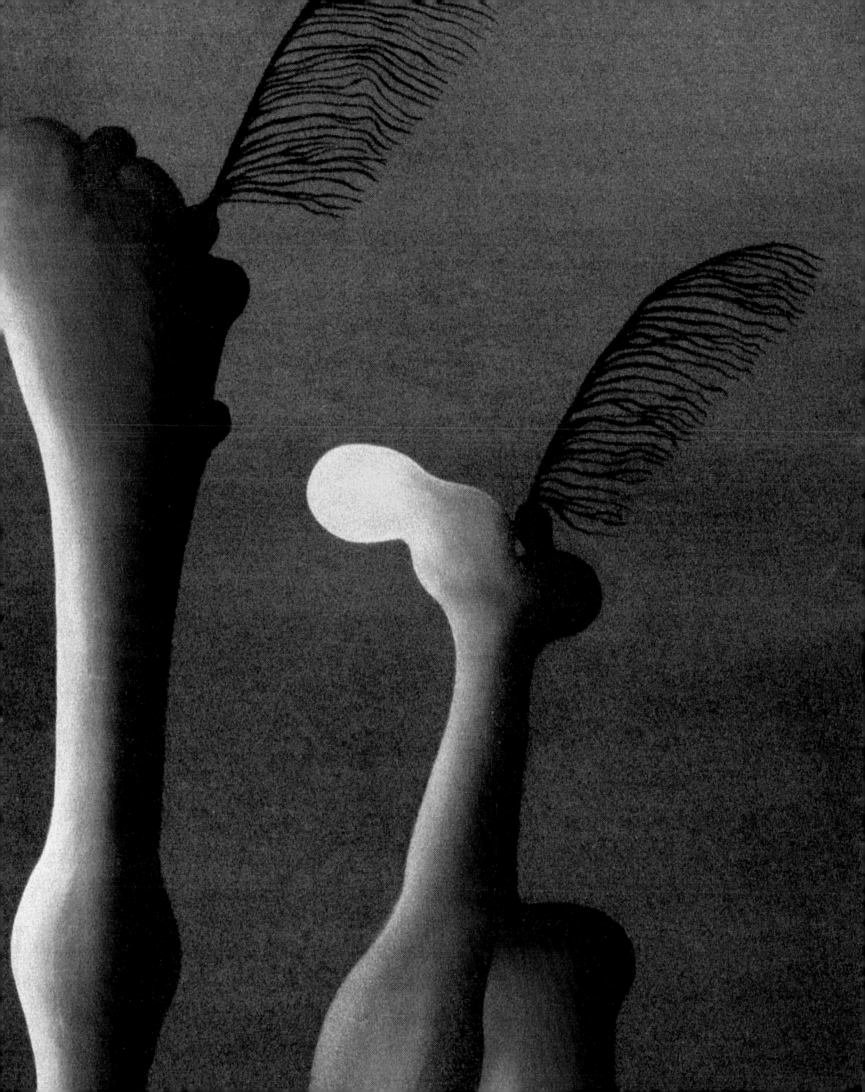

The return of the totems 1981–1990

Desmond Morris did not return to his easel until 1985, when he began a cycle of five particularly fruitful years. In 1988 alone he produced a hundred small paintings, not to mention dozens of drawings. In general, works from this period are of a smaller format and only five or six canvases are larger than 16 × 20 in. The reduction in size is accompanied by a deliberate concentration of the forms themselves, a sort of focalization of the dramas played out in them. This is due to the fact that at the time – as he points out in the interview that accompanies this study – he became conscious of the proliferation which had led to his saturating certain works during the Seventies, when the temptation to give himself up to the surging forth of new forms and their possible inter-weaving was too great. This relative suspension of conscious control over the products of the unconscious is not however a sign of weakness; it should be seen as being akin to the automatism that underlies any association of images, and which, working from any or all of them, tends to invade the entire space of the painting.

Early Bronze Age vessels and figures from Cyprus (2000 BC). Illustrations by Desmond Morris to his book *The Art of Ancient Cyprus* 1985

In the aesthetic ascesis that Morris imposed on himself to forestall this proliferation there quite probably lies the generating force behind the enormous quantity of drawings done in 1986. They are of course exploratory studies, and should not be judged in the same manner as the paintings, but it is striking to remark how they could all very easily evolve into paintings. This is rarely the case though, since repetition of this kind is absolutely out of keeping with Morris's mind. Each stroke and shape pushes the drawing forward, and yet identical renewal is avoided. Even if these drawings do respond to one another by the similarity of their sym-metrical structure, by their central opening on to

intestinal worlds, or by the arrangement and relationship settled between organs, they all offer new combinations. It is manifest that each form contains in itself all the other forms born of the open-endedness and 'asepsis' of the artist's mind. More than ever, and in keeping with the rapidity with which they were done, we are plunged into a world where forms are in a state of *uprising*: not only do they assert themselves and put forth claims, they also mark the place of permanent parturition. The stroke literally becomes a body, but a torn body, since it traces both the newly-acquired autonomy of its parts and the teratogenic coupling which goes on much to the amazement of these parts. It is an ambivalent stroke: joining and separating bodies that can only reappear in the questioning of their mad identity.

The 'strategic' importance of these drawings appears plainly when we consider them as being the prolongation of over 1,300 other drawings done between 1982 and 1984 to illustrate Morris's book dealing with the art of Ancient Cyprus, a singular work published in 1985. These drawings re-copied and adapted sche-matically the decorative motifs on vases, craters, pots, dishes, cups, bowls or other recipients that Desmond Morris had gathered since 1967 in an impressive collection (no doubt the richest private collection of its kind), which he decided to catalogue in its entirety. References ran to over 600 pieces: objects, recipients, clay figurines, all of them reproduced, to which were added photographs and drawings of other objects for comparison. This colossal iconographic summa ends with a sort of informal treatise on what Desmond Morris calls *archaeo–aesthetics*, a careful scrutiny of which enables us to restitute this particular line of research in the perspective of the surrealist proposition as expressed else-where in his paintings and drawings. Once again, we are precipitated into a world on which we are asked to cast a different eye, one detached from habits, suspended so to speak between the present and a past beyond memory. In our interview, Desmond Morris emphasizes the role played by the aesthetics of ancient art:

What fascinates me in ancient art and tribal art is that it reminds us that ninety per cent of human artistic activity has not been aimed at the accurate representation of the external world. The European mode of thinking, from Classical Greece to Victorian times, has been dominated by the idea that the artist is someone who serves society by

precisely recording external reality. And this explains why the work of the early surrealists was viewed as something extraordinary and bizarre. In fact, what is strange and unusual – in global terms – is to want to represent the external world with precision. That is what is atypical. Because if you look at ancient or tribal art, you won't find that.

In this we see the roots of the same aesthetics that Desmond Morris had posited in 1946. It is interesting to note that during a visit to the Cyprus Museum in Nicosia in June 1967, on another day rich in objective chance, Morris experienced a validation of these same aesthetics. Passing into the Museum's second room, where Bronze Age art produced some 4,000 years ago was on exhibit, he had a flash of revelation: the vases and pots all appeared as sculptures in their own right, whose forms could only have their origin in the imagination, so great was their degree of abstraction. This meant that the notion of a model, of repetition, of a mould as it were, was totally unknown to these ancient artists, and that each creation rose as a sort of unique totemic sign. This way of understanding

modified forms that were very nearly biomorphic hit Desmond Morris like a thunderbolt. For him, it meant a new and sudden initiation into living forms. Another passage from his interview points out the relation that henceforth appeared in the inspiration of his works:

Desmond Morris with his collection of ancient artefacts

Prehistoric or ancient art stands out by its magical distilling of the world. Look at the human figures in my book on The Ancient Art of Cyprus, *they have two heads, three necks, no arms, eyes made of a circle of little dots – all kinds of variations. This playfulness is part of the ancient artist's inventiveness, of the pure joy of creation. These early potters had no wheel, so every vessel they made is unique.*

It is a reflection of the craftsman's ingenuity, the handles of a jug are arms, the neck of the vessel becomes a throat, or a face, the bottom of the vessel a fat belly . . . Human and animal figures may be the basis of these works of art, but the shapes are constantly changed, and manipulated . . . and it is this distillation of externals that is important.

The few drawings reproduced here clearly illustrate this magical process of apprehending the world; simplification, in particular in the short-circuiting of forms and the omission of linking organs, points to the instinctive desire to enter into direct communication – beyond superficial forms – with the forces of the cosmos. All primitive and tribal art (and here it is significant that Desmond Morris has also given considerable attention to Australian Aboriginal art) is based on this expulsion of surfaces, on the search for direct contact with the highest-powered currents. Hence the fluidity that is a constant in his paintings.

Is it a primitive vision – aboriginal in the broad sense – which inspires the following text from the Sixties? In any case, the poem appears as a condensation of Morris's osmotic approach, which once again found expression in Cyprus:

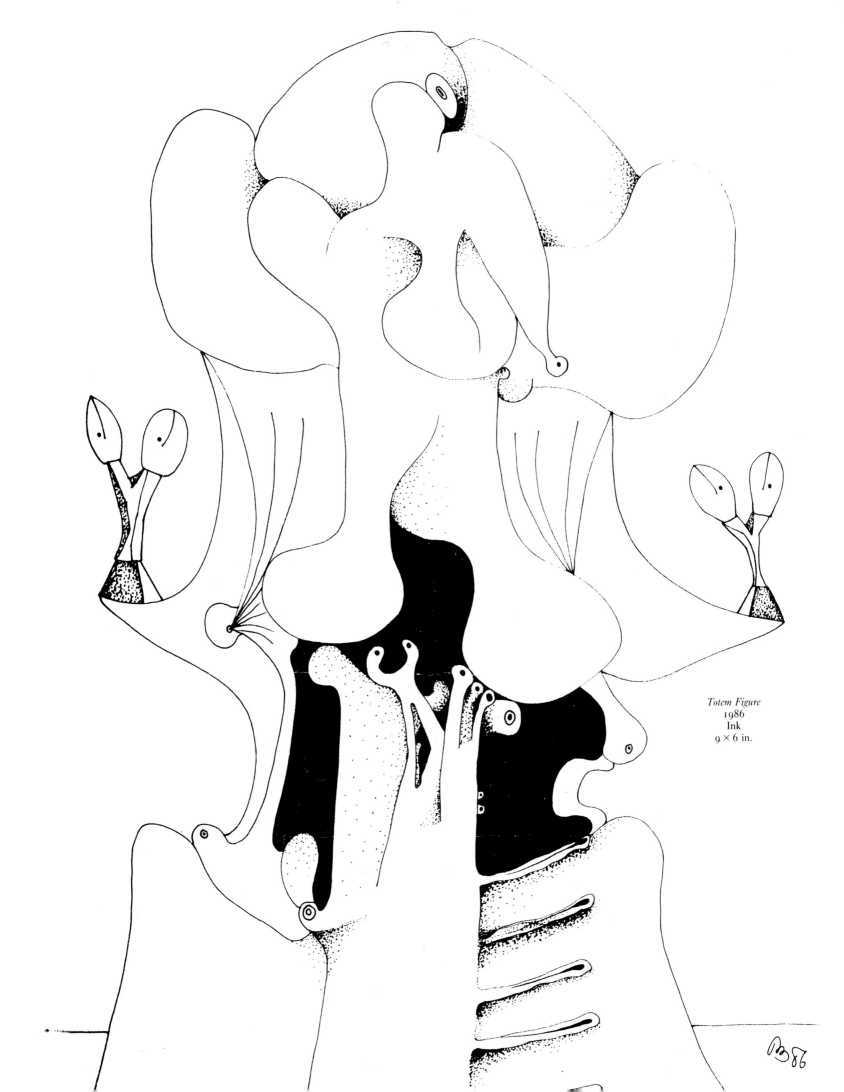

Totem Figure
1986
Ink
9 × 6 in.

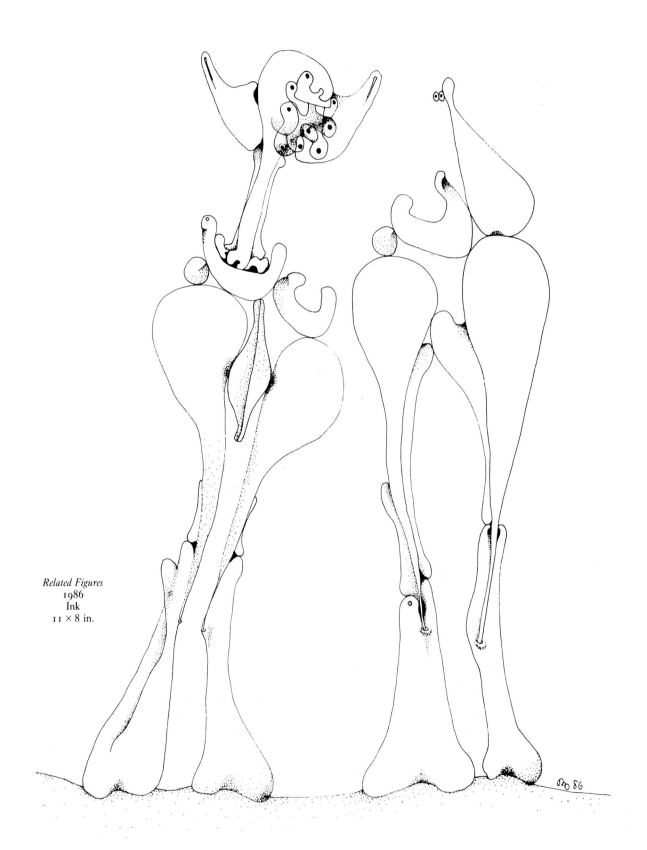

Related Figures
1986
Ink
11 × 8 in.

Aggro
1981
Oil on canvas
24 × 36 in.
Collection Dr and Mrs
Peter Marsh, Oxford

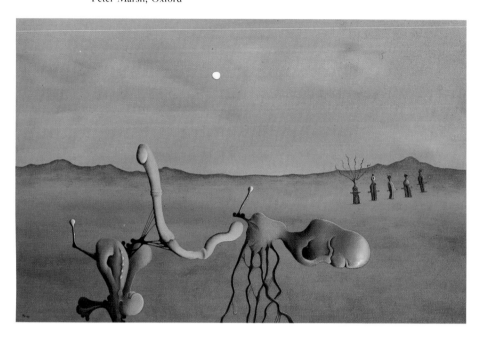

Your limbs are mountains
on the face of my brain.
You are walking along the tightrope
that stretches between the eyes I have for you.
Yet all I can hear is your eyelashes
burning inside my ears.

Amongst these trees a small pile
of folded sheets lies silent,
the unused sails of a sexual yacht.

There is a rug lying upon the sea
and our voyage is pursued by scissors
which cut off the buttons
of our gaping volcanoes,
as the Persians were said to do.

This itinerary – which we might term 'archaeo-poetic' – retraces a return to sources and points to a re-orientation, a purification of "style". In Morris's pictures this came about in a singular rarefaction of the "landscapes" that had appeared in the Seventies and an ascetic stripping of the biomorphs which still inhabit them. Among other things, this is what is striking in the first painting to break the silence of the late Seventies: *Aggro*, the ironic title not only refers to the open hostility between the two forms, the one pistil-like, brandishing a section of intestine or uterine tube, the other threatening with what it seems to be holding in reserve (an ovary perhaps?), but it also evokes the violent rupture which this work operates with regard to preceding paintings. Morris's friend, Peter Marsh, is said to have

remarked on first seeing these two forms that they seemed to him to be sufficient. Morris, who had been meaning to people the space, accepted the criticism, and added only five small figures, the surprised witnesses of this scene. As in a caesarian birth then, this exterior intervention forced the passage for a more 'selective' peopling of the painting's space.

Four years later, in 1985, after an interruption caused by the publishing of several books, he returned to his studio and painted *The Seven Sisters*. The structure used in this work seems to dominate these years: the presence in the foreground of several witness-figures in front of whom a scene takes place, and whose signs they must read; in this instance we have ocular and sexual organs, along with other bodily fragments. The two parental figures of *The Seven Sisters* are onlookers in a confrontation between a parade of the spermatozoid forms of their daughters, all of them the same, and the monstrous shapes that appear to be courting their favour. The mutant elephant of *Seasonal Positions* is party to the escape of spermatozoid forms from the end of an animal trunk, all of which vary in appearance according to the usual rules – as Morris would certainly say – of the seasonal dimorphism that affects certain insects at different times of the year. *Green Landscape* bears witness to this same discipline; the few forms that are shown there, some of them in series, clearly indicate an interior landscape whose green – obtained by a decal procedure – evokes the thick interior

The Seven Sisters
1985
Oil on board
24 × 36 in.

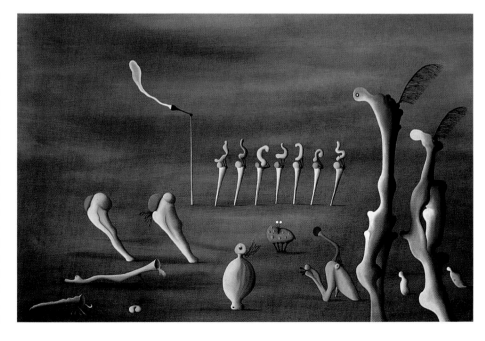

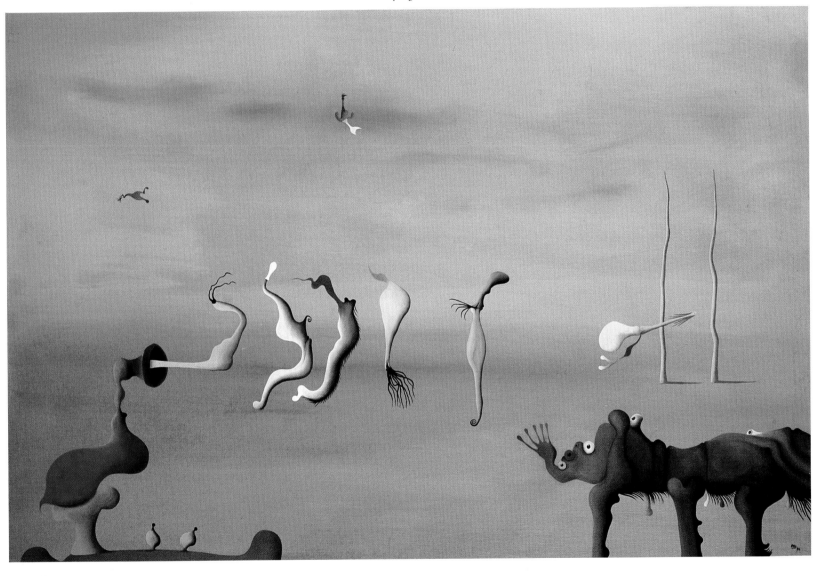

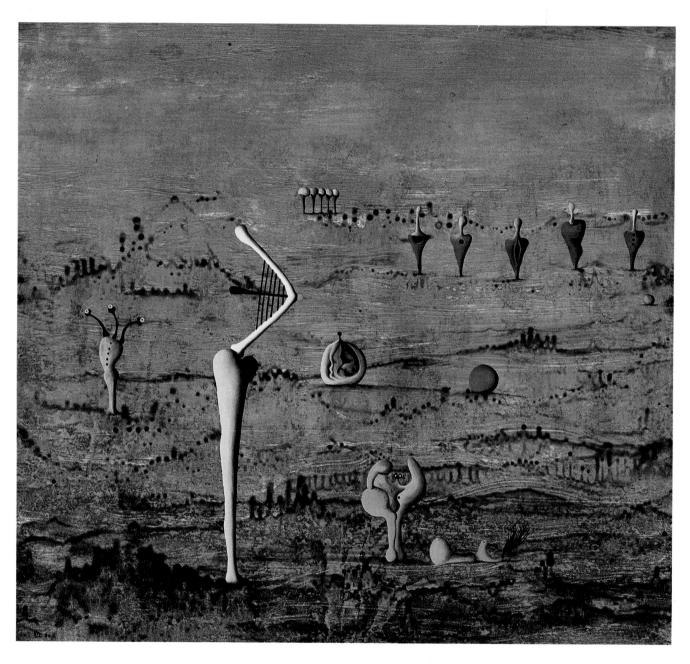

Green Landscape
1986
Oil on panel
26 × 22 in.
Private collection,
New York

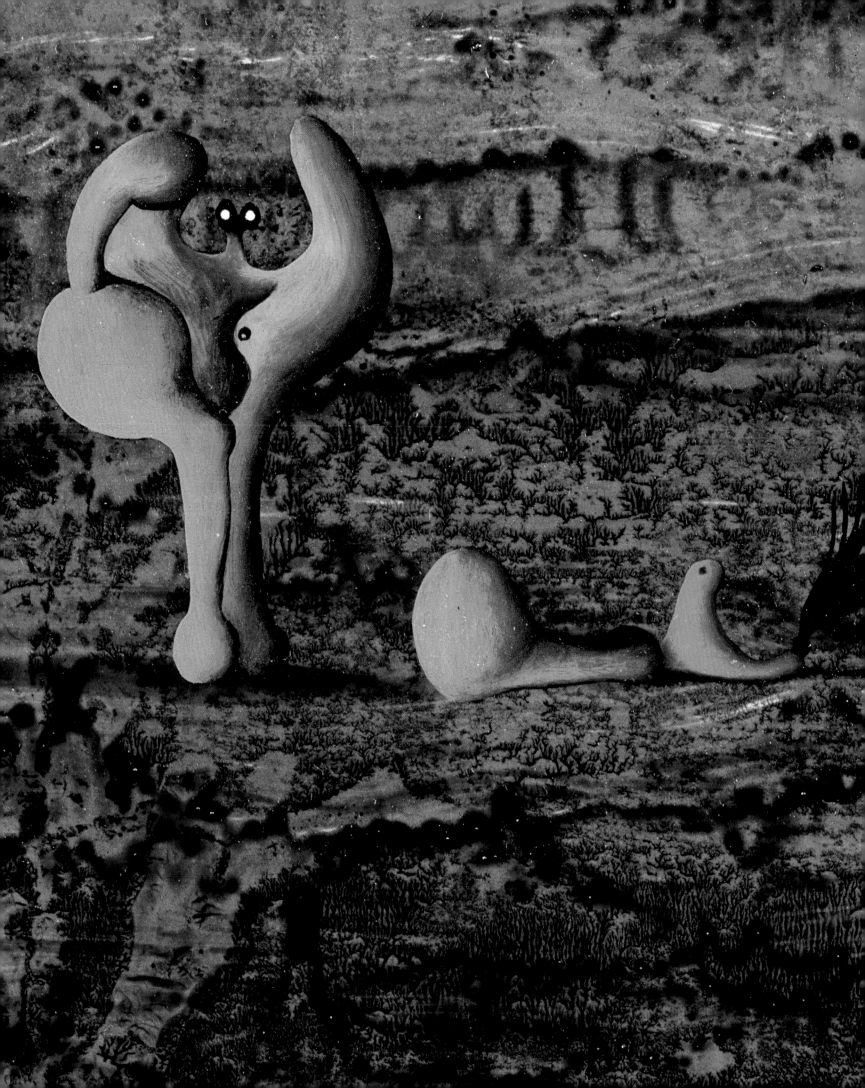

The New Mood
1989
Oil on canvas
24 × 30 in.

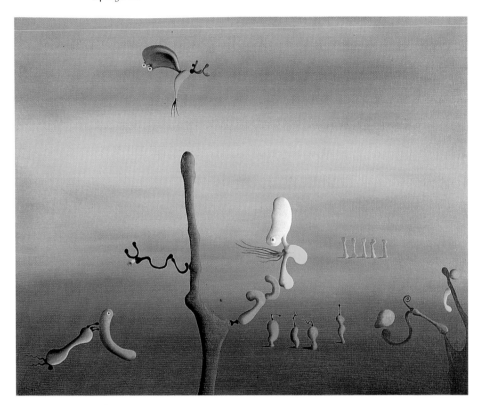

by the central dividing line emphasizes this internal duplication. *The Illusionist* should be added to these three works; here a head, which at first glance blends into the torso, is surmounted by a Harlequin cap which has metamorphosed into a five-eyed octopus. This confusion-pro-fusion is attenuated here, compensated by a particularly threatening central nasal slit, a form which recurs throughout Desmond Morris's work.

forests of the subconscious inhabited by the improbable ghosts of parts of our body. Finally, *The New Mood*, painted in 1989, resumes soberly the forms and gametes and the uterine crescent of the Sixties, arranged in *series* with regard to two fork-shapes in the foreground, where two slings lie limp, while at the top of the painting flies a composite being who seems to have escaped the gravity down below.

The same technique is to be found in *The Bipedal Surprise*, the 'portrait' of a long-legged figure whose body is formed of two white and gelatinous testicle-like shapes, and whose "head" is replaced by a yellow penis. Here again the title is ironic since the figures that are surprised by this spectacle are just as monstrous as the central figure itself. The generating principle *par excellence* is thus reduced to a static state, while in the distance a small feminine crescent flies away . . . In *Hybrid Vigour* we have a similar composite figure, masculine and feminine, where Fallopian tubes dominate like a bull's horns two bright red kidney-testicles. This hybridization is condensed with added force in *The Usher* in which black and white circles, inversely similar, situated at eye and shoulder level, spaced apart in the first case but close together in the second, vaguely evoke in turn eyes, breasts, testicles or even follicles. The perfect symmetry underlined

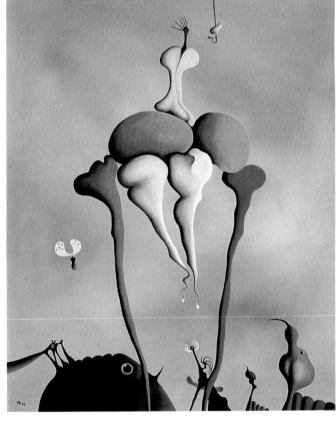

The Bipedal Surprise
1986
Oil on canvas
22 × 18 in.
Collection Mr and Mrs
Nathan M. Shippee,
New York

Concerning this, we would do well to bear in mind what he wrote in *Bodywatching* about the underlying meaning of certain forms, and in particular in dealing with the example of the double sphere. The form is perhaps the most fundamental element of human eroticism and aesthetics, and by an inevitable movement of the imagination suggests at once the breasts, the buttocks, the shoulders, the knees, the back of the hand, the dimpled chin, the ear lobes, the testicles, the eyes and the cheeks. While certain of these features exist in all primates, many are confined to humans alone. If we extend this observation to the significant forms of insects, mammals, fish and birds – where a brown triangle, a red dot or a green streak can carry

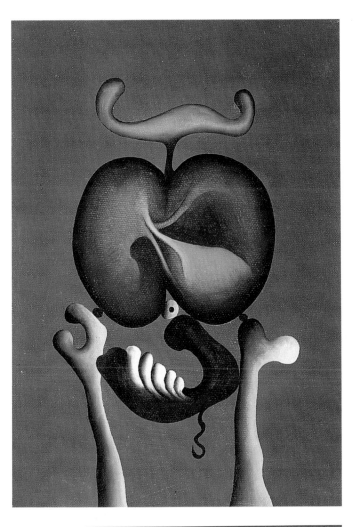

Hybrid Vigour
1985
Oil on board
10 × 7 in.

The Usher
1986
Oil on canvas
12 × 16 in.

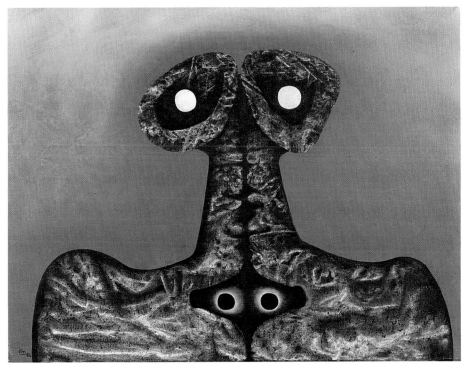

The Illusionist
1986
Oil on canvas
16 × 12 in.

considerable sexual signification – we can easily discern in Desmond Morris's painting an attempt to constitute and represent a sort of biology of the collective imagination.

In the four pictures we have just considered, the figure is articulated around a fracturing median line, and it is significant that this line's possibilities, which the drawings from 1986 began to explore, are systematically developed in the works done in 1988. Indeed, with this fracturing line comes an overall change in pictorial technique. Oils are no longer used alone. Mixed with water, they 'float' until they 'run aground' on the dried paper. At this stage Desmond Morris works over the surface with Indian ink or coloured inks, and heightens with water-colours. This technique creates a marbled effect which, depending on the dominant colour, can evoke stone, earth, or even dense forest. Space is thus more "interior" than in his oil paintings, all the more so since the marbling effect traverses – in other shades – the figures in the composition.

155

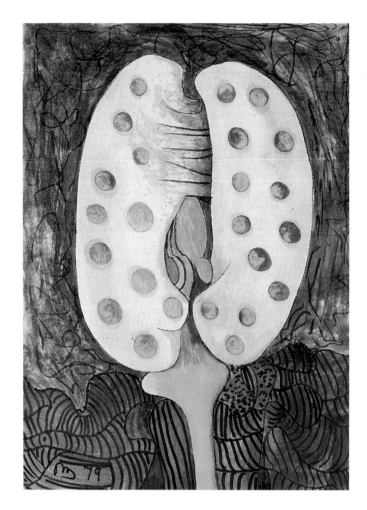

Brain Fruit
1979
Ink and watercolour
8 × 6 in.
Collection The Viscount
Windsor, Shropshire

fundamental preoccupation, but in a totally new way because here we touch on the world of matter. Soft, smooth and swollen forms constituted a primordial phase; the proto-plasmic cells are now replaced by bone cells. The body is stripped bare, flayed of its flesh and organs in an attempt to seize on the secret of its construction. Hence the bony scaffolding of *Family Secrets* and *Memories of Home* where anonymous and identical

figures present a closed and impenetrable facade on which only a small crack betrays the presence of eyes and tiny cells: the organic memories and secrets. Noteworthy is the fact that the necks and supports of these stone "faces" are tibia-shaped, and that the head thus evokes a pair of testicles.

Regarding this, Desmond Morris fondly relates a story told to him by Henry Moore on the subject of bones. One day, when Moore was a young student at the London School of Fine Arts, and bored to tears painting according to the academic conventions that were still enforced

Just as this sophisticated technique gives the image weight, consistence, and a certain un-shakeable solidity, the shapes of the "characters" spreading practically all over the canvas are massive, angular, and approximately four-sided, or at least composed of trapezia whose sides are more or less parallel. The intention is clear, as the drawings show: there is a desire to frontalize – and not to theatralize in a supposedly three-dimensional space as before – the relations, transformations and modifications of the figures. We might also add that the forms and colours of these figures evoke quite clearly bones – tibias, femurs, ribs or iliacs – and that though bone matter looks dead, it actually supports and structures the body and is in fact living and vital. A subtle dialectic thus appears between apparent life and apparent death. Where is real life? is the first question that comes to mind. And the second is: Where does it come from?

Brain Fruit, a drawing done in 1979, prepares the way for the technique mentioned above and at the same time reveals the obsessional question of the "joining fracture". Indeed, as the title suggests, from between the two hemispheres of the brain (which might just as well be kidneys or ovaries) there appears an hypophysial form, the fruit of their womb, on a background of intestinal convolutions; they link up and break apart by virtue of an apparition that differentiates them.

This brings us back to Desmond Morris's

Family Secrets
1988
Mixed media
8 × 13 in.

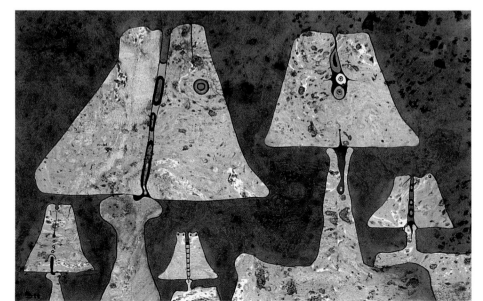

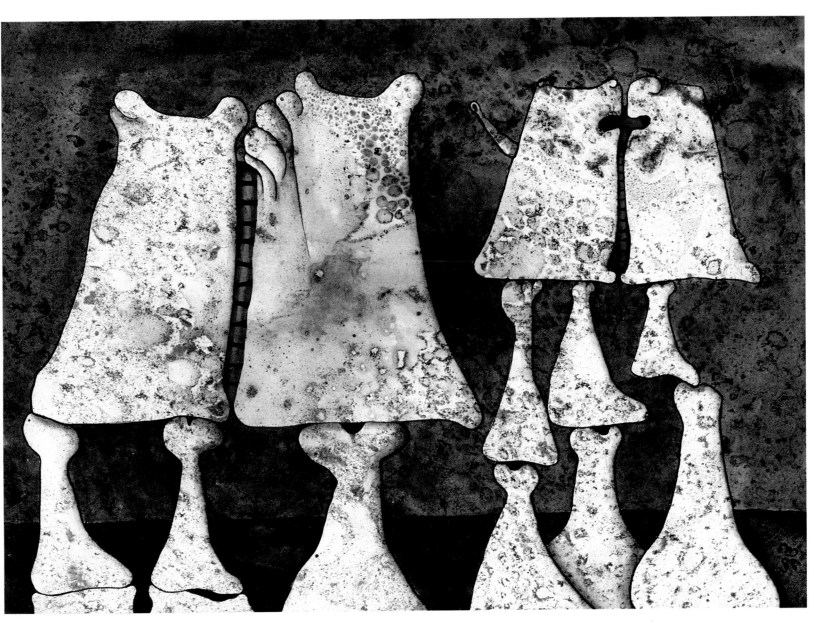

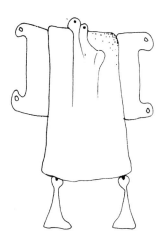

Memories of Home
1988
Mixed media
11 × 8 in.

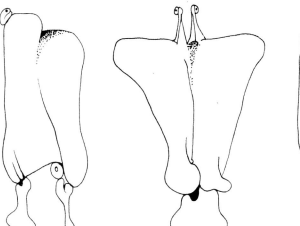

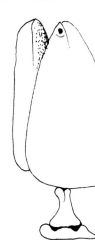

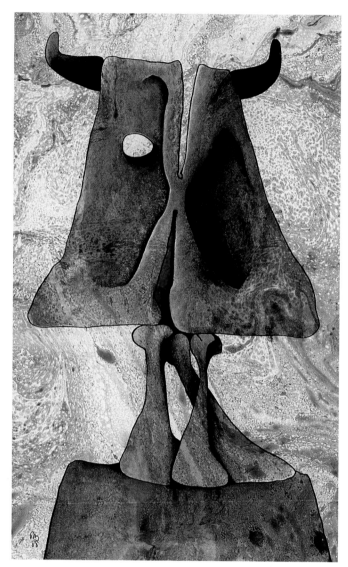

Ancestral Figures
1988
Mixed media
11 × 8 in.

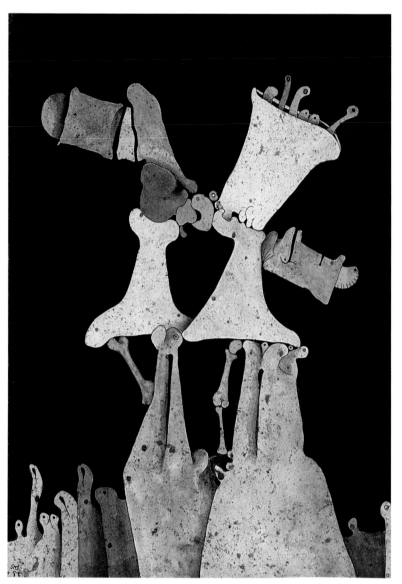

Totemic Figure
1988
Mixed media
13 × 8 in.
Collection Mr Alan
Durham-Smith, Dallas,
Texas, U.S.A

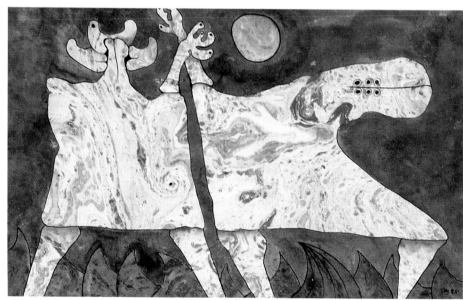

The Greeting
1988
Mixed media
8 × 13 in.

in those days, he searched about the room he was in and came upon a drawer full of old bones. It was the revelation of a new world of forms for him. And as Morris adds, it is plain that the bone

disjunction: the face in the first painting is slipping apart in its middle, while in the second the face has split and one of the halves has lost an eye. Similarly, *Metaphor for an Old Friend*

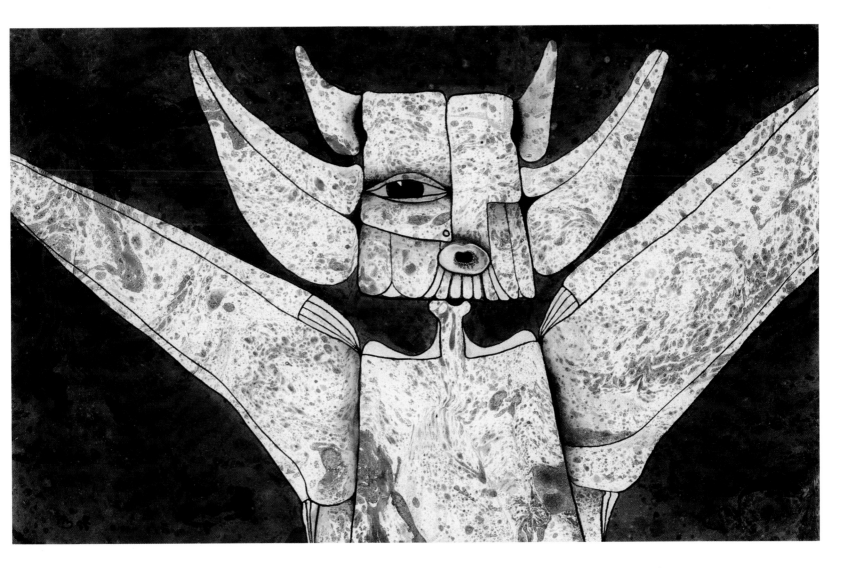

Warrior Angel
1988
Mixed media
8 × 13 in.

has a surprising capacity to evoke living forms, whether biological or organic.

As we have said, the plastic leitmotif is the central slit which divides and separates the space of the picture. Of course, in paintings like *The Greeting* or *Ancestral Figures* there are two figures present, but what is interesting is that in the first painting they seem to be on the verge of joining together, and in the second, of holding each other in a close embrace: are we confronted with a slit of separation or a space that will become the scene of union? *Warrior Angel* and *Totemic Figure* are clearly representations of organic

bases its symmetry not only on the two crescents – emblems of creation – on either side of a static rectangular mass, but also on two violet bottle-necks which seem to have the power of joining up and separating the mass in two. Quite different are the paintings *Longing for Something* and *The Riddle of the Great Mother* with their evocation of the fluidity of coitus, which turn this slit into the place of resurgence of non-bony organs such as eyes, Fallopian tubes; in the first painting the slit is even repeated in the figure's neck. Little by little, then, we witness the return of the organs.

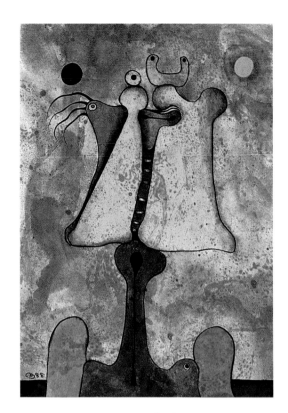

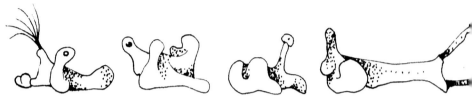

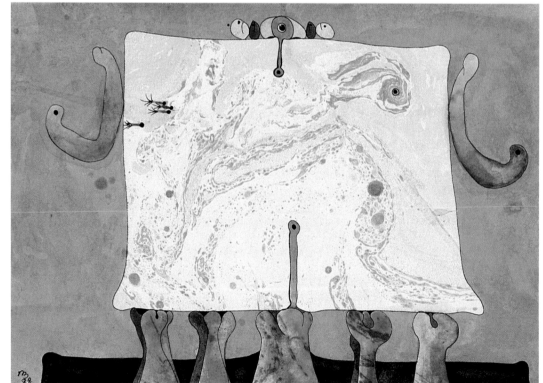

The Riddle of the
Great Mother
1988
Mixed media
13 × 8 in.
Collection Pamela Wynn,
London

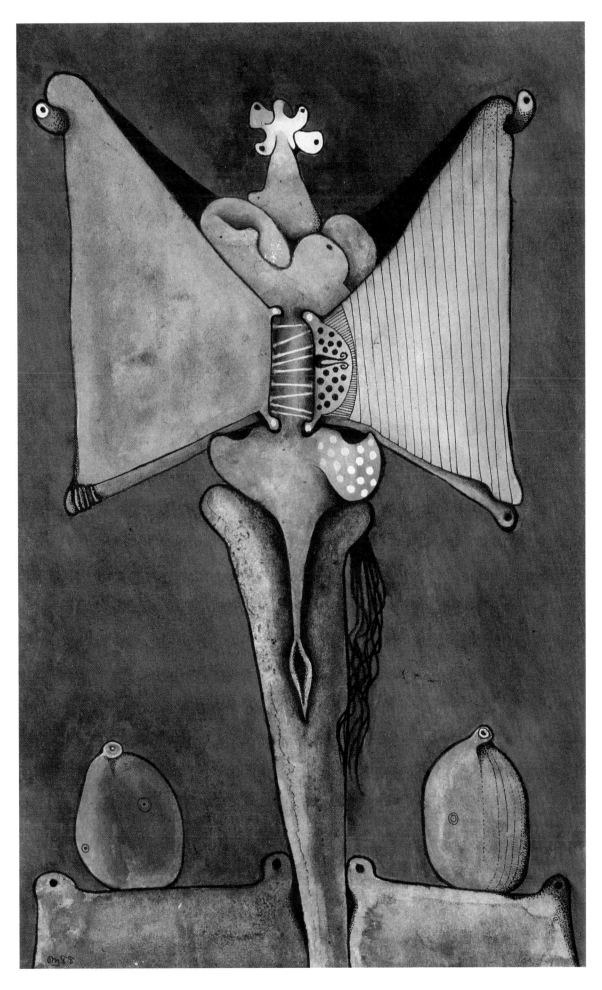

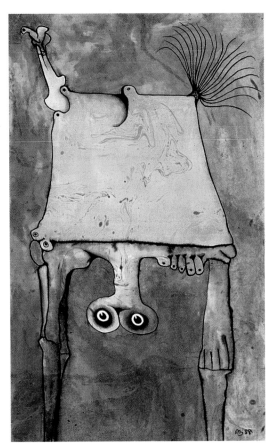

A Paragon of Vice
1988
Mixed media
13 × 8 in.

The Novice
1988
Mixed media
11 × 8 in.

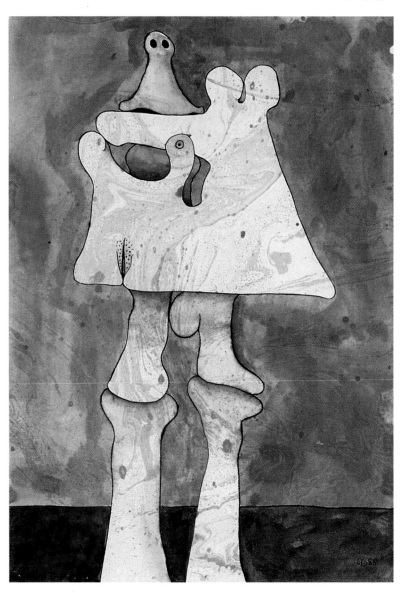

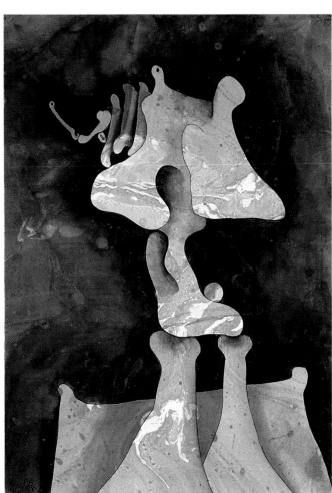

Lost in Thought
1988
Mixed media
11 × 8 in.

A Paragon of Vice, painted towards the beginning of 1988 (along with *Totemic Figure*) announces this return with the appearance, in the corners of a table which represents a body, of sexual elements underscored by an enormous penis equipped with two eyes hanging in front of it. But it is in two more recent works, *Lost in*

Thought and *The Novice*, that the liquefaction of bones is literally presented. The colours themselves seem to have less substance and more fluidity, while contours admit round protuberances, some of them equipped with eyes. *Lost in Thought* is a more complete statement, softening almost all the bone shapes into an amorphous mass bathed in a uniform iridescent colour. The fissure, or the two sides of the brain (another possible connotation of this division), seem to come into fusion in a pure loss of thought. Could it be that this central fissure has liberated all that is repressed?

A sign of separation and junction, the fissure is a source of division and creation, referring us back to the primordial operation of the cell, which is the prime unit of living matter. In other words, this fracturing of matter liberates matter from itself, from its mass, and – to use a term from chemistry – from the valence of its atoms. Metaphorically, matter has been laid open, that is to say it has been 'detached' or 'off-set' from its surface and its own effects. At the same time, as it opens, it becomes an agent of the revelation

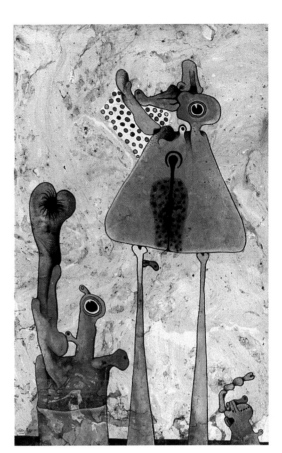

Daydreamer
1988
Mixed media
8 × 13 in.
Private collection,
Belgium

Diverse Figures
1988
Ink
8 × 11 in.

of the interior, an instrument of creation. *The Daydreamer*, at once feminine and masculine, liberated from its ochre-brown trapezium, contemplates the presence of imaginary human and animal organs, a male organ, possibly grafted on with an anus, crab claws, and ovules marbled like the background. We are between the closed body and the open body.

Indeed, this recurrence of elementary male and female forms, mixed together bears witness to another opening, that of bodies; the fissure is quite obviously the symbolic vagina which lead under the skin, the hymen that separates the inside from the outside, and which masculine desire dreams of penetrating in the fury of getting at the secret of origins. It is this same desire which is at work in Desmond Morris's paintings, but hanging as it were, on the lips of bones. In uncovering osseous matter, Desmond Morris is perhaps revealing another form of desire, not that which aims at rubbing up against organs, but the desire to fissurate, to open and penetrate. As a result our vision becomes particularly *active*, in the intransitive sense.

Questioned about these new forms, Desmond Morris ascribes their origin to an upsurge of the unconscious which was triggered off a little after the series got under way, by his seeing, in a Sotheby's catalogue, a Grecian helmet with a central slit flaring outwards at the bottom. Indeed, the mass that occupies the space of these paintings acts like a mask, whose slits afford a partial vision of the face: eyes, mouth and skin. It is the hard shell that protects the vulnerable and soft interior, such as man tends to develop to preserve himself from external aggression. A maternal mass if ever there was one.

Just as pertinent is the fact that these fractures, these ephemeral gaps, hark back to another great creative division, the 'continental drift' , especially in paintings like *Totemic Figure, Ancestral*

Figures and *The Greeting*. The bone-shaped bodies are continents which – by the upthrust of magma – split and separate. This parallel increases the immemorial dimensions of Morris's 'icons', projecting them simultaneously into the fields of geology, chemistry, gynaecology and eroticism. In this respect the pictorial technique used is significant: the cave-wall aspect suggests that these figures and places are part of an unprecedented telluric birth. *The Mind's Eye* is a portrait painting which sums up and yet over-shoots these suggestions: the symetrically-structured, volcano-shaped figure is brandishing in its outstretched hands two forms that are at once foetal and bird-like, resting on beds of flame. The figure itself, in burnt sienna, resembles a gigantic penis, and yet there is a vagina-like opening in its middle, extended below by a series of buttons, thus suggesting a garment. This is a complex painting indeed, one that suspends us

between openness and closure, between desire and its accomplishment as Derrida would say, between image and memory, mastery and eruption, earth and fire, the body and – judging by the title – the mind, the eyes that see and the buttons which will reveal. Virtually the last of a long series done in 1988, the work is a condensation of Morris's research and as such reveals the dynamic tension of opposites that appear at the portals of the origin. Though Morris wrote few poems after the Sixties, an example from 1966 heralded this libidinal impulse toward division and separation:

Any body
will split the difference
and suck
the poison of a
lightning fork
spreadeagled
on the field
of love.

On the edges of this field stand the totems: magical representations of our bodies, sources of magic power because they are sources of infinite doubles, and of the reiterated desire of a confrontation with the double figure we carry in ourselves. It is this double – as the French art critic Marc Le Bot has suggested – which painting attempts to render visible, by *assuming our own desire to have a body through the embodying of images*. We might add that these images also become double through a division of the *Same*, by which *the other side* is revealed. This is especially true of Desmond Morris where the double takes the form of totemic figures which

an origin which, because it depends on this representation, is continually deferred.

As organic elementary figures, these totems sprout organs of reproduction. Their almost-geometric mass – hard and solid – betrays the presence of genital fragments which refer to their potential of creation and revelation. *The Novice* is a good example of this, if only for the sexual relationship that it literally reveals in all innocence. In this way, as an extension to the term "biomorphs", we might do well to coin the term "bioliths" to describe these creatures of flesh and earth, body and matter: bone and rock, caught in a magical fusion of principles such as presided the continental drift and the creation of living things and mankind. These are totems valid for all primitivisms, and as skeletal entities they refer back to the primeval elaboration, out of soft matter, a process of differentiation by which protoplasmic cells became bone cells, and which Desmond Morris retraces here *backwards*.

For these figures are really splitting; and the totem, as the depository of original knowledge on which life, procreation and sociality are founded, is manifestly a party to this separating in the course of which edges and outlines are overshot, placed in a dialectical movement by a disturbance that is not external but internal, so true it is that the totem stands for science and ignorance, secret and knowledge, the internal and the external, law and desire. This division, which haunts the symmetry of Morris's images, reveals the profound specular nature of the totem: it is our mirror, the mirror of our law and of our desire, the mirror of our secret history.

And it can only reman in existence by repeating itself. Just as in the Seventies the

repeat the symmetry internal to human or animal bodies. The paintings of the Seventies introduce these totems, but without really posing and situating them, except in a few cases like *Totemic Decline*, *The Arena* or *Ancestral Figures*. Ten years after they appear again without their masks. Of course, strictly-speaking, these are not the totems of so-called primitive peoples, sacred animals pregnant with the power of taboos; they are immemorial *figures* of the origin,

biomorphs ritualized their own transformations, the repetition of the totemic figures (striking indeed when we consider the paintings for 1988 alone) looks like a desperate evocation of the Same and the One, the Unique and the Original: a reiterated attempt to approach and embrace as a predator does its prey. The totems can only repeat themselves then, not only in the slightly-varied forms (since too great a variation would introduce the threat of moving away from

the postulated *centre*) but also in their opening onto their other world.

But here – and it is here that lie both the defeated purpose and the secret – the opening cannot be widened. The origin cannot be revealed because it is the basis of the totem itself. If the totem separates to such an extent that it moves away from its base, we are projected back into the night of time. The totem is at once the guarantee and the justification. It marks the origin and at the same time effaces it. It is the breath of the origin and as such is inseparable from it, since the origin can never be presented in its naked self but only transcribed in the totemic figure, energetically and libidinally. This is the fundamental drama played out in any work of art, and it is to Morris's credit that he has presented it in its infinite trembling, accumulating and reproducing the organic archives in the hope of repeating, by this gesture, the inaccessible – in other words that which cannot be repeated.

For Morris, the Eighties saw an intensification of activity in exhibitions. In 1982, the first exhibition of English surrealism in France, organized at the Galerie 1900–2000 in Paris by Marcel Fleiss, Edouard Jaguer and the author of the present work, included a painting by Desmond Morris, who was thus recognized as one of *The Children of Alice*, according to the exhibition's title. At Christmas 1983, he participated in a group exhibition at the Wylma Wayne Fine Art Gallery in London, and in April 1985 figured in the touring exhibition *A Salute to British Surrealism* (Colchester, London and Hull) organized by Jonathan Blond and James Birch. September 1986 saw three of his works in another itinerant exhibition, *Contrariwise*, organized by Ian Walker and devoted to English surrealism and its affinities. And of course, the period is also notable for the publication of the curious fiction work entitled *Inrock*, a dreamlike fantasy that marked these years.

Inrock began in 1967 on a beach in Cyprus when Morris made a note of a daydream. The text was subsequently developed and re-written on Malta in 1970, and completed twelve years later in a hotel room in Monaco before finally reaching publication the following year, in 1983. It is impossible to give a brief and precise analysis of the book here, suffice to say that it is related to science-fiction like works dealing with origins, a genre whose most brilliant exponent is no doubt J.R.R. Tolkien, the creator of the hobbits. In writing this work, Morris attempted

Tripod Figure
1960
Painted metal and plaster
Ht: 12 in.
Private collection,
New York

Mother Goddess
1969
Painted metal and stone
Ht: 9 in.

Painted Pot
1950
Ht: 6 in.
Collection Mr Andrew
Murray, London

to give his biomorphs a body, or rather to retrace their exploratory wanderings in the narrative and dramatic mode. The story is that of a child whose first name – Jason – is also that of Desmond Morris's own son, an onomastic and symbolic projection of the irrepressible desire for exploration and discovery.

Jason penetrates into a rock by one of its fissures, miming thus the original gesture we first spoke of with regard to the inaugural work *Entry to a Landscape*, painted in 1947, and which recurs latterly in works done in the late Eighties. He finds himself in a strange world peopled by biomorphic creatures which – when they come into contact with him – begin to speak and act. A series of adventures marked in turn by hostility, friendship, fear and hope follow, involving this young male Alice who has fallen into a well outside of time, and been brought back to a place where organs live independently of their functions, a protoplasmic world peopled by social amoebae. Can it be that this world is the conserved vestige of the primitive life of cells, of the first protozoic forms to have appeared on earth? Or perhaps it is the temporary underside of our being, whose presence is always removed, in other words our double, existing in the space where we continually reinvigorate ourselves since it is from there that we originate? Whatever the case may be, the narration of adventures and events confers on this never-present world a temporary thickness and ephemeral materiality whose illusory and dreamlike character cannot exclude the feeling of the inescapable, and even reinforces it. For it is interesting to note that this book was begun just after Morris left the museum in Nicosia of which we have already spoken. According to his account, he went almost instinctively into a store to buy an exercise book and sat down to write facing the sea. The receptacle-characters he had just discovered, the eternal representatives of the first men, had suddenly been joined – in the course of strange imaginary exchanges – by cell-characters and eternal foetuses. If we bear in mind that these musuem exhibits derived from underground caches or had been unearthed, it is easy to see the extraordinary visual filiation, beyond space and time, that the imagination had thus translated – a filiation which Morris was bound to meet up with sooner or later.

Desmond Morris's paintings and drawings – and the few objects he has tried his hand at – relate to us, over and over again, the *fiction* of the origin.

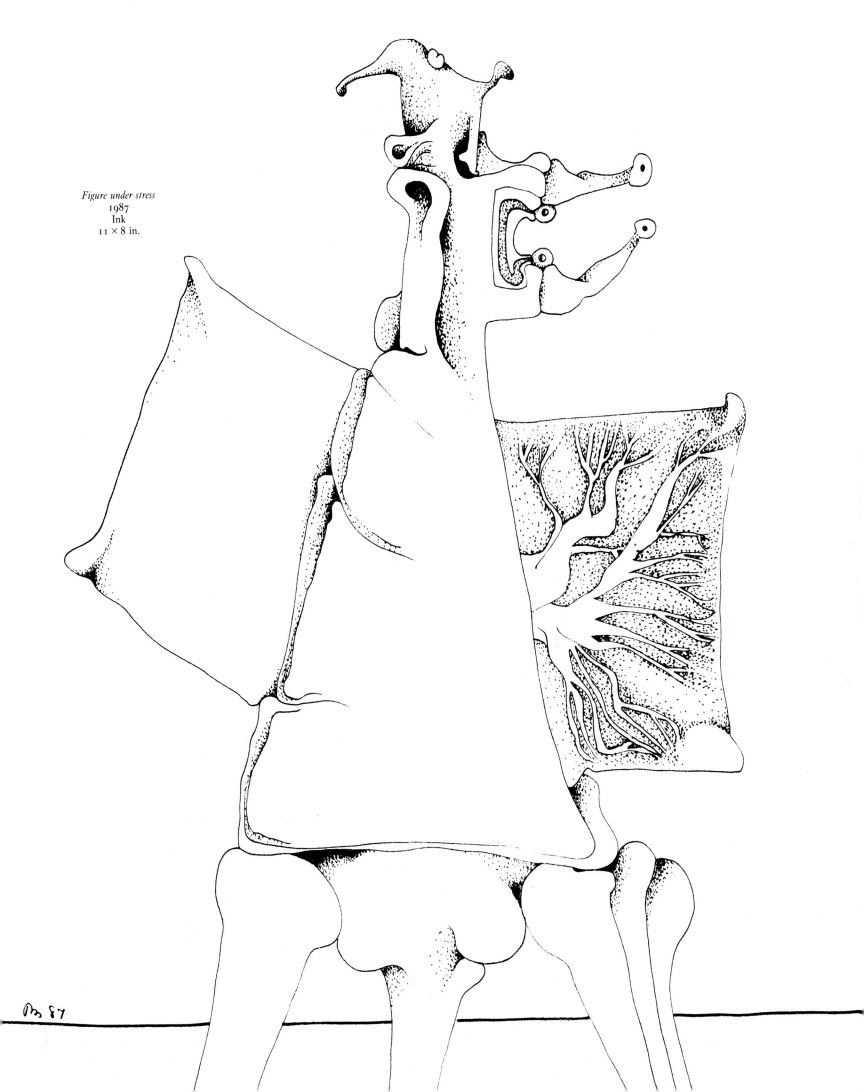

Figure under stress
1987
Ink
11 × 8 in.

The fathers' ultimate absence

André Breton's well-known phrase: "vertiginous descent into the hidden places" takes on its full meaning in paintings such as those of Desmond Morris. Quite plainly, rather than engage in voluntary and descriptive research on the denizens of the subconscious, or sketch maps of unknown parts, Morris creates a sort of state of weightlessness in himself, which results in the detachment and suspension of everything that is recognizable. In opening these endless interior spaces and accepting to confront forms which he can neither choose nor control, Morris projects himself – in both senses of the term – into the world of origins. We have already said enough of this projection into a universe of ephemeral, metamorphic and totemic signs, and it is now time to show to what extent the epistemological complexity of this approach is part and parcel of the surrealist desire to explore the primitive forces that still inhabit the mind of man, and to welcome the return of whatever has been repressed, in the hope of *displacing* the systems of reference inherited from the fathers.

Desmond Morris's position is clear: the origin does not exist *per se*. It has its being only as a displaced imaginary point and a displaced imaginary moment; it can only be postulated and no authority can authenticate its presence. In their desperate attempt to grasp the moment of creation, Desmond Morris's paintings espouse the ontological difference between signs and the things they refer to. All the creatures that people his paintings are derived and secondary, they either come from visibly known forms of which they are only fragments, or they announce other forms. The process of origination can only be read in the differences of developing forms – even if these seem content to be what they are and refuse to develop themselves – and in the difference of the state to which each of them seems to have arrived. Thus the process inevitably refers to the primordial difference – between 'nothing' and 'something', between chaos and the created world – which founds in a rebound the unceasing movement of differentiation, and from which – when one thinks in terms of evolution – there is no escape. In other words, Desmond Morris's creatures, biomorphs or bioliths are life forms that show that life has no form.

Everything begins by reproduction and Morris's biomorphs are the depositaries of a meaning that has never been present and can only be grasped in delayed action, a sort of inevitable betrayal of truth, which can only be apprehended through

New Girl
1951
Ink
6 × 5 in.

the lie of forms. In this way, what appears to be a repetition of slightly varying forms is in fact the never-ending process of re-inscription that forces us to create new networks of meaning; each sign is a signal given to *the other*, simply because it carries in itself the force of that difference by which it was created in the first place. Hence the impossibility, on one hand of identifying what we see, and on the other of resisting the discursive temptation to refer everything back to the known. This tension between the eye and the mind is indeed one of the most interesting aspects of Desmond Morris's work. The titles themselves reflect this tension; even if Morris claims they are *mere labels obtained by free association and attached to the paintings once they are finished for the sole aim of identifying them*, the fact that they are virtually interchangeable from one work to the other underlines the problematic drift of meaning at work. The painted image and the written word enter into a sort of *excess-in-difference* relationship, just as we speak of *death-in-life*.

Recurring motifs in the titles point to the asymptotic thread that wends through the paintings. Without wanting to impose categories (the exceptions to which would threaten their validity) it seems reasonable to postulate three main themes. First, the insistence on grouping and meeting is patent, as if there was a will to call together the elemental forces: *Confrontation* (1948), *Celebration* (1948), *Nuptial Display* (1948), *The Game* (1950), *The Colony* (1957), *The Assembly* (1960), *Processional* (1961), *Ceremonial Pastimes* (1966), *Coupling Strategies* (1966), *The Ceremony of the Hole* (1977), *The Presentation* (1976), and many others illustrate these themes. Space in these paintings is so open that it seems to be proclaiming its unlimited capacity to receive all manner of traces. But to avoid saturation, and the disappearance of these traces that would result from it, other spaces must open in other paintings, *ad infinitum*.

This is why the second motif of Morris's titles conveys the idea of an imminence that insists, on the one hand, on the ephemeral nature of the biomorphs present, whose only mistake is to have appeared, and on the other hand, on the biomorphs to come. *Entry to a Landscape* (1947) is the founding work of this series, examples being *The Visitor* (1949), *The New Arrival* (1960), *Movement of Judgement* (1961), *The New Challenge* (1961), *Fertilization* (1961), *Point of Contact* (1962), *Bold Moment* (1964), *The Explorer has Arrived* (1969), *Until It's Time to Go* (1970), *The*

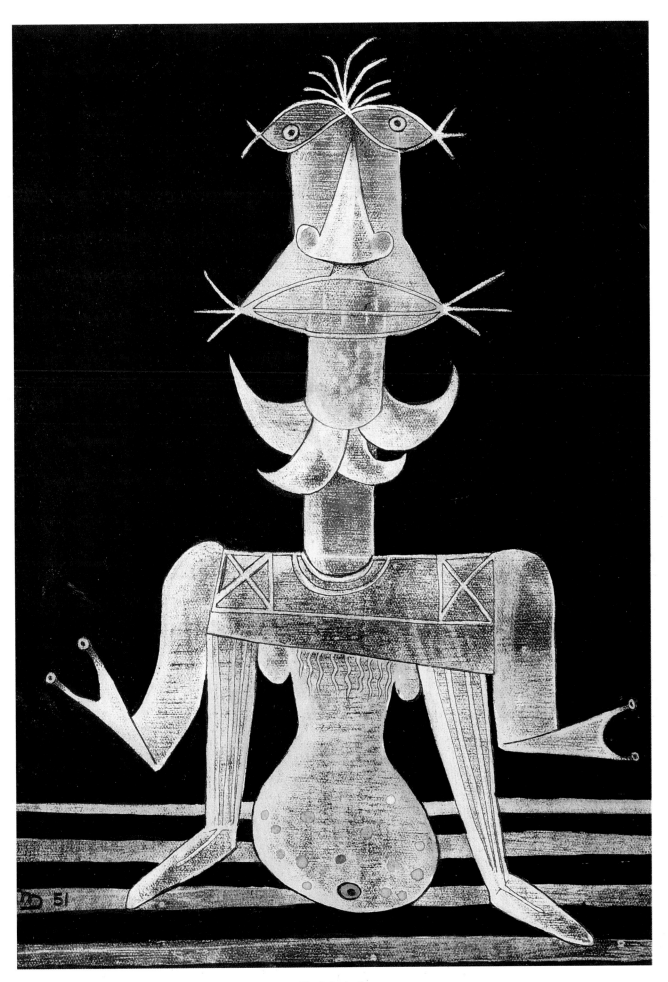

Sketch for the Jester
1951, Mixed media, 10 × 7 in.
Collection Miss Jessica Murray,
London

Budding Force (1973) . . . All these titles are attempts to describe the moment of appearance; they are *moments of partial truth* – to borrow an expression from another title from 1973 – moments when the future is already resting in the past, and when destiny depends on the memories these moments recall. They are paintings that belong to a generation that has gone mad, that has overreached its own paternity.

The totemic figures seem to be the only ones that can save us from a dead end. And indeed they constitute the third motif in the titles, and introduce a certain rational relief for the eye by their centrality and frontality. But what goes on around them or amidst them escapes from their control. The *Master of the Situation* (1947) is obviously not master of the proliferation around it, *The Hunter* (1948) cannot take hold of the lightning bolts of colour that are the traces of its prey, *The Intruder* (1949) is disturbed and *The Apple-pickers* (1949) strive in vain to reach the fruit. *The Survivors* (1950) seem to be lost, *The Jester* (1951) is the butt of his own jests just as *The Comforter* (1952) is threatened by her own distortions; *The Protégé* (1972) smothers itself, *The Sentinel* (1976) is incapable of maintaining order, *The Orator* (1986) is a victim of the proliferation of his words, and *The Usher* (1986) is far too disquieting a figure to be of service to anyone at all.

A great many other titles corroborate this same attempt to say what cannot be said. The very important series of *cell-heads* and *egg-heads* from 1961 and 1962 brings us closer to the origin, just as the round or oval shapes attempt to enclose forms as *original* as circles, triangles, squares, crescents, in a way slightly reminiscent of Paul Klee's pictures. These heads show no expression because they exist before any expression, and all meaning is reduced in them. Similarly, the experiences carried out by Morris on plaster-covered canvases (*The Dove*, 1948, *The Hunter*, 1948, *Egghead*, 1961, *Point of Contact*, 1962, and *Intimate Decision*, 1966) show his determination to place himself in the primeval conditions of pure inscription which were those of the cave-man working on the cave-walls around him, before history came to order time.

Preoccupations of this sort – centred on the systematic challenge of any stable form of interpretation – inevitably place Desmond Morris in the current of international surrealism beside names that art historians and critics have rendered famous – those of his predecessors Joan Miro, Yves Tanguy and Jean Arp. Concerning Miro

The Blind Watchmaker 1986 Oil on canvas 30 × 24 in. Used here as a dustjacket of the book by Richard Dawkins

we should bear in mind the use of colour, the fluid and minimal forms, and the attempt to reproduce the most elementary gestures of the child. Both Morris and Miro are thus intent on shifting the pre-natal sensations of an obscure world into a world of light and imperturbable frontality, in the joyous celebration of a perpetual game. But this comparison, which is mainly valid for certain of Morris's early works, goes no further: it is obvious that the stances of the two artists are only similar up to a certain point. While Miro is essentially fond of objects and beings that people daily life, and in which he finds humble simplicity and formal perfection, Morris has chosen to explore an organic and corporal life. Miro takes hold of a star, a hand, a leg, a face, a body or an animal to minimalize them in an automatic and poetic vision of the essence of forms; he reduces forms. Morris on the contrary, undertakes a growth and transformation process, seizing hold of forms and fragments at any stage in their imaginary evolution. He describes his approach as follows:

For myself, the botanical and zoological world supplies me with biological concepts and natural processes with which neither Tanguy nor Miro could have been closely familiar. There is little or nothing in my paintings that can be identified as belonging to a particular species in the external world, but the underlying principles active in natural forms are all there. (. . .) What I mean is that if you have an inner knowledge of such developments as segmentation, differentiation, articulation and the growth patterns of lobes, spicules, fins and spines – and you happen also to be a painter – then automatically these biological phenomena are going to work through you and into the pictures without any conscious intervention.

Miro's painting, which is often considered as abstract, is based on an extraordinary exigency of purity, and this is miles away from the proliferation that characterizes Morris's works, especially those of the Seventies. Miro's alchemy of sublimation is opposed to Morris's formation of bodies; just as his poetic and elementary obviousness is opposed to the ambiguity and the many-voiced bodies of Morris. Miro's beings are deposited in paintings, whereas with Morris they push up and grow; the rhythms are not exactly those that link man to the universe, but rather those that link man to his body. In Miro, as Patrick Waldberg has pointed out, there is a

desire for *universal analogy* between forms, a compulsion to take hold of *the wandering images which escape from the sleeping mind and that daylight dissolves, indefinable and unfinished images*, in short, a cosmic and cosmogonic intuition. There is nothing of the kind with Morris, where matter is heavy and forms have a substance that alienates them from our world, if only by the grafts, derivations and couplings they are subjected to. Miro's world is one of apparitions that are often suspended, that of Morris is a world of mutations and evolutions. Oddly enough, the strange phonic similarity between their names seems to give us an echo image evocative of the levity of the one and the gravity of the other.

In this sense then, the visions of Desmond Morris might perhaps be more akin to the imaginary depths in Yves Tanguy's works. In both cases the field of vision is open, washed clean by the outflow of the diluvian ocean. Light replaces water and the eye plunges into pure distance, as if each painting was a point of no return. These are worlds of traces that refer back to before the age of man, where, as Breton said, paraphrasing Nerval, *in the corridors of life . . . the figures of the past and those of the future all coexist, like the characters in a play that has not yet begun but which is nonetheless already over in the mind of its author.* This text most certainly applies to the principle of both Tanguy's approach and that of Morris. But it goes no further than that. Tanguy's visions are inspired by obscure, nocturnal forces which raise up forms that are at once unidentifiable and evoke nothing. With Desmond Morris, as we have already noted, while forms are impossible to identify, they are part of a ritual, and are placed in a situation or a relationship that orientates them. The mechanical coldness, the bluish malaise, the minerality and at times the metallic aspect of Tanguy's works are in definite opposition to the vital, non-static, diurnal and sensual exuberance of Morris. Tanguy wails amidst his "bioliths", Desmond Morris sings among his biomorphs; Tanguy wanders amidst silence and absence while Morris raises up and provokes presences.

It is undeniable that as painters they participate in the same regressive movement, in the psychoanalytical sense, and we might here add to their names that of Arp, whose fluid plastic forms are those of growth, and whose "human concretions" express the 'metamorphosing' principle of life. The smooth, the round, the organic, are also terms which apply to Arp's protuberances, but in

his case they are marked with the desire to reach the infinite, the cosmic and the eternal, and are not without a certain deliberate hermeticism. While Arp seems to slip out of the world, Morris, the biologist and zoologist, delves into life's deepest recesses. Because of this, he occupies a unique and independent domain in international surrealism.

It is obvious, though, that there is a field of research which Morris, Miro, Tanguy and Arp all share, not to mention the somnambulistic half-consciousness and the almost automatic thinking which presided over the production of their works. The forms that they conjure up send us back to times before memory, to times we are inclined to believe in, because they open a rift in us, a difference so elementary that the original difference, the initial irruption, are immediately evoked. We are cast into the geological, biological, and mental dawn of the universe.

This having been said, it seems far more pertinent to situate Morris's painting in another current, more precise, which takes into account his dual interest and his scientific and non-scientific ambivalence.

In the comparisons we have just made nothing at all was said of this double game, which was certainly not one indulged in by Miro, Tanguy or Arp. Indeed, Morris's scientific determination to refuse the diktats of reason, his dialectical attitude towards the data of science, and his faith in strategic automatism relate him more closely to members of the English surrealist group such as Len Lye and Humphrey Jennings. All three have challenged the narrowness of the scientific mind, without rejecting scientific knowledge *a priori*. Through this knowledge, they have sought other fathers.

What Len Lye and Humphrey Jennings tirelessly explored are the outer limits of science where poetry begins to make itself felt and to intervene. In this context, poetry means wild creation which escapes from law and formula. A stance of this sort is perfectly comprehensible in our day and age when scientific research – in constantly striving to be more adventurous – has no qualms about casting off its most solid results to surge forward. In the eyes of the public there is always some pretension in considering science as a province of poetry, yet this is the attitude that is asserted in peremptory fashion in the works of Lye, Jennings and Morris.

Like Morris, Len Lye is an explorer of man's biological past through the prism of the sub-

conscious. A New Zealander by birth, Lye lived in London between 1926 and 1944 before moving to the United States, and was one of the first moderns to become deeply interested in tribal art and its "icons" as an expression of the collective unconscious. His main fields of research were Australian Aboriginal art, Bushman art, and that of the Maoris, and it was in them that his search for archetypes and primitive symbols helped him come upon the abstract forms that enable man to identify himself with his past. No doubt Morris's work tends rather towards a disidentification of forms and of those who view them, in the sense of a de-stabilization. But both painters have the same obsession with the uni-cellular life of antibodies, genes, chromosomes and ovules. The Brownian movement that agitates these beings refers back to immemorial time and space: those of genetic truth. Like Morris, Lye developed a personal mythology of "snow-birds", "three-headed snakes", "pond" and "fern" people, a hybrid mythology between animism and biology, mind and matter, the human and the vegetable.

Lye's "individuality totems", as he called them, which were repeated in almost hypnotic fashion from one painting to another, supposedly revealed the existence of mental powers beyond all rationality that have now been lost, and that existed in the Ancient Brain; in Lye's categories, the latter is something of a biological equivalent of the Freudian subconscious. Without advancing any theory, it is my opinion that Morris too is an artist who is familiar with the Ancient Brain, forever attempting to give us access to a pre-natal and pre-cognitive material, to a knowledge devoid of concept, an image-knowledge, composed not only of the individual's memories but also of those of prehistory. Lye's fascination with intra-uterine life, with the formal correspondences between embryo, genes or protein and plant and animal molecules from the dawn of mankind like the coelacanth or the crustacean, is coupled with his intense interest in the creation and sacrificial rites of the so-called primitive peoples of Polynesia, South America and Africa. But this syncretism, which we find as a *principle* in Morris's work, is confined to the space of Len Lye's microscope lens; Morris's space includes this lens and goes beyond it in order to integrate in the painting itself, the space of the laboratory, the zoo or the body which haunts them. Len Lye looks to Jung and Wilkins, the discoverer of the DNA molecule; Morris descends from Freud and Darwin. The one spreads out and separates

the codes of genetic inscription; the other spreads out and separates the codes of biological and zoological evolution. However, in the work of both painters there is the same suspension of the dichotomies that found Western ideology, the same independence of the automatic traces of the memory with regard to the brain, the same scientific approach that stands a little aside from science.

Closer to us, Humphrey Jennings set out in the early Thirties to explore the creative impulse of the adult, a citizen of the industrial world. What he was looking for was the primitive organic energy that crosses simultaneously man, the animal and the machine, beyond time and space. In his sole and unique vision, Jennings sets in the same kaleidoscope the horse and the locomotive, the dome of St Paul's and Darwin's skull, Jethro Tull's plough and the guitar. Jennings's poetics (it is significant that with Mesens, the leader of the English surrealist group, he organized an exhibition on machines and their artefacts) is founded on what Edouard Jaguer has called "imaginative materialism" – a formula that could just as well be applied to Morris. The passionate search for the point of fusion between the mineral and the vegetable, the natural and the industrial, the human and the animal, that underlies Jennings's paintings, collages and texts is close to Morris's *archaeological* preoccupations, especially in the way they *over-shoot* scientific knowledge. Of course, Morris multiplies the short circuits in the *logos* of this archaeology much more than Jennings does, and we might even say that he sets out to explore the *arkhe* of mankind's biological mind before the formation of any logos whatsoever. The visions of Jennings are trans-historic, while those of Morris are a-historic; but for both artists, the quest is trans-mental.

A simultaneous study of Morris's paintings and his position in international surrealism enables us to cast some light on the radical absence that haunts his works, and which his metamorphic rituals and totemic figures attempt to make up for. Morris's cells, organisms and biomorphs exist in a purely differential mode and are dependent on an original separation (we might even say 'aboriginal' given his interest in prehistoric art), a separation where the principle of creation itself quivers. As with the artists of the same family whom we have considered, but in our opinion to a greater degree in Morris's case, space is non-space, a non-site whereby the very ideas of space and place are called into

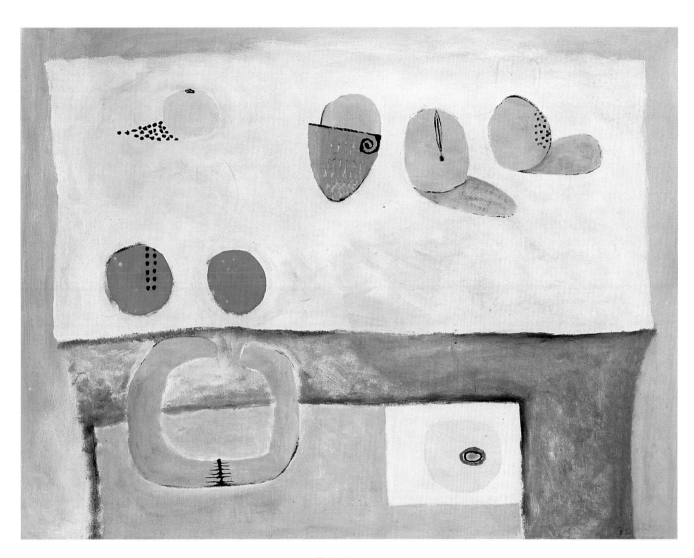

Table Pleasures
1969
Oil on board
45 × 59 in.

question. Forms do not find a location there, they are not situated; rather they generate a site – their own – and situate themselves by a kind of self-proclamation, since they rarely have an external reference. Space exists only by the *difference* which they introduce, in a sort of Hegelian *Aufhebung.* This is what we have in a painting like *Table Pleasures*: the space of these pleasures can only be a dissecting table, a very imaginary one at that, and a convenient support indeed whose reality is inversely proportional to the pleasure offered and played out there.

These approximate groupings, doubtful fili-ations, and informal relations between Miro, Tanguy, Arp, Len Lye and Jennings (and we could add others, since Edouard Jaguer proposes the Americans Baziotes and Gorky), confer on this "spiritual family" vague contours and an internal disparity in keeping with the essential and primordial absence at their core. This absence, which is conceptually inseparable from Morris's resistance to the static logos, his desire to plunge into a never-ending archaeo-typological census-taking and to multiply ephemeral figures in constant transformation, denotes the absence of a generating principle or figure which can be easily isolated and identified. Is this obsessional and ritualized search for the origins then nothing more than the search for an original father-figure? The erect masculine and feminine flying figures concentrated in the painting *Edgy* bear witness to this exploration of limits.

Indeed, it is clear that the feminine principle of proliferating creation is at work, and that the re-tracing upstream of the being's biological evolution is a plain example of regression (in the psychoanalytical sense of the word). As well, it is obvious that this space, which barely shows an horizon and is non-differentiated and twilit, is an amniotic space. We have given abundant examples of this in the preceding chapters. But this does not settle the problem of the origin which – beyond these proliferations and these spaces, and *before* them – fascinates Desmond Morris, in the same way as he was fascinated as a child by seeing a cytoplasmic whitish mass floating under the surface of the lake on his family's property. This fascination is of a complex narcissistic order; since the child's desire seems to have been to plunge into this maternal water (we must remember here that this mass seemed to him then to be the corpse of an infant), we might say his desire was also to join the interior and the exterior together, the masculine and the feminine, the little boy and his mother, in the

Biomorph
1972
Ink
6 × 3 in.

absence of the father. In that respect, we should remember that in the mind of the young Desmond Morris, this infant corpse could only have been that of a mother *abandoned* by her infant's father. Law and desire, Oedipus complex and regression, the father leaves the field open for the battle to be fought.

The origin lacks, then, the other member, the other partner in the process of origination, and this lack is compensated for by an evocation of doubles, by the production of organs that tend towards a full body, by meticulous attention to detail, and by an entire series of strategies beginning with diverse anthropo-sociological studies. These numerous volumes analyse human behaviour and the origin of gestures in a kind of attempt to return to the first man, above and beyond differences, and reach again the funda-mental man, the lost Adam, in a paradise that is just as lost. Hence the totemic figures that aim at exorcising this absence by referring back to the ancestral image, whose role is perhaps to protect, but who remain at a distance all the same, forever. Of course, we could quote at length from Freud's work *Totem and Taboo* and in particular from the last chapter, but a few lines here will suffice to sum up Freud's position, which – let us remember – results from psycho-analytical research and Darwinian hypotheses:

> The totem is the father-substitute . . . the totemic system was like a contract made with the father, a contract by which the father promised all that the infantile imagination could expect of him: protection, care, favours; in exchange for which was given an engagement to respect his life, that is to say, not to renew the act that had cost the life of the real father.

As we have seen, these birth rituals of forms are inseparable from the divisions that appear in the totemic figures of the Eighties. The "characters" of preceding years had already admitted – in the titles of the paintings – their powerlessness to impose order on the situation they found them-selves in, and the only direct reference to the totem is to be found in the highly significant title, *Totemic Decline*. Moreover, the masses are splitting up and this fracturing takes on a double meaning: on the one hand it liberates what proliferates and germinates, and on the other, it makes the original mass double. In both cases, there is an express wish to gain access to the missing element, to the complementary *unique double*, the "messenger" who, in a recent painting,

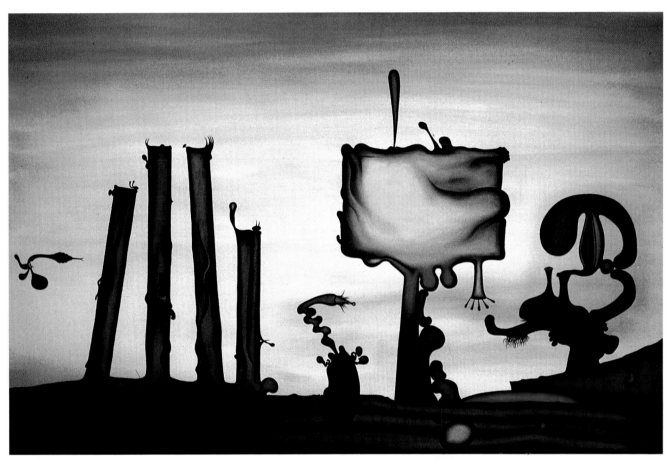

sets us dreaming by its static flight of the phantasmatic androgyne, the source and end-term of what is lacking.

We know from the text Morris wrote for *The Secret Surrealist* that, as a boy, he was deeply disturbed by the presence of his ailing father, whose slow agony was a result of the First World War. No doubt the paternal image deep down in him was irremediably damaged by the responsibility which, from that moment on, he projected onto the politicians, priests and military leaders for the death of his father. This image was cast into further confusion, and detached even further still, on the night when he paid a visit to the mortuary where the mutilated bodies of soldiers were laid out, opened up – dead soldiers, so many father figures abandoned there. But it is in no way our intention here to proceed with an amateurish psychoanalysis of Desmond Morris; these considerations are only superficial points that give possible reasons for the painter's leitmotifs, because – and this is what interests us – it is no less true that, from the image of the beast in the water to the coloured mirage of paternal organs, something of an aesthetic birth is taking place, in an emptiness that no one could attempt to fill.

In this way Desmond Morris's particularly fervent and obstinate production – almost 1,000 paintings if we count those he destroyed at different periods – can be considered as an enormous act of replacement whereby each painting attempts to tell not only of its own paternity, but also of that of others. Morris's insistence on the necessary inter-relation, and even interaction, between successive paintings

The Messenger
1988
Mixed media
13 × 8 in.
Collection Mr Robert
Page, London

of a same period – if we are to believe his words in the interview that begins this volume – is a good indication of the dispersion of this ultimate genetic authority. And in the heterogeneous nature of forms which are supposed to evoke ovules and spermatozoids, feminine and masculine organs, in their variations, in short, in the overall varying at work here, we can clearly discern the fragmentation of the entity to whom the power to engender was entrusted.

In his autobiography – since it is there that everything is played out, and to which we must refer – in each declaration or memory, Morris's father seems to be replaced by his great-grandfather. The latter was the one-time owner of the microscope discovered in the attic, and it was thus he who opened the *eye* of the painter and zoologist, and who is responsible for the revelation of the quivering at the limits of the visible, the discovery of the secret dramas played out *behind the eye*, upstream from it, towards the sources. This teaching which rests on the

Ancestral Biomorphs
1987
Ink
8 × 8 in.

this teeming interior life which is repeated in his paintings, to James Morris, his great-great-grandfather, whose arm was taken off by a French cannon-ball during the Napoleonic Wars, and who, no longer able to be the farmer he had set out to be, opened a bookshop in Swindon, thus introducing his family to the world of writing and intellectual reflection. This story reminds us that with Morris there is always an *elsewhere*, which is already there, another *origin*, another father. The totem returns eternally.

We have gained untold riches from this situation, and doubtless there are many others to come. In Morris's film, *Time Flower*, the father-doctor, though slain, continues to paint. This image signifies that the movement of Morris's eye, which according to Edouard Jaguer's phrase *goes further than any experimental verification*, is at the same time the movement of the mind that brushes away inherited mental catgories, which ceaselessly recalls an otherness that refuses to be mastered, and brings to our knowledge those

forefathers evidences a remarkable conjunction between seeing and reading. Indeed, in the desire to ensure the replacement of the father by the father's grandfather, Desmond Morris pushes further back the *origin* of his interest in

things we are unable, or unwilling, to remember. Desmond Morris's painting demands the memory's total engagement beyond itself.

Henceforth, the molluscs can sleep in peace: they have forgotten the shells they are to inherit.

CONCLUSION

In the first writings with which Desmond Morris attempts to situate his pictorial approach in the history of aesthetics, one idea recurs continually. It is that the invention of photography changed outright the laws and codes that govern representational painting – the art whose aim it is to *surrender* to external reality and to the models that it supplies. This viewpoint is to be found in the conclusion of *The Biology of Art* and recurs in many articles and interviews, including the interview to be found at the beginning of this work. For Desmond Morris, photography suddenly exposed the aesthetic aberration and deception which consists in believing that the function of painting is to represent. More than five hundred years of Western art were thus crossed out in their legislation pretensions – three thousand years even if we consider the art of the Bronze Age to be one of the last manifestations of the rejecting of exclusively exterior models.

According to Morris, with the perfecting of photographic techniques – to which were added sound-reproducing techniques – all oddly contemporaneous with the disappearance of the religious urgency underlying the aesthetic gesture – mankind arrived at a moment in its mental history where pictorial art was no longer invested with a function of communication, but with one of intuition or premonition. The interest which man shows in actual painting is of the same nature as that which a chimpanzee has before a canvas: both feel something of the pure joy procured by aesthetic creation and the sensation of discovering new spaces (hence, as we have seen, the degree of similarity in the automatic and spontaneous creations of both man and ape). The history of painting, or rather of the act of painting, has thus reverted to a point of departure, to the dawn of the world before the man-ape became the man-hunter, before the food gatherer turned into the predator. It is the importance of this return into the past – of vital significance in the development of man's imaginative power – that "The Lost Image" exhibition of 1958 attempted to emphasize.

For Desmond Morris, the important thing was to find again the source of the aesthetic creative gesture, and to do away with the false fathers who hid the access to it; this in order that we should be able to re-situate ourselves in a space purified of false idols and false truths. In tending towards this, we must rid ourselves of the superfluous images that encumber us by their stability and their relationships to the real,

The oracular work

Loved Figure
1987
Ink
6 × 4 in.

which they neither trouble nor question. Such is Morris's lesson.

Now losing the representational image means losing the entire body, and opening it to a necessary fragmentation. Moving back into the interior of the body, from fragment to fragment, often barely hinted at, and contrariwise to any unity, Desmond Morris is nonetheless able to celebrate the resurgence of the enigmatic image, the one which is supposed to inform the mystery and supply it with an answer. This is a singular paradox which consists in giving form to that which is without form, in saying what cannot be said, in telling the truth in a language as veiled as a lie, where forms argue over meaning. Through their ephemeral figures, their metamorphoses, their totemizations, Desmond Morris's paintings are enigmas that attempt to tell us the truth of the ancestors, or rather the truth of ancestrality. Was not the enigma-oracle of the Sphinx sitting by the roadside outside Thebes the expression of whatever is sacred in this ancestrality? In its prediction of a future event, it forced them to revert to a primordial scene; in speaking of the future, it referred to a past that was gone forever. Desmond Morris's paintings are places of eternal return.

After losing the image we find its trace, albeit a fleeting trace that constantly effaces itself, since, if it were not so, it would make a new image. After losing the father, we find again the father of the father who, in turn, is lost and replaced by his own father, and so on and so forth in an eternal return to the *origination* rather than the *origin* – it is easy to grasp the difference. Because the origin is always "already effaced", and the paintings can only announce its future effacement. Never present once and for all, the origin can only be postulated through biomorphic manifestations which, far from being echoes of the past, are announcements of what is as yet unheard of. In this way, without our being immediately aware of it, Desmond Morris asks us to understand these enigmas by re-thinking not only our relationship to the generating origin but also to the structure of thought that has been found on it. More Darwinist than Darwin himself, he plunges us into an infinite evolution removed from time, and consequently, un-originated, a sort of pure evolution: he produces the oracle according to which the question of origins is henceforth unthinkable and, by thinking the unthinkable, engages our biological, mental, physical and social *life*.

It is true that the unthinkable and the

unidentifiable are part of any oracle. All the Ancients were the pawns of this deep secret. Whether it be Croeseus, Pyrrhus or Philip of Macedonia, travelling to Delphi to consult Apollo, Colchis to consult Diana, or Dodonus to consult Jupiter – whatever the case may have been, the oracular words spoken were as peremptory as they were indecisive. Through these words the ancestors were made to speak, and even the unique and ultimate ancestor, the primordial voice and truth. Now the message transmitted was, in fact, already there, contained in forms that had to be interpreted, read in a different fashion, linked together between themselves in a solemn challenge to traditional knowledge and the usual modes of logic. The oracular value of Desmond Morris's paintings resides in this same principle: they announce a future which, in fact, is already present, contained in forms whose knowledge is situated beyond established knowledge, and whose history is perhaps to be read in a sort of prehistory, and most certainly in a meta-history. What better example could there be of the provocation of the limits of knowledge than the dream of 1949 entitled *The Day the Animals Came*, which gave rise to a long text sent in a letter to Conroy Maddox, the companion of Morris's most adventurous explorations. It is in this text that we see Morris's bioforms begin to stream by in premonitory fashion. Stretched out in the grass in the middle of a circle of breasts which point up to the sky, he feels that his neck has become the target for one of them; the goose-flesh covering his right hand is manifesting itself in small skin eruptions that look like teats; these begin to change colour and to explode in a swarm of small sexual glands . . . Following this there appears the double of the painter-narrator who gets up from the grass where he was lying and questions himself thus:

I wonder if the fleas I can feel running through my feathers are as red as my head must be now? I wonder if the rain will loosen the skin on my skull? I wonder if I ought to wave a flag if the King and Queen come by? I wonder why the summer is so obscene? (. . .) But I can see the man beneath me now and he is lying down on the grass. Now I feel all sticky and I think I want to touch him.

The logic that upholds our rational, public and official history is mocked at and short-circuited by a 'secondary' story, whose episodic irruption plunges us into a division of the ego.

Tripod Figure
1987
Ink
6 × 4 in.

The obsession with duality which is central in the most recent paintings corresponds to this hesitation between the legible and the illegible, the visible and the invisible. It is in this gap that new knowledge is to be found, it is there that words and images whisper with all the trembling of their many-voiced nature, like the rustling of the Sibyl's leaves in the trees around the oracle at Delphi. What falls from the mouth of the oracle are ambiguous and doubtful words whose paternity reverts to ourselves. As heirs of the oracle, whose function is to remind us of our duty, we move back into a history that has been kept secret and dark up till then, as implied in this text written in 1970:

There was a plop
in the well of my head
today.
An unseen hand
dropped something in.
Was it an accident?
Was it a jewel from a wrist,
or a pebble from a fist?
Or was it a small corpse,
the disposal of which
will foul the water of my thinking?
And how can I tell?
It is so dark inside my head.

From one question to the other, from one double to the other, from one foetus to the other, Desmond Morris, while pursuing a dialogue with himself, coaxes us into beginning a dialogue with what is deepest in ourselves, a dialogue which – because of its fragmentation – we exhume against our wishes in front of each drawing and painting. His images are mirrors of our past history as much as of our future conscience, twilit spaces which prove to be the oracular places of the dawn to come. This explains his fascination with a space where the image loses itself, a space in gestation, a space between two waters where dead bodies drift like embryos. It is the fascination of the oracle itself, whose voice is the plural voice of the totemic god who is supposedly the sire of the species, a *borrowed* and delayed voice, authoritarian but forever detached from its own authority.

The origin of Being lies in the impossibility of knowing its origin. That is the *drama* of all evolution which Desmond Morris's paintings, drawings and poetical writings theatralize almost unconsciously, with their repetition that attempts at exhausting what is an inexhaustible drama.

And this drama is not only present in the paintings – over there – but in the Other, who watches and becomes in turn one of the numerous scenes where the primordial struggle goes on. Because these divisions which we see, these moments of tension and imminence, are they not the faithful echo of the primordial mitosis and the reinscription of the process of cellular division *in new species*? By projecting this obsession with the origin into a non-chronological time, and expressing it through the mediation of oracles – signs of power without power – and by bringing us to integrate it in our interior life (or *intestine* as we have said), Desmond Morris turns biology into an enormous phantasy.

As the oracle announces, the new role of the painter is to reveal – in the difference between one painting and another – the inevitably phantasmic quality of signals of life and biological growth, of the search for the origin and of the very idea of the origin. In its desire for the meiotic moment, the ego is caught in the centre of a web of dissimilation, the centre of an emptiness that it is impossible to compensate for. The truth of the ego *is* this emptiness, and paintings and drawings are mechanisms destined to outwit and veil this dissimilation and the emptiness it causes – to thwart the dissolution of the foetal and narcissistic image under the surface of the water. Let us not forget this episode from Desmond Morris's childhood, inseparable from the original division figured by the father's abandoning of the mother. This separation is translated in the ego's unavowed desire to be given back its origin and be plunged once again by the father into the mother. Now this desire is thwarted (if we bear in mind the phantasm reported above) by the absence of the father; hence the constantly renewed effort to make up for this lack with an excess of paternal and totemic figures.

A perfect oracular structure! For let us remember that the person who addresses an oracle reads in the answer only what he or she desires to read, thus proving that he or she is or is not the controller of his or her own phantasies.

Beach Figure II
1987
Ink
6 × 4 in.

The oracle is nothing more than the objective, exteriorized confrontation between the individual and that individual's phantasy. By soliciting it, by begging it to speak, by listening to it and interpreting it, the individual opens on to his or her own double. The oracle is in fact a phantasmal mechanism.

In the same way, Desmond Morris tells us that the future of the biological ego obeys a phantasmal mechanism, that is to say it obeys a desire to actualize in the future a past absence. Just as law and repressed desire are one and the same thing, the pictorial discourse, however metamorphic it may be, cannot exhaust the desire that underlies it: they are the reverse sides of each other.

Such is Desmond Morris's contribution to international surrealism. He shows us how to play with the myth of the origin, and how to detach it from itself, that is to say how to play with what founds all rational discourse, religions and ideologies. Between Miro and Len Lye, Tanguy and Jennings, he traces out a new imagination, a new type of relationship between our so-called external and internal realities. It is to his heightened consciousness of the emergence of forms, to his sensitivity to their variations, and to his systematic exploration of them, that we owe the creation of a new and literally mythopoetic space. Psycho-biology? Phantasmology? Originology? We wish there was some word to sum up Desmond Morris's approach, but the *object* of his pictorial oracles cannot be delimited at all.

All we can say – and this remains valid for all Morris's works – is that by apertures and deformations which are all *initial*, we continually slip from the single to the double, from the mental to the social, from the individual to the collective, from the dreamlike to the mythical, without ever completing this passage from one to the other. In this slipping, or rather in the repeated attempt to master it, the ego finds itself irreversibly confronted with the ultimate anonymity of its species. Darwin has lost his name.

APPENDICES

I
Biographical Notes

1928 Born at Purton in Wiltshire, England.

1945 Began painting seriously and set up first studio, at Swindon in Wiltshire, England.

1947 Appointed lecturer in Fine Arts at the Chiseldon Army College, during his army service.

1948 First one-man show of paintings, at Swindon. Second exhibition there later in the year.

1949 While attending Birmingham University, joined the group of surrealists led by Conroy Maddox and exhibited with the Birmingham Artists Group.

1950 First one-man show in London, at Edouard Mesens' London Gallery. Wrote and directed two surrealist films: *Time Flower* and *The Butterfly and the Pin.*

1951 Exhibited at Bristol, as part of the Festival of Britain activities, and also at an International Arts Festival in Belgium.

1952 While at Oxford University, exhibited at the Ashmolean Museum there.

1957 Organized an exhibition of paintings by chimpanzees at the Institute of Contemporary Arts in London.

1962 Published *The Biology of Art*, a study of the roots of picture-making.

1964 Visited By Joan Miro in London.

1967 Became Director of the Institute of Contemporary Arts in London. Published *The Naked Ape.*

1968 Moved to the Mediterranean for five years, setting up a new studio on the island of Malta.

1973 Returned to England and a large studio at Oxford.

1974 Held one-man show of new paintings at the Stooshnoff Fine Art Gallery in London.

1976 Held four exhibitions. One-man shows at Wolfson College, Oxford, at the Quadrangle Gallery, Oxford and the Lasson Gallery in London. Also a restrospective exhibition at the Public Art Gallery in Swindon.

1978 Held one-man show at the Galerie D'eendt in Amsterdam, and also exhibited at "Surrealism Unlimited" at the Camden Arts Centre in London.

1982 Was included in an exhibition of British surrealism, called *Les Enfants D'Alice* at the Galerie 1900–2000 in Paris.

1983 Published a fantasy called *Inrock.* Exhibited in a Christmas show at Wylma Wayne Fine Art in London.

1985 Published *The Art of Ancient Cyprus.*

1986 Included in the exhibition *Contrariwise: Surrealism and Britain, 1930–1986*, at the Glyn Vivian Gallery in Swansea, Wales. The exhibition then travelled to Bath, Newcastle and Llandudno during 1986 and 1987.

1987 Held one-man show at the Mayor Gallery in London. BBC TV presented a film about his painting in the programme *Review.* Exhibited at the Keats Gallery in Belgium. Phaidon published *The Secret Surrealist: the Paintings of Desmond Morris.*

1988 Held a one-man show at the Shippee Gallery in New York. Also held a one-man show at the Keats Gallery in Belgium, and exhibited at the Ghent Art Fair there. Included in *The Avant-garde in Britain, 1910–1960* at Fine Art Associates in London.

1989 Held a one-man show at the Mayor Gallery in London.

1990 Exhibited in *Surrealism: From Paris to New York* at the Arnold Herstand Gallery in New York. Also represented in *Surrealism, a Permanent State of Lucidity* at John Bonham, Murray Feely Fine Art, London.

II
Time Flower

Film Scenario. Summer 1950

A girl lies with her head buried in the grass.
Her hands claw at the turf.
A man stands nearby, smoking and thinking.
Suddenly he realizes she is running.
He pursues her.
The faster he runs, the faster she runs.
Thoughts flash through his mind as he runs and he sees himself entering a church.
He is in evening dress.
Inside, he is astonished to find himself in a strange room.
He sees a carnation and secures it for his buttonhole.
Looking around the room now, he finds he is not alone.
A white-robed doctor is sitting, quite still, as if waiting for him.
The doctor advances and hands the man a card on which he sees the number 53.
He feels he should accept it and puts it in his pocket.
The doctor is manipulating a hypodermic, and beckons the man to sit down.
This he does and the doctor injects his carnation, a painful operation for the man, whose closed eyes begin to flicker.
As they open, his mouth tries to open.
It succeeds laboriously and a third eye, within the man's mouth, is revealed.
All three eyes begin to blink, and now the carnation has turned into a disc which says 53.
The doctor finds that his watch has stopped (one of his eyes has also disappeared) and this annoys the man who takes a dart from a tray of surgical instruments, and throws it at the large clock on the wall.
The clock, which has no numbers on its face, but odd letters instead, begins to bleed where the dart has pierced it.
The pendulum is still, and is held under the clock by a rotting glove.
The doctor shakes his head at this, and the man is so furious that he tears off the disc saying 53 and destroys it.
The doctor hurries to the mirror, which has taken up the position that he himself first occupied, and covers it over with a drape.
The man is fed up and sits down at the table again, and strums his fingers.
His fingers strum faster and faster, and then suddenly they are his feet running again.
The girl is coming to a rabbit-warren and the frightened rabbits scatter as she trips in one of the holes and falls headlong.
The man, seeing this, runs faster than ever, but she is up and away, glancing over her shoulder in terror.
As she flees, she too experiences a kaleidoscopic vision.
Her bobbing eyes become the swirl of wine being poured out of a bottle.
She is sitting at a table in another strange room.
On the table are the glass, the bottle, and a telephone.
As she drinks, she is being watched by a magician (who has the doctor's body).

She is in evening dress.
The magician offers her a pack of cards fanwise and, although she is listening at the phone, she takes one.
As she realizes what she has done, she leaves off phoning and turns the card slowly over.
On it she sees an eye.
This makes her cry and her tears fall into the wine, which the magician drinks.
This makes her furious so that she leaps up and whips the magician's face, producing black, horizontal lines.
The magician, unmoved, produces two white balls out of the air.
He places them on the table, and the girl, who is lighting a cigarette, ignites them.
She then sits moodily at the table, smoking and tapping her heel.
Her heel taps faster and faster, and becomes her legs running.
She makes for a forest now and, once there, hides behind a tree, resting.
The man has lost her and searches wildly among the undergrowth.
Then he sees her skirt showing around the base of a tree.
But suddenly he realizes he has come to the edge of a deep ravine.
As he stands on the edge looking down,
the ravine turns into the brick surface of a yard over which he is walking.
He is in evening dress again, with a scarf and gloves.
He enters a shabby garage door.
Inside he is annoyed to discover that he is in the same strange room again.
He dispenses with his gloves and scarf and begins to smash the table and chairs in a fury.
He is arrested in his actions by the sight of the doctor painting at an easel.
He is painting a large picture of the number 53.
Half his head is black, half white.
The man is so annoyed that he rushes to an old chest on which there are two swords.
Throwing one to the doctor, he begins to fight him.
The latter is quite calm.
Then the man knocks down a lighted candle which diverts the doctor's attention.
In that second the man plunges his sword into the doctor's stomach, up to the hilt.
Blood pours from the wound, but to the man's amazement, the doctor simply nods slowly and seriously.
Irritably, the man withdraws his sword, and the doctor returns to his painting.
The man goes to the treasure chest and opens it with his sword.
Inside he finds a mass of keys.
These he starts to try one after the other in the door.
None fit.

In the meantime the doctor has finished painting and now sits again in his original position, smoking an opium pipe. The man throws himself onto a pile of cushions and begins to play with a balancing toy.

The toy slips and falls off its stand.

It becomes the man himself, who is slipping over the edge of the ravine.

The noise frightens the girl, who flees once more.

The man clings to some tree stumps on the slope, but they are rotten and he falls.

The girl runs wildly through the undergrowth, but is stopped by the sight of a hedgehog which is fleeing from her.

She stares at the animal which becomes a large skull.

She is standing by it in evening dress once more, and the magician, who had been worshipping the skull, on seeing her, takes it in his arms to protect it.

On consideration, however, he offers it to her.

She directs that it shall be put onto her table.

She sits at her table again.

A hammock swinging low near her contains a young alligator.

The magician produces two plums out of the air and places them on her table.

After listening at the phone for a while, the girl looks at the magician and with her eyes fixed on him she reaches out and puts the plums into the eye-sockets of the skull.

This upsets the magician, who wrenches the phone out of her hand.

As he does so the woman gives a jump, for she realizes that the man is now crashing through the bushes quite near to her.

His arm and hands are cut and bruised, but he stumbles after her as she flees again.

The girl leaves the wood now and comes to a peculiar hill. She begins to climb.

The man follows slowly, but when the girl has reached the top of the hill, she can only stand and stare and wait.

Slowly the man appears over the top of the hill.

The girl stares into space.

Her eyes close, and their closing becomes the clasping together of the magician's hands.

The girl is in evening dress again and stands against a black wall in a maze of cords.

The magician cuts her loose and she walks aloofly towards her table.

Halfway across the room she sees the magician's earring swinging and tears it off, putting it into the hand of a black figurine.

The magician holds his ear for a moment, then brings both hands down to the front of his body.

Two eggs appear in his palms and these he places, as before, on the table.

The girls picks them up and as she turns them over two eyes appear on the shells.

At the same time, she opens her eyes to find the man is now facing her on the summit of the hill.

He advances to stand close in front of her.

She faints.

The man, clasping his wounded arm, looks down at her.

He sees his feet walking on a gravel surface in evening dress.

He enters the door of a house and discovers, almost pathetically, that he is in the same room again.

He sees that a body on a slab is covered with a sheet.

He uncovers the head to see the doctor lying there.

The face of the corpse is white.

He goes to the feet and uncovers them.

One is black and one is white.

Around the white foot is a label saying 53.

The man shrugs, but has one more look at the head which, to his horror, is now his own.

Around his neck he sees a key which he snatches and tries in the door, but without much hope.

Nevertheless it works.

In the half-open door, he turns.

He sees a bird sitting on a violin which is exploding.

He leaves and as he does he finds himself walking to the edge of the hill.

He pauses, then falls to his death at the bottom of the hill. His feet twitch.

The girl's feet, however, are quite still as she lies on top of the hill.

But her head, which is buried in the grass, moves perceptibly from side to side.

Her hands claw at the turf.

(*Time Flower* was filmed in August and September, 1950, at locations in Swindon, Wanborough, Avebury and on the Marlborough Downs.)

Surrealist poetry by
Desmond Morris (selection)

THE ONE-EARED GODS

The one-eared gods of inopportune belly-laughs,
accentuated by one whimpers-worth of visceral-warped
female pebbles,
beleaguered by ornate inkpots of a bygone era,
prostituted by the sisters of the government's
flag-sellers,
decided to reserve their occupations as essential,
owing to the national situation
brought about by the production
of synthetic women.

September 14th 1947

THE GREAT WINGS

The great wings
of the poison penumbra
beat slowly above the heads
of the semi-intimate
as they small-talk their way home,
not a contraceptive's throw
from that breeding place of lonely houses
where pink crinkle and ivy rubber
are stowed in every love cupboard.

1947

THE LINCOLN WALLS

The Lincoln walls
and the hard green
seduction of the night's
unwilling charge,
changing with the
race of horses and
the race of blood,
to yet another
yesterday.

And the sun had to shine.

March 1948

FOR LEONOR FINI

Her brush is a muted trumpet and
from her eyes come bullets
which fail to penetrate
but splatter perfumed acid
on the surface of our tanks
and melt our snouting guns.

Her thoughts are metal feathers
which catch the wind and
quickly prod aside tomorrow's

curtains, showing some other
place, where seasons hold their fire,
an easy target for her loaded eyes.

November 1948

THE KETTLE-HEADED BOYS

The well placed ball tears out the breast,
pulled from the body's most illustrious folds
by unborn mutants weaned on tube-struck foam,
and pits the throat with orange fins
until the shutting hinges
pinch the curving fear of stale distractions
which stain the underclothes of sterile hairs
until the cry is heard of swarming
pattern tales.

The gleaming limbs ascend the sterile hills
of calm solidity,
watched by an ear of salted yesterdays,
upon another's back,
waving to the several crowds who run apart
to show the engine's clothes
to nearby altar-pans whose single rims
reveal tomorrow's learned symmetry.

The velvet shirt unwraps,
revealing unkind telephones whose lines depart
to see the grandchild's chest of drawers,
from which a quiet sneezing sings
to the American toilet . . .

. . . while all around walk stairs
up which no hands may climb
to see the sonnet thrash from doors
unlocked to these ten sailors who,
changing their dresses,
call and tie their pockets to a shining can,
by which a laughing gate can open all our eyes.

The puckered teeth of the brain
roam around the palace grounds
searching nowhere for the uttered thoughts
which little words are needing,
and the slope is filled with the yellow desks
upon whose lobes these gentle screams
are spoken to an audience
of kettle-headed boys
whose pastimes are unheard of.

November 15th 1948

SHOULDER HIGH

If there is a loud bang in your fingertips
never permit your reflection

to look at you from shop windows.
If you are sitting in a room with no ceiling
try and remember what time it was
when you had your first nose-bleed,
or the occasion when you climbed over
the third side of the fence of screaming reciprocals,
and heard a bell ringing in the distance.

The grass in the bedroom is damp
and it is probably better to wear
horn-rimmed spectacles
than burn your tongue.
But the heat from the mirror
that was a funeral gift
has brought on the rain.
The drops are very large
and each is falling several feet away
from its neighbours,
so that it is just possible not to get wet.
In the distance three firemen
are carrying off a plastic surgeon
shoulder high.

<div align="right">1948</div>

THE SIDEWAYS MEN

The orange flowers of the sideways men
swing from the fifty debts of the ancient bottles
that belonged to the dejected clearing
beyond the folding hills over the fence across the crimson
field
where in our youth we stripped the moon.

The legs and toes of unlisted lives wave to the winged
plants
of some other minute.

Below the spines of glass stems the furcoats are unlocked.

Around the sun and moon a sphere engraves its name.

The daughters of the outsides are coming in
on toads-wings feathers.

Aabbcc and the rain is dead.

Welcome to your two spheres at once.

<div align="right">1948</div>

EXOTIC HEADS

Exotic heads and happy unicorns
trample the antlers of the polar saucers
in the husband's library.
The fiddle on the floor is sitting
in front of the fire
without noticing the flowers

in the chimney
and outside the air is crowded with boulders.
Squares of hairs are singing in parallel
with no particular aim in view
and the suicides
on the edge of the interminable armchairs
are feeling bored.

<div align="right">ca. 1949</div>

WOMAN IN THE MOON

The face of the woman in the moon
is watching a young girl
who is reading the directions on a sealed box:
". . . If there is damp on your elbow,
unwind the ribbons around your chair's legs.
If there is a whisper in your navel,
burn your letters in no uncertain tone of voice.
If there is a fireplace at the bottom of your garden,
never blow your lover's nose . . ."
She throws the box angrily to the ground.
Turning her face, she watches three men
as they walk down the street and into a building.
She follows them.
Three tables are sitting at a bar smoking
their ashtrays.
They separate in the middle as she enters
and stand up straight.
Three of the halves are the three men.
With each is a woman holding a moistened shirt.
One of the three men receives a message
and they tie the shirts between their legs.
They begin to dance back and forth
in different coloured lights from a stained-glass
window, by which a weeping tree can tell the time
of night.
The girl is sick.
She leaves by a series of revolving doors. . . .

. . . The glass in the first door is cracked,
in the second it is broken,
and in the third, frosted over.
There is no glass at all in the fourth door
and through it she can see the sloping street.
Walking up and down are policemen disguised
as whores.
The girl is terrified and runs back to where
the broken pieces of her box lie scattered
on the pavement.
Laboriously she begins to stick the bits together
with some discarded chewing-gum.
An hour later she finds she has made three small boxes.
This puzzles her, as it seems the only way
the pieces will fit together again.
One of the policemen finds her crying.
They link arms and disappear.

In the distance a lorry runs over a peacock,
but the driver does not stop.
He is looking at the face of the woman in the moon.

March 16th 1949

THE DAY THE ANIMALS CAME

It's no good, they won't go away, they are following me into
the studio and grazing all over the canvases. There's one
enormous creature I can just see out of the corner of my
eye perched on one of the highest branches of the tree that
hangs close over this glass roof. Without looking straight at
it, it seems different from the rest. It has a single claw and a
red head with big teeth fixed all around it which strangely
enough seem quite sad. Going out through the door I can
now see that I was wrong; it is in fact a circle of very
pointed breasts and although I am lying on the grass in the
heat of the afternoon, one of them hangs right down out of
the circle and reaches the side of my neck. For some
reason this produces goose pimples all over my right hand.
The goose pimples grow and it's as though the whole of my
palm is giving birth to a field of nipples. This makes me
want to bite at my clenching and unclenching fist. I find I
am having to figit my legs. Just as I am going to bite, each
nipple changes into a colour of its own and bursts off and
flies up into the air. They start circling, a swarm of little
sexual buds, around the creature on the branch which sways
precariously. The wretched thing begins to fall slowly and
the frightened pebbles, which have grown long female
hairs, scatter up into the sky which is now changing colour
rapidly, reminding me of an overworked coloured fountain
at a seaside resort. I can just catch a glimpse of them as
they disappear into one of the four black spheres that have
taken up their positions in the four corners of my vision.
But then the great soft creature falls over me and the sky
has gone blue again . . .
There's a lorry going by and a dog sniffing and a cat
scratching and fine spider's webs are falling and a ditch is
spitting and two stones are hissing at one another and some
concrete is making a hard noise and a tree trunk pitted with
all sorts of human bits and pieces is trying to twist as
though it were singing the blues or just waking up after a
night of contemplating an abortion.
I am lying with my face on the ground with a clump of
grass in my mouth and my eyes shut. I have been
wondering for some time whether, if I opened one eye,
someone would mistake me for a needle and thread barbed
wire through my brain. The idea now terrifies me so much
that I have to strain my imagination tight over my skull so
that both eyes are slowly pulled open exactly together.
There is now a moment of peculiar, mounting tension that
makes me expect to hear panting in my ear, but instead I
feel the swish of leaves and my skull is still tight. My legs
are also tight together and I find on looking down that they

are now a single hard claw and the grass is a long way
below and I am eating leaves.
Inside a glass roof a man is painting watched by a circle of
animals. He sees me out of the corner of his eye and begins
in a curious way to watch me. I can feel myself starting to
blush to a deep red. He has stopped his painting now and
is coming slowly out of the door until he stands and looks
straight up at me. Hundreds of thoughts rush through my
mind as he stands there. I wonder if the fleas I can feel
running through my feathers are as red as my head must be
by now? I wonder if the rain will loosen the skin on my
skull? I wonder if I could copulate in flight? I wonder if I
ought to wave a flag if the King and Queen come by? I
wonder why the summer is so obscene? I wonder why
those bells are making such a noise? I suppose they must
be selling something at the church, or perhaps something
is wrong? I wonder what could go wrong on such a bright
summer afternoon as this?
But I can see the man beneath me now and he is lying
down on the grass. Now I feel all sticky and I think I want
to touch him.

June 28th 1949

SOFT CAT CALYX

Soft cat calyx
under little moons stirring
with no wind's blather
as each other's stars
sway in this far-fetched string of knots.

A forest would work
and no leaves seem harder
in a book of black silk memory
unless the tittering pollen in her eyes
is shed to sting the skin of the waterfall
that never listens to a single cry.

1950

AFTER-THOUGHTS

A clumsy nodule never clearing
up or down or inside round
the smooth eclectic sound
of mud petals sleeping
in and out the slanting moment
whose curse is only taken home
to bring about a coarser hair
upon the great fat little mat
when no-one calls for help
in hell upstairs
where children never go
until they die from day to day
on spiral springs
of acid after-thoughts.

1950

THE CLOWN'S GOWN

The clown's gown is worn
in towns whose rims smoulder
and flood with tears each sexless bladder
on these stumbling beaches
by and by and buy the best is always going first
and if again minutiae
escape the eye
come back yesterday
and slash your beaming backs outside
the striated banner box
in which no coloured balls can bounce
a tune quite half as well as
razors read a blistered book.

1950

BOTANY LESSON

The petals are falling from the Freudian flower
as the precarious parrot
calls to its ancestors
to launch the lifeboat
that the one-eyed needle god
dubs wicked.

The flowers are dying on the platonic planet
and the parrot seed
is alive and kicking the gong
in the temple of the polygamous priest.

The plant is wilting in the fidgeting field
which is ploughed by the ants
who strangled the vicar
with bootlaces.

And now the field is dead.

1950

A SMALL DESPERATION

Finding a crimson stone on the edge of the carpet,
there was nowhere to go.
There was nothing to do
except dust the weeping ornaments,
but tears are the property of the cracked glass
and should not be dried.
Their stream fertilizes the grass
which can be made of coloured metal or twisted swords.
Only now and again
can the clarity of mislaid temper
wield the blacksmith's hammer,
and blow after icy blow solve this filthy honesty.
Sickness of the legs can be cured
by a wonderfully reflecting transparent rope,

but the cords hanging from the trees
are never clean enough to swing from
by one's hips.
Blood running to the head can be diverted
into graduated bottles
and the humidity may be calculated
to reveal the hideous beauty of the drop of sweat
that is about to appear.

July 1950

THE ENVOY

The cephalized tauric envoy
interrupted in translocation
by an enigmatic asteroid . . .

An irradiated union blessed
by the nunnery slaughterhouse
in waltz-time every week.

25 January 1951

THE SCENTED LINE

Beyond the scented line,
the corrosion of my seeing limbs
grows soft with unbelievable spray
which staggers from the foliage
at your leaning feet.
The lips of my heart grow weak
at the threshold of your great vision
and my hunting bones subside,
attendant on the flight
of the white arrows' swarm.

February 1951

EASTER MONDAY

Come down the steaming ladder
into our embrace
and find the staggering focus
frowned with painted cracks
upon the smoking glass,
blinked with crooked cymbals
lain in disarray,
until, hoarse-calling, the clinging sabres,
blessed with copper-crumbled grace,
unfrenzied below the frantic nostril's flare,
can splinter into blind fountains,
cursing, teasing, pleading
with a dying garland
bathed in sacred milk.

1952

LEES COTTAGE

This is the poem of the destruction of rubble
the song of the birth of beetles,
or of the rich crying of book-ends.

In the dying moment with sweet blunted points
there is no calling out
and the air is filled with water.

Tumbling, fur-lined bones, crystal leaves,
and petal-scales
drift in light mists around the floor-beds.

This is the time of the caged grasses,
the hour of abstract ritual,
or the infinite fluttering that circles
the dimly-lit cavities of the mind.

With a slower pace
the solemn peace of tidal memory
finds itself alone, surrounded
by stupid, cursing waves.

August 14th 1952

THE EVENING'S HORSES

The evening's horses run their race
towards the simple shapes
of shadowed yesterday.
The nightwind's plumage feels
its flutter ending in the target's rim,
and then my echoes are mingled
with the salt of a stone's shallow tears
calling softly to my mate
to unfold the story of her white seduction.

1952

THE GREEN EYE

Past the green eye
to the open field of incurable screens
I am driven
and wander, browsing with reluctance.
There must be an easy corner somewhere else
and a slight push in the wrong direction
would lead to a multi-coloured circle
in which black letters spell out
next year's mistakes.

1952

THE FACE OF MY BRAIN

Your limbs are mountains
on the face of my brain.
You are walking along the tightrope
that stretches between the eyes I have for you.
Yet all I can hear is your eyelashes
burning inside my ears.

Amongst these trees a small pile
of folded sheets lies silent,
the unused sails of a sexual yacht.

There is a rug lying upon the sea
and our voyage is pursued by scissors
which cut off the buttons
of our gaping volcanoes,
as the Persians were said to do.

1952

ALLIGATORS' TOES. A DREAM

A small lake, dark and wooded at one end,
light and open at the other.
Black forms are swimming in the water
at the dark end of the lake.
They have seen me.
They follow my canoe.
I paddle faster.
The faster I paddle the faster they follow.
I make for the open part of the lake,
the alligators following close.
I reach the bank and leap out.
I begin to run from the water.
The alligators follow as fast.
I reach my bicycle and ride away speedily.
They still follow.
At first I gain speed but they never lose sight.
I reach the cinema at the corner of the street.
Throwing my bicycle down, I rush in.
I buy a cheap seat and sit in the centre
of a crowd of women.
They are all cackling.
The scene is upside-down.
I have seen the film before.
There is shrieking at the door.
The alligators are pushing their way in.
The women scream.
I jump up and scramble over them.
I walk on their heads.
The alligators are coming on.

I jump into the pit where the orchestra plays
and squeeze through their exit and entry hole.
I can hear the alligators coming . . .
. . . I am in a passage and it is a dead end.
All the walls are flat.
The floor has started moving,
moving in the direction of the orchestra pit
where the alligators are.
I can hear them now.
They have taken up the instruments and are playing.
Water starts trickling in the direction of the musicians.
The water level gets higher and higher.
It reaches the five inch mark and then stops.
There is a war on.
An air raid.
Bombs.
People start coming down into the shelter.
They crowd in.
There is not enough room.
Bombs falling.
An artist rushes in to draw the frightened people.
He finishes and goes out.
I follow him up the winding stairs.
He gets out of sight round the corner
and when I arrive at the top he is gone.
I find myself in a deserted street.
I turn to the left and right and start walking.
It begins to rain.
A thunder-storm.
The flashes of lightning illuminate the cars.
Inside them are engine drivers and firemen.
The cars are out of control.
They are washed away.
I follow, running, to see what happens to them . . .
. . . The water gets deeper.
We come to a cliff that he has been turned into a waterfall.
The cars are going over the edge and disappearing.
An engine driver falls from one of the cars
and as he hits the water he is an alligator.
I jump back and feel myself falling over the cliff.
I land on a tree at the bottom.
The squirrels are curious.
They are chattering as they knit.
The wool stretches in long lines down to the ground.
I jump onto one and climb down it to the ground below.
The wood is very thick.
I come to a golf-hut.
They are playing golf with human heads.
They see me and start chasing me for my head.
I hide in a bunker and climb into a rabbit hole.
Everything is dark.
I hear music.
It is the alligators playing.
I am back in the cinema.
One of the alligators' jaws are around me.

Thousands of teeth.
I give in.
I am too weak.
They kill me and I sink.
I sink into blackness.

ca. 1952

DAWN CHORUS

There are flowers on the grave of night
as day's embryo-hour
greets with hard pellucid stare
the haze of that nocturnal funeral
that has held
in its all-embracing void
the quiescence of a tomb
of royalty.

1960

STOP THEM IF YOU CAN!

The end
stands at the corner of the field.
There is a follower whose rose's cobwebs
drip and spray the pollen of his tears,
until the undulating furrow
flows with arrows.
A flight of shafts moves
towards the orchard's wall
and to the prone beginning.

1960

SHE IS . . .

She is a rock pool
She is the bed on which I hang my Christmas stocking
She is a furious whisper in my navel
She is a field of blue poppies
She is a sneeze in the dark
She is a coloured lantern
She is an ice-cream in the desert
She is a swarm of bees between my toes
She is a graceful yacht skimming across the sea of my brain
She is a dreaming hammock in the garden of my arms
She is a golden bottle whose label reads 'Now'
She is the ticker-tape
She is the Milky Way
She is the sphinx whose paws tread my chest
She is the purple cloud that drifts across my mouth
She is my burning snow
 my avalanche of fire

my stick of rock
 my secret sand-dune
 my tunnel of love
 my pendulum of timeless hours.

August 25th 1964

ANY BODY

Any body
will split the difference
and suck
the poison of a
lightning fork
spreadeagled
on the field
of love.

ca. 1966

LOVE IS A LIZARD

Love is a lizard,
handy with a fly,
hot on a flat stomach stone,
quick of glance
and slow in winter,
skin bright, feather-tongued,
clinging like lichen,
vanishing
like
a
mirrored
smile . . .

April 7th 1970

DARK INSIDE MY HEAD

There was a plop
in the well of my head
today.
An unseen hand
dropped something in.
Was it an accident?
Was it a jewel from a wrist,
or a pebble from a fist?
Or was it a small corpse,
the disposal of which
will foul the water of my thinking?
And how can I tell?
It is so dark inside my head.

1970

THE LOST ART

Leaves and hair-parcels
end their days in quiet
embrace with rising fears
and soft faces watching
the frosty glass.

Passing the long night
before the inner roots
begin to nose their proud
beginnings, we are deaf to
the elephant's tidy song.

Smoke slides flat in
friendly waves under the
rim of the great bowl
that used to catch our
tears before we lost the
art of angry clowning.

April 21st 1989

THE SOCKET OF GREEN

The socket of green,
close by the crowded limb,
calls to our moist palms
and dares our knotted tongue
to recall the day the clock stopped
with deep regrets that all our pains
are folded down
and stuck fast to the memory
of neglected eggs,
lying snug in the nest
of our longing.

1989

IV
Checklist of paintings by Desmond Morris

This is a complete list of all the known surviving paintings, giving in each case the title, medium, dimensions to the nearest inch (height before width), and owner.

An asterisk indicates that the present whereabouts of the picture is not known. Where there is no asterisk and no owner's name, the painting is still in the possession of the artist.

1944

1 **Night Music** Crayon on paper, 5 × 7 in.
2 **Dream-flight** Crayon on paper, 10 × 8 in.*
3 **Sleep** Crayon on paper, 8 × 13 in.*
4 **Chicago** Crayon on paper, 8 × 13 in.*

1945

1 **Portrait** Wax crayons and pencil on paper, 9 × 6 in.

1946

1 **The Kiss** Oil on board, 16 × 13 in.
2 **The Entry of a Siren** Ink and water colour on paper, 10 × 8 in.*
3 **Sunbath** Ink and watercolour on paper, 10 × 8 in.*
4 **Night Comes** Ink and watercolour on paper, 10 × 8 in.
5 **They Came to the Door** Oil on board, 15 × 20 in.*
6 **Over the Wall** Oil on board, 30 × 26 in.*
7 **Sketch for the Philosopher's Abyss** Ink and pastel on paper, 8 × 10 in.
8 **The Philosopher's Abyss** Oil on board, 19 × 24 in.*
9 **Girl Selling Flowers** Oil on board, 29 × 35 in.
10 **Two Fish in Heaven** Oil on board, 22 × 29 in.
11 **The Family** Oil on board, 28 × 19 in.*
12 **Seated Woman** Oil on card, 19 × 14 in.
13 **Nightscape** Oil on board, 14 × 10 in. Collection Mrs Marjorie Morris, Oxford.
14 **Last Drink** Oil on board, 18 × 14.*
15 **The Actress** Oil on board, 21 × 14 in.*
16 **Aquascape** Oil on board, 14 × 11 in.*
17 **Woman in an Armchair** Oil on board, 27 × 16 in. Collection Mr Tony Hubbard.
18 **Knock Once** Oil on board, 20 × 25 in. Collection Mr John Comely.
19 **Portrait of a Lady** Oil on board, 22 × 10 in.*
20 **Landscape Without a Memory** Oil on canvas, 8 × 11 in. Collection Mr Clement Attwood, Swindon.
21 **Christmas Painting** Oil on board, 24 × 32 in.*
22 **Mother and Child** Pastel and wax crayon on paper, 10 × 8 in.

1947

1 **Portrait** Pastel on paper, 15 × 12 in.
2 **Portrait** Pastel on paper, 16 × 11 in.
3 **Four Soldiers** Pastel on paper, 16 × 11 in.
4 **Portrait** Pastel on paper, 15 × 11 in.
5 **Cat and Bird Landscape** Oil on canvas, 9 × 12 in.*
6 **Portrait-landscape** Oil on card, 16 × 11 in.*
7 **Entry to a Landscape** Oil on board, 20 × 16 in. Peter Nahum Gallery, London.
8 **The Bride** Oil on board, 21 × 18 in.*
9 **The Bird Above** Oil on board, 26 × 33 in.*
10 **Young Woman on a Bus** Oil on board, 25 × 17 in.*
11 **Discovery of a Species** Oil on canvas, 19 × 14 in.*
12 **Woman and Two Green Apples** Oil on board, 16 × 21 in.*
13 **The Illegitimate Dance of the Long-nosed Woman** Oil on canvas, 12 × 10 in.
14 **Potrait** Oil on board, 18 × 14 in.*
15 **Kittentrap** Oil on board, 12 × 16 in.*
16 **Bird Sunscape** Oil on board, 14 × 21 in.*
17 **Woman Reading** Oil on card, 16 × 12 in.
18 **Still Life with Fish** Oil on board, 12 × 12 in.
19 **Giant Instrument for the Production of Synthetic Women** Oil on canvas, 10 × 8 in. Collection Mr Francis Wykeham-Martin, Gloucestershire.
20 **Birds and Insects** Oil on board, 8 × 10 in. Collection Miss Nancy Norris, Swindon.
21 **The Departure** Oil on board, 14 × 10 in.
22 **The Nest I** Oil on board, 13 × 17 in. Collection Professor Aubrey Manning, Edinburgh.
23 **The Nest II** Oil on canvas, 13 × 19 in. Private collection, Vienna.
24 **Nude Woman** Oil on board, 38 × 25 in.*
25 **Portrait of an Actress** Oil on canvas, 28 × 13 in.*
26 **Portrait of Patricia** Oil on board, 20 × 16 in. approx. Collection Mr J. Mitchell.
27 **The Widow** Oil on canvas, 20 × 30 in. approx. Collection Mr Mervyn Levy.
28 **Bird Singing** Ink and pastel on paper, 11 × 18 in.
29 **Moonscape** Oil on card, 10 × 8 in.
30 **Landscape for a Para-introvert** Oil on card, 14 × 18 in. Collection Mr Hugh Clement, Wales.
31 **Master of the Situation** Oil on canvas, 16 × 12 in. Collection Mr Alasdair Fraser, London.
32 **Acrobat** Mixed media, 8 × 4 in.
33 **Dancing figure** Mixed media, 4 × 5 in. Collection Mr S.J. Kennedy, London.

1948

1 **Confrontation** Oil on canvas, 18 × 12 in. Eric Franck Gallery, Geneva.
2 **Hypnotic Painting** Oil on canvas, 13 × 28 in.

3 **Reclining Nude** Oil on canvas, 15 × 30 in. Collection Mr Gordon Harris, London.
4 **The Encounter** Oil on canvas, 6 × 8 in.
5 **The Parent** Oil on canvas, 6 × 8 in.*
6 **The Lovers** Oil on canvas, 8 × 6 in.
7 **Red Landscape** Oil on board, 13 × 27 in.*
8 **The Green Sprite** Oil on canvas, 8 × 6 in.
9 **The Dreaming Cretin** Oil on board, 14 × 19 in.*
10 **Celebration** Oil on board, 28 × 37 in. Eric Franck Gallery, Geneva.
11 **The Dove** Oil and plaster on canvas, 23 × 26 in.
12 **L'Enfant Terrible** Oil on canvas, 27 × 23 in.*
13 **The Edge of the World** Oil on canvas, 12 × 16 in.*
14 **Man and Machine** Oil, pastel, ink and pencil on paper, 9 × 7 in.
15 **The Hermit Discovered** Oil on canvas, 16 × 22 in.
16 **Flower Machine** Oil on canvas, 20 × 26 in.*
17 **The Hunter** Oil and plaster on canvas, 17 × 21 in. Collection Mr Paul Conran, London.
18 **The Green Forest** Oil on canvas, 10 × 16 in.*
19 **The Red Flower** Oil on board, 10 × 17 in.
20 **The Suicide** Oil on glass, 8 × 11 in. Collection Mr Peter Carreras.
21 **Flower Woman Machine** Oil on canvas, 14 × 7 in.*
22 **The Encounter** Oil on canvas, 8 × 16 in.
23 **Man Jumping** Oil on canvas, 21 × 16 in. Collection Mr Gordon Harris, London.
24 **The Love Letter** Oil on canvas, 20 × 16 in.
25 **The Voyager** Oil. Collection Mr Tony Stevens.
26 **The Close Friend** Oil on canvas, 26 × 20 in. Collection Dr John Treherne, Cambridge.
27 **The Red Dancer** Oil and pastel on card, 18 × 13 in.
28 **Red and Orange Situation** Oil on card, 16 × 12 in.
29 **The Courtship I** Oil on canvas, 54 × 38 in. Collection Mr Joris de Schepper, London.
30 **The Table** Oil on canvas, 14 × 18 in. Phipps and Company Fine Art, London.
31 **The Courtship II** Oil on canvas, 14 × 19 in. Private collection, Vienna.
32 **Owl** Chalk and ink on paper, 15 × 11 in.
33 **Informal Landscape** Ink, crayon and pastel on paper, 8 × 6 in.
34 **Statue** Ink and pastel on paper, 16 × 12 in.
35 **Two Figures** Crayon and pastel on paper, 11 × 8 in.
36 **Silent Figure** Mixed media, 6 × 3 in.
37 **Comparative Anatomy** Mixed media, 8 × 13 in. Peter Nahum Gallery, London.
38 **Crisis of Identity** Mixed media, 8 × 13 in.
39 **Explaining the Riddle** Mixed media, 7 × 5 in.
40 **Two Friends** Mixed media, 8 × 6 in. Collection Mr Joris de Schepper, London.
41 **Startled Goddess** Mixed media, 7 × 4 in.
42 **The Partygoers** Mixed media, 4 × 6 in.

1949

1 **The Desiccation of the Poet** Gouache on card, 9 × 7 in.
2 **The Jumping Three** Oil on canvas, 30 × 50 in.
3 **Colony Relations** Watercolour on paper, 10 × 7 in.
4 **Acrobatic Dispute** Gouache on paper, 9 × 12 in.
5 **The Suicides** Oil on board, 50 × 30 in.*
6 **The Observer** Oil on canvas, 17 × 22 in.*
7 **The Inhabitants** Oil on canvas, 10 × 16 in. Private collection, Berkshire.
8 **The Intruder** Oil on card, 12 × 16 in. Collection Mr Paul Weir, Wroughton, Wiltshire.
9 **Design for a Statue** Oil on board, 34 × 25 in.*
10 **Farewell** Oil on canvas, 30 × 25 in.*
11 **The Visitor** Oil on canvas, 9 × 12 in.*
12 **The Actors** Oil on board, 11 × 13 in.*
13 **The Restless Soldiers** Gouache on paper, 6 × 10 in.
14 **The Lookouts** Gouache on paper, 6 × 9 in.
15 **The Explorer** Gouache on card, 7 × 18 in.*
16 **The Assault** Oil on board, 18 × 29 in.*
17 **The Bathers I** Oil on paper, 8 × 13 in.*
18 **Family on the Beach** Oil on paper, 7 × 12 in. Collection Dr Philip Guiton, Les Eyzies, France.
19 **Only the Guest is at Ease** Oil on paper, 10 × 15 in. Collection Mrs Celia Philo, London.
20 **The Bathers II** Oil on paper, 8 × 13 in.
21 **Ageing Dancer** Oil on paper, 8 × 13 in.
22 **Storm Coming** Oil, 7 × 10 in.*
23 **The Apple-pickers** Oil and indian ink on paper, 8 × 13 in. Collection Mr Philip Oakes, London.
24 **The Fatal Attraction of the Poet** Oil on paper, 8 × 13 in.
25 **Moonscape** Oil and pastel on paper, 8 × 13 in.*
26 **The Farmer** Oil on board, 8 × 12 in.*
27 **The Monster** Oil on paper, 5 × 6 in.*
28 **Work Force** Oil and gouache on paper, 8 × 13 in.
29 **St George and the Dragon** Oil on paper, 8 × 13 in.
30 **St George** Oil on paper 8 × 13 in.
31 **Dragon** Oil on paper, 7 × 8 in.
32 **The Nest IV** Oil on paper, 7 × 11 in.*
33 **The Herd** Oil on card, 29 × 48 in.
34 **The Daymare Begins** Oil on paper, 8 × 13 in. approx.*
35 **The Family** Mixed media.*
36 **Siblings** Oil on paper, 10 × 14 in. Collection Mr Joris de Schepper, London.
37 **War-woman** Mixed media on board, 28 × 17 in. Mayor Gallery, London.
38 **The Proposal** Oil on paper, 14 × 9 in. British Museum, London.
39 **The Witness** Mixed media on board, 9 × 13 in.

40 **The Red Ritual** Oil on board, 14 × 22 in. approx. Collection Mr Tony Hubbard.

41 **Cat I** Oil on paper, 13 × 8 in. Collection Dr John Treherne, Cambridge.

42 **Cat II (three cats)** Oil on paper, Collection Mr Oscar Mellor, Exeter.

43 **Cat III (two cats)** Oil on paper, Collection Mr Oscar Mellor, Exeter.

44 **Cat IV** Oil on paper, 13 × 8 in.*

45 **Cat V** Oil on paper, 13 × 8 in. Private collection, Berkshire.

46 **Cat VI (two cats)** Mixed media, 13 × 8 in. Peter Nahum Gallery, London.

47 **Cat VII (cat and kitten)** Mixed media, 13 × 8 in. Collection Mr Joris de Schepper, London.

48 **Cat VIII (cat and moon)** Mixed media, 13 × 8 in. Collection Mr Joris de Schepper, London.

49 **Cat IX (three cats)** Mixed media, 13 × 8 in. Collection Mr Joris de Schepper, London.

50 **Cat X (four cats)** Mixed media, 13 × 8 in. Collection Mr Joris de Schepper, London.

51 **Cat XI** Mixed media, 13 × 8 in.

52 **Cat XII** Mixed media, 13 × 8 in.

53 **Cat XIII (four cats)** Mixed media, 13 × 8 in.

54 **Cat XIV (two cats with flag)** Mixed media, 13 × 8 in.

55 **Cat XV** Mixed media, 13 × 8 in.

56 **Cat XVI (cat, moon and insect)** Mixed media, 8 × 13 in.

57 **Cat XVII (four cats with moon)** Mixed media, 8 × 13 in.

58 **Cat XVIII (six cats)** Mixed media, 8 × 13 in.

59 **Cat XIX (three cats and sun)** Mixed media, 8 × 13 in.

60 **Cat XX (four cats and moon)** Mixed media, 8 × 13 in.

61 **King** Oil on paper, 13 × 8 in.

62 **Dog, Man and Woman** Oil on paper, 8 × 13 in. Collection Mr Paul Weir, Wroughton, Wiltshire.

63 **Acrobat** Oil on paper, 13 × 8 in. Collection Mr Paul Weir, Wroughton, Wiltshire.

64 **Creating a Disturbance** Oil and gouache on paper, 7 × 12 in. Collection Mr Oscar Mellor, Exeter.

65 **Reclining Nude** Oil on paper, 5 × 13 in. Collection Mr Hugh Clement, Wales.

66 **The Cabaret Message** Ink and gouache on black paper, 10 × 12 in.

67 **Bird-dream** Watercolour on black paper, 10 × 7 in.

68 **Family Fissions** Ink and watercolour on black paper, 10 × 12 in.

69 **Primitive Performer** Oil on paper, 8 × 13 in.

70 **Poseurs in Love** Oil on paper, 20 × 13 in.

71 **Playtime Posturing** Gouache on paper, 9 × 12 in.

72 **Tribal Conceits** Oil and crayon on paper, 20 × 12 in. Collection Mr Joris de Schepper, London.

73 **The Trappings of Privacy** Oil on paper, 20 × 12 in. The Department of Prints and Drawings, The British Museum.

74 **The Rage of the Celibate** Oil on paper, 13 × 8 in.

75 **The Important Arrival** Oil on paper, 8 × 13 in.

76 **Susanna Bathing** Oil on paper, 7 × 8 in.

77 **The New Friend** Ink and gouache on paper, 14 × 21 in.

78 **Formal Relations** Oil and ink on paper, 10 × 17 in.

79 **The Waiting Time** Oil on glass, 8 × 12 in.

80 **Still Life** Gouache on paper, 6 × 9 in.

81 **Figure** Oil on paper, 13 × 7 in. Collection Dr Fae Hall, Bath.

82 **Seated Figure** Oil on paper, 12 × 7 in. Collection Dr Fae Hall, Bath.

83 **The Princess** Mixed media, 13 × 8 in.

84 **The Butterfly** Mixed media, 7 × 9 in.

85 **Rank and File** Mixed media, 10 × 8 in.

86 **Nest Site I** Mixed media, 8 × 13 in.

87 **Nest Site II** Mixed media, 8 × 13 in.

88 **Display Ground** Mixed media, 8 × 13 in.

89 **Reclining Figure** Mixed media, 8 × 13 in.

90 **The Journey Begins** Mixed media, 8 × 13 in.

91 **Artist and Model** Mixed media, 7 × 12 in.

92 **Carnal Friends** Mixed media, 8 × 13 in.

93 **Acrobat II** Mixed media, 13 × 8 in.

94 **Day of the Fireflies** Mixed media, 13 × 8 in.

95 **Clairvoyant Surprised** Mixed media, 13 × 8 in.

96 **Private Beach** Mixed media, 8 × 13 in.

97 **Lost Bird of Youth** Mixed media, 8 × 13 in. Collection Mr Richard Read, Bowden, Cheshire.

98 **Garden Spirits** Mixed media, 8 × 13 in.

99 **Lost Friendship, New Friendship** Mixed media, 6 × 9 in.

100 **Memories of the Dance** Mixed media, 7 × 5 in.

101 **The Inheritor** Mixed media, 7 × 5 in.

102 **Garden Ritual** Mixed media, 6 × 7 in.

103 **Three Neighbours** Mixed media, 6 × 9 in.

104 **Vision of Mortality** Mixed media, 7 × 9 in.

105 **Dawn Chorus** Mixed media, 3 × 13 in.

106 **Jack-in-the-Box** Mixed media, 7 × 7 in.

107 **The Young Pretender** Mixed media, 5 × 6 in.

108 **Smart Set** Mixed media, 5 × 4 in.

109 **Courtship Ritual** Mixed media, 4 × 5 in.

110 **Three Witnesses** Mixed media, 3 × 7 in.

111 **Colony Alert** Mixed media, 5 × 7 in.

112 **Waiting Game** Mixed media, 11 × 15 in.

113 **Important Presence** Mixed media, 10 × 13 in.

114 **Breeding Grounds** Mixed media, 9 × 12 in.

115 **Night for Remembrance** Mixed media, 8 × 13 in.

116 **Squatting Figure** Crayon and pastel, 17 × 12 in.

117 **Bird Machine** Mixed media, 5 × 7 in.

118 **Declaimer** Mixed media, 8 × 7 in.

119 **Statue for a Lost Child** Mixed media, 13 × 18 in.

120 **Star Performer** Mixed media, 8 × 13 in.
121 **Dreamer** Mixed media, 6 × 8 in.
122 **The Cloak** Mixed media, 13 × 8 in.
123 **Dreaming Woman** Mixed media, 8 × 13 in.
124 **Warrior I** Mixed media, 13 × 8 in.
125 **Persistent Melody** 13 × 8 in.
126 **The Middle-Class Fantasy** Mixed media, 13 × 8 in.

1950

1 **About to Begin** Oil on board, 8 × 10 in. Collection Dr Fae Hall, Bath.
2 **Equals and Opposites** Oil on card, 9 × 12 in. Collection Mr Paul Weir, Wroughton, Wiltshire.
3 **Two Figures** Gouache on paper, 8 × 10 in. Collection Dr Fae Hall, Bath.
4 **The Bride** Oil and ink on paper, 13 × 8 in.
5 **War Hero** Oil and ink on paper, 13 × 8 in.
6 **The Ugly Puritan** Oil and ink on paper, 13 × 8 in.
7 **First Glimpse of Treasure** Oil, ink and watercolour on paper, 8 × 13 in.
8 **The Star is Ready** Oil on paper, 13 × 8 in.
9 **The Winner is Confused** Ink, pastel and watercolour on paper, 14 × 10 in.
10 **Woman of the World** Ink and pastel on paper, 15 × 10 in.
11 **Bird Machine** Ink and pastel on paper, 15 × 10 in.
12 **The Overpowering Friend** Ink and pastel on paper, 15 × 10 in.
13 **Face of Concern** Oil on paper, 8 × 13 in.
14 **Blue Landscape** Oil on board, 12 × 14 in. Collection Professor Aubrey Manning, Edinburgh.
15 **The Loved One** Oil on board, 6 × 8 in. Collection Mrs Ramona Morris, Oxford.
16 **The Gloved Face** Oil on board, 9 × 12 in.
17 **The Survivors** Oil on canvas, 10 × 14 in. Collection Mr & Mrs Paul McCartney, Sussex.
18 **The Progenitor** Oil on canvas, 12 × 16 in. Collection Mr Mark Seidenfeld, New York.
19 **Father at the Nest** Oil on paper, 8 × 13 in. Collection Mr Joris de Schepper, London.
20 **Sunset Figure** Oil, ink and crayon on paper, 7 × 10 in.
21 **False Ego** Ink and pastel on paper, 8 × 10 in.
22 **The Adolescents** Oil on paper, 13 × 8 in. Collection Mr Arnold B. Kanter, Evanston, Illinois, USA.
23 **The Warrior** Oil, ink and watercolour on paper, 13 × 8 in. Collection Mr Arnold B. Kanter, Evanston, Illinois, USA.
24 **The One-trick Life** Gouache on paper, 13 × 8 in.
25 **Earthbound Companion** Gouache on paper, 8 × 10 in.
26 **Girl of Prey** Gouache and ink on paper, 8 × 10 in.
27 **Confidential Enemy** Ink and watercolour on paper, 8 × 7 in.
28 **Parental Group** Coloured inks on paper, 15 × 10 in.
29 **Moon Blood** Ink and watercolour on paper, 15 × 10 in.
30 **The Serious Game** Oil on canvas, 10 × 16 in.
31 **Landscape with Watchers** Oil on board, 10 × 8 in. Private collection. Berkshire.
32 **The Trap** Oil on canvas, 16 × 20 in. Collection Mr Tom Maschler, London.
33 **The Silent Friend** Oil on canvas, 12 × 8 in.
34 **The Starry Night** Oil on board, 12 × 8 in. Collection Mrs Ramona Morris, Oxford.
35 **The Hunter's Surprise** Oil on board, 8 × 10 in.
36 **The Springing Season** Oil on card, 14 × 24 in.
37 **Endogenous Activities** Oil on canvas, 21 × 31 in. Collection Mrs Mary Horswell, Hampshire.
38 **Bird Rising** Ink and watercolour, 5 × 4 in.
39 **The Long Journey I** Mixed media, 8 × 13 in.
40 **The Long Journey II** Mixed media, 8 × 13 in.
41 **Balancing Act** Mixed media, 8 × 5 in.
42 **Industrial Landscape** Mixed media, 6 × 6 in.
43 **Anguish in Springtime** Ink and watercolour, 8 × 10 in.
44 **Face of Concern II** Oil on paper, 8 × 13 in.
45 **Face of Concern III** Oil on paper, 8 × 13 in.
46 **Flowerseller I** Oil on paper, 8 × 13 in.
47 **Flowerseller II** Oil on paper, 8 × 13 in.
48 **Woman without Companion I** Oil on paper, 13 × 8 in.
49 **Woman without Companion II** Oil on paper, 13 × 8 in.
50 **Woman without Companion III** Oil on paper, 13 × 8 in.
51 **Woman without Companion IV** Oil on paper, 13 × 8 in.
52 **Woman without Companion V** Oil on paper, 13 × 8 in.
53 **Woman without Companion VI** Oil on paper, 13 × 8 in.

1951

1 **Girl Studying** Oil on canvas, 16 × 12 in. approx.*
2 **Squatting Figure** Oil on board, 16 × 12 in. approx.*
3 **The Entomologist** Oil on board, 28 × 20 in. Collection Dr John Godfrey, London.
4 **Woman Thinking to Herself** Oil on board, 12 × 24 in. Collection Mr Oscar Mellor, Exeter.
5 **The Jester** Oil on canvas, 24 × 18 in. Collection Dr Fae Hall, Bath.
6 **The Greeting Ceremony** Oil on board, 7 × 10 in.
7 **Introspective Moment** Oil on card, 29 × 21 in.

8 **Angels at Play** Oil on canvas, 20 × 25 in. Collection Mr Norman Goldstein, Canada.

9 **The Young King** Oil on board, 37 × 27 in. Collection Mr Paul Weir, Wroughton, Wiltshire.

10 **Remoteness of the Leader** Oil on canvas, 14 × 7 in.

11 **Everyday Martyr** Oil on canvas, 20 × 12 in. Collection Miss Muriel Brat, Brussels.

12 **Abstract** Pastel on paper, 8 × 6 in.

13 **Lonely Actress** Oil on board, 8 × 6 in.

14 **The One at Home** Coloured inks on paper, 15 × 10 in.

15 **Unloving Couple** Gouache on paper, 12 × 10 in.

16 **Family Outing** Ink and gouache on paper, 10 × 8 in.

17 **Family Group** Ink and gouache on paper, 10 × 8 in.

18 **Portrait** Oil on paper, 9 × 6 in. Collection Dr Philip Guiton, Les Eyzies, France.

19 **Read Head** Oil on board, 9 × 12 in. Private collection, Berkshire.

20 **Hierarchic Head** Mixed media, 3 × 4 in. Collection Mr Philip Oakes, London.

21 **The Orator's Daughter** Oil on canvas, 27 × 21 in. Collection Dr John Godfrey, London.

22 **The Zoologist,** Oil on board, 12 × 24 in. Collection Dr John Godfrey, London.

23 **The Knowing One** Mixed media, 10 × 8 in.

24 **Sketch for the Jester** Mixed media, 10 × 7 in. Collection Miss Jessica Murray, London.

25 **Head of Girl I** Mixed media, 10 × 8 in.

26 **Head of Girl II** Mixed media, 10 × 8 in.

27 **High Priest I** Oil on paper, 12 × 9 in.

28 **High Priest II** Oil on paper, 9 × 11 in.

1952

1 **The Admiral's Son** Oil on board, 19 × 15 in.

2 **Ball Game** Oil on canvas, 24 × 16 in.

3 **Impatient Lovers** Coloured inks on paper, 10 × 8 in.

4 **Startled Inmates** Ink and watercolour on paper, 13 × 8 in.

5 **Pedagogue** Coloured inks on paper, 10 × 8 in.

6 **The Comforter** Oil on board, 32 × 26 in. Private collection, Devon.

7 **The Attack** Ink and watercolour on paper, 8 × 13 in. Collection Professor Aubrey Manning, Edinburgh.

8 **The Bird-lover** Ink and watercolour on paper, 8 × 13 in. Private collection, Berkshire.

9 **The Scientist** Oil on board, 13 × 10 in. Collection Mr Norman Goldstein, Canada.

10 **The Clown** Oil on canvas, 20 × 12 in. Collection Dr John Godfrey, London.

1953 No surviving paintings.

1954

1 **The Horizontal One** Oil on panel, 10 × 15 in. Collection Dr John Godfrey, London.

1955

1 **Portrait of a Thinking Girl** Oil on card, 18 × 13 in.

1956

1 **Woman with Birds** Oil on canvas, 9 × 12 in. Collection Mrs Ramona Morris, Oxford.

2 **Keep Together** Oil on canvas, 7 × 14 in.

3 **The Parade** Oil on canvas, 7 × 14 in.

4 **Weeping Head** Oil on card, 12 × 15 in. Collection Dr John Godfrey, London.

1957

1 **The Indelible Incident** Oil on canvas, 7 × 14 in.

2 **Cyclists** Oil on canvas, 7 × 14 in.*

3 **City Games** Oil on canvas, 7 × 14 in.

4 **The Performers** Oil on canvas, 7 × 14 in. Collection Lee Materia, Dallas, Texas.

5 **Totem** Oil on canvas, 7 × 14 in. Contemporary Arts Society, London.

6 **The Colony** Oil on canvas, 7 × 14 in.

7 **The Blind Leader** Oil on canvas, 7 × 14 in. Collection Mrs Marjorie Morris, Oxford.

8 **The Silent Gathering** Oil on board, 7 × 14 in.

9 **The Sacrifice** Oil on canvas, 7 × 14 in. Collection Mrs Marjorie Morris, Oxford.

10 **The Enclosure** Oil on canvas, 7 × 14 in. Collection Mr Stamatis Moskey, Hampshire.

11 **Fear of the Past** Oil on canvas, 7 × 14 in.

12 **There's No Time Like the Future** Oil on canvas, 7 × 14 in. Collection Mrs Marjorie Morris, Oxford.

13 **The Spanish Table** Oil on canvas, 7 × 14 in. Collection Dr Gilbert Manley, Durham.

14 **Dragon Patrol** Oil on canvas, 7 × 14 in.

15 **The Charioteer** Oil on canvas, 7 × 14 in. Collection Mr Michael Lyster, London.

16 **Alter Ego** Oil on canvas, 7 × 14 in. Collection Mrs S. Sandman, New York.

17 **Two Heads are Worse than One** Oil on canvas, 7 × 14 in.*

18 **Private Body** Oil on canvas, 7 × 14 in.*

19 **The Courtyard Drama** Oil on canvas, 7 × 14 in.*

20 **The Victor** Oil on canvas, 7 × 14 in. Private collection, London.
21 **The Eager Anticipants** Oil on canvas, 7 × 14 in.*
22 **The Playground of Power** Oil on canvas, 7 × 14 in. Private collection, Berkshire.
23 **Training Ground** Oil on canvas, 7 × 14 in. Private collection, Berkshire.
24 **The Bond of Mutual Distrust** Oil on canvas, 7 × 14 in.*
25 **A Longstanding Hateship** Oil on canvas, 7 × 14 in.*
26 **The Antagonists** Oil on canvas, 7 × 14 in.*
27 **Rite de Passage** Oil on canvas, 7 × 14 in. Private collection, Berkshire.
28 **Interrupted Game** Oil on canvas, 7 × 14in. Private collection, London.
29 **The Bull** Oil on canvas, 7 × 14 in. Collection Dr John Godfrey, London.
30 **The Hunt** Oil on canvas, 7 × 14 in. Collection Dr John Godfrey, London.
31 **The Seawatchers** Ink and Watercolour, 10 × 14 in. Collection Mr Robert Page, London.
32 **Seabathers**. Ink and watercolour, 10 × 14 in.

1958

1 **Bird Warning** Oil on board, 9 × 10 in.
2 **Night Beast** Oil on canvas, 7 × 14 in.
3 **The Serpent's Choice** Oil on canvas, 7 × 14 in.
4 **Spinster in the Spring** Oil on canvas, 7 × 14 in.
5 **The Birdcatcher** Oil on canvas, 7 × 14 in.
6 **The Orator's Moment** Oil on canvas, 7 × 14 in. Collection Mr James Mayor, London.
7 **The White Horse** Oil on canvas, 7 × 14 in.
8 **Family Relations** Oil on canvas, 13 × 36 in.
9 **Premonition of Life** Oil on canvas, 11 × 16 in.
10 **Monster Manqué** Oil, ink and watercolour on paper, 8 × 12 in.
11 **Four Figures** Oil and ink on paper, 8 × 13 in. Collection Mr Alan Durham-Smith, Dallas, Texas.
12 **Extinction Beckons** Oil and ink on paper, 8 × 10 in. Eric Franck Gallery, Geneva.

1959

1 **The Revolt of the Pets** Oil on canvas, 10 × 12 in. Collection Mr Gerald Grinstein, Fort Worth, Texas.
2 **Virtuoso without an Audience** Coloured inks on paper, 10 × 14 in.
3 **Woman with a Cruel Past** Oil and ink on paper, 8 × 13 in.

1960

1 **Loving Couple** Oil and ink on paper, 11 × 9 in.
2 **Day-starved Mannerisms** Oil and ink on board, 24 × 36 in.
3 **Don't Leave Me Here** Coloured inks on paper, 14 × 10 in.
4 **The Expansive Invitation** Coloured inks on paper, 11 × 8 in. The Currier Museum, Manchester, New Hampshire, USA.
5 **Rites of Winter** Coloured inks on paper, 10 × 14 in.
6 **Yesterday Went Quickly** Coloured inks on paper, 13 × 10 in.
7 **False Appearances** Ink and wash on paper, 10 × 8 in.
8 **Best Man Loses** Coloured inks on paper, 9 × 11 in. Collection Mr Martin Fuller, London.
9 **The Finder** Oil and ink on paper, 14 × 10 in.
10 **Declamation of Bias** Coloured inks on paper, 11 × 10 in.
11 **Exodus Blues** Coloured inks on paper, 8 × 11 in. Eric Franck Gallery, Geneva.
12 **The Egg-thieves** Oil and plaster on canvas, 14 × 17 in. Collection Mr Tom Maschler, London.
13 **The Killing Game** Oil and plaster on canvas, 16 × 20 in.
14 **Family Group** Oil on canvas, 22 × 25 in.
15 **Figure with Birds** Oil on canvas, 20 × 24 in. approx.*
16 **Woman with Birds** Oil on canvas, 20 × 24 in. approx.*
17 **Two Women with Bird** Oil on canvas, 24 × 20 in. approx.*
18 **Self-portrait** Oil on canvas, 24 × 20 in. approx.*
19 **The Assembly** Oil and plaster on board, 34 × 84 in.
20 **The New Arrival** Oil on canvas, 20 × 30 in. Collection Mrs Mary Horswell, Hampshire.
21 **Rivals Meeting** Ink and watercolour, 5 × 5 in.
22 **Official Guests** Ink and watercolour, 2 × 6 in.
23 **Woman with Six Birds** Mixed media, 8 × 10 in.
24 **The First to Arrive** Ink and watercolour, 3 × 4 in.
25 **Fish Hiding in a Landscape** Mixed media, 8 × 13 in.
26 **Family Portrait** Mixed media, 8 × 13 in.
27 **Expectant Figures** Mixed media, 12 × 16 in. Collection Mr Robert Page, London.

1961

1 **Processional** Oil and plaster on board, 12 × 96 in.
2 **Three Rivals** Oil on canvas, 19 × 23 in.
3 **First Love** Oil on canvas, 13 × 27 in.
4 **Nest-figure** Oil and plaster on canvas, 26 × 12 in.
5 **White Landscape I** Oil and plaster on canvas, 20 × 24 in.

6 **White Landscape III** Oil and plaster on board, 13 × 18 in.

7 **White Landscape VII** Oil and plaster on board, 13 × 16 in.

8 **White Landscape VIII** Oil and plaster on board, 12 × 16 in.

9 **White Landscape IX** Oil and plaster on board, 16 × 22 in.

10 **White Landscape XI** Oil and plaster on board, 14 × 21 in.

11 **White Landscape XII** Oil and plaster on board, 14 × 21 in.

12 **White Landscape XIII** Oil and plaster on board, 20 × 25 in.

13 **Moment of Judgement** Oil and plaster on board, 24 × 12 in.

14 **The New Challenge** Oil and plaster on board, 24 × 15 in.

15 **The Ruling Power** Oil and plaster on board, 24 × 12 in.

16 **The Dominion of Vulgar Piety** Oil and plaster on board, 14 × 7 in.

17 **The Pimple on the Face of Art is Really a Beauty Spot** Oil and plaster on board, 14 × 7 in.

18 **The Beautiful Behind of the Dog-faced Girl is not Appealing** Oil and plaster on board, 14 × 7 in.

19 **The Predator Smells of Lavender** Oil and plaster on board, 14 × 7 in.

20 **The Interpreter is Late Again** Oil and plaster on board, 16 × 8 in.

21 **The Great Populator** Oil on paper, 19 × 26 in.

22 **Cell-head I** Oil on card, 18 × 14 in. Peter Nahum Gallery, London.

23 **Cell-head II** Oil on paper, 12 × 16 in.

24 **Cell-head III** Oil on paper, 12 × 16 in.

25 **Cell-head IV** Oil on paper, 15 × 20 in.

26 **Cell-head V** Oil on paper, 22 × 17 in. Peter Nahum Gallery, London.

27 **Cell-head VI** Oil on paper, 21 × 17 in. Collection Mr Ivor Braka, London.

28 **The Child of Nocturnal Occasions** Oil on canvas, 8 × 14 in.

29 **Festive Symbols** Oil and plaster on canvas, 8 × 12 in.

30 **Lost Friend** Oil and plaster on board, 14 × 7 in.

31 **Cell-head VII** Oil on card, 20 × 15 in.

32 **The Philosopher has Lied** Oil and plaster on board, 24 × 12 in.

33 **Cell-head VIII** Oil on board, 19 × 15 in.

34 **Cell-head IX** Oil on paper, 10 × 15 in.

35 **Cell-head X** Oil on paper, 15 × 22 in.

36 **Cell-head XI** Oil on paper, 16 × 10 in.

37 **Cell-head XII** Oil on paper, 16 × 10 in.

38 **Cell-head XIII** Oil on paper, 16 × 10 in.

39 **Cell-head XIV** Oil on paper, 26 × 18 in.

40 **Cell-head XV** Oil on paper, 10 × 14 in.

41 **Cell-head XVI** Oil on board, 18 × 14 in approx.*

42 **Cell-head XVII** Oil on paper, 16 × 10 in.

43 **Cell-head XIX** Oil on board, 36 × 24 in.

44 **Cell-head XX** Oil on paper, 10 × 12 in.

45 **Cell-head XXI** Oil on paper, 23 × 17 in. Peter Nahum Gallery, London.

46 **Cool Head** Oil on paper, 18 × 25 in.

47 **Egghead I** Oil and plaster on board, 18 × 24 in. Eric Franck Gallery, Geneva.

48 **Cell-head XXII.** Oil on board, 20 × 15 in.

49 **The Diversity of Personal Surprise** Oil and plaster on board, 24 × 15 in.

50 **Lovejoy and Killjoy** Oil and plaster on board, 24 × 15 in.

51 **Force of Fusion** Oil on canvas, 16 × 12 in.

52 **Growing Point** Oil on board, 36 × 24 in.

53 **Fertilization I** Oil on board, 41 × 35 in.

54 **Fertilization II** Oil on board, 39 × 30 in.

55 **Ovulation** Oil on canvas, 29 × 22 in.

56 **The Addiction of Privacy** Oil on canvas, 30 × 20 in.

57 **Cell-head XXIII** Oil on board, 21 × 14 in. Collection Mrs M.D. Charles, London.

58 **Cell-head XXIV** Oil on board, 28 × 38 in.

59 **Cell-head XVIII** Oil on paper, 16 × 10 in.

60 **Moon-dance** Oil on canvas, 12 × 24 in. Collection Dr John Godfrey, London.

61 **Warrior in Love** Mixed media, 8 × 4 in.

62 **Townscape** Ink and watercolour, 5 × 3 in.

63 **Night-figure** Ink and watercolour, 4 × 3 in.

64 **Campaign Figure** Ink and watercolour, 3 × 3 in.

1962

1 **Splitting Head** Oil on canvas, 19 × 14 in.

2 **The Offering** Oil on card, 26 × 32 in.

3 **Indigenous Head** Oil on board, 36 × 24 in.

4 **Hardhead** Oil on board, 36 × 24 in.

5 **Cell-head XXV** Oil on canvas, 26 × 20 in.

6 **Cell-head XXVI** Oil on board, 27 × 15 in.

7 **Cell-head XXVII** Oil on card, 28 × 20 in.

8 **Cell-head XXVIII** Oil on canvas, 22 × 29 in.

9 **Fertilization III** Oil on canvas, 16 × 12 in.

10 **Children of Fortune** Oil on canvas, 15 × 11 in.

11 **Red Riding Shock** Oil on canvas, 16 × 44 in.

12 **Egghead II** Oil and plaster on board, 20 × 25 in.

13 **Willing Victim** Oil and plaster on board, 24 × 12 in.

14 **Point of Contact** Oil and plaster on board, 24 × 18 in. Eric Franck Gallery, Geneva.

15 **Simple Pleasures** Oil on board, 32 × 43 in.

16 **Game Signs** Oil and plaster on board, 24 × 34 in.

17 **Sex-starved Banker Fleeing from Vision of Horned Snakes** Oil on board, 25 × 18 in.

18 **Egghead III** Oil and plaster on board, 18 × 24 in.
19 **Egghead IV** Oil and plaster on board, 18 × 24 in.
20 **Tutor** Mixed media, 8 × 5 in.
21 **Dreaming Figure** Ink and watercolour, 5 × 5 in.

1963 No surviving paintings.

1964

1 **Boundary Dispute** Mixed media on board, 24 × 18 in.
2 **Bold Moment** Oil on board, 25 × 23 in.
3 **Landscape** Oil on board, 29 × 23 in. Private Collection, Belgium.

1965

1 **Parasite in the House** Oil on board, 36 × 24 in.
2 **The Translator's Whim** Oil on canvas, 40 × 24 in.
3 **Climactic Mirage** Oil on board, 36 × 24 in.
4 **The Morphology of Envy** Oil on board, 36 × 24 in.
5 **The Mysterious Gift** Oil on canvas, 39 × 28 in. Swindon Art Gallery.
6 **Ambiguous Offering** Oil on canvas, 54 × 37 in.
7 **Genius Embryo** Ink and watercolour, 8 × 5 in.
8 **Classical Longing** Ink and watercolour, 11 × 8 in.

1966

1 **Ceremonial Pastimes** Oil on board, 14 × 21 in.
2 **Before the Bang** Oil on canvas, 29 × 22 in.
3 **Pair Bond** Oil on board, 10 × 14 in.
4 **Proud Figure** Oil on canvas, 24 × 17 in.
5 **Strong Figure** Oil on canvas, 25 × 21 in.
6 **The Day of the Zygote** Oil on canvas, 20 × 16 in.
7 **Guard Figure** Oil on wood, 17 × 13 in.
8 **Intimate Decision** Oil and plaster on canvas, 18 × 15 in. Private collection, Belgium.
9 **Organic Statue** Oil on card, 17 × 21 in.
10 **Beast of Burden** Oil on canvas, 54 × 72 in.
11 **Lonely Quadruped** Oil on board, 17 × 20 in.
12 **Growing Signals** Oil on canvas, 21 × 14 in.
13 **Body Flower** Oil on canvas, 33 × 23 in. Collection Mr Frank Kolodzief, Puerto Rico.
14 **Introvert** Oil on canvas, 24 × 20 in. Collection Mr Frank Kolodzief, Puerto Rico.

15 **Figure of Some Importance** Oil on canvas, 32 × 25 in.
16 **Days of Quantity** Oil on board, 25 × 30 in.
17 **Warrior Waiting** Oil on board, 24 × 18 in.
18 **Extrovert** Oil on canvas, 36 × 48 in.
19 **The Hidden Stimulus** Oil and plaster on board, 24 × 18 in.
20 **Coupling Strategies** Oil on panel 10 × 14 in.
21 **Fine Figure** Oil on canvas, 19 × 15 in. Collection Mrs Marjorie Morris, Oxford.
22 **Sketch for Figure of Some Importance** Ink and watercolour, 7 × 4 in.

1967 No surviving paintings.

1968

1 **The Debris of Fixations** Oil on board, 48 × 60 in.
2 **Posture of Dominance** Oil on board, 72 × 48 in.
3 **A Lapse of Heart** Oil on board, 45 × 60 in.
4 **Resting Goddess** Oil on board, 45 × 60 in.
5 **Beneath the Censor** Oil on board, 46 × 60 in.
6 **Nuptial Display** Oil on board, 29 × 23 in.
7 **The Adviser** Oil on board, 32 × 27 in. Collection Dr & Mrs Michel Remy, Nice.
8 **The Antagonist** Oil on board, 32 × 27 in.

1969

1 **Table Pleasures** Oil on board, 45 × 59 in.
2 **Festival** Oil on board, 45 × 60 in.
3 **Birthday Emotions** Oil on board, 33 × 27 in.
4 **Daydream Zone** Oil on board, 33 × 27 in.
5 **The Scale of Amnesia** Oil on board, 29 × 24 in.
6 **Mother Goddess** Oil on card, 20 × 15 in.
7 **Earth Mother** Oil on board, 29 × 29 in.
8 **Rival Deities** Oil on board, 27 × 48 in.
9 **Fertility Figure** Oil on board, 28 × 47 in.
10 **Great Mother** Oil on board, 28 × 25 in.
11 **The Teacher's Doubt** Oil on canvas, 12 × 26 in.
12 **The Explorer has Arrived** Oil on canvas, 8 × 12 in. Collection Sir David Attenborough, London.
13 **The Ritual** Oil on canvas, 24 × 36 in. Private collection, London.
14 **Loving Figure** Ink and watercolour, 8 × 5 in.

1970

1 **Neophilic Excitements** Oil on board, 45 × 59 in.
2 **The Entertainer** Oil on board, 29 × 23 in.
3 **Greenery Pastimes** Oil on board, 45 × 59 in.
4 **Restraints of Kinship** Oil on board, 45 × 59 in.
5 **Until It's Time to Go** Oil on canvas, 10 × 12 in. approx.*
6 **Days of Plenty** Ink and watercolour, 9 × 10 in.

1971

1 **Festa Day** Ink and pastel on board, 12 × 15 in.

1972

1 **The Titillator** Oil on canvas, 12 × 18 in. Collection Dr Richard Dawkins, Oxford.
2 **The attentive Friend** Oil on canvas, 12 × 18 in. Collection Mrs Marjorie Morris, Oxford.
3 **The Unimportance of Yesterday** Oil on canvas, 12 × 18 in.
4 **The Protector** Oil on canvas, 16 × 22 in. Collection Equinox Ltd, Oxford.
5 **Sting Appeal** Oil on canvas, 12 × 18 in. Collection Dr Kate MacSorley, London.
6 **The Onlookers** Oil on board, 11 × 21 in. Collection Mr Herman Friedhoff, Oxford.
7 **The Ceremony of the Hole** Oil on canvas, 20 × 30 in.
8 **The Fertility of Pain** Oil on canvas, 20 × 30 in.
9 **The Visitor** Oil on canvas, 12 × 16 in.
10 **The Gravidity of Power** Oil on canvas, 20 × 30 in.
11 **The Three Members** Oil on canvas, 12 × 18 in.
12 **Polymorphic Growth** Oil on canvas, 12 × 18 in. Collection Mrs Helen Profumo, London.
13 **The Protégé** Oil on board, 10 × 8 in.
14 **The Expectant Valley** Oil on canvas, 24 × 30 in. Collection Dr Richard Dawkins, Oxford.
15 **The Guardian of the Cycle** Oil on canvas, 12 × 18 in.
16 **The Parade of Memories** Oil on canvas, 20 × 30 in.
17 **The Insensitive Intruder** Oil on canvas, 12 × 16 in. Collection Mr & Mrs Norbert Francfort, Brussels.
18 **Dyadic Encounter** Oil on canvas, 20 × 30 in. Yale Center for British Art, New Haven, Connecticut.
19 **The Obsessional Meal** Oil on canvas, 12 × 18 in. Collection Mr Richard Veen, Amsterdam.
20 **The Collector's Fallacy** Oil on canvas, 24 × 30 in. Private collection, London.
21 **Leaders of the People** Ink and watercolour, 8 × 10 in.
22 **Table for Two** Ink and watercolour, 9 × 10 in. Collection Mr S.J. Kennedy, London.

1973

1 **Stop Them If You Can!** Oil on canvas, 24 × 30 in.
2 **The Observers** Oil on canvas, 20 × 30 in.
3 **The Mediator** Oil on board, 10 × 8 in.
4 **The Agitator** Oil on board, 10 × 8 in. Collection Mr Roy Heenan, Montreal.
5 **For Insiders Only** Oil on canvas, 16 × 22 in. Collection Professor E.V. van Hall, Noordwijk, Holland.
6 **Lovers' White Dreamtime** Oil on canvas, 24 × 30 in. Collection Mr and Mrs James Vaughn Jnr, Texas.
7 **The Perennial Discovery** Oil on canvas, 12 × 16 in.
8 **The Well-groomed Bride** Oil on canvas, 22 × 16 in. Collection Mr Edward Anixter, Chicago.
9 **Disturbance in the Colony** Oil on canvas, 20 × 30 in. Collection Mr Edward Anixter, Chicago.
10 **The Neglected Rival** Oil on canvas, 20 × 30 in. Collection Equinox Ltd, Oxford.
11 **The Familiar Stranger** Oil on canvas, 20 × 30 in. Collection Mr Arnold Kanter, Evanston, Illinois.
12 **The Erosion of Longing** Oil on canvas, 16 × 22 in. Collection Mr Hans Redmann, Berlin.
13 **Deciduous Decisions** Oil on canvas, 12 × 16 in. Private collection, France.
14 **The Kill** Oil on canvas, 20 × 30 in. Collection Christopher Moran and Co. Ltd, London.
15 **The Last Breakfast** Oil on canvas, 12 × 16 in. Private collection, London.
16 **The Guardian of the Trap** Oil on canvas, 20 × 36 in.
17 **The Audience Discovers it is the Performance** Oil on canvas, 20 × 36 in. Private collection, Oxfordshire.
18 **The Day After Yesterday** Oil on canvas, 12 × 16 in.
19 **Edgy** Oil on board, 24 × 36 in. Private collection, London.
20 **The Budding Force** Oil on canvas, 16 × 12 in. Private collection, Oxfordshire.
21 **The Moment of Partial Truth** Oil on canvas, 20 × 36 in.
22 **Power Figure** Ink and watercolour, 14 × 9 in.
23 **Biomorphic Landscape** Ink and watercolour, 9 × 14 in.

1974

1 **Metamorphic Landscape** Oil on board, 23 × 29 in. Collection Sir David Attenborough, London.

1975 No surviving paintings.

1976

1 **Contestants** Oil on canvas, 24 × 36 in.
2 **Private Figure** Oil on board, 10 × 7 in.
3 **Ancestors** Oil on panel, 20 × 22 in. Collection Mr Herman Friedhoff, Oxford.
4 **Public Figure** Oil on board, 16 × 12 in.
5 **The Presentation** Oil on canvas, 24 × 36 in. Edwin A. Ulrich Museum of Art, Wichita, Kansas.
6 **The Arena** Oil on canvas, 24 × 36 in.
7 **The Sentinel** Oil on canvas, 24 × 36 in. Collection Mr H. Slewe, Laren, Holland.
8 **Ascending Figure** Oil on canvas, 24 × 36 in.
9 **Totemic Decline** Oil on canvas, 24 × 36 in.
10 **The Sleepwalker** Oil on canvas, 24 × 36 in.

1977–1978 No surviving paintings.

1979

1 **Brain-fruit** Ink and watercolour, 8 × 6 in. Collection The Viscount Windsor, Shropshire.

1980 No surviving paintings.

1981

1 **Aggro** Oil on canvas, 24 × 36 in. Collection Dr and Mrs Peter Marsh, Oxford.

1982

1 **Negotiator** Ink and watercolour, 3 × 3 in.

1983 No surviving paintings.

1984

1 **Political Head** Ink and watercolour, 3 × 2 in.

1985

1 **Brown Figure I** Oil on board, 10 × 7 in.
2 **Brown Figure II** Oil on board, 10 × 7 in.
3 **Hybrid Vigour** Oil on board, 10 × 7 in.
4 **The Seven Sisters** Oil on board, 24 × 36 in.
5 **January 24th** Mixed media on paper, 8 × 8 in. Collection Andrew Jones Art, London.
6 **Affluent Figure** Ink and watercolour, 4 × 3 in.
7 **Rebel Figure** Ink and watercolour, 11 × 8 in.

1986

1 **The Blind Watchmaker** Oil on canvas, 30 × 24 in. Eric Franck Gallery, Geneva.
2 **The Orator** Oil on board, 10 × 7 in. Collection Mr Jerome Rotstein, Florida.
3 **The Red Guard** Oil on canvas, 24 × 36 in.
4 **The Usher** Oil on canvas, 12 × 16 in.
5 **The Illusionist** Oil on canvas, 16 × 12 in.
6 **The Bipedal Surprise** Oil on canvas, 22 × 18 in. Collection Mr and Mrs Nathan M. Shippee, New York.
7 **Protean Diversions** Oil on canvas, 16 × 22 in. Private collection, France.
8 **Seasonal Positions** Oil on canvas, 24 × 36 in.
9 **Green Landscape** Oil on panel, 20 × 22 in. Private collection, New York.
10 **The Warrior** Mixed media, 13 × 8 in. Collection Mr Jeffrey Steiner, New York.
11 **An Everyday Goddess** Mixed media, 11 × 8 in.
12 **Company Rules** Mixed media, 8 × 13 in.
13 **Sketch for the Blind Watchmaker** Mixed media, 8 × 6 in.

1987

1 **The Collusionists** Ink and watercolour, 10 × 14 in.
2 **The New Neighbour** Ink and watercolour, 10 × 14 in. Collection Mr T.S. Hayne, Bristol.
3 **Star Guest** Ink and watercolour, 8 × 9 in.

4 **The Actress Remembers** Ink and watercolour, 16 × 11 in.

5 **Celebrity** Ink and watercolour, 16 × 11 in.

6 **The Helpful Expert** Ink and watercolour, 16 × 11 in.

7 **Social Occasion** Ink and watercolour, 12 × 18 in.

8 **Unstable Relationship** Ink and watercolour, 12 × 18 in. Collection Alan Durham-Smith, Dallas, Texas.

9 **The Suitor** Ink and watercolour, 18 × 12 in.

10 **The Day of the Rumours** Ink and watercolour, 12 × 18 in.

1988

1 **Larger Than Life** Mixed media, 8 × 13 in. Collection Mr Patrick Robinet, Lewisburg, Pennsylvania.

2 **The Disbeliever** Mixed media, 8 × 13 in.

3 **The Bearer of Rumours** Mixed media, 8 × 13 in.

4 **The Old Acquaintance** Mixed media, 8 × 13 in. Collection Dr Michel Remy, Nice.

5 **Extravagant Friends** Mixed media, 8 × 13 in. Collection Mrs Litsa Tsitsera, Arlington, Virginia.

6 **Consenting Adult** Mixed media, 8 × 13 in.

7 **Silent Partners** Mixed media, 8 × 13 in. Collection Baroness Fiona Thyssen, London.

8 **The Old Dilemma** Mixed media, 8 × 13 in.

9 **Moment of Truth** Mixed media, 8 × 13 in. Collection Drs Elizabeth and Robert Boylan, Larchmont, New York.

10 **Family Secrets** Mixed media, 8 × 13 in.

11 **Face of Fashion** Mixed media, 8 × 13 in. Collection Pamela Roderick, Brooklyn, New York.

12 **Warrior Angel** Mixed media, 8 × 13 in.

13 **The Protector** Mixed media, 8 × 13 in.

14 **Old Money** Mixed media, 8 × 13 in. Private collection, Belgium.

15 **Listen to the Goddess** Mixed media, 8 × 13 in.

16 **The Greeting** Mixed media, 8 × 13 in.

17 **Totemic Figure** Mixed media, 13 × 8 in. Collection Mr Alan Durham-Smith, Dallas, Texas.

18 **Procrastinator** Mixed media, 13 × 8 in.

19 **The Applicant** Mixed media, 13 × 8 in.

20 **A Paragon of Vice** Mixed media, 13 × 8 in.

21 **Memorial Figure** Mixed media, 13 × 8 in. Collection Mrs Litsa Tsitsera, Arlington, Virginia.

22 **The Riddle of the Great Mother** Mixed media, 13 × 8 in. Collection Pamela Wynn, London.

23 **The Messenger** Mixed media, 13 × 8 in. Collection Mr Robert Page, London.

24 **In Attendance** Mixed media, 13 × 8 in.

25 **The Day-dreamer** Mixed media, 13 × 8 in. Private collection, Belgium.

26 **Forgotten Leader** Mixed media, 13 × 8 in.

27 **Rising Star** Mixed media, 13 × 8 in.

28 **Territorial Figure** Mixed media, 13 × 8 in.

29 **Cruciform Figure** Mixed media, 11 × 8 in.

30 **Horned Head** Mixed media, 11 × 8 in.

31 **Private Couple** Mixed media, 8 × 11 in. Collection Mr Arnold B. Kanter, Evenston, Illinois, USA.

32 **Secret Thinker** Mixed media, 11 × 8 in.

33 **Split Decision** Mixed media, 11 × 8 in.

34 **Three Friends** Mixed media, 8 × 11 in.

35 **Silent Figure** Mixed media, 11 × 8 in.

36 **Memories of Home** Mixed media, 11 × 8 in.

37 **War Hero** Mixed media, 11 × 8 in.

38 **Newcomer** Mixed media, 11 × 8 in.

39 **Forgotten Friend** Mixed media, 11 × 8 in.

40 **Neighbours** Mixed media, 8 × 11 in.

41 **Another Family** Mixed media, 8 × 11 in.

42 **Intimate Relations** Mixed media, 8 × 11 in.

43 **Flower Child** Mixed media, 11 × 8 in.

44 **Romantic Figure** Mixed media, 11 × 8 in.

45 **The Rainmaker** Mixed media, 11 × 8 in.

46 **The Statesman** Mixed media, 11 × 8 in.

47 **Lonely Figure** Mixed media, 11 × 8 in.

48 **Cult Figure** Mixed media, 11 × 8 in.

49 **Patient Figures** Mixed media, 11 × 8 in.

50 **Proud Figure** Mixed media, 11 × 8 in.

51 **Pet-Lover** Mixed media, 11 × 8 in.

52 **Woman of the World** Mixed media, 11 × 8 in.

53 **Exuberant Figure** Mixed media, 11 × 8 in.

54 **The Inventor** Mixed media, 11 × 8 in.

55 **Special Agent** Mixed media, 11 × 8 in.

56 **The Loved One** Mixed media, 11 × 8 in.

57 **The Audition** Mixed media, 11 × 8 in.

58 **Mood of the Moment** Mixed media, 11 × 8 in.

59 **The Novice** Mixed media, 11 × 8 in.

60 **The Expert Witness** Mixed media, 11 × 8 in.

61 **Illusions of Ancestry** Mixed media, 11 × 8 in.

62 **Valued Companion** Mixed media, 11 × 8 in.

63 **Important Figure** Mixed media, 11 × 8 in.

64 **Longing for Something** Mixed media, 11 × 8 in.

65 **Official in Crisis** Mixed media, 11 × 8 in.

66 **Reclining Figure** Mixed media, 8 × 11 in.

67 **Breeding Season** Mixed media, 11 × 8 in.

68 **Ancestral Figures** Mixed media, 11 × 8 in.

69 **The Protestor** Mixed media, 11 × 8 in.

70 **Silent Witness** Mixed media, 11 × 8 in.

71 **Changing Relations** Mixed media, 8 × 11 in.

72 **Welcome Presence** Mixed media, 11 × 8 in.

73 **Declamation Fallout** Mixed media, 8 × 11 in.

74 **Lonely Predator** Mixed media, 8 × 11 in.

75 **Exchange of Views** Mixed media, 8 × 11 in.

76 **Major Figure** Mixed media, 11 × 8 in.

77 **Expressive Figure** Mixed media, 11 × 8 in.

78 **Playful Figure** Mixed media, 11 × 8 in.
79 **Waiting Figure** Mixed media, 11 × 8 in.
80 **Family Relations** Mixed media, 8 × 11 in.
81 **The Warlords** Mixed media, 11 × 8 in.
82 **Lost in Thought** Mixed media, 11 × 8 in.
83 **The Mood of the Crowd** Mixed media, 8 × 13 in.
84 **The Schemer** Mixed media, 11 × 8 in.
85 **Metaphor for an Old Friend** Mixed media,
11 × 8 in.
86 **The Spacemaker** Mixed media, 8 × 11 in.
87 **The Late Arrivals** Mixed media, 8 × 11 in.
88 **The Mind's Eye** Mixed media, 8 × 11 in.
89 **Daydreamer** Mixed media, 8 × 11 in.
90 **Member of the Jury** Mixed media, 11 × 8 in.
91 **Biomorphic Landscape** Ink and watercolour,
12 × 18 in.
92 **Established Pair** Ink and watercolour, 12 × 18 in.
93 **Idealist** Ink and watercolour, 8 × 6 in.
94 **Creative Figure** Ink and watercolour, 20 × 16 in.
95 **The Paradox of Anger** Mixed media, 8 × 13 in.
96 **The Premonition** Mixed media, 13 × 8 in.
97 **The Survivor** Mixed media, 8 × 13 in.
98 **Four Heads** Ink and watercolour, 12 × 8 in.
99 **Ambiguous Relations I** Ink and watercolour,
8 × 11 in.
100 **Ambiguous Relations II** Ink and watercolour,
8 × 11 in.

1989

1 **The Vegetarian Dream** Mixed media, 13 × 8 in.
2 **The New Mood** Oil on canvas, 24 × 30 in.
3 **Memories of Tomorrow** Oil on canvas, 24 × 20 in.

1990

1 **Hierarchy Games** Mixed media, 11 × 10 in.
2 **The Price of Ambition** Mixed media, 11 × 10 in.
3 **The Dilemma of the Poet** Mixed media, 11 × 10 in.
4 **Wistful Ancestor** Mixed media, 11 × 10 in.
5 **Position of Power** Mixed media, 11 × 10 in.
6 **End Game** Mixed media, 11 × 10 in.
7 **The Joy of Learning** Mixed media, 11 × 10 in.
8 **Beach Scene** Mixed media, 11 × 10 in.
9 **Power Play** Mixed media, 11 × 10 in.
10 **Distinguished Company** Mixed media, 11 × 10 in.
11 **Conflicting Opinion** Mixed media, 11 × 10 in.
12 **The Actor's Mirror** Mixed media, 11 × 10 in.
13 **Moment of Magic** Mixed media, 11 × 10 in.

14 **Warning Signals** Mixed media, 11 × 10 in.
15 **The Unknown Gifts** Mixed media, 11 × 10 in.
16 **The Star Attraction** Mixed media, 11 × 10 in.
17 **Matriarch** Mixed media, 11 × 10 in.
18 **Avoidance of Certainty** Mixed media, 11 × 10 in.
19 **The New Couple** Mixed media, 11 × 10 in.
20 **The Great Illusion** Mixed media, 11 × 10 in.
21 **A Vow of Caution** Mixed media, 11 × 10 in.
22 **Adolescent Figure** Mixed media, 11 × 10 in.
23 **Mother and Child** Mixed media, 11 × 10 in.
24 **Ancient Message** Mixed media, 11 × 10 in.
25 **Private Performance** Mixed media, 11 × 10 in.
26 **The Sting of Love** Mixed media, 11 × 10 in.
27 **Carnal Dream** Mixed media, 11 × 10 in.
28 **Iconoclast** Mixed media, 11 × 10 in.
29 **The Unknown Object** Mixed media, 11 × 10 in.
30 **Ascetic Vision** Mixed media, 11 × 10 in.
31 **Trio** Mixed media, 11 × 10 in.
32 **Vigil** Mixed media, 11 × 10 in.
33 **Private Moment** Mixed media, 11 × 10 in.
34 **Silent Witness** Mixed media, 11 × 10 in.
35 **Preoccupied Figure** Mixed media, 11 × 10 in.
36 **Monument for a Lost Friend** Mixed media,
11 × 10 in.
37 **The Survivor** Mixed media, 11 × 10 in.
38 **Lasting Obsession** Mixed media, 11 × 10 in.
39 **Legacy of a Sheltered Childhood** Mixed media,
11 × 10 in.
40 **Absent Friends** Mixed media, 11 × 10 in.
41 **The Arbiter** Mixed media, 11 × 10 in.
42 **Intimate Couple** Mixed media, 11 × 10 in.
43 **Woman of the World** Mixed media, 11 × 10 in.
44 **The Magic of Ignorance** Mixed media, 11 × 10 in.
45 **The Price of Mystery** Mixed media, 11 × 10 in.
46 **The Newcomer's Game** Mixed media, 11 × 10 in.
47 **The Nightwatch** Mixed media, 11 × 10 in.
48 **Public Appearances** Mixed media, 11 × 10 in.
49 **A Fond Embrace** Mixed media, 11 × 10 in.
50 **Man of the World** Mixed media, 11 × 10 in.
51 **The Competitor** Mixed media, 11 × 10 in.
52 **The Instigator** Mixed media, 11 × 10 in.
53 **The Offering** Mixed media, 11 × 10 in.
54 **The Knowing One** Mixed media, 11 × 10 in.
55 **Prophetic Pastimes** Mixed media, 11 × 10 in.
56 **Time to Remember** Mixed media, 11 × 10 in.
57 **Heavy Angel** Mixed media, 11 × 10 in.
58 **Official Figure** Mixed media, 11 × 10 in.
59 **The Settlers** Mixed media, 11 × 10 in.
60 **Beaten Champion** Mixed media, 11 × 10 in.
61 **The Necklace** Mixed media, 11 × 10 in.
62 **The Genetrix** Mixed media, 11 × 10 in.
63 **The Oasis** Mixed media, 11 × 10 in.
64 **The Timekeeper** Mixed media, 11 × 10 in.
65 **The Dancer's Dream** Mixed media, 11 × 10 in.
66 **Relative Values** Mixed media, 11 × 10 in.

V

List of books by Desmond Morris

1 **The Biology of Art** (1962) Methuen, London.

2 **The Mammals: A Guide to the Living Species** (1965) Hodder and Stoughton, London.

3 **Men and Snakes** (with Ramona Morris) (1965) Hutchinson, London.

4 **Men and Apes** (with Ramona Morris) (1966) Hutchinson, London.

5 **Men and Pandas** (with Ramona Morris) (1966) Hutchinson, London.

6 **Zootime** (1966) Rupert Hart-Davis, London.

7 **Primate Ethology** (Editor) (1967) Weidenfeld and Nicolson, London.

8 **The Naked Ape** (1967) Jonathan Cape, London.

9 **The Human Zoo** (1969) Jonathan Cape, London.

10 **Patterns of Reproductive Behaviour** (1970) Jonathan Cape, London.

11 **Intimate Behaviour** (1971) Jonathan Cape, London.

12 **Manwatching: A Field-Guide to Human Behaviour** (1977) Jonathan Cape, London.

13 **Gestures: Their Origins and Distribution** (Co-author) (1979) Jonathan Cape, London.

14 **Animal Days** (1979) Jonathan Cape, London.

15 **The Soccer Tribe** (1981) Jonathan Cape, London.

16 **Inrock** (1983) Jonathan Cape, London.

17 **The Book of Ages** (1983) Jonathan Cape, London.

18 **The Art of Ancient Cyprus** (1985) Phaidon, Oxford.

19 **Bodywatching: A Field-Guide to the Human Species** (1985) Jonathan Cape, London.

20 **The Illustrated Naked Ape** (1986) Jonathan Cape, London.

21 **Catwatching** (1986) Jonathan Cape, London.

22 **Dogwatching** (1986) Jonathan Cape, London.

23 **The Secret Surrealist** (1987) Phaidon, Oxford.

24 **Catlore** (1987) Jonathan Cape, London.

25 **The Animals Roadshow** (1988) Jonathan Cape, London.

26 **The Human Nestbuilders** (1988) Crown, Darwen.

27 **Horsewatching** (1988) Jonathan Cape, London.

28 **The Animal Contract** (1990) Virgin Books, London.

29 **Animalwatching** (1990) Jonathan Cape, London.

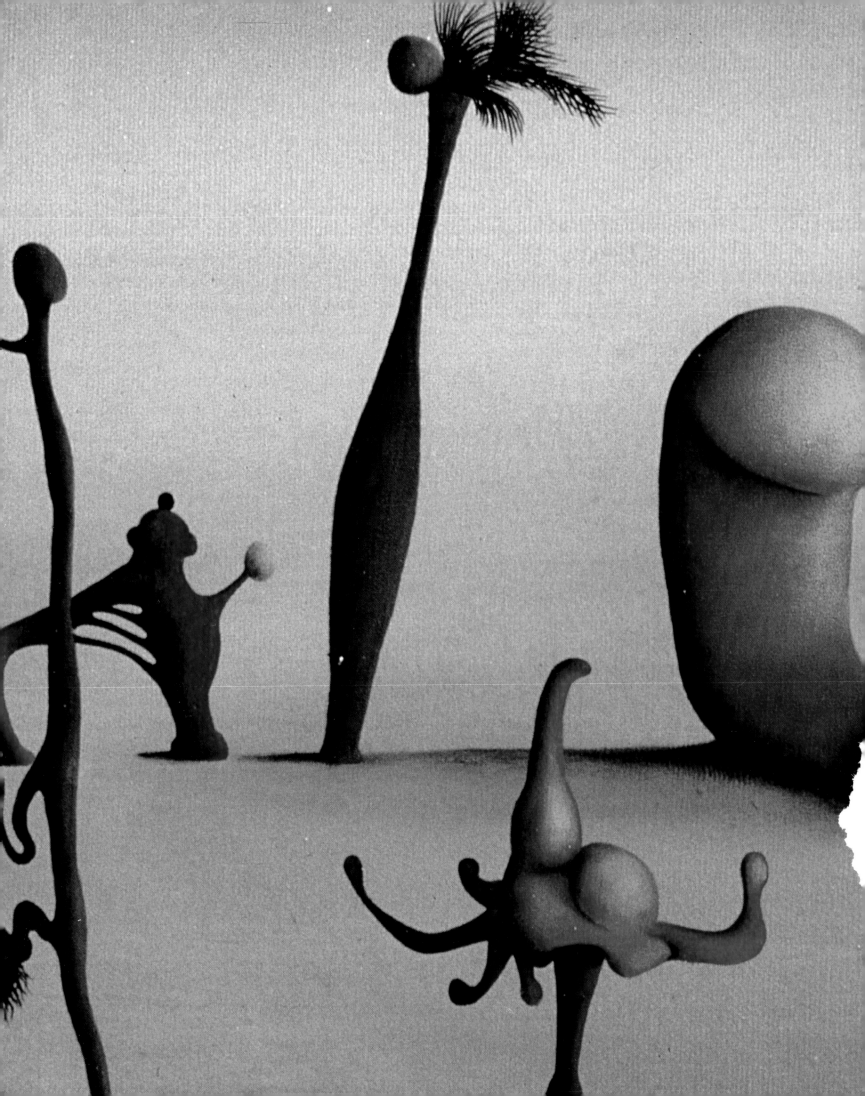